T0379863

'This book is at once penetrating and kaleidoscopic, full of exposition coupled with evocative ethnographic illustration. It extends Gell's ideas into new domains… The synthesis is extraordinary. Ranging across time and space and diversity of perspectives compared and contrasted, this volume will take its place alongside others—one thinks of *The Savage Mind, Purity and Danger*.'

— Frederick H. Damon, *University of Virginia, USA*

'Küchler and Carroll have brought their different anthropological experiences and deep knowledge together in a book to engage the anthropology of art with a deep reading and extension of Alfred Gell's framework. Calling for a "return to the object," a theoretical project that follows Gell's movement away from the emphasis on signification and to the study of "relations immanent within objects", the book is ethnographically detailed and philosophically articule. Readers may find it a challenging formulation, spanning over numerous case studies, but it rewards us in profoundly enriching the possibilities of the anthropology of art.'

— Fred Myers, *New York University, USA*

'Vivid, generous, and theoretically exciting, Küchler and Carroll bring the Anthropology of Art back to the world of big ideas. But never at the expense of the objects themselves. Featuring an extraordinary array of ethnographic detail and insight, this landmark publication is a must-read for anyone seeking to become more alive to the generative, relational, and conceptual capacities of images and objects. The work of apprehension it argues for—and offers up—is astonishing.'

— Jennifer Deger, *James Cook University, Australia*

A RETURN TO THE OBJECT

This book draws on the work of anthropologist Alfred Gell to reinstate the importance of the object in art and society. Rather than presenting art as a passive recipient of the artist's intention and the audience's critique, the authors consider it in the social environment of its production and reception.

A Return to the Object introduces the historical and theoretical framework out of which an anthropology of art has emerged, and examines the conditions under which it has renewed interest. It also explores what art 'does' as a social and cultural phenomenon, and how it can impact alternative ways of organising and managing knowledge. Making use of ethnography, museological practice, the intellectual history of the arts and sciences, material culture studies, and intangible heritage, the authors present a case for the re-orientation of current conversations surrounding the anthropology of art and social theory.

This text will be of key interest to students and scholars in the social and historical sciences, arts and humanities, and cognitive sciences.

Susanne Küchler is Professor of Anthropology and Material Culture at University College London, UK.

Timothy Carroll is a principal research fellow and a UK Research and Innovation Future Leader Fellow in Anthropology at University College London, UK.

A RETURN TO THE OBJECT

Alfred Gell, Art, and Social Theory

Susanne Küchler and Timothy Carroll

LONDON AND NEW YORK

First published 2021
by Routledge
2 Park Square, Milton Park, Abingdon, Oxon OX14 4RN

and by Routledge
52 Vanderbilt Avenue, New York, NY 10017

Routledge is an imprint of the Taylor & Francis Group, an informa business

© 2021 Susanne Küchler and Timothy Carroll

The right of Susanne Küchler and Timothy Carroll to be identified as authors of this work has been asserted by him/her/them in accordance with sections 77 and 78 of the Copyright, Designs and Patents Act 1988.

All rights reserved. No part of this book may be reprinted or reproduced or utilised in any form or by any electronic, mechanical, or other means, now known or hereafter invented, including photocopying and recording, or in any information storage or retrieval system, without permission in writing from the publishers.

Trademark notice: Product or corporate names may be trademarks or registered trademarks, and are used only for identification and explanation without intent to infringe.

British Library Cataloguing-in-Publication Data
A catalogue record for this book is available from the British Library

Library of Congress Cataloging-in-Publication Data
A catalog record has been requested for this book

ISBN: 978-1-350-09348-5 (hbk)
ISBN: 978-1-350-09347-8 (pbk)
ISBN: 978-1-003-08433-4 (ebk)

Typeset in Bembo
by Newgen Publishing UK

CONTENTS

List of figures	*ix*
Acknowledgements	*xi*
Preface	*xiii*

Introduction: Gell and his influences	1

PART I
Rethinking the frame

17

1	Lessons from the art nexus	19
2	The index and indexicality	34
3	The prototype and the model	50
4	Immanent relationality and its consequences	67

PART II
Following the prototype

83

5	Virtuosity and style	85
6	Aesthetics and the ethics of relation	102

viii Contents

7 Generativity and transformation116

8 Agency (social)133

PART III
Rediscovering the object149

9 Material agency151

10 Colour, palette, and gestalt169

11 Patterns and their transposition188

12 Motile animacy206

*Afterword*223
*Bibliography*227
*Index*248

FIGURES

All images, unless otherwise noted, are the original line drawings of Ian Fogden.

1.1 An extended meditation on the permutations of the art nexus, after a sketch of Alfred Gell's, found amongst his papers in the RAI archive. Text appearing in square brackets are the authors' interpretation. The + and − are, as Gell noted elsewhere on the page, indicative of the presence and absence, respectively, of that constituent part of the nexus. Redrafted by Timothy Carroll. 23

1.2 An original line drawing showing a side-by-side comparison of the *'nkisi*, which appeared in Carl Einstein's *African Sculpture*, stripped of its nails (right), and a 19th century *'nkisi* figure from Kongo (left), composed of wood, natural fibres, and nails; part of the Christina N. and Swan J. Turnblad Memorial Fund, 71.3, Minneapolis Institute of Arts. A similar layout was used by Einstein. 28

2.1 The diagram of kinship and trade circulation, after 'Figure 4. Canoe paths' in Nancy Munn (1986, 133). 46

3.1 A sample of continuous and discontinuous forms, after 'Figure 1: Elementary Visual Categories' in Nancy Munn (1966, 938). 56

3.2 A line drawing of an Aboriginal Australian hollow log coffin, detailing the cross-hatching design, after the object with accession number M.0079 in UCL's Ethnographic Collections. 61

3.3 A selection of the Wilkinkarra Series, after the sample provided by Fred Myers (2002, 110) in *Painting Culture*. 64

4.1 Diagram showing quadrants of the Khipu from Pachacamac, after Gary Urton's (2003) 'Figure 3.14 Four-part organization of knot directionality on khipu from Pachacamac' (87). 78

x Figures

4.2 Malanggan funerary figure. Drawing after a figure collected by
 Alfred Bühler held in the Basel Museum of Cultures. 80

5.1 Line drawing comparing the architectonic similitude between the
 Sepik initiation house and the yam trellis, after 'Figure 16. Seitenriß
 des korambo der nordwestlichen Abelam, Wewungge, Kuminimbis'
 in *Kulthäuser in Nordneuguinea* by Brigitta Hauser-Schäublin (1989a,
 92) and field sketches provided to us by Ludovic Coupaye. 95

6.1 Yoruba *Gelede* headdress, after Figure 14.7 of Robert Farris
 Thompson ([1973] 2006, 266). 104

6.2 After Captain JG Stedman's sketches of 'Manner of catching Fish
 by the Spring-Hook' and 'Manner of catching Fish by the Spring-
 Basket', in his *Narrative, of a five years' expedition against the Revolted
 Negroes of Surinam, in Guiana, on the Wild Coast of South America*
 (1813, 236–237; cf. Gell 1996, Figure 11). 109

7.1 Line drawing of design of *ida* dancers used in the *ida* festival
 alongside the path traced in the clearing by the dancers, and
 the colour diagrammatic, showing move from black to red, after
 'Figure 42 The transformation of mask-types' and 'Figure 46 The
 sequence of colours at *ida*' in Alfred Gell (1975, 299, 322–323). 125

7.2 Line drawing of a *mola* design. 129

8.1 A dramatized rendering of Alfred Stieglitz photographing the
 Fountain by R. Mutt, 1917. 134

9.1 An example of a patterned *tivaivai* and the colour squares strung on
 a string, ready for assembly, after photos by Susanne Küchler. 158

9.2 The light and incense smoke playing with each other within an
 Eastern Orthodox cathedral. 166

10.1 A close-up of painted beadwork, after an example from
 Louise Hamby and Diana Young (2001). 171

11.1 Pattern, and its elements, after Figure 4, and permutations and
 degradations of the pattern, after Figures 15 and 16 from
 Alastair Clarke (2008, 21, 30). 190

11.2 A map of Pitcairn, a landfall image, and one proposed by Alfred Gell,
 after Figure 2 of Gell's 'How to Read a Map' (1985, 281). 199

12.1 The face of a god, 'Oro, tattooed on the posterior of a Tahitian,
 after Alfred Gell's interpretation of Sydney Parkinson's eye-witness
 sketches from the Cook expedition in 1769. 209

12.2 A diagram of the Fang *mvet* (harp), showing right and left sides,
 and the musical notes achieved with each string, after 'Figure 1
 The Fang harp', from Boyer (1988) in 'Authorless authority'
 by Carlo Severi (2016, 138). 216

ACKNOWLEDGEMENTS

It is our joy to thank the generations of students, some of whom are now practitioners and colleagues, who have taken the Anthropology of Art course we taught over the years. Unknown to them, they have helped shape our ideas and helped select the case studies we employ in these pages.

We also are deeply grateful to Simeran Gell and the staff at the Royal Anthropological Institute, especially Sarah Walpole, Archivist and Photo Curator at the RAI, for their help and encouragement during this process, and for the use of Gell's sketch as a cover image.

We also thank Ian Fogden for his great skill and invaluable labour in preparing the sketches used herein as figures.

To our many colleagues at UCL, most notably Ludovic Coupaye who kindly allowed us to consult his field sketches, we are deeply grateful. Our ability to bring this volume together is in no small part due to the rich intellectual community in which we work, and the stimulating conversations we are able to have while teaching.

PREFACE

This book is something of a surprise. In retrospect, it has had a long history, going back at least as far as the publication of Alfred's *Art and Agency*, and even before that in his teaching and other means of influence upon the authors. In the 20 years since *Art and Agency* came out, Susanne has used it in her teaching of a course on the Anthropology of Art. Timothy took over this course during a period when Susanne, as Head of Department, was unable to continue teaching it. In the ten years of teaching this course together, and the development of Timothy's research in dialogue with the core ideas present throughout the course, a unique and budding conversation has developed between the two of us. Over the years, we have had the privilege of working through, testing, critiquing, and developing the core theoretical frameworks posited in Alfred's work, and we also sought to uncover the often covert and only implicit legacy of ideas and influences shaping Alfred's thoughts.

This gave rise to a co-authored chapter, on Art in the 20th century, where what had been a slow and accidental conversation took on a more purposeful and earnest engagement. During the process of writing that chapter, we realised that there was much more to say about the epistemic nature of an object and its value as data. In the excitement of discovery during that small writing project, we landed upon the idea to write a book-length exploration and elaboration of Alfred's core theoretical *oeuvre*. In the course of this, we uncovered germinating ideas that had influenced our thinking as well as that of certain other contemporary scholars. These ideas have their antecedents in the influences upon Alfred Gell's work, and writing this book has allowed us a view of the *longue durée* of these ideas, as they influenced Alfred's work, developed in his work, and continue into the present day. The core aspect of this theoretical development is the importance of what we have taken to call 'relational immanence' and the abstract geometric imagination accompanying it. In a sense, nothing that we present in this volume is particularly new; rather, it is the rearticulation of an ongoing stream of argumentation that has been held to the

xiv Preface

side because of the preference towards a more linear approach to geometric and logical thought.

Given this opportunity to step back and consider Alfred's *oeuvre* in its wider context of ideas and scholarship, we have worked to not only unpack his contributions, but also bring them into conversation with important ethnographic works 'high art' case studies, some of which have emerged since his untimely death, and others well known to Alfred, though implicit in his writing. In developing his ideas, we take his legacy in new directions, but hold strongly to his conviction that an anthropology of art is pertinent to all art-like production, and that the object is as central to anthropology as it is to the study of art. The return to the object, therefore, is intending to make explicit a paradigm shift in anthropology, envisioned by Alfred, away from relations signified by objects, to a study of relations immanent within the object and the theoretical implications thereof.

INTRODUCTION

Gell and his influences

For Alfred Gell (1998), the anthropology of art is the study of 'social relations in the vicinity of objects mediating social agency' (7). This frames 'art' in the broadest sense, not limited to canonical, institutional definitions, but nonetheless deeply tied up with these institutions as part of that mediated social agency. From this perspective, 'anything whatsoever could, conceivably, be an art object from the anthropological point of view, including persons, because the anthropological theory of art . . . merges seamlessly with the social anthropology of persons and their bodies' (Gell 1998, 7). Thus the anthropological point of view considers the 'real and biographical consequential [relationships], which articulate to the agent's biographical "life project"' (Gell 1998, 11). In this view, the object is a temporal thing whose endurance and biographical development is done in tandem with that of its human counterparts. In fact, it is via the object, and particularly the enchained relationships made present because of the object, that the human mind is able to comprehend and navigate time. This is done via abstracted mental images of the artefact, or space or, in fact, time (Gell 1992a, 242f, 1995a). These images are mental maps of time – or what Gell (1992a) calls 'chrono-geography' – which are the result of 'time-geographic model-building' that in turn allow for the 'theoretical possibilities of choreographing social activities' (191). This, then, presents us with the issue of the image and its endurance across media and generations as the crucial point of departure. In this respect, the anthropological view of art is shared across Anthropology, Archaeology, and Art History, and it is this broader science of the image from which we take our departure.

Image science is based on the careful reading of the largely unpublished works by the early 20th-century art historian Aby Warburg which, as Georges Didi-Huberman (2017) observed, displaces, defamiliarizes and thus 'disquiets' art history in its concern with the 'anthropology of the image' (23). The importance of ethnographic collections and ethnological writing about images has been central to

2 Introduction: Gell and his influences

the development of object-centred disciplines from Archaeology to Art History to Anthropology and beyond. Warburg's own research on the image within the Hopi snake dance holds a pivotal place in the understanding of what Didi-Huberman (2017) calls the 'survival of the image'. The image's paradoxical durability across media and time poses a problem for the science of the image as the ephemerality of the image, and yet its endurance – particularly across media – demands an explanation. The emphasis Warburg offered on the relation between the iconography and the context within which images circulate as vehicles of emotion and memory had a profound impact on 20th century interpretations of Renaissance art.

By contrast to Warburg, Franz Boas (1955, among others), influenced by the school of cultural diffusion and language in late 19th-century Germany, pursued research amongst North American First Nations Peoples that worked to uncover the elements of composition found in language, image, and the body. The elemental quality of composition, both interior (mind) and exterior (form, style), was, for Boas, explained via his concept of virtuosity. This concept of virtuosity became analytically central to the work of subsequent pillars within the anthropology of the image, notably Claude Lévi-Strauss and Gregory Bateson, who each in their own way developed an explanation for the 'survival of images' based on the independence of the logic of image separate from culture, yet fundamental to culture. While not working within the same framework, Nancy Munn has also been crucially important in the development of this line of thought within Anthropology. Her work in both Australia (1966, 1973) and in the Massim (1986) was influential in Alfred Gell's thinking and in the formation of this book.[1]

Whereas for Warburg, the logic of the image is the pathos (i.e. the emotional pull), for Boas and subsequent theoreticians in anthropology, the survival of the image rests not in its relation to pathos, but in its own self-similarity. The nature of self-similarity is one wherein the form is an isomorphic configuration of an idea of relation. This idea, in being externalised – or concretised – in an object, becomes an image, manifesting the patterns that are analogical to the social world.

1 In this regard, it is also worth noting an epistemic difference between the work of Boas, Bateson, Lévi-Strauss and Munn – and many others during the same period drawing on similar influences – and those like Marilyn Strathern (1979, 1988) or Simon Harrison (2005) who, in the 'discovery' of New Guinea as an ethnographic focus in the 1960s to 1980s, were forced to rethink the spatialisation of relation as it becomes concretised in material form. The move from Africa to Oceania troubled many of the well-seated assumptions of ethnographic observation and the understanding that can be derived from its analysis. While in Africa the social organisation was typically mapped out physically within village arrangement, in Oceania the fluid and ephemeral nature of the discrete social nexus meant that observation had to target and reconstruct abstract ideas of assemblage via objects and the practices surrounding them. However, in this renewed attention to objects and their social relations, those like Strathern tended to analyse the artefactual as part of the (in)dividual nature of the human person. This is an analytical focus distinct from the one drawn out here, in which the wider social implications of the object are a temporally inscribed aspect within social practice. In the work of Munn, Bateson, Lévi-Strauss, and Gell, the object is the driver of the epistemic ability to contemplate the social; by contrast, in the work of Strathern and Harrison, the artefactual form is a residual substance external to the person, and the artefact is only ever referential to the person as a 'partial connection' (Strathern 1991).

By contemplating the nature of relation held within the object (and intuitively recognisable in the motivic elements by which the image is composed), the subject is able to understand, and thereby participate in, social worlds. For Anthropology, the idea of relation, its longitudinal capacity to connect inter-generationally and cross-culturally, and its non-random and yet diverse configuration that invites cross-comparative analysis, has remained central; and it is because art actively contemplates relation – both in its making and in its provocation of thought – that it is a principally theoretical domain. As Didi-Huberman (2017) has noted, the survival of the image 'disquiets' the classificatory tendency of Art Historical practice to identify an art object by its genre; in Anthropology, the images' survival is equally unsettling as it challenges the notion of cultural boundedness and the importance of an anthropocentric context.

The image – or at least those that survive in the ecology of mind (Bateson 1972) – is itself a paradoxical thing. It is unitary – the child imagines a dog – and multiple, as the dog is recognised as a token. In the idea of the gestalt (Arnheim 1974) there is already before recognition the basic compositional elements of identification. Similarly, in Panofsky's (1939) theory of apprehending images, the pre-iconological stage makes use of the gestural elements that, even before recognition, help build towards the iconographic recognition and iconological understanding. These theories, each in their own way, speak to the elemental relations within the image and between the image and the objects upon which they come to rest. Each object, then, unique and total in itself, is also the complex composite of gestures, images, and intertextual and interartefactual relations. Objects are, fundamentally, always unsettling. They manifest this paradox of the idea of the multiple resting upon the finitude of the one.

Boas' recognition of the relation between the dynamics of composition and style, and particularly the link between the interiority and the exterior form, continued in American Cultural Anthropology only up through the middle of the 20th century. At this point, dominant theories, such as Geertz's definition of religion as a system of symbols (1966), reduces the importance of the concretised image to the symbolic, and thereby conceptual, value alone. What is lost in this emphasis on symbol is what Claude Lévi-Strauss formulated, at the same time, as the conditions for the 'science of the concrete' (1966). The science of the concrete takes as its starting point the understanding that the idea of relation is present *a priori* in the qualitative aspects of social life; fundamental to this is the fact that we have access to these relations apart from and before language and communication. The fundamental importance of Lévi-Strauss's (1966) science of the concrete is that the 'savage mind' of 'small scale societies' is identical to that of the 'scientist' in its ability to think through complex abstract geometric objects, exemplified in his 'canonical formula'. The important implications of this have been lost in large part due to the bias in Western scholarship identified by Jürg Wassmann (1994). As he says, 'this idea of one's own body as the centre of the universe, and the conviction that the relativistic conception of space is "more natural and primitive", is deeply rooted in Western traditions of scientific and philosophical thought' (647, citing Miller and

4 Introduction: Gell and his influences

Johnson-Laird 1976). The impact that Geertz's versus Lévi-Strauss's bodies of work has had on American and European Anthropology, respectively, is still felt today. While there are obvious points of cross-pollination – notably for our argument, the work of Gregory Bateson on ecology and cybernetics (1972, 1979; Bateson and Bateson 1988) – the predominant move toward signification and language, as seen in the work of American scholars of material culture such as Webb Keane (1997, 2003, 2007), has dominated North American writing on cultural artefacts.

It is in the writing on cultural artefacts, and in fact the contrast between the writing and the artefacts themselves, that a crucial difference comes to light in terms of the problem of text-based tradition versus traditions based on a canon of images (Barthes 1983, 1997; Severi 2016). The danger with movement to text, like the movement to signification, is that the immanent relationality of the object – and its concomitant images – is pushed to the side in favour of the referent to which it is assumed to point. Assumption about the relation between image and object, and the bias toward interpretation, has important ramifications in how different disciplines have responded to the challenge posed by the 'survival of the image'.

To the contrary, this book takes as a starting point the problem of the survival of images, by tracing the lineage of thought evidenced in the work of Boas, Bateson, Lévi-Strauss, Munn and Alfred Gell. By excavating this lineage and its lasting importance in understanding the object, we hope to help kindle a fundamental paradigm shift in the approach to the object, which has not yet occurred because of the obfuscation of objects-as-thought in favour of their interpretation. The assumptions of what governs the survival of the image across media and time, and why this is important to social theory, have lasting impact upon methodological and theoretical approaches. Our argument rests on two movements, which appear paradoxical. The first is to deny interpretation in favour of 'incantation' – that is, the invocational capacity of the object as thought (cf. Gell 1992b, 1996; Küchler 2003). The second is to advance the universal capacity for 'post-Newtonian' abstract modelling as foundational to human thought. While the second may appear as a kind of interpretation, it is – as demonstrated throughout this book – in fact an immanent capacity of the object in its own relations.

This book centres on the work of Alfred Gell as a pivotal moment in which a paradigm shift was emerging from a context when the dominant forms of semiotic analysis and representation began to crumble under the crisis of representation and political upheaval of the late 20th century. Through an exploration of the ideas that have informed the Gellian project of reconnecting the object to thought, and embedding objects within the heart of anthropological investigation of the relations in which thought unfolds, we work to place this paradigmatic moment in its wider intellectual context and thereby sketch out a scaffold for the development of new methodologies and theoretical imperatives.

The object in its multiplicity

In a period dominated by the shift from mechanical to digital production, and thus by a concern with the language of things and with a burgeoning technical

vocabulary for marshalling a collective unconscious in support of an increasingly market-driven economy, Michel Foucault's publication of *The Order of Things* ([1966 in French] 1970) marked a turning point in the project of social science. By excavating the assumptions informing science in the age of the Enlightenment, Foucault exposed the centrality of the concern with 'Man' as a unifying idea without parallel and yet with questionable duration. Against this background of an overarching concern with Man, Foucault identified an equally remarkably consistent concern with the order espoused by things themselves, and with the classificatory frameworks that helped to contain and transmit this order. *The Order of Things* set out to question the veracity of the methodological approach and the theoretical conclusions science had taken so far to the study of things, unsettling in the process the very epistemic foundations upon which the study of things had been founded thus far. *The Order of Things* thus developed the radical idea that things could indeed be approached and theoretically appraised from a perspective that does not assume an ego-centred, relative, and anthropomorphic relation between things and persons, yet this proposition was drowned out by increasingly shrill objections. It took more than five decades for the resurgence of this idea to gain ground, interestingly, though not unsurprisingly, in conjunction with the reappraisal of the writings of Claude Lévi-Strauss. *The Order of Things* was written at around the same time as Lévi-Strauss's work on *The Savage Mind* ([1962 in French] 1966), published in French just four years later. The two works had a remarkably similar message: Where Enlightenment science emphasizes observable quantities in ways that can be expressed in numbers, the emphasis on the time-sensitive order of things expresses itself qualitatively while remaining accessible to evidentiary reasoning. Claude Lévi-Strauss's writing reflected on the need to recognize 'the science of the concrete', which attends to the qualitative properties of the world and the distinctions that can be discerned between them, and to which a proliferation of concepts and a technical language draw attention in everyday life (Lévi-Strauss 1966, 2).

Lévi-Strauss's call to assert the framework for a new science of things resonates powerfully with Foucault's call to attend to relations immanent within and between things on their own terms, yet both failed to firm up the foundations of a new science of things. The reason for this failure is twofold. In a period of global decolonisation, and also the Cold War, the burden of social scientific thought was captured by the urgency to amplify the politics of social structure. Anglophonic anthropological work, ranging from that of Mary Douglas to those in the Manchester School and those in the US, like Ruth Benedict, focused on the sociocultural problems of governance. Within this broader context, the concern with things was predominantly focused on the issues of consumption and communication as a cloak for governance. Secondly, the concern with cognition, memory, and communication – emblematic of a concern with governance and world order – was fuelling technological advancements around communication and an emerging economy of knowledge, in which things were relegated to the servile position of mediation. In this paradigm, the understanding of things was grounded in much earlier theorisations of the relation between persons and persons via things, drawing on

6 Introduction: Gell and his influences

a theory of objectification as substitution which had gained increasing popularity throughout the 20th century. Grounded in the reading of Hegel and Marx, the idea that things can stand in or substitute for persons came to frame the cornerstone of social anthropological theory with the publication of Marcel Mauss's work on *The Gift* ([1923 in French] 1967). Arguably it was the simplicity of the idea of mediation underpinning the gift, and its resonance in the world of 'objects of desire' (Forty 1986) that enabled its popular acceptance across social sciences and the emerging fields of communication technology and of cognition. It is a sign of the remarkable persistence of ideas (itself, ironically, a problem of the survival of the image) of how things work that the first ever publications questioning this idea of objectification begin to emerge only at the end of the century (Gell 1998; Freedberg 1989).

A significant rupture in the technology of media, and the streaming of imma-terial forms of information, appeared toward the end of the 20th century. The advent of new digital media that worked in ways that did not resonate with the monologic of mediation began to emerge through technological inventions that changed how information was captured and transferred via material architectures newly presented to the world. These new forms challenged the very ideas that had formed media theory and other object-oriented disciplines to date (Wiberg and Robles 2010). However, while the dominant discourse around design and medi-ation remained focused on the casing of informational architectures, irrespective of the internal logics, the proposed harmony between interiority and exteriority has been a constant and sustained minor discourse since at least Gottfried Herder's *Sculpture* ([1778] 2002). In the advent of high modernism, in Vienna of the turn of the 20th century, a series of scientific advancements in surgery (notably by Zuckerkandl and colleagues), the emergence of Freudian psychoanalysis over and against phrenology, and artistic modernism as seen in the work of Gustav Klimt (Kandel 2012), all pushed at the locus of true essence, moving the frame from the visible external to the invisible internal.

At the same time, anthropologists like Franz Boas, while still actively practicing the kinds of measurements that undergirded a phrenological science of race and personality, began reframing the visual field of objects and how they should be understood. For Boas, the formal analysis of people (1891, 1898, 1915) and things (1897, 1916, 1955), based on form and proportion, spoke not to the evolutionary advancement of the population (1915) but rather suggested a relation between how the mind works via objects. Boas's formal analysis of 'primitive' art (1955, based on lectures from 1925) was built upon an understanding of the link between the physical and visible elements of objects and the cognition of the people (both craft person and society) who made it. While the cognitive capacity of all human populations was the same, the specific style and form was a concretisation of how cognition worked. This was not, for Boas, as it became for subsequent symbolic and semiotic anthropologists, representational; rather, the connection between the visible exterior of the artefactual surface and the internal cognitive content was a question of 'how' the California First Nations People thought, not 'what' they thought about. In Boas's discussion of the craft person, the process of feeling,

Introduction: Gell and his influences **7**

sensing and knowing the material was a process 'with' the materials, such that the matter participated in the cultural production.

The link between the craft person, the material, and the artefact is made via Boas's (1955) term 'technical virtuosity' (17). This speaks to the 'beauty of form, the evenness of texture' (17) acquired 'through constant practice' (18) on the part of the craft person. 'Virtuosity', on another level, speaks to 'complete control of technical process' and 'means an automatic regularity of movement' (20). The virtuous artist, skilled with technical precision, is able to make beautiful craftwork via the systematic deployment of each particular technical action. Through this, the virtuosity of the maker is inscribed as a quality of the object (Boas 1955, 21), and an artefact, Boas argues, that lacks the 'regularity of form and surface pattern' is also 'lacking in skill' (22). In this idea of technical virtuosity, as well as in the formal analysis of artistic forms he goes on to analyse, there is a scalar relationship between each element of an artefact and the wider artefact, corpus (or *oeuvre*) in which that element is found.

In this light, the relationship between artefacts – and specifically their relationship to the cognitive faculty of 'how' people think – is of primary importance, over and against the tendency to categorise ethnographic artefacts according to type. Within the established scientific economy of knowledge, arising out the Franciscan Orders dispersed around the world and their collecting of objects as tokens of knowledge about the world, the classification of knowledge via objects became a primary concern (Findlen 1991, 1996). Arguably, this extends further back into the long history of cataloguing trade goods and partners in ancient trade practices (Wengrow 1998). The glut of goods coming into Europe throughout the missionisation and colonial periods presented a problem for European knowledge, and increasingly stratified systems of categorisation came into place in order to make sense of this surplus. This need to categorise objects by kind carried through into early anthropological work, such as in the case of Alfred Cort Haddon (1901) and the Torres Strait Expedition (Herle and Rouse 1998). However, in the anesthetisation of knowledge (itself a Kantian legacy) carried out through the modernist project, information became increasingly divorced from objects. With the growth of digital media, the surplus of knowledge separated from the specificity of the artefact gave way to the possible reappraisal of the object not subservient to its classificatory structure.

It is only now with the turning away from the preoccupation with order as classification of knowledge gathered for communication that we can fully appreciate the scale and impact of the neglect of the paradigm shifting insights set forth by Lévi-Strauss and Foucault. The philosopher Patrice Maniglier (2013) grapples with the recovering of these earlier approaches to the object, bypassing the misunderstanding that revolved around the attention paid to non-random, systemic relations between and immanent within things. The cause of the forgetting, which was sweeping and lasting, is explained by Maniglier as a misunderstanding of the core of the structuralist project; it was deemed to lack a concern with the temporal dimension that is an inescapable part of relations between persons and persons and things to which

8 Introduction: Gell and his influences

object's systemic relations draw attention. Structuralism has long been accused of being incapable of exposing the nature of social change – and this may be true of some structuralists more than others. However, structuralism's turning away from a concern with Man toward a concern with things was aimed precisely at engaging with the understanding the logical possibility of conceiving of change (Maniglier 2013, 119). Foucault's thought, unlike that of other structuralist theorists such as Bourdieu – for whom change is always necessarily exogenous – gives central place to the possibility of change within a system (Faubion 2011, 45–46).

Change as a possibility is inherent within the relation between objects, which is of itself described in terms of similarity and difference. Gregory Bateson, in his argument concerning the model, articulates the notion of double description, including both formal resemblances and differences, that give rise to higher levels of understanding and knowledge. Bateson's approach starts in formal analysis, as does categorical thinking, which probes the world for 'patterns of relation' (1979); however, he moves away from strict categorisation by invoking *abduction* as the lateral extension of recognising similarity between two discrete units (objects, behaviours, etc.) which proposes the possibility of further similarity. Abduction is a process that goes hand in hand with other types of reasoning, namely inductive and deductive, and thereby forms this process of 'double description'. The cooperation between deductive and abductive reasoning is the starting point of abstract modelling and predictive reasoning. Abduction, thus, is the lateral extension of the description of difference, whereas deduction is the lateral extension of the description of similarity. The recognition of multiple relations, opening out of the recognition of formal resemblance and difference – that is 'double description' – leads to the possibility of change within the system, not open ended, but infinitely variable within a bounded system of generative forms. This boundedness, or coherence within a set, is best described by Gell as 'the principle of least difference' (1998, 218). This movement away from straight categorisation of sameness and difference pushes the object as model into larger relations of thought, as not just a model of itself (i.e. an example of a genre) but as a model for, and in fact a model driving, operational thinking.

The possibility of thinking with models is an issue of metacognition founded upon metapattern. It is pattern that connects the sameness and difference across genre, and this abstracted pattern is recognised via abduction. In Bateson's (1979) argument, 'The *pattern which connects is a metapattern*. It is a pattern of patterns. It is that metapattern which defines the vast generalization that, indeed, *it is patterns which connect*' (11, emphasis original). Bateson argues, quite controversially, 'Mind is empty; it is no-thing. It exists only in its ideas, and these again are no-things. Only the ideas are immanent, embodied in their examples. And the examples are, again, no-things,' (11) they are the relation between structure and process inherent in the doubleness of the description produced by abduction and deduction. He continues, saying that an example, or model, 'is not the *Ding an sich*, it is precisely not the "thing in itself"' (11). There is no thing in itself, there is only thing as relation. This is not a constructivist's argument saying the viewer can make of an object what

Introduction: Gell and his influences **9**

they will, it is the recognition of the relations immanent within the object and the ideas they foreshadow. These ideas are the extension of the possibilities of relation contained within form laterally – across genre – and, as a protention (Husserl 1991; Gell 1992a), across time.

In Bateson's pointed critique of the Heideggarian tradition of *Ding* theory, we also find the root of ongoing misapprehensions of the role of objects in contemporary social theory. At this point it may be helpful for us to draw some lines of distinction from other important work in the fields of art and object-oriented study in order to clearly position this book's theoretical drive. There has arguably been a fundamental misunderstanding in the tradition following Gregory Bateson's and Lévi-Strauss's writings concerning the nature of relation between thought and thing, and its implications to anthropological theory. This is a misunderstanding around the 'science of the concrete' (Lévi-Strauss 1966). The science of the concrete, as formulated by Lévi-Strauss, uses the description of qualities to make inferences in a parallel manner to how science uses quantitative analysis to arrive at its conclusions. In this way, the science of the concrete has offered the promise of an objective footing for a science based on subjective experience, and, in this capacity, the structuralist paradigm was taken up by wider anthropology to help substantiate its methodological rigour. This is, ironically, the very same reason for which Peircean semiotics was taken up by semiotic anthropology at about the same time (Singer 1980; Mertz 2007). However, while both credit the object as grounds for analysis, they each remove the object from view in favour of the abstracted structure or meaning, respectively. In doing so, each of these major trends in the theorisation in the second half of the 20th century have been reliant on referential reasoning in which the objects were merely illustrative. This is, however, not the principle claim of Warburg, Boas, Bateson, Lévi-Strauss, Munn, and Gell. In the work of each of these scholars, the object is first and foremost already constituted as a relational entity engaging ideas directly.

At heart, it is a question of *what the object is* in relation to the idea, and as Maniglier has pointed out, it is a problem that arises out of the interference with the role of language in concept formation. For example in the work of Lambros Malafouris, thought is seen to arise out of the Heideggerian thing in itself. This emphasis on *Ding as sich*, however, ignores the relations immanent in the object that externalises an already abstract formulation of thought and enables the contemplation of similarity and difference. And while Malafouris's (2013) work in *How Things Shape the Mind* sets out to highlight the artificiality of the 'ecology of memory' – which includes, and is made manifest by, the object – its principle concern is the relation of the artefact and technological advancement to the material constitution of the brain. This focuses the argumentation on the kinds of cognition that can be mirrored by the brain out into the world and, secondarily, how that mirroring can then change the brain. It takes in its scope the longitudinal process of evolution, assuming a movement from 'anchored' to 'absolute' (Wassmann 1994) cognition. In this it fails to attend to the abstract qualities of thought already immanent in a single object, via which the mind comes to shape worlds.

10 Introduction: Gell and his influences

Malafouris's attention to how the material plays within the development of mind can be counterpoised with other models of cognition and transmission. Most notable is the contribution of Dan Sperber (1985, 1996), in his study on narrative form, using models from medical science to understand the distribution of images as a form of 'epidemiology of representation'. Another aspect of the externalisation of mind is advanced in Lawrence Hirschfeld and Susan Gelman's (1994) work on domain specificity in cognition and culture which proposes that objects stimulate or trigger mental modules as a precondition for their transmission. David Wengrow (2014) combines these approaches in a productive way in his work on the composite images of the monstrous in the ancient world. Wengrow, referencing Barbara Stafford's *Echo Objects* (2007), seeks deeper insight into the longevity and potency of certain kinds of composite representations. This approach to the survival of the image allows Wengrow (2014) to advance the thesis that 'physical objects as nonhuman bearers of thought-like processes, carrying "images that make shared learning possible"' (6, citing Küchler 2005a, 207). The transmission of composite images

> can be interpreted via two different notions of modularity, one rooted in cognition and the other in technology. . . . Although their respective starting points are very different—one being inside the mind and the other outside the body—both concepts of modularity have implications for cultural transmission.
>
> (Wengrow 2014, 6–7)

and both are used by Wengrow to address and complexify the relationship between mind and matter. Our own argument in this book continues to address this question of the interrelation between internal and external, between mind and material, and proposes that the mind reaches out to materials that it can work with in the isomorphic externalisation of itself.

This aspect, of thought-with-object, is also addressed in the work of the editors of *Thinking Through Things* (Henare, Holbraad, and Wastell 2007), who focus on the role of the object within the heuristic practices of people in various contexts. In taking an object as a heuristic device, Henare et al. place the burden of investigation on the possibility of strategic learning via things. However, this position of heurism is built on an *a priori* object that 'may dictate a *plurality* of ontologies' (7, emphasis original) without acknowledging the object's immanent metapatterns. So, for Malafouris, objects are part of a task-oriented project, involving, for example counting of clay objects, and thus, understanding comes only as a secondary result of the process of the task, creating the ecology of memory as contingent on the practice of objects, not in the objects themselves. Similarly, for Henare et al., it is the learning with the object, not the formal qualities of the object itself *as* thought, that furnish the starting point for possible ontologies. Both Malafouris and Henare et al. focus on the artefactual qualities of the object, concentrating on the thing and the behaviours and patterns of thought that it can elicit. By contrast, Wengrow, while

Introduction: Gell and his influences **11**

looking at artefacts, is primarily concerned with composition as both an internal and external act of social cognition.[2] We follow Wengrow in this, developing the notion of composition in regards to the sequentiality of thought as it is manifest in the sequentiality of the inter-artefactual domain – including artefacts, music, language, and other creative gestures. It is by this sequentiality, manifest in the object, that innovation occurs, and thus new understandings and knowledge may be learnt (cf. Wallace 1978, 294; Wagner 1975).

This idea of learning with things is also central to the work of Tim Ingold (2011, 2013, 2017). For Ingold, the perceptual paradigm of the embodied mind demands that, in order to acquire new skills, the mind needs to empty itself of any intentionality or plan. The allusion to the emptiness of mind as a starting point for both art and science may appear to be a Bergsonian move, as it draws attention to the process of learning within a frame. Learning is a process outside the body, including the natural environment. However, while the Ingoldian person may recognise patterns of similarity and difference, we have no recourse to how this knowledge can help to manage the system of which we are a part. Nor can it be utilised with specific desired outcomes within the ecology in which we sit. For Ingold, it is not ideas that drive making, but rather people (and cats[3]) are made secondary to the generative flow of things.

In each of these theoretical contributions to the relation between thought and thing, the theorisation does not allow the object to be contemplated as an abstract model in an intersubjective and empathetic manner. The neglect of the object as model, connecting the mind and material, has prevented anthropology to have fully developed an anthropology of objects. While there is an obvious place for heuristic trial and error, or 'tinkering',[4] there is the need, following Claude Lévi-Strauss, to admit that the model arises out of and contains complete understanding. Successful trial and error depends on the individual's ability to abduce ideas via the metapattern from partial information in order to intuitively and skilfully build toward total understanding. So, while the thing as heuristic is true, in part, it only works to advance the first stage of learning. The success of such a practice must rely on the ability of the object to be recognised as a model by fostering double description. It is the virtuosity of the artist/craftsperson – their knowledge of the

2 It may be helpful to note the contrast between Wengrow and others working in social cognition, for example, Webb Keane (1997, 2003, 2013) and Nancy Munn (1966, 1973, 1986). Whereas the semiotic approaches offered by Keane and Munn focus on the interpretive meanings of the signage, Wengrow focuses more closely on the materiality of the signifier. In this way, the theoretical insights offered by Wengrow are not tied to the heritage of linguistic abstraction. Instead, he offers a new perspective on the image as both a material and cognitive agent. In Munn's work on the qualisigns of value (1986), the materiality of the sign is seen as important, but the materiality of this qualisignage is not considered in reference to the endurance of the image as it is in Wengrow's work.

3 In his 'Textility of making' (2010, 95), Ingold uses Carl Knappett's (2005) example of catflaps to problematize the agency of the human, the cat, and the object.

4 For an extended discussion of the negotiation around material used in care settings as 'tinkering', see Mol, Moser, and Pols (2010).

12 Introduction: Gell and his influences

medium and the intended design of the outcome – that allows the production of new artefacts and in turn captures the 'relational nature of action' (Gallese 2001, 34). The relational nature subsequently enables the new artefact to take on the status as model. It is the relational nature of action inscribed in objects that serve as models which gives rise to the higher-order intellectual processes of abstraction emerging out of double description. In a move that is at once forgetful of its origins and inventive of new theoretical possibilities, Gell bundles Boas, Bateson, Lévi-Strauss, Munn, Warburg, and many others as he proposes to return to the object as 'constitutive graphic act' (Gell 1998, 191) and 'articulatory gesture' (Gell 1979, 1999).

Gell's posthumously published *Art and Agency*,[5] sits at a crucial point in the history of the development of the science of the image, when the technology of information processing had reached a level of complexity that posed a problem to innovation. The separation of discrete units of information from the material infrastructure of information processing, which had constituted the model for computer interaction design and cognition, had to be reappraised. Across the disciplines, from linguistics to cognition to computer sciences and the emergence of big data, the overriding concern with classification gave way to an emphasis on modelling structure and process as sequence. As we return to the question of how objects, on account of their similarities and differences, make relations of a higher logical type perceivable, conceivable, and describable, we realize the enormity of the impact that the reduction of structuralism to a method and the forgetting of its theoretical impetus had on social science.

Summary of chapters

The chapters in this present volume begin slowly, taking the theory of the Art Nexus as a starting point. The chapters are framed so as to revisit the cornerstones of Gell's argumentation and to elaborate these aspects of this theory in reference to ethnographic case studies that he himself drew upon, as well as bringing into the conversation new case studies arising from more recent ethnographic work. This is then expanded in the subsequent chapters, as we elaborate the theoretical implications of shifting from the definition of objectification as substitution to one of sequence. The volume then circles around and revisits the theoretical framework of *Art and Agency* in the last chapter, bringing new insight to our understanding of Alfred Gell's *oeuvre*.

This book is explicitly about human concern with the object, not human concern with humans via the object. This means that, like Gell, we move between cultural contexts and historical periods with the fluidity that Peter Ucko (1969) advanced as a core methodological aspect of the new school of material culture

5 It may be interesting to the reader to note that, at least at the time of writing his obituary, Chris Fuller (1997) referred to *Art and Agency* by the anticipated title of *The Art Nexus*. This title, in fact, concurs with our reading of the book as being about relations being made apprehensible via the art object, rather than being about human agency, from which the second part of the book departs.

studies in his Curl Lecture in 1969. As mentioned in the Preface, this book is the outgrowth of a module taught for two decades on the Anthropology of Art. This course was never a survey of art, and while it drew on ethnographic case studies from across the world and from 'canonical' Western art, it focused on what the art object is and does, as a modelling of processes in a Lévi-Straussian (1966) sense of 'science of the concrete'. The object, we argue, enables the sharing and contemplation of difficult-to-fathom logical connections that are essential to the prediction and explanation of events (Gell 1988). This approach, therefore, does not have its focus in explaining the relation between the object and context, but rather explicating the intellectual work of the object that extends beyond its own space time.[6]

Chapter 1 examines Gell's theory of the Art Nexus as a way to unpack the position of the art-like object in relation to the artist, the viewing audiences, and the intentions behind its design. The chapter develops a critique and extension of this theoretical position, highlighting the importance of sequentiality within the complexity of objectification. This moves away from the 19th-century model of subject–object duality, to a reappraisal of the object as folded time.

Chapter 2 presents the semiotic critique of objectification, placing Gell's model within the longer history of the theory of the sign and emphasises the purchase and limitations of these different approaches. The chapter investigates the influences of Lévi-Straussian structuralism on Gell, and recovers the insights often overlooked. It examines the Kula system, wherein no singular aspect of the system stands alone, and each is situated in relation to the other aspects of the whole. In this way, the various objects and practices are indexes of the wider system as a whole. The interrelatedness of the indexes, what Gell refers to as their involute nature, is seen in how each is agentive in its relation toward the other. This produces a system of effect wherein each individual aspect is pushing upon their neighbours. It is this neighbourly relation that creates the nexus, thereby producing the object as index.

Chapter 3 focuses on the concept of the 'prototype' within Gellian semiotics. The chapter compares the relationship between the index and the Peircean 'object' after which it is made with the notion of the model as something that can be known. The chapter examines the epistemological implications of these different material ways of considering knowledge, and works through a series of case studies to discuss the epistemology and prototypicality of objects as systems.

In Chapter 4 we see that the capacity of the index is much more real and urgent than simply representation, as the materials and motifs of the artifice work as the basis for the showing forth of the prototype as immanent in the object. It is because of this capacity that the object is the model. The chapter moves forward the theoretical consequences of recovering 'structuralist' insights for a paradigm shift in our understanding of the object-as-knowledge which allows it to exist as part of a system. We introduce the concept of 'representational immanence', tracing

6 For specific works in this direction, related to and beyond art, see Tim Flannery (1994), Knut Rio (2009), and Douglas Bird et al. (2019).

14 Introduction: Gell and his influences

its history alongside the more commonly recognised substitutionary and mimetic representation. In so doing, we oppose the assumption of what Carl Einstein called 'optical naturalism' with a non-anthropocentric understanding of representation.

Chapter 5 traces the notion of 'virtuosity' from Boas, through Bateson and Gell, as an intersubjective quality within the artist and object that is recognisable to the viewer. Using the concept of the 'canon', which we take to be a set of collectively held understandings of relation, we expand the aspect of virtuosity within the object, as a quality discernible through intuition, making accessible the relational nature of action. It is this relational nature of action that provides the groundwork from which 'style', as the dynamic boundedness and interrelation of art work, emerges.

Chapter 6 reviews the relational aspects of aesthetics and the role this plays in art as action. The chapter argues for structural parallelism between the ethical boundedness of social practice and the aesthetically bounded material form. The relation between aesthetics and the work of form in conjuring to mind ways of being in relation that unfold in social practice has implications for methodology, both in terms of research orientation and within the ethnographic context as impetus toward, and model of, social action.

Chapter 7 explores art as action; it is the gesture of invention that shapes the contours of convention and is a generative, holographic thing. Outlining the importance of generative transformation as shown in Claude Lévi-Strauss's discussion of the canonical formula, the chapter examines a series of case studies, looking at the transformational capacity of gestural action. Each object offers an understanding of the whole and thus the possibility of invention. Taking seriously the object's role in facilitating transformation is critical to an understanding of bounded and dynamically fluid representations. In the generative capacity of objects, the sequentiality within an *oeuvre* is manifest in both the artefactual and social domains, as the human person is inculcated within that interartefactual seriality of action.

Chapter 8 addresses the concepts of agency and how different theoretical approaches to the efficaciousness of art are numerous and problematic to varying degrees in terms of the assumptions implicit within their framework. While much of the debate has rested around the question of intention, placing intention entirely in the social or denying its importance entirely, they assume egocentric and anthropomorphic impetus. The problem, however, is that the vector of action can only make sense, indeed can only come into being, within the relational commensuration of value. Agency is not a vector, with point of origin and infinite direction, but rather a measure between the recipient of action and the index that drives abduction. When taken at this level, the possibility of art as action and the effect of intention comes to rest in the valuation of material and the affordances of their relation.

Chapter 9 considers the material, as a site of substance and surface, standing in an immediate relation to the prototype. At this point, Bateson's (1979) elucidation of the mind as a 'no-thing' and 'empty' makes greater sense. As he says, 'Mind is empty; it is no-thing. It exists only in its ideas, and these again are no-things. Only the ideas are immanent, embodied in their examples' (11). Rather than the material world

Introduction: Gell and his influences **15**

being arbitrarily drawn upon and assigned semiotic value, we highlight now that the material affords certain kinds of thought, such that specific materials are sought out in order to allow the kind of thinking necessary for the contemplation of the prototype. The idea, that is the prototype, is immanent in the material of the index.

Chapter 10 examines material properties in terms of colour and concepts of substance. How colour relates to itself within a palette, and how colour may be taken as light or tangible matter, produces larger ramifications for social form. The gestalt phenomena of colour and its synaesthetic relations to other senses (especially sound and smell) make colour a much larger issue than simply the play of light waves. Colour's capacity for mutability affords suggestive ways of understanding and making visible the invisible and the not yet conceived.

Chapter 11 examines pattern as the predictable completion of a unit of elements. Without the recognition of pattern, it is simply sequence. To discern between pattern and sequence not only requires the knowledge of the unit, but also the ability to differentiate between the pattern and noise. Knowing the pattern, and the possible meta-patterns that may be playing atop each other, allows for recognition of error, or humour, or novelty. In the orientation within the pattern, as a subject moves from points A to B, or from the start to the end of a ritual, the ability to situate oneself within the geometric configuration of concrete elements, as well as mythical and ephemeral elements, depends on the intuitive apprehension of and relation toward the various elements and their internal relationality.

The final chapter, Chapter 12, expands upon the notions of pattern and transposition, highlighting the movement implicit in such sequencing. The possibility of movement, within the static form, opens the possibility of movement within the conceptual frame. Movement within the composition affords the possibility to make animation and association manifest in the object. Through animation, via the material, colour, and patterns, abstract ideas and entities are made immanent within the object.

In this way, we are provoking Gellian thought by tracing its 'intentions' and their legacy. In so doing, we are making visible elements of his work, present throughout his *oeuvre*, but hidden in plain sight within this work. In our return to the object, we aim to enable the return to the big questions in social theory, and invite Anthropology to return to the grand theoretical project of the questions posed by the 'phenomenon of man[kind]' (Wagner 1975, 1). In the long history of Anthropology and related disciplines, the object has been excluded, or denied a stake in theorisation. Dismissed as simply a substitutional objectification, or merely the footprint of mankind's past actions, or interpreted only as receptacle of the sign, the object has been side-lined within social scientific methodological endeavours. However, the endurance of the image, in terms traceable and stable while transforming relations across 'objects' (in the broadest sense), demands a reappraisal.

PART I

Rethinking the frame

1

LESSONS FROM THE ART NEXUS

Let us start simply. This chapter is intentionally introductory, setting the groundwork for subsequent chapters. It focuses on Alfred Gell's final work, *Art and Agency* (1998), particularly the theoretical framework with which he opens the volume. The ideas he expounds within his opening pages are the culmination of a life's work and provide the scaffolding upon which he builds his final argument about the role of image in the extension of the mind into the relational 'biographical life project' (11) of social beings. In following his lead, this chapter offers a re-examination of his scaffolding. As such, it may be a review for seasoned readers, or a necessary support for those who encounter his ideas for the first time.

In *Art and Agency* (1998), Gell sets out a theoretical framework for understanding art-like objects. He was not strictly interested in 'art' in a canonical European sense, nor was he interested in 'art' in a 'world art' context. He went beyond these frameworks in order to expand the category of 'art' to 'art-like objects', in which he included all manner of things – even a rock that one might find on the beach – if people responded to the object as if it was intentionally made. To avoid the complication around 'art' and assumptions people tend to have about what is or is not 'art' (and usually people mean what is good or bad art), Gell moves away from using the words 'art' or 'art-like' and starts using the word 'index' (pl. indexes or indices) instead. This chapter outlines Gell's theory of the 'art nexus', and looks at a few examples of indices in order to give examples of how Gell's theory of the art nexus can help illuminate, and trouble, our understanding of 'art' objects in canonical European art, world art, and the archaeological or historical context. Subsequent chapters of this book build on and problematize this model, even as Gell did in *Art and Agency*.

20 Rethinking the frame

The nexus

The art nexus is made up of four components. These are the Artist, the Index, the Prototype, and the Recipient. The Artist is the intentional actor (usually human, but not necessarily) that makes the artefact. The Index, as mentioned above, is the art-like object itself. The Prototype is the model (or inspiration) after which the index is made. The Recipient is the audience (intended or otherwise), that views (or hears, etc.) the index. The next two chapters develop the ideas of the index and the prototype in much more detail; for now, the most important concept to unpack is how these four components are held together.

Gell offers the example of a painting of the French King. The artist is commissioned by the king to paint a portrait. The painting (the index) is made to look like the king (the prototype), and then is shown in public places for the people (the recipients) to see. In this sort of example, it is easy to see how these four components of the nexus are related to each other through different social relationships. However, the situation can also be more complicated if one looks more closely. A painter, when told to paint a painting of a king, will rarely paint exactly what they see.[1] The king is, after all, the first recipient of the painting, even before the public sees it. The painter must please the king or risk the loss of good favour. So the painting of a king will not be a portrait in the strictest sense (the sitter as they are); the prototype of the painting will be more complex, somehow capturing both the king and the regal ideal of the French monarchy. In this example, then, there is one artist, one index, but the king is both part of the prototype and the primary recipient.

Within the nexus, the other factor to consider is the idea of agency. Agency is discussed in more depth in Chapter 8, but at its most basic level, agency is the capacity of an individual (the 'agent', who for our purposes is usually human, but could be otherwise) to bring about an intentional action in the world. It can be helpful to think about agency in the context of Vladimir Propp's (1968) ideas of an actor versus an actant. Propp, a Russian folklorist, was interested in the functional role of characters within stories. A character is an actor if their choices within the narrative serve as key elements in the plot development. An actant has a more minor role, they tend to not be main characters, and their actions function more as a matter of staging for the story. In the work of Bruno Latour (1993), the concepts of actor and actant are collapsed and simply describe anything that performs an action. He gives this one-dimensional definition to provide a theory that places human and non-human action within a system (such as a public transport system, or a scientific discovery) on the same footing. Latour's idea of agency as performing an action misses out on two important aspects of social activity. The first aspect is present in

1 The portrait of Winston Churchill, painted by Graham Sutherland in 1954, is a good example of what happens when a painter does paint what they see. Churchill hated it, and after its initial unveiling, it was removed and subsequently burned.

Propp's distinction between actants doing things and actors doing things that shape the narrative, plot, and character development. Things that just happen – what Gell (1998) calls the 'causal milieu' (20) – are not as consequential to social situations as actions that are performed intentionally. This idea of intention brings us to the second aspect. In Gell's idea of agency, the agent's actions are intentional – or at least they are assumed to be intentional by those around them (i.e. the recipients).

The issue of agency, then, is largely an issue of the *attribution* of agency. This is a complicated issue, and within *Art and Agency* there are times when it is hard to tell if intentional making (by the artists) or the assumption of intentional making (by the recipient) is more important. While many scholars who have used Gell's model of the art nexus put emphasis on the intentional making, there is good reason to put the emphasis on the assumption – or specifically the abduction – of agency. The reasons for this will become clearer in subsequent chapters, but first let us examine what abduction is and how it holds the nexus together.

Abduction

In the Introduction, we provided a definition for abduction as it appears in the work of Gregory Bateson (1972, 1979). For Bateson, it is the lateral extension of abstract components of description. Paired with deductive reasoning, it forms the 'double description' that allows – in Bateson's understanding – the extrapolation from similarity/difference on one level to imply the same on another larger level, or in a different domain. Along with inductive and deductive reasoning, abductive reasoning was introduced into modern logic by the philosopher Charles Sanders Peirce (1931; Fann 1970). While deductive reasoning follows logical progression from cause to effect (if there is fire, we should prepare for smoke), and inductive reasoning allows the drawing of a conclusion based on a known sample (Kelly burned dinner last time, so we should open the window before they cook tonight), abduction follows the logical progression backwards from effect to cause (if there's smoke, then there's a fire). In some places, Peirce also called abduction 'hypothesis', as this kind of logical reasoning is to a large degree a guess, even if an intelligent one.

Gell defines abduction drawing on the work of Umberto Eco – most famous as an Italian novelist, but also a critical theorist and semiotician. Quoting Eco, Gell (1998) defines abduction as 'a tentative and hazardous tracing of a system of signification rules which allow the sign to acquire its meaning' (14), and elaborates by saying,

> Abduction covers the grey area where semiotic inferences (of meanings from signs) merges with *hypothetical inferences* of a non-semiotic (or not conventionally semiotic) kind, such as Kepler's inference from the apparent motion of Mars in the night sky, that the planets travel in an elliptical path.
>
> (14, emphasis in original)

22 Rethinking the frame

While taking abduction from a semiotic tradition – which is concerned with taking linguistic meaning from signs – Gell (1998) differentiates his use of abduction, allowing for this kind of creative extrapolation to work in situations without linguistic interpretation. As he says,

> Abduction, though a semiotic concept (actually, it belongs to logic rather than semiotics) is useful in that it functions to set bounds to linguistic semiosis proper, so that we cease to be tempted to apply linguistic models where they do not apply, while remaining free to posit inferences of a non-linguistic kind.
> (15)

Abduction, working 'backwards', as it were, from effect to cause has a very practical aspect.[2] As a method of reasoning and interpretation, it allows the individual (recipient) to interpret an object's behaviour or qualities (i.e. the formal qualities of the index) and thereby assume its source. The source is both from whence it came (the artist) and why it was made (the prototype). In this way, it is the abduction of agency that holds the art nexus together. This becomes clear in looking at how Gell (1998) defined each of the four constituent parts of the nexus. He lists and defines them as follows:

1. Indexes: material entities which motivate abductive inferences, cognitive interpretations, etc.;
2. Artists (or other 'originators'): to whom are ascribed, by abduction, causal responsibility for the existence and characters of the index;
3. Recipients: those in relation to whom, by abduction, indexes are considered to exert agency, or who exert agency via the index;
4. Prototypes: entities held, by abduction, to be represented in the index, often by virtue of visual resemblance, but not necessarily. (27)

The index motivates abductive inferences, in the recipients, and these inferences include the ascription of 'causal responsibility' and the recognition of representation. In each case, the index is the starting point for abduction. However, the agency that is being abducted may be coming from various sources. As we mentioned above, the artist – though the causal being responsible for the painting of the king – is not ultimately the primary intentional actor to have initiated the painting. In the moment of creation and in the long years after, the king holds primary agency over the artist, the painting, the French people, and, as it now hangs in a museum, the school children and tourists laughing at his strange breeches. This brings us to the issue of the agent and its opposing pair, the patient.

2 For a comparison with cognitive evolution, see the work of Stewart Guthrie (1993), who highlights the evolutionary advantage of assuming the rustling of a bush or the face in a cloud is an intentional agent – such as a bear or a god.

	Self portrait	Self-p. with WOA	'the artist's studio' ([Johannes] Vermeer)	[Gustave] Courbet's studio	Copy of W.O.A.	[José Francisco] Borges 'studio' pictures	¿Saint + picture + worshipper see in Freedberg? St Lawrence??? (el Greco?)	Any picture	Picasso	altarpiece with donors & onlookers
Artist	+	+	+	+	-	-	-	-	+	+
Index	-	+	+	+	+	+	+	-	-	-
Prototype	-	-	+	+	-	+	+	+	+	+
Recipient	-	-	-	+	-	-	+	-	-	+

FIGURE 1.1 An extended meditation on the permutations of the art nexus, after a sketch of Alfred Gell's, found amongst his papers in the RAI archive. Text appearing in square brackets are the authors' interpretation. The + and − are, as Gell noted elsewhere on the page, indicative of the presence and absence, respectively, of that constituent part of the nexus. Redrafted by Timothy Carroll.

Agent–patient relations

Within the nexus, any constituent part may potentially act as agent over any other constituent part. While Gell suggests that primary agency must be sourced in animate intentionality (e.g. humans), agency can be inscribed by this primary agent into any sort of index. This 'secondary agency' may then act with or without, or even against the original source. The subsequent sections of this chapter work through case studies to help expand this in more detail. In thinking about how the different parts of the nexus relate to each other, however, it is very important to think about how the agent and the patient are related in each step of a causal chain. Gell suggests that there are two – inner and outer – spheres for both the agent and the patient. The inner sphere of the agent is where they as 'primary agent' are 'an intentional being'. The outer sphere is an extension of this and is 'the causal milieu over which the artist may exercise agency, [it is] the sphere of causal control and influence' (1998, 38, Fig 3.8.1/1). Depending on how powerful the agent, and how technologically advanced or persuasive their use of media, the extended sphere of influence may be quite large. The inner sphere of the patient is similar to that of the

24 Rethinking the frame

agent: it is the patient 'as an intentional being' (38). The outer sphere of the patient, however, is 'the causal milieu of the patient, the sphere within which the patient is vulnerable to control and influence via outside agents' (38). Imagining these outer spheres as an overlapping Venn diagram, the index resides in this sphere of overlap, where the influence of the agent overlaps with the vulnerability of the patient.

This method of analysis does very little for getting at what something 'means', and as Shirley Campbell (2002) has argued, it is important to pair this kind of analysis with indigenous knowledge of motifs in order to gain a fuller impression of the work. However, Gell, in resisting the linguistic models of meanings, brings to light an important aspect of art. Jeremy Tanner (2013), in a comparison between the Mausoleum of Halicarnassus and the Tomb of Qin Shihuangdi, highlights that many analyses of these monumental works of antiquity focus on the symbolic qualities, looking for embedded meanings about life and death in these societies, or even as evidence for cultural diffusion (64f). Tanner is interested, instead, with how the indexical relations around and in the tombs extend the kinds of social relations in which these two men were situated. For this kind of analysis, Gell's framework of the art nexus is ideal. It does not ask 'what is art', but 'how does art work, and what does it do', and seeks to understand the index as both a map for and constitutive of social relations.

It is this emphasis on social relations that undergirds Gell's approach to the anthropology of art and likewise forms the basis for the theoretical drive in this present volume. In opening *Art and Agency*, Gell (1998) defines the 'anthropology of art' as the theoretical study of 'social relations in the vicinity of objects mediating social agency' (7). At first reading, particularly in the first few chapters of *Art and Agency*, this idea of 'mediating social agency' may appear to suggest that the index is simply a representational artefact and a conduit of the more abstract sociality it moves. However, this role of mediation must be read in light of the above quoted perspective on abduction as a non-linguistic rational process. The social relations of the object are not a milieu in which it sits, but rather a nexus bound within the object itself. The relations are manifest in the form and materiality of the object. This idea of manifest relations brings us to the idea of an object's totality and the immanence of the artefact.

Immanent relations of the object

What we propose here as 'relational immanence' has been a minor discourse in the shadows of a dominant paradigm in 19th- and 20th-century art history. The dominant paradigm that arose in the enlightenment ideals of humanism assumes the primacy of the process of art vis-à-vis the position of the viewer, as frontal and distanced, thus determining the pictorial aspect of sculpture (Zeidler 2004, 29; Einstein 2004a, 2004b). This paradigm is therefore called 'optical naturalism', by the turn of the 20th century art critic Carl Einstein (see Chapter 4 for a further discussion of this). While Einstein marks 'optical naturalism' as an issue of spatial distanciation, our specific interest here is in the relational aspect of the piece and

in the relationship it establishes via the work of art with persons and other things. Optical naturalism proposes the art object as conduit between viewer and artist, implying the unimportance of the art object itself, except as mediator of symbolic, relativistic meaning. In proposing relational immanence we are instead developing Gell's (1998) proposition of artefactual indexicality, specifically building on the capacity of the index to 'motivate abductive inferences' (27).

Object forms are conventionally taken as the strategic starting point 'for engaging the historically specific circumstances of intercultural circulation' (Myers 2004, 206; Thomas 1991). This book does not pursue an account of objects entangled in social and historical contexts. Rather, we are bringing to the fore the consequences of the formal autonomy of the object, and its capacity to provoke a double description, as captured by Bateson, that allows for the understanding of complex relations that are otherwise difficult to grasp and reconstruct. Recognising the importance of Alfred Gell's (1998) idea of the 'graphic gesture' as a 'constitutive act', not a representational one (191) we situate ourselves in a line of thought that can be traced through the work of Carl Einstein on African sculpture. Einstein, like Gell, emphasised the logic manifest in objects as commensurate with the logic of social relations.

Einstein (2004b), concerned with African statues as art, makes the point that objects are a 'totality', and each 'makes possible concrete apprehension and by means of it, every concrete object becomes transcendent' (119–120). This 'transcendence', as Zeidler (2004) points out, 'is not a realm of pure ideas or forms that hover above the empirical world as its purified *summa*; transcendence is rather the immanence that knowledge must produce as outsider in order stabilize itself' (38). In our reading of *Art and Agency* and Gell's wider work, this is a key idea underpinning his theoretical intentions. As we will develop further in Chapter 4, the motivic presentation of a god figure *is* a god, in Gell's understanding (1998, 1995a), and rather than categorising an art object by its type, the methodological attention to the object must, like Kant argued, recognise the aesthetic possibility of the motif as 'purposive without purpose' (Kant 2007). In Kant's theoretical framework, to appraise something with 'purpose' is to categorise it within a rational taxonomy. However, to do so, ruins the possibility of enjoying the aesthetic object. In the same way, we see a similarity between Einstein's argument in favour of the object as a totality – that cannot be fitted into a hierarchical taxonomy – and Gell's argument that the motif must be recognised as what it shows, rather than taken as a token of some genre. The object as a totality, therefore, cuts across and links existing trajectories within wider social and material domains. It is not a subsidiary category within a larger hierarchy of epistemological framing. Rather, in that it is an index of potential relation and relationality, 'art transforms vision' and 'the individual work of art itself constitutes an act of knowing and of judgement' (Einstein 2004b, 116–117).

There have always been, according to the historian Carlo Ginzburg (2001), two rival interpretations of the nature of a representation; the first one, well known to us, references what can be independently verified. This is a mimetic representation that can be verified deductively. The second mode of representation is substitutionary and references what can only be induced. This process of induction is part of the

26 Rethinking the frame

artificiality of the graphic gesture as understood by Georg Simmel ([1916] 2005) in his account of Rembrandt's movement between three- and two-dimensional form. Einstein, in advocating a third mode of representation introduces this capacity of transcendent/immanental totality at roughly the same time that Peirce introduces abduction into formal logic. To understand the involute character of such objects, 'which may objectify a whole series of relations' (Gell 1998, 62), we can explore a few examples.

This chapter now turns to discuss two case studies, both as Gell frames them and as subsequent scholars have problematized and expanded upon them. The art nexus is a very simple theoretical framework that, upon closer exploration, is shown to belie a deeper level of complexity and nuance. Some of that complexity comes to light in the case studies of the Rokeby Venus and the 'nkisi nail fetish, and is more fully developed in light of the issue of temporality, and is then explored in the next two chapters, which look closely at the index and the prototype, respectively.

Rokeby Venus

The *Rokeby Venus* (1647–1651), painted by Diego Velázquez, is an image showing a nude female, facing away from the viewer, with her face shown in the reflection of a mirror being held by a winged Cupid. In 1914, a suffragette, Mary Richardson, entered the National Gallery in London where it hung, and with a small meat clever concealed in her overcoat, attacked the painting, leaving a series of incisions in the surface of the painting along the hip, waist, and back of the reclining nude Venus. Richardson's intervention was done to draw attention to the case of Emmeline Pankhurst, a fellow suffragette, who at the time was on a hunger strike in prison. In her court hearing, Richardson give testimony saying:

> I have tried to destroy the picture of the most beautiful woman in mythological history as a protest against the Government for destroying Mrs Pankhurst, who is the most beautiful character in modern history. Justice is an element of beauty as much as colour and outline on canvas. Mrs Pankhurst seeks to procure justice for womanhood, and for this she is being slowly murdered by a Government of Iscariot politicians. If there is an outcry against my deed, let every one remember that such an outcry is an hypocrisy so long as they allow the destruction of Mrs Pankhurst and other beautiful living women, and that until the public cease to countenance human destruction the stones cast against me for the destruction of this picture are each an evidence against them of artistic as well as moral and political humbug and hypocrisy.
>
> (*The Times* 1914)

In a rather masterful manner, Richardson brings together Greco-Roman mythology and narratives from the New Testament to parallel Mrs Pankhurst to Venus, the government to the traitor Judas, and those sitting in judgement to those who brought the woman caught in adultery before Christ. This inversion of nudity and

innocence is a masterful example of artistic creativity. Gell focuses specifically on the alignment made between Venus and Mrs Pankhurst on the surface of the canvas. While Velázquez is the artist, *Rokeby Venus* the index, Venus the prototype, and the public the recipient in the first instance, Gell takes Mrs Richardson's creative intervention as the making of a new index. In 1914, then, the artist Mrs Richardson, working in the medium of meat cleaver on canvas, produced *Mrs Pankhurst, Slashed Rokeby Venus* as index, in the likeness of a conjoined dual prototypicality, for the government and the people of Britain as the recipient. Mrs Richardson's artistic act linked two otherwise unrelated images.

This level of complexification, where the nexus has hierarchies and orders within itself, Gell (1998) called the 'involute hierarchical structure' of the index (54). In mapping out the relations that come to be concretised in the index, Gell demonstrates an anthropology of art that is able to investigate the social agency mediated in and around objects via the deductive and abductive double description of the object. The compound prototype of Venus = Mrs Pankhurst, both in terms of the creative alignment of the two and the violence of their joining, is, as Buchli (2013) points out, an act that makes the image all the more powerful via the collapse of two otherwise unrelated images. These relationships of prototypicality in the index and in Mrs Richardson's testimony can be traced into larger socio-political networks, but they reside – uncomfortably and potently – within the index itself.

'Nkisi nail fetish

While with the painting *Mrs Pankhurst* as an index sits closely within the social relations of its human counterparts, the autonomy of the index becomes all the more clear in the example of the Congolese *'nkisi* nail fetish.[3] Gell (1998) describes this object as a 'visible knot which ties together an invisible skein of relations' (62). The fame that the nail fetish has achieved in and beyond anthropology is symptomatic of how the social sciences have been influenced by the Marxist tradition. The tradition has given rise to the interpretation of objects as commodity fetish, and its legacy has caused anthropology to have a problem with an object's capacity to hold and catalyse social relations whose extension in time and space gives rise to a form of authority without authorship (Severi 2016). *'Nkisi* figures exemplify the complex relationality made manifest in the form and materiality of the object.

In the Congolese basin, a common practice of creating small wooden figures prevails. When a new figurine is to be made, the priest oversees the cutting of a tree, which exudes a sap which is mixed with the blood of a sacrificed chicken. At the point of felling the tree, the name of a strong hunter or boy of great spirit is called out. This named person is presumed to be dead within ten days. In this way, the life of the tree, the life of the chicken, and the life of the strong hunter are made into

3 The *'nkisi* nail fetish figure has been the subject of many anthropological works, both before and after Gell's exposition. For major works in this regard, see Caldwell (2018), MacGaffey (2000), Mack (2011), Vanhee (2000), and Volavkova (1972).

28 Rethinking the frame

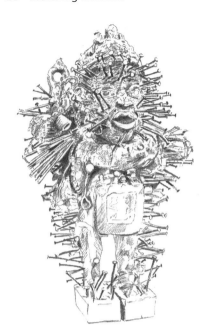

FIGURE 1.2 An original line drawing showing a side-by-side comparison of the *'nkisi*, which appeared in Carl Einstein's *African Sculpture*, stripped of its nails (right), and a 19th century *'nkisi* figure from Kongo (left), composed of wood, natural fibres, and nails; part of the Christina N. and Swan J. Turnblad Memorial Fund, 71.3, Minneapolis Institute of Arts. A similar layout was used by Einstein.

one and become the figure carved from the tree. In carving the figure, the priest also affixes to the chest a broken piece of mirror. Once made, the *'nkisi* is a knot of partial relations of the community. Anyone can invoke the aid of the *'nkisi*, making an oath before the figure and driving a nail into its body. In standing in front of the figure, the oath-making individual sees not only the composite of tree, chicken, and strong hunter, but also a partial reflection of their own self as part of the figure. These oaths are provoked by community disputes, and may either be a plea of innocence or a cry for vengeance.

In driving a nail into the figure, the individual does not simply call to mind the contested relations that are known within the village. Each nail is not a substitutional representation of conflict. Rather, it captures the futurity of relations reworked via the capacity of the *'nkisi*. The accumulation of nails driven into the figure further develops the complexity of relations that come to be manifest in the figure. The growth of the *'nkisi* enacts the invisible desire of the oath-maker. The attribution of judicial capacity to the *'nkisi* figure, which is said to kill the person named as the nail is driven into the wooden frame of the figure, shows a logical sequence of alternating passive and active relations that allows *'nkisi* to manifest the operative quality of a cumulative agency of which it is itself a part.

When the tree is cut, the wood is said to bleed, thus foreshadowing in this act of violation the future actions and relations that involve a progressive transformation from passive to active states as the figurines receive their form and become the agent of judicial actions via each nail driven into the frame. The structural homology between the ritual sequence that ends in the sacrifice and the making of the figurine, which ends in its enacting of a judicial killing, effects a doubly active index in which all relations, extending in space and time, are tightly bound in the body of the index. The social body of the community itself has become synonymous with the body of the figurine whose accumulation of nails recalls both past and prospective rebounding of violence.

'Nkisi figurines, in the words of Carlo Severi (2016), manifest an authorless form of authority, given their capacity for judicial action that settles disputes without the intervention of reflexive thought or mediation. The double sacrifice – of the strong hunter at its creation and the specifically invoked adversary in the moment of oath taking – opens and closes an accumulation of events that, in the manifold iterations seen in the nail-covered body of the figurine, manifests the logic of judgement, yet does not permit the reflexive appraisal necessary for understanding. Severi compares the authority of such artefacts-based traditions – in which knowledge has multiple authors and is directed towards the future, with effects that are both inherently uncertain and yet premeditated – with the authority of book-based traditions that base knowledge on actual or mythical authors and on a canonized resource that is transmitted faithfully via mnemonic practices.

While this distinction has for long been thought to be absolute, Severi argues that even unwritten traditions can make use of propositional statements to establish the veracity of claims to authority whether it is emanating from a person or an artefact. He argues that the 'nkisi is a situation where a source of knowledge is uncoupled from its human counterpart and grounded solely in an object that is endowed with a form of intentionality that is independent of human will and thus uncontrollable. To explore the authority of authorless intentionality, Severi compares the kind of propositional truth 'nkisi figurines manifest with the complex song cycles of the Fang described by Pascal Boyer (1988). Central to Fang song cycles is the harp whose sound, or hidden voice, is not so much learnt as 'found'. The musician trains as apprentice, learning ornate song couplets and the complex lyrics accompanying the two harmonies. The Fang harp, as is described in more depth in the last chapter, is designed with a left and right set of strings, such that the 'left' and 'right' songs are played one by each hand, on opposing sides of the instrument, at the same time. Emerging from within the instrument itself, a third melody appears, manifesting the transcending capacity of the instrument that shapes rather than follows human intentionality. It is this third melody that is the important object at hand. It is not simply evidence of authority that has emerged out of the object (the harp), but its own unique authoritative index that has emerged out of the interartefactual domain of the musician and the two sides of the harp.

30 Rethinking the frame

Temporalities of the index

The autonomy of the object – that is, its ability to cause an effect in society in a way that acts independently of or supplementary to a human source – also brings to the fore the issue of time and continuity. While Gell's (1998) example of the land mine (20) is a clear example of the intention of the 'artist' (the military personnel) being 'held', and thus delayed, within the object for subsequent deployment at a later time, the temporal quality of the index is an important element that will be developed more fully in subsequent chapters. At this stage, two examples are helpful to establish the idea.

Within the context of early twentieth century art production, the debates within the wider art critical arena – as highlighted by Carl Einstein's (2004a, 2004b) critiques of both Adolf von Hildebrand and Georg Simmel – was concerned with the means of translation between three- and two-dimensional form. However, at the same time within philosophy, great thinkers like William James, Henri Bergson, and Edmund Husserl were concerned with continuity, and the relation between mental images and the perception of development and change (for a discussion of this, see Gell 2013). In artists' circles, the assumption that the pictorial gesture should flatten form along the lines of visual representation was generally unquestioned. While the advent of cubism introduced multiple, partial perspectives rather than one situated view, it did not trouble the otherwise dominant assumption concerning perspective as an atemporal observation. So, while cubism sought to show multiple vantage points of the same object, and thus broke from Hildebrand's distanced, mono-optical stance that favoured the statuesque in relief, cubism still assumed the same 'optical naturalism' (Einstein 2004b), advocating the derivation of three to two dimensions with only a change to a poly-optic perspectivism. Thus, the art object produced by cubist portraiture captured several partial perspectives of the same sitting subject, but maintained the pictorial gesture as a flattening of the three-dimensional form to a flat viewing surface. In this context, Duchamp engaged briefly in cubism, painting first *Dulcinea* (1911) and then *Nude descending the staircase No 2* (1912).

In *Dulcinea*, Duchamp offers five stages of a female figure walking in a tight turn and progressively disrobing at each stage. The five figures, superimposed upon themselves, suggest the collapse of movement into a still frame. *Nude* took this a step further and portrays the linear motion of a figure (hardly recognisable as human, almost mechanical in its lines) moving down a set of stairs. While distinctly cubist in the geometric forms upon the surface of the canvas, *Nude* is distinctly not cubist in that its portrayal of the figure is not from multiple perspectives, but rather partially capturing the significant lines of movement at the stages of descent. It is for this reason that Duchamp's *Nude* brought about his rejection from the cubist movement; the cubist galleries refuse to exhibit his work. While the piece is formally cubist, it radically rejected the optical naturalism of the cubist and wider artistic modes of representation. What is interesting to consider is that both *Dulcinea* and *Nude* are not only a collapse of three-dimensional form into the second dimension. Rather,

like the photographic studies of Eadweard Muybridge on movement at the end of the preceding century – most notably, by comparison, his 1887 *Woman Walking Downstairs* – Duchamp's figures are the collapse of the fourth into the second (viz. Gell 2013, 1998, 243). Duchamp's *Nude* is not a project of showing multiple perspectives of the stationary form, but an exploration of movement, the visualisation of time lapse itself. By containing movement in the index, a cinematographic quality arises whereby the viewer can contemplate movement and time duration. This is most clearly possible with the animated collotypes of Muybridge – where the sequence of image frames is played as a video short or GIF – but is also present in the still images of Duchamp's paintings.

In these cases, there is a discrete period of definite time captured in the index: the actual original moment(s) of Muybridge's photography, or the imagined (or staged?) moments of Duchamp's painting. However, these moments may be expanded via the object or image to include a wider temporal frame. As Gell notes, with reference to Husserl (1991), the temporality of the object casts both forwards and backwards via what Husserl calls protentions and retentions, and thereby expands the discrete temporality of a given index into something potentially more expansive. For Husserl, a protention is an aspect of an event that points forwards in time. It is matched, in a future event, by a retention, which is the influence of the past event in the new event. Taken together, Husserl calls these 'intentions'. Gell discards the language of 'intentions', but uses the idea of protentions and retentions to show how objects within an artist's, or culture group's, *oeuvre* are related to each other by strong or weak ties of influence and intertextual (or, rather, inter-artefactual) reference (Gell 1992a, 223f, 1998, 232ff, 2013). Husserl's (1989) understanding of time and participation is explained in a work on geometry, and the intentions he identifies are what allow the student 'now' to experience the revelation of a mathematical proof not as a historical fact, but as something in which to participate. In this sense, the proof as an index is linked to the *ab original* moment of discovery and allows the contemporary mathematician to experience, alongside the original genius, the excitement of discovery.

This possibility for participation *in* and *with* historical events has wide implications not only in mathematics, but also in art and religion. Take, for example, the religious imagery of holy icons. In Eastern Orthodox Christianity, icons are used extensively within devotional practice. The images, often done in a purposefully non-naturalist style, show holy personages (such as God or various saints and angels) and present them for veneration by the faithful. In venerating the image – usually bowing before it and kissing it – the Orthodox Christian shows an act of humility and reverence towards God. As Carroll has described (2015, 2016, 2018), this is also a means of an intersubjective relationship between the devotee and the saint, whereby the icon becomes, as one iconographer explained, the 'interface' between the saint and the living person.

As an object, the icon is produced within a tradition of production that allows the saint to be – at least to those who are familiar with the genre – immediately recognisable. While there is also a textual inscription upon the surface of the icon,

32 Rethinking the frame

giving the name or title of the individual, the visual representation of the individual is done according to a received tradition of their likeness. For example, St Spyridon of Trimythous (a shepherd from Cyprus, d. 348 CE) is always shown dressed as a bishop, wearing a specific straw hat; and, the Three Holy Hierarchs – Ss John Chrysostom, Basil of Caesarea, and Gregory of Nazianzus – can be distinguished by the shape of their beards. Similarly, for images of the Virgin Mary – called the Theotokos (The one who bore God) or the Panagia (All Holy) in Orthodox practice – the different ways she sits, stands, and holds her arms around the Christ Child speak to distinct, but highly replicated, forms of representation. While these have their origin in the likeness of the living saint, or in apparitions, the subsequent production of new icons is done in fidelity to the received visual tradition. In this way, each icon is a retention of the past likeness.

In speaking with iconographers, for example, the London-based artist Christabel Helena Anderson, the importance of the longevity of the object comes to the fore. As Carroll (2015) summarises, the

> longevity of the art-like object will allow for multiple generations of Orthodox worshipers to join together in the same act of veneration—something that can be seen to heighten the unity of the Church in an embodied, praxiological way. . . . [Anderson] seeks to produce art-like objects that as material protentions can most effectively extend the present continuity of the Orthodox Church in Britain into the future.
>
> (200)

If the icon is a high-quality object, made from well-sourced materials and crafted with virtuosity, it is able to be a focal point for the collapse of movement through time. Taken as a sort of figure-ground reversal between time and space, the icon then becomes a prism through time in the inverse of the way that Duchamp's (not quite) cubist paintings are a prism of movement. As a devotee approaches the icon, bows, and prays, they join in the intersubjective veneration of the saint and participate in the icon as an act of worship and fellowship.

Following his cubist period, Duchamp moved away from painting. In 1913, he produced *Standard Stoppages*, playing with a metre length of string, tracing the irregular line produced when dropped. This stoppage, or arrest, of movement appeared again in *Network of Stoppages* in 1914. It is telling that Gell chose *Network of Stoppages* as the image cover for *Art and Agency*.[4] As a 'temporal perch' (Gell 1998, 250), an index is an object not only situated in time in a historical sense, but engaging in time via its intentions. In reading the theory of the art nexus from the beginning of *Art and Agency* in light of the theorisation about time at the end of the same volume, we are making a claim about the continuity of Gell's final book that is not always accepted in the wider literature.

4 This is even more true if he, as Chris Fuller (1997) suggests, intended the book to be titled *The Art Nexus*.

In a way, *Art and Agency* reads almost like two separate works, with a distinct kind of voice and framing between the beginning and end; the first half is about the art nexus and agency, and the second half is about style and distribution. It is our firm conviction, however, that it is one clear and integrated theoretical framework, and the two parts harmonise together. One of the key elements that comes to fruition in the end of the volume, which needs to be brought 'forward' in thinking through the art nexus, is the aspect of temporality. In this light, it becomes evident that the index is a type of Deleuzian fold (1993), wrapping time into itself. Deleuze arrived at the understanding of 'folded time' in his study of Baroque imagery and Gottfried Leibniz's contemplation on the arts and nature. While it is not explicit in the way Gell frames his early examples, the issues of duration, causation, and participation are very much present in his case studies of – for example – the bomb, the *'nkisi*, the slashed Venus, and even the matchstick Salisbury Cathedral or the rock he mistakenly picks up on the beach. His fascination with Duchamp brings to light the importance of the index, for Gell, as a means of, or medium for, contemplating the idea of relation in the abstract. Duchamp's *oeuvre*, and especially the shift in his thought and practice marked in the *Dulcinea – Nude – Standard – Network* sequence, makes explicit a change in the understanding of art, away from the kind of referentiality of historical claims to the conceptualisation of the relationality of movement and sequentiality held within the form of the object.

Summary

This chapter examined Gell's theory of the art nexus as a way to unpack the position of the art-like object in relation to the artist, the viewing audiences, and the intentions behind its design. It developed a critique and extension of this theoretical position, highlighting the importance of the sequence underpinning double description, and the capacity of cause and effect to be made manifest within the object. The emphasis on abduction opened up a third kind of representation, one that builds on Einstein's ideas of immanence within the artefact. This idea of relational immanence and the complex ways it can be found within objects like the slashed Venus and the *'nkisi* fetish lay the foundation for the next chapter's investigation of the index and indexicality. This next chapter presents the semiotic critique of objectification, placing Gell's model within the longer history of the theory of the sign and emphasises the purchase and limitations of these different approaches. The chapter investigates the influences of Lévi-Straussian structuralism on Gell, and recovers the insights often overlooked.

2

THE INDEX AND INDEXICALITY

The previous chapter introduced Gell's framework for the art nexus and began to unpack the role of abduction in connecting the parts of the nexus together. Through the discussion of the case studies the chapter also began to trouble the simplistic interpretation of the model, highlighting the important aspect of sequence in the double descriptive process – that is, the interplay between deductive and abductive interpretation – of understanding the index. This chapter focuses more closely on the index and the role of indexicality. To do so, it begins by looking at semiotics as the analytical context out of which Gell drew many of his key terms, and also as a larger discourse with important implications to how we understand the science of the image and the anthropology of art. The latter part of the chapter works through an expanded case study of the *kula* canoe prows to think through in more detail what the index is and how it works.

The sign

The science of the sign is dominated by two theorists: Ferdinand de Saussure and Charles Sanders Peirce. In the semiology – that 'science which studies the role of signs as part of social life' (Saussure 1960, 16) – of Saussure, the sign is made of two component parts, the signifier and the signified. A knocking sound (the signifier) indicates someone wanting to come in (the signified). The sign, for Saussure, is a purely arbitrary, analytical relationship; a thing is a sign if it is interpreted as a sign. There may be potential signs everywhere, but if they are not taken as a sign, they do no signification. Peirce agrees with this point and identifies this act of interpreting something as a sign as being abduction. It is a process of looking at an effect and assuming its cause. In the context of Peircean semiotics, the thing perceived is called the 'referent'; the causal phenomenon is the 'object'; and the

'interpretant' is the relationship that imputes meaning. For example, if you hear a knocking sound (referent), you abduce a person knocking (object), and know someone wants in at the door (interpretant). So, while the Saussurian sign has only two components, the Peircean sign has three. By highlighting the abductive process of logic, and its role in meaning-making, Peirce offers us a way of linking the abstraction of semiotics to the empirically observable 'real'. As Milton Singer (1980) highlights, Peirce's triadic model of the sign 'escapes from subjectivism and solipsism since it assumes that the objects may exist in the outer world independently of the signs they determine and independently of the persons whose interpretations are determined by the signs' (489). In this way, 'Peirce pushes scholars to integrate issues of social context more systematically into the analysis of meaning' (Mertz 2007, 338); it also demands attention to the possibility that the sign not only 'exists in the outer world', independent of persons and interpretations, but also helps shape those persons and interpretations via its pre-discursive material properties.

In addition to identifying three parts of the sign, Peirce also qualifies three types of signs. These are the icon, the index, and the symbol. These are characterised, respectively, by mimetic representation, causal (or deictic) representation, and abstract/arbitrary representation. Along with these three main categories, Peirce – over successive publications and collected notes – identified as many as 66 classes of signs (1931; Weiss and Burks 1945). This level of precision has provided some highly valuable insights – particularly in the example of qualisigns (discussed in subsequent chapters) – but is entirely impractical. Most social theory keeps to this basic triad, with the occasional exception. For our purpose here, the most important to focus on is the index, particularly its deictic – or contextually determinative – qualities.[1]

The deictic and causal sign

In linguistics, the term 'deictic' (or deixis, from the Greek for 'to show' or 'reference') is used to describe words like 'here', 'there', 'that', 'this', or phrases like 'next Wednesday' or 'her mother'. In order to gain the communicative meaning of the linguistic utterance, the hearer must know the context external to the speech phrase. Rather than repeating the specific name of a person, most languages use pronouns once the context is established. In this manner, this form of substitution allows for the expedience of communication – as long as everyone is familiar

1 It is worth noting the parallel to the work of Carlo Ginzburg (2001, 63ff), who, following Roger Chartier, set out to ground the science of representation in a dual typology of mimesis or substitution. This is also seen in the anthropological interpretation of magic, following James Frazier and Walter Benjamin (see Taussig 1993; Gell 1998, 100). It is our contention that the rising importance of representational immanence in the European context was, in no small part, in response to the arrival of the artefacts from around the world.

36 Rethinking the frame

with the shared context. Peirce (1931) takes the idea of deixis (taken, at root, from Aristotelian philosophy) and expands the indexical relation to include cause. This form of substitutionary representation, then, allows for the recognition that signs – such as footprints – have a mimetic formal similarity (with the bottom of the animal's foot), but more importantly an indexical relationship with the animal that left them behind. So while the sign (the footprint) does not give direct access to the 'object' (in this case, the bear that left the print), the index 'has a direct determinative influence on the sign' (Keane 2003, 413). Indexical signage has a non-arbitrary relationship to the objective cause; similarly, while it may have, it does not necessarily have to have, a mimetic similarity to its referent.

Gell, in using this language of the index, makes an interesting analytical move. He essentially (and we argue purposefully) misreads Peirce (via secondary sources) by focusing solely on the index. He also expands the category of the index, building on the idea of causality, particularly in line – as we showed in the previous chapter – with the abductive capacity of the viewing, interpreting 'recipient'. It follows that, logically, even an arbitrary symbol is the effect of some knowing subject (these words, though themselves arbitrary signs, are a trace of our co-authorship, etc.). All signs, then, for Gell, can be taken as indices. While they might have other semiotic values – pointing to mimetic or arbitrary relations – they are, for Gell's project of the anthropology of art, first and foremost the indexical effect of intentional agents. The 'object' (in Peirce's sense) of each indexical sign is (in Gell's sense) a 'person'.

This produces a problem in the terminology, and is no doubt one of the reasons Gell did not follow Peirce's model closely. As Layton (2003) has argued, Gell switches out the Peircean term 'object' in favour of 'prototype' – which is discussed more fully in the next chapter. For Gell, speaking in a context of art and ethnographic objects, the word 'object' is a broad category, quite distinct from Peirce's specific understanding of it as the source (cause) of the sign. Gell's theoretical framework of the art nexus, as discussed in the previous chapter, is built on an underlying structure of semiotic theory, but divorces it from the complexification of various categories. Instead, Gell focuses the question not on the meaning-making, but on the sociality made possible via this causal connection – and specifically the possibilities of the abducted connection, real or imagined.

This move away from semiotics, and the focus on the index as a relational rather than a meaning-imbued thing, has been controversial in the anthropology of art. The rest of this chapter focuses on an extended case study (or a set of related case studies) to unpack further the relationship between the index, the sign, meaning, and sociality. The paradox of the index is that while it appears to enable us to understand ever-changing situations and contexts, it however is never changing. It is always illusively identifiable, but not affected by the event itself, or that which it references.

Circulating indices: Kula exchange

The most well documented and comprehensive case study that allows us to explore the relation between the indexical qualities of objects and relations in the lived-in

The index and indexicality **37**

world, is the *kula* of Papua New Guinea.[2] The *kula* is a system of trade and exchange linking ecologically diverse islands in the Milne Bay area in southwest New Guinea, an area also known as the Massim. A number of artefacts figure prominently in the exchanges. Alongside the iconic armshells (*mwali*) and necklaces (*soulava*) described below, whose passage through the hands of partners allows the complex exchange sequences and their duration to be navigated, the object that attracts the most attention is the elaborately constructed and embellished sailing vessel that makes inter-island journeys possible. The *kula* canoe[3] sails between hundreds of atolls and small volcanic islands, carrying vital food and associated products, people, and information.

The *kula* canoe facilities a trade system that connected the many islands in the Milne Bay to each other, all of the islands depend upon one another for essential items such as sago, dried fish, yam, betel nut, wood for canoes, and pottery. The first description of this was provided by the anthropologist Bronisław Malinowski in his monumental study of *The Argonauts of the Western Pacific* (1922). Malinowski was the first to point out the systemic properties of this trade, underpinned by a quest for the accumulation of valuables and personal fame. By showing the embeddedness of trade and exchange in the life cycle of islanders, he opened the analysis of the system to the depth-of-focus perspective peculiar to anthropology. Typically, old men, retiring from the *kula* activities, teach young men about the system and pass on their shells, *kula* paths, and partners to these junior apprentices, whether relatives or not. Most men enter the *kula* around the time of their first marriage with the receipt of a promise of a first shell from a senior man, handed over in private some months later. The start of a *kula* career is initiated when the young man joins a collective expedition taking his shell to the elder man's partners to the east or west of the island. A young man is told in detail of the partnerships and is meant to take the place of the elder. Following partners and paths with exactitude is said to ensure the rehearsing of the *kula* poetic formula, the rote recall will enable the man in mid-career to break paths and create new ones. All partnerships and paths connect inter-island groups and are thus always long distant, extending into foreign areas, with each distant area being visited once every three years.

2 The Kula and the Massim as a region have been the centre of attention in Anthropology for over a century, and there is a surplus of literature and debate on this. Importantly, for methodological reasons, we are presenting the logical coherence of the *kula* as a system of distribution. It should be clear that the *kula* practice has changed, and in some places changed radically, while arguably maintaining its logical coherence. Key sources include Weiner (1976), Leach and Leach (1983), Munn (1986), Battaglia (1990), Campbell (2002), Kuehling (2005), MacCarthy (2016), Damon (1980, 1983, 1990, 2016), and Hermkens and Lepani (2017). What we present here is, by necessity, partial and represents a summary and our interpretation of the ethnographic facts as presented in the anthropological literature. The complexity of the system, and the open and ongoing debate amongst regional specialists, cannot be fully represented here. We are deeply grateful for the careful corrections and insights provided by Frederick Damon.

3 In fact, there are two kinds of canoes, one produced in the west of the Massim and one in the east, in addition to the Maylu type that comes from outside the system (Damon, personal communication).

38 Rethinking the frame

The Kula, as a system of exchange, has entered anthropological literature as a classic example of a 'total social fact', a phenomenon that incorporates economic, political, social, cultural, and cosmological aspects in a manner that is difficult to disentangle and yet intuitively recognized in the objects that officiate as key actors in the system. While it is intuitively recognised on the recipient's side, the system and its interlocking array of practices is, as Damon (2012) argues, 'derive[d] from focused experience, observation, and intelligent adjustment' (191) of which the canoe is a manifestation.

Like the canoe that is composed of interlocking parts (Munn 1977; Campbell 2002; Damon 2016), the armshells and necklaces are extraordinary assemblages of great complexity, incorporating different materials that are by analogy associated at once with bodily substance and immortality. Armshells, which are traded in a clockwise direction around the ring of islands, are made of the carved piece of a conus shell that changes in colour from white to red through handling and repeated trade. Attached to these large shells are smaller shells fastened with banana seeds and strung onto a rib from the pandanus leaf. *Kula* armshells, particularly as they age and gain their own fame, command the networks of trade by which they move. The change in colour is literally a trace of the hands through which they pass, as the skin oil facilitates the change in colour and the strength of the red. A red shell is therefore an index of the capacity of a man to extend himself in time and space and the reach and longevity of his personal networks.

Traveling in the anticlockwise direction, necklaces are composed of shiny pearl shells and the reddish carved round disks of shells that are used as shelter by small crabs. Necklaces are added to and extended, and as assemblage, these attachments index the complex confluence of a number of paths coming together within the trajectories of exchange that extend across past, present, and future. There are other objects that are made as assemblage, notably ceremonial axes, made as abstract representations of the human body and figuring prominently in mortuary exchanges (Battaglia 1990).[4] The axe as a whole takes its name from the stone blade, considered the *hinona* or the 'vital substance' of the valuable, a term that can also be translated as 'genitals' and the 'right hand'. The flat wooden handle or 'arm' displays and supports the blade, whose shape is associated with 'bones'. The handle is carved from red wood associated in myth with red maternal flesh and in verbal exegesis with the matrilineal clan. Likewise, the 'head' of the handle is carved in the primary emblem of clanship, the head of a 'bird' rendered in profile. Thus, as bones, 'flesh', and 'head', the wooden shaft is a representation of the 'body' of a social person: the person as a clan member. At the death of an elder, the axes of all the men with whom he has established connections throughout his career in the *kula* exchange are gathered into a large pile, indexing the extension of the body to the social body.

4 Battaglia's (1990) ethnography is based on her research on the island of Sabarl, and shows the local variation of practice within the larger system.

These axes are then recirculated within the clan of the deceased; thus, the social body of the clan is 'grown' (strengthened) through its extension via *kula*.

Many ethnographies have been written on the Massim since the days of Malinowski, all exploring the systemic properties of *kula* and the paths and partnerships entangled with objects and their circulation. What stands out as a common feature of all analyses, each describing the *kula* from the vantage point of a particular island group, is the consistent way in which islanders, as Campbell (2002) puts it, 'are picking out patterns of difference from a sea of similarity' (86). The feature that is constant is the emphasis on relationality and transformation indexed by objects as much as by persons and their actions. A now classic example of the relational and transformational capacities of persons and objects is found in the work of Annette Weiner (1976, 1989) who reconfigured, with her account of women's power over wealth production, Malinowski's theory of the primary relations between objects, the armshells and necklaces, and the relations between persons (men) they make possible. Weiner documented the ways in which women's production of cloth used in ritual exchanges in the mortuary context is central to the maintenance of status within kin groups. The death of a male elder is marked by the prestation of vast quantities of cloth, in the form of banana leaf bundles, made by his sisters and given to members of other matrilineages who gave objects, notably armshells and necklaces, to the deceased during his lifetime. By doing this, Weiner (1989) argues, women expose and reclaim for their own matrilineage 'all that went into making the dead person more than they were at conception' (40).

As impermanent objects, banana leaf bundles are able to index persons by explicating in their material capacity the inherent mobility of women who leave their matriclan in marriage. Her understanding of power as a relational concept and of an object's transformational properties as effecting an inter-subjectively recognized and intuitive understanding of the relations that exist between persons, and persons and things, via these objects had a lasting impact on anthropological theory. Weiner's (1992) contribution was to draw attention to the quality of objects as significant to understanding the cognitive work they perform, even if they remain hidden or intangible. That objects are made to 'work' and effect a change in the understanding of the nature of relation was taken up by Alfred Gell in the early 1980s in a paper entitled 'The Technology of Enchantment and the Enchantment of Technology', performed at a seminar on the anthropology of art held at the University of Oxford in 1985 (first published in 1992; see Gell 1992b). This early paper was to be the foundation for Gell's posthumously published work on *Art and Agency* (1998) in that it outlined the framework for a theory of art grounded in the conceptual work undertaken by objects on account of their properties. Chief among the range of properties he considered in this early paper is the decorative and its effect, explicated with an account of the incised and painted *kula* canoe prow. Made to allow the canoe to sail swiftly and unhindered through the seas, the prows decorative butterfly eye effect, he argued, was directed at the *kula* partner to disorientate and overcome their senses so as to release the maximum number of armshells and necklaces desired by the travelling party.

40 Rethinking the frame

In this early paper, he was already in conversation with the anthropologist Shirley Campbell's (2002) ethnography[5] published only in 2002 but written as PhD in the mid-1980s. Campbell makes the observation that while Gell's framework of the art nexus does well to investigate the social relations mediated in and around the art-like object, it does not – in her view – sufficiently address the semiotic value of the motivic components. Her own approach, drawing heavily on the mythic corpus of the Vakutan people, focuses the attention on the indigenous knowledge of local fauna and mythical beings (various birds, butterflies, and flying witches) and how this knowledge undergirds and empowers the agency of the canoe prows. Campbell uses a highly formal approach, drawing a distinction between three 'categories' of form each with possible variations carved into the prow. These categories, having both positive and negative spaces, produce a three-dimensional scape upon the surface of the prow boards. The boards, comprised of a prow (*tabuya*) and splash board (*lagimu*), are first and foremost functional aspects of the canoe, providing balance and speed. To facilitate this role, the boards have a highly articulated geometric relation to the overall balance and harmony of the boat (Scoditti 1990). The asymmetrical form of the splashboard, always being larger on the left side than the right, moves the geometric harmonies from the totality of the boat into the face of the prow as art-like object. To draw out the technical function (i.e. the 'working' of objects – such as art or gardens; see Gell 1992b) of the prows, therefore requires an attention to the internal, logical, and formal properties. The division of the space internally into recognisable and stereotypical self-similar shapes is the characteristic feature of prowboards, and the focus of the attention of many scholars, such as Shirley Campbell (2002) and Giancarlo Scoditti (1990).

In Campbell's work the functional role of prowboards as balance and speed for the boat, however, is addressed only as the context for understanding the cultural importance of the motivic symbols carved upon the face of the boards. The motifs are effective within the sailing voyages and the *kula* exchange due to the 'evaluative judgements' concerning the representational properties of the motifs (Campbell 2001). Campbell's focus on the motivic surface, their structure and patterns of variation, fits within what Scoditti calls the 'expression plain', which is a geometric and logical surface of articulation. Campbell's attention to the 'expression plain', is only a means to situate the 'content plain' – the symbolic meaning of the design – within the object. By contrast, Scoditti, in his understanding of the 'logical mechanism of carving', is deeply concerned with the importance of the 'expression plain' and the geometric constitution of the object. While Campbell sees the mythical corpus as primary, Scoditti (1990) sees the mythical reference as an 'overflow' from the 'logical properties' of the prow board (84).

In this way, Scoditti (1990) argues, 'the mechanical copying of the model will assume the value of a logical exercise, in the sense that the apprentice will learn to

5 Alfred Gell met Shirley Campbell while at the Australian National University, between 1978 and 1980, while Shirley was writing up her doctoral research.

The index and indexicality **41**

arrange the g.ss. [graphic signs] according to temporal and spatial axes' (85). This dual nature, being both temporal and spatial, is a product of the process of carving. The temporal element is the progressive qualities of the distribution of elements across the surface of the *lagimu*, and the spatial element is the spatial distribution of the graphic signs on the surface, whereby the temporal element is 'absolutely unalterable and which in its turn conditions the technical-temporal succession' of graphic signs (73). When one looks at the design surface of the *lagimu*, what one actually looks at is an image of time.

Both Campbell and Scoditti acknowledge the importance of the miniature physical model of the prow boards that is used to train the apprentice carver. Key to the training of the apprentice is learning the intrinsic relation between technical ability to faithfully reproduce a miniature model, imagination, and the capacity to realize the graphic signs on a wood surface. Together these qualities emerge as a reflection of the generosity of the patron who must support the cutter and the carvers for a period of up to two years. For Scoditti the schema of the prowboard, which itself is transmitted by the master carver to his pupil via the physical model, makes manifest the logic of relations the canoe – once the prow boards have been installed – is able to extend beyond the carver and his apprentice in its journeys around the islands. The schema references the temporal execution of the graphic signs and their spatial distribution across the prowboard. What Scoditti in his painstaking analysis of the prowboards is able to show is that the surface decoration of the boards works as a kind of map of sequences of operations that call forth associations with the temporal sequences underpinning the *kula* system of trade and exchange as a whole.

This idea that the *kula* canoe maps temporal sequences underpinning a complex system of social ecology whose resources are managed by extending their capabilities is central to the work of Frederick Damon (2016) who made it his life's work to understand the way the relation between trees, land, and persons in Muyuw, Woodlark Island is modelled by the canoe. Damon sets out to explain how the canoe works as a conceptual and generic – and at the same time concrete and localized – model of a complex operational system informing gardening and the distribution of products. His work opens our eyes to a world of knowledge about trees, their properties, and their manifold associations with growing crops and 'growing people' in a distributed, heterogeneous, and at the same time individuated and localized system that is intuitively recognized on every island the canoe touches in its journeys.

Damon wrestles with the assumption that the sailing vessel, once made, is a technical entity par excellence whose composite parts and embellishment is merely symbolic, referencing ideas that exist independently of the vessel in the society and culture of the Massim (Campbell 2002). After painstaking research lasting two decades, he concludes that, in contrast to this assumption, the canoe makes manifest the operational sequences of trade connecting individual islands and the complex environmental knowledge marshalled in support. In making his case for an analysis of a body of knowledge directed to sustain a just-in-time system of distribution of

42 Rethinking the frame

food and information across a fractured landscape dominated by a vast expanse of sea, Damon draws on the work of the geographer Tim Flannery (1994) who argues for the distinctiveness of the ideas that enabled Australasian settlement. Europeans, says Flannery, came out of an environment conducive to the exercise and use of raw power, as the landscape was rich and extractable. By contrast, the flora, fauna, and human inhabitants of Australasia had to learn how to make a lot out of a little, to husband meagre resources by seeing how far they could be extended rather than how quickly they could be extracted. This perspective is surprisingly important when it comes to unpacking the informational capabilities that inform the making of the *kula* canoe.

A cornerstone of Damon's (2016) theory is the observation that 'trees are a property of a category of land and the land in turn being understood by its trees' (39). Islanders, says Damon, conceptualize their place as a physical entity via the intimate knowledge of trees, which encompasses the understanding of the properties of different trees. Different trees, with various properties, are used across the domains of boat building, gardening, and person-making. This understanding directed to the properties of trees is complex and not unified across the islands that participate in the *kula* voyage. The main tree used for the mast, one of two species of the genus *Calophyllum*, does not in fact grow on Gawa, where the boats are made. As such, the boats are finished with a mast everyone recognises as unacceptable, and sent out in this incomplete form. Upon arrival at the destination island, the mast is immediately replaced. Thus, canoes are made to be exchanged, much like other objects that pass through many hands in the *kula*, and parts of the canoe are replaced with local timber as they are received before being given in turn to others along the paths of the *kula*.

Trees are as significant to the growth of crops in gardens as they are to the thriving of persons, with some used to enhance the fertility of gardens while others are used for medicinal purposes and construction. As in most of island Melanesia, slash-and-burn agriculture also prevails in the Massim, meaning that crops regularly alternate with forest growth. There are three types of fallow periods distinguished by the length of time gardens are left to fallow, from the shortest period of five to fifteen years, a medium period of twenty to forty years, and a long period of forty years and more (Damon 2016, 37). At the most extreme end, the fallows are so long that there are no gardens. Damon observed that a tree known as *gwed*, believed to return 'sweet' things into the soil, is only found on land with short fallow periods. The *gwed* tree, moreover, produces brilliant white flowers that turn into very dark blue or black berries with seeds, thus exhibiting transformational properties that are thought to be essential to assuring continued growth. People sometimes plant large taro seeds next to *gwed* trees as the association with the tree is said to transform the crop that is grown to be used for ritual occasions when taro is mashed up, rolled up, and re-cooked with coconut oil, underpinning in its doubly transformed state the transformation of persons whose enmeshing in marriage and procreation is foreshadowed by the food. Although *gwed* trees are not generally used in large seafaring Kula outrigger canoes and other important constructions,

The index and indexicality **43**

such as yam houses[6] – as the wood is light and rots easily – it is useful to stay with *gwed* for a moment longer as it is the knowledge of its properties that demonstrate an understanding of interrelations between different elements of an environmental system of which people are just a part.

Gwed trees flower earlier in more westerly islands, starting around January, while in more easterly parts the blooming is associated with the arrival of a southeasterly trade wind in April. The timing of the flowering of *gwed* is important as the flower's nectar is the favourite food for local marsupials who grow plump and fat from the nectar just in time for a season in which fishing is made impossible by the strength of the winds. Marsupial meat then becomes a fish substitute. This is not simply the substitution of one meat for another, but rather, within the interartefactual domain the relation of space and timing between the flower, the wind, and the marsupial signals the shift between seafaring and land-based activities. The flower, then, is the index of a chain of relations involving both humans and nonhumans across space and time.

The social ecology of trees, which the growing of *gwed* in gardens with a short fallow period demonstrates, is specific to place. Among the factors that attracted Damon's interest was his growing awareness of intriguing patterns of relations between the length of fallow periods of gardens and the geometric form of both gardens and villages that transform in a non-random manner as one moves from island to island. Gardens everywhere in the northern part of the Massim have a rich structure that is thought to index the time the first canoe arrived on the island. The shape of a garden is of crucial importance to the growth of crops planted in it. The garden is square to rectangular and consists of at least four units divided by at least one east-westerly and one north-southerly path, with the easterly orientation likened to the base and the westerly orientation to the tip.

The orientation of the garden and its geometric construction is likened to the construction of the outrigger canoe, and terms that are specific to garden construction are used when making a boat and vice versa. Moving from the island of Muyuw, where Damon conducted most of his research, to the Trobriand Islands, he observes that the orientation and form of gardens transforms from one based on an axial separation of two parallel forms to a concentric form, and from a horizontal orientation to a vertical one in which gardens are suffused with vertically arranged structures common in the Trobriand Islands. While these might appear to be superficial aesthetic differences, each is understood to be vital to the growth of crops in the gardens, and there are surprising continuities across the islands of the northern Massim and possibly beyond. These continuities pertain to the way the outrigger canoe is thought to model relations between parts of villages and gardens and the practices people perform (e.g. fishing versus gardening). On the island of Muyuw, he observes that people living in a position on the island associated with the rudder

6 However, in central Muyuw, the yam house is moved each year to a new garden. Here, because of its lightness, *gwed* is used for the two main beams that support its containing structure on its posts (Damon, personal communication).

44 Rethinking the frame

of a canoe are associated with the base of the island and have the most extensive use of maritime resources.

Perplexingly, the use of maritime resources steadily decreases the further west one goes on the island even though the population itself becomes larger (Damon 2016, 50–53). This variation in the intensification of resource use is mirrored in the pattern of intensification of gardening mapped by the presence or absence of *gwed*; with the decrease of *gwed*, the length of the fallow period grows to the point of there being no gardens at all at the most western side of the island, which is also the base or rudder of the canoe. In the same way as *gwed* trees are specific in relation to places, they are also positioned geometrically in relation to an imagined model outrigger canoe. Given this use of the canoe as model of temporally differentiated intensification of resource use, it is no surprise that the wood used for the construction of a canoe is taken from different trees. Each tree is associated with a specific location that is in turn associated with the canoe and a specific pattern of land and maritime resource use.

The mapping of the social ecology of trees onto the practices and temporal sequences of land use and the modelling of this spatiotemporal map in the form and technical specification of the outrigger canoe comes to a head in the description of the mast of the boat whose properties and position is arguably the most important element of the stability and speed of the vessel. The mast of the canoe is made from one of two species of *Calophyllum* trees, which are only grown inland. These two are recognised as part of a 'group' or genus – with six local species in total – that offers many uses, some of them medicinal, some used for animal husbandry, and in investigating their use we realize the intimate understanding of its properties that vary depending on the island's ecology. The continuities and variations of the wood used for the mast across the Kula region enable islands visited in inter-island trading to be seen as similar, but different, each oriented in similar and yet different geometric forms around the central mast, with exchanges flowing in directions that are understandable from the perspective of the canoe. Most crucially, it is the consistent modelling and mapping of practices at the core of the social fabric, involving exchanges and the direction of their flow as well as the husbanding of land and sea, that enables the extension of persons beyond the shores of an island to the furthest reaches of the region. The canoe in fact works as the 'third space', invoked by the philosopher Sartre (1967, 319), as the model or external vantage point from which relations between persons and persons and things become apparent. In this way, the canoe, the village, and the island are each an index of the same 'four-dimensional map' (Gell 1998, 249), and serve as plateaus, or 'temporal perches' (250), from which to view the whole system.

It is a small and yet crucial step to connect Damon's understanding of the way the model canoe underpins practices and their consistent and intuitive understanding on Muyuw island with Nancy Munn's (1986) observations, conducted on the island of Gawa, of the phenomenon of inter-subjective space–time, which she saw articulated in the capacity of fame of being accumulated and distributed via objects. The bewildering detail of how the model canoe maps onto the land and its people

The index and indexicality **45**

and across the region as a whole – enabling the physical canoe to index the flow of produce and of people from specific locations in both directions – is given pertinence when we remember that the exchange routes between islands are fixed, as are trading partners, and exchange is based on very definite and complex rules.

Underpinning the exchanges of food and valuables known as the Kula is a credit-bearing and credit-clearing system in which giving is not met just with its equivalence, but with what Munn (1986) calls 'a new level of control potential: the hierarchizing status increment available through kula' (127). Food being given away freely at the feast is given to the *kula* traders in expectation for a reciprocation that is the sign of 'non-equivalence or increment' (127) as the donor of food converts or transforms the self into the expanding space time of *kula* shells via the presentation of food.[7]

Munn's analysis of the *kula* distinguishes the idea of hierarchy 'embodied in the product' from the idea of equivalence in the transactions of *kula* in which a *kula* shell is met with the return of an equivalent of the opposite category by the initial shell recipient. Critical to the increment drawn from reciprocal exchange is the canoe and its place in the marriage exchange cycle. Canoes are owned by the building matrilineal clan and transmitted by the chief builder, either to another man of his matrilineal group who then usually gives it to his wife and her clan, or else to the chief builder's wife and her kinsmen. Only when canoes have been transmitted along affinal paths in this manner can they be given to overseas partners along their southerly journey, transacted in the direction from which armshells come because these alone are durable and travel back to the canoe building matriclan (Munn 1986, 128). Critically, subsequent recipients of the canoe are considered its captain, able to make decisions about when and where it sails, but the original owner and builder of the canoe are the recipients of all payments the canoe's voyaging brings home and are still able to sail it with a new captain and their own crew. The canoe therefore extends the control of the builder's matriclan via any subsequent captain of the canoe in an onward motion forming an exchange path punctuated by the ownership of the canoe. The gifting of a canoe is thus a vital strategic act that either extends the owner's influence in the inter-island world, as each subsequent captain is forced to recall the name of the original builder and owner to reciprocate gifts

7 An intriguing example from early in the anthropology of Oceania that drew attention to objects that hold credit is Yap stone money, described by the American explorer William Henry Furness III during his two-month visit to the Micronesian island in 1903 (Furness 1910). Describing Yap's complex society, with a caste system, slaves, and competing fraternities, Furness famously offered an intriguing explanation for one of his most perplexing observations. The Yap, he concluded, had an economy based on money in the form of large, solid, and thick stone wheels, called *fei*, ranging in size from between 2 feet to 12 feet. Although *fei* were used to secure transactions, the stone wheels, taken from quarries by canoe from islands outside Yap territory, were never or rarely moved. This is because rather than serving as quasi commodities in barter-like exchange, they served to make manifest the potential for future transactions of the household. The measure of a stone wheel thus denoted not a relation to a hypothetical set of commodities purchased with it. They thus were not mere stone coins, just of an unusual size, but instrumental to a temporally structured system of credit and clearing – 'a tangible and visible record of outstanding credit the seller enjoyed with the rest of Yap' (Martin 2014, 12).

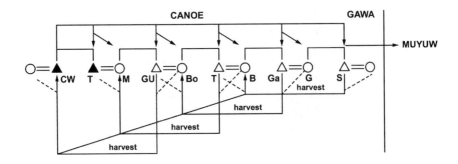

FIGURE 2.1 The diagram of kinship and trade circulation, after 'Figure 4. Canoe paths' in Nancy Munn (1986, 133).

received by affines, thus strengthening internal affinal relations. Like named *kula* shells, canoes and their paths are remembered as sequences of individual names that recall the onward sequence of their transmission.

As a sign of the shift from female- to male-centred exchange and from stasis to motion, the food that is given by the wife's or affinal matriclan to the builder and/or owner of the canoe is taken from the tops of trees, rather than from gardens. Men scrape the coconut and mix it with the boiled taro prepared by women into a pudding, which is cooked by the men in large clay cooking pots that are stirred vigorously while standing. The taro pudding produced by men in this way is accompanied by the slaughter of pigs that, like all mobile and thus masculine elements, are known by names. Over time, as the canoe is transmitted from one owner to the next, return gifts flow in a multiplicative manner back to the original canoe builder along the canoe's path. The return gifts are public events of inter-hamlet processions marked by vivid expressions of vitality and of the spatiotemporal analogue of movement as the processions forms linear passage that traces the canoe's journey connecting hamlets and islands with one another. The canoe's path thus connects and extends affinal relations that span hamlets, villages, and islands, moving as it does as a gift from the male side, and transacted in relation to *kula* shells. Within Gawa, the canoe and *kula* shells go in the same direction, as they are both marital gifts from the man's kin; when the canoe is transacted to the southerly islands, it is moving against armshells and pots that are moving north. Armshells and pots eventually reach the canoe builder as a return gift by the overseas recipient on his journey north.

The sequence by which returns are made is attended to closely, although in actual fact they rarely happen as described. It is a common understanding that what should happen is that the initial recipient of the overseas returns is the last Gawan

The index and indexicality **47**

captain who transacted the canoe southward and that it is this final recipient who should then transact all returns to the original canoe builder and his clan. The shells returned to the canoe builder become important 'starting' or opening gifts, called *kitomu*, that are transacted again outward to other islands to strengthen the fame of the canoe builder and his clan, while the pots are retained by the women. With the receipt of the armshells in return for the canoe, the canoe is regarded as the generative source of any *kula* transactions built upon a *kitomu* of an armshell that had been received as a return gift. Closing the cycle of exchange, the canoe thus opens any number of subsequent *kula* transactions and cycles of exchange whereby the shells that open a new cycle do not remain the canoe builder's *kitomu* when they enter *kula*.[8] Instead, the necklace, moving in the opposite direction to the armshell and regarded as the correct matching gift, becomes his *kitomu*, while 'all the transactions and instantiations started by the first *kitomu* have their *wouwura* (base) in the originating canoe' (Munn 1986, 136).

Munn's (1986) analysis is directed to the question of how fame manifests as an outer sign of a shared value associated with an externalising process involving the separation of internal elements (garden crops and trees) and their transaction in the inter-island world. Searching for the underlying cultural logic that governs value-producing practices, Munn exposes the intersecting levels of spatiotemporal transformations and specific connectivities that disclose a relational nexus that informs any given form or practice (7). Far from abstract, Munn captures the logic of practice in a lived world in which every practice is self-consciously conditioned by its covert relation to self-similar practices. The implicit nexus of relation between notions of land, food, and bodies, for example, condition practices surrounding where, when, and with whom to eat, as the bodies of women who cook the food are thought to be heavy and require distance from the bodies of men associated with the lightness of the canoe travelling at speed across the sea.

The values that inform food transmission come to the fore in ceremonies when baskets of cooked food are distributed for collection and redistribution so that each person becomes at once the donor and recipient of food. Munn pinpoints the capacity of artefacts and substances to hold and transmit value within the qualitative aspects of the items. These qualities, or what she calls 'qualisigns of value' using Peirce's terms, signal the value of the artefact as a relational and transformative object. Qualisigns, according to Munn, are a type of icon that 'exhibit something other than themselves *in* themselves' (74, emphasis in original). For example, in the initiation rites of young men, in order to make them swift and lively, the boys are hit with shiny fish, whose shimmering slippery and streamlined bodies exhibit the ideal qualities of the young men. These qualities are seen to be opposite to the sedentary stability of cooking stones that rest at the hearth where women sit.

With food, the qualities of heavy food, such as taro, inform rules about food consumption by certain persons and various times. For example, sailors preparing

8 This kind of looping closure is examined in more depth in the final chapter.

48 Rethinking the frame

for voyage decorate their bodies on the outside and obey strict food taboos for their bodies to share the qualities of swiftness and buoyance with the canoe. The inverse relation between food taboos and the externalising of internal bodily substances in the decoration of the bodies of sailors whose colouring matches the beautified vessel in bewitching splendour follows with equal logic force from the relational opposition of land and sea, crops and water, heaviness and lightness that is extended into directionality and relations of distance. As Munn takes the reader through the intricacies of the relational nexus that pervades every practice – from gardening and procreation, to food transmission and sailing vessels beyond the horizon, from marriage exchange to the carving and giving of the canoe, to mortuary exchanges and dissolution of relations formed through marriage and the exchange of valuables – there is an implicit reference to Pierre Bourdieu's (1977) theory of practice.

Bourdieu coined the theory of practice as the structuring structures that condition the habitus, which themselves emerge against a background of an index of relationality and transformation. Without directly referencing Bourdieu's (1984) analysis of Parisian patterns of consumption, Munn follows his lead in crediting values, albeit conceived in a relational and transformative manner, as the analytical vantage point used by islanders in the Massim to understand, intuit, recognize, and predict each other's practices in ways that allow them to extend sociality across islands fractured by a vast expanse of seascape. Fred Damon, in turn, offers an ingenious uncovering of the way the canoe serves as model for a shared social ecology and as model for a spatial and temporally extended, and yet inherently transformational, form of sociality and, thus, adds a vital ingredient to understanding how it is that the Kula as a system operates in an at once supremely diverse and yet supremely unified island region. Bewildered by the detail Damon's ethnography has brought to light as he extended his research in time and space, we glimpse the possibility that the difference in the orientation and geometric layout of gardens and villages and the different practices that have been documented for different islands and different places on different islands are not motivated by an abstract concept of relation, but by the concrete technical and comprehensible workings of a sailable, and indexical, outrigger canoe.

Summary

As we have shown, the Kula system is comprised of a diverse array of objects and practices. No singular aspect of the system stands alone, and each is situated in relation to the other aspects of the whole. In this way, the various objects and practices are indexes of the operationality of the wider system as a whole. As such, they are attended to not in terms of their classificatory position, but rather in terms of their relational position within a sequence of social action. The interrelatedness of the indexes, what Gell refers to as their involute nature, is seen in how each object (or index) is agentive in its relation towards the other object, bringing forward future-directed relations. In this sense, the object remains unchanging in its capacity as a

model, and yet is generative and transformative in its actualisation. There is a poesis of its futurity, as is suggested in Gell's essay on Duchamp (2013) and his work on time (1992a, 1998, ch. 9). This poesis produces a system of effect wherein each individual aspect concretised in an object or action is pushing upon their neighbours. It is this neighbourly relation that creates the nexus, thereby producing the object as index.

The next chapter extends the account of the index by focusing on the concept of the 'prototype' within Gellian semiotics. The chapter compares the relationship between the index and the Peircean 'object' after which it is made with the notion of the model as something that can be known. The chapter examines the epistemological implications of these different material ways of considering knowledge.

3

THE PROTOTYPE AND THE MODEL

So far we have introduced the 'art nexus' and emphasised the importance of abduction within the logical process of understanding art-like objects, or indexes. In the previous chapter, we focused on the index, showing how Gell's use of the term developed out of Peircean semiotics, but became a way of framing the object as the effect of social agency. We then explored an extended case study of the *kula* exchange to think through how the unchanging indexical object is able to help us understand ever-changing situations and contexts. The object is unchanging in its model-like qualities and its ability to retain the relationality of the index. While any specific ideation of 'the model' may change over time, and even change media in which it comes to be articulated, the 'object' in its capacity to remain what it is – that is, a model of the index – may have permutations but remains unchanged. In the discussion of this paradoxical poesis of the object, the complexity of the index came into focus, and the issue of prototype began to be introduced. This chapter focuses on the prototype.

As mentioned in Chapter 2, Gell uses the term 'prototype' in place of Peirce's 'object' to avoid confusion between Peirce's specific meaning and the word's more general sense. With this in mind, we can start with an understanding of the prototype as the source (or 'vehicle') of the sign. The knuckles hitting the door, as discussed in the last chapter, is the prototype of the knocking sound. Peirce made a distinction between two kinds of 'objects': the immediate and the dynamic. The 'immediate object' is the cause as understood by the partial (and intuitive) knowledge of abductive reasoning. The 'dynamic object' is the 'real' cause, established through further investigation. This distinction in Peirce's philosophy is helpful when we come to an apparent conundrum in Gell's theorisation of the prototype.

There seems to be a contradiction in *Art and Agency* between the intentional causation of the index through design by the artist and the assumed cause from the perspective of the recipient. The reason for this tension – which has caused

The prototype and the model **51**

various interpretations about the nature of agency in terms of its design in subsequent scholarship – is due to the relationship of parts and wholes within the knowledge of the prototype. There is an important figure-ground reversal to consider in the contrast between the artist–index relationship and the index–recipient relation. While the recipient abduces the prototypical relation and its agency via intuition, the artist, as noted in the previous chapter, works with 'experience, observation, and intelligent adjustment' (Damon 2012, 191). As Damon highlights with the design of Chinese calligraphy, in which he sees a striking similarity to the making of Melanesian boats, the

> more strokes [in a character] increase [the] ability to achieve the balance and aesthetic feel intrinsic to the inscription process. With more strokes it is easier to offset one relatively imprecise form with another that can make up for it.
>
> (186)

This capacity of intelligent adjustment – where 'originals are followed until their coursings engender their own new creations' (187) – which we see as part of artistic virtuosity, is shown by Damon to be in intrinsic part of human labour processes across domains of production. To understand the prototype is, thus, an issue both of the material constitution of the index and epistemological implications of how knowledge comes to reside in things. As the prototype itself is removed (by time or distance) from the recipient, it is via the materiality of the sign/index that it can be known.

This chapter starts with a discussion of materials and memory, and then progresses to consider how these ideas of the prototype (and similar theories) have been shaped in anthropological scholarship on art.

The loom

There is nothing that speaks to the translation of memory between the mind and material quite as eloquently as the loom. When a weaver sits and weaves, she moves a pattern held in her mind out through her fingers via the manipulation of coloured yarn and onto the visible surface of the blanket or rug. In the ethnographic account of carpet weaving, such as in the work of Myriem Naji (2009) on Moroccan women, the pattern in the mind passes out into the world by the experienced women trained by the previous generation to know the simple movements of the wrist and arms as well as the complex patterns and designs. The designs are recorded nowhere – they exist in the mind of the artist and in the material of the index. When training a young apprentice – usually a younger relative of the experienced artisan – no words are spoken. The apprenticeship consists of long hours of watching, then mimicking. The girl, as she grows, is then given the task of laying out the wool and the rugs – a chance to know the weight and contour of the finished product, as well as to see and manipulate the pattern from different angles. Through these stages, the girl is 'impregnated with the properties of the material

52 Rethinking the frame

and familiarised with the gestured techniques' (Naji 2009, 9, authors' translation). Observation – not verbal instruction – is understood as sufficient for young girls to acquire the required knowledge, and 'competence is the ability to quickly and effectively apprehend the repertoire of potential actions that the material contains and the culture dictates' (10). After years watching, the young girl learns to undo, and redo, the knots of the older weaver, such that

> in time the repetition of the gestures, corresponding to particular forms, trains a fluid articulation that assures memorisation, such that the simple sight of a motif permits its subsequent reproduction. The sensorimotor impregnation of the properties of the environment is done through the bodies of others.
>
> (10–11)

This 'impregnation' is of the knowledge of the materials, the techniques of production, and of the patterns. In tracing the relationship from the index (the rug) back 'up' towards the prototype, what is found is a specific mental image and musculature know-how of making the rug. The prototype, held in the mind and body of the senior weaver, is inculcated into the youth through the slow impregnation of the body with the prototype.

This gives us two questions. The first is 'what is mind?' such that it can allow the passage of prototype from one person to another. The second is 'what is material?' such that it can hold pattern and become the reservoir of mind. Before we address these questions, however, let us consider one more kind of loom.

In 1804, the Frenchman Joseph Marie Jacquard invented a new kind of loom. Where previously looms required the artisan to sit at and move the pattern from their mind to the threads – much as the example given above of the Moroccan carpet weaving – Jacquard's invention allowed for the separation of the artisan-designer from the technician working the loom. Like most brocade fabrics, Jacquard textiles exhibit ornate patterns achieved via the manipulation of threads being brought forward (to be visible) or to be pushed back (to be hidden). Whereas in traditional weaving the weaver must manipulate which threads are brought forward at which point, the Jacquard loom uses a series of punch-cards to manipulate each line of the textile. Much like later coding machines (and subsequent computers), each punch-card – originally made from ivory – presented one line of code that told the machine which threads to suppress, and which to make visible. Once the threads were positioned, the shuttle could run through the threads, and the next line was 'programmed' via the next card. The cards could then be looped such that the pattern was repeated as the bolt of fabric was made.

In this setting, the designer need never see the making of the textile. Once the motif was designed, it would be translated into punch-cards, and these loaded into the loom. The person working the machine need only know how to work the machine. They may, in fact, never see the whole design they are making. The implications of this are really quite extraordinary, as it does two very significant things. In the first, it – much like other forms of mechanical reproduction – divides

the technical steps of production and enforces a new kind of hierarchy of knowledge. More important for our context here, however, is that, secondly, it moves the prototype out of the head of the artisan-maker into the material artefact of the ivory punch-cards. The ivory cards, as a digitalisation (in a crude sense, but none the less an 'on' 'off' setting, much like 0s and 1s) of the design can live on well past the life of the artisanal designer. So while the prototype of the Jacquard textile originates in the mind of the designer, it is transferred into the ivory. It can subsequently be concretised as the index with each bolt of successive fabric, but the maker of each bolt need not have any relationship to the specifics of the prototypical design. As mechanical looms developed, in fact, the factory worker may never see the design they are manufacturing.

It is important to note, however, in the relationship between the index and the prototype, that the bolt of Jacquard textile is not the only index in this example. The ivory punch-cards themselves are an index, too. The technician who translates the pattern's visual design into the digital code (as artist) produces the cards (as index) after the model of Jacquard's technique of weaving (the prototype). In this way, several indices may be entangled, and at each stage of cause–effect transfers (i.e. agency), the elements from one 'art nexus' may fill another role in a subsequent nexus. In each case of this involution, however, the index is the effect of some (or multiple) prototype(s). It also must follow that any given artefact may be simultaneously an index of one prototype and contain that prototype for the making of another index. Let us then consider how prototypes might move from one place to another.

The mind and the material

The mind, as the locus of thought and intention, is both intricately linked to the physical body (most especially brain and neurological system) and expansive beyond the physical body. The question of whether the mind is 'immanent', within the body, or 'transcendent', expanding beyond the body, is important to consider in this context of how the prototype moves from one mind to another, or indeed comes to reside in an object. Gregory Bateson helps resolve the issue through his work on cybernetics and systems. Rather than placing the frame of the material context of mind at the limits of the body, Bateson (1972) argues that 'mind is immanent in the larger system – man plus environment'. In the context of a man cutting down a tree, the 'self-corrective (i.e. mental) process' is 'tree-eyes-brain-muscles-axe-stroke-tree', and 'it is this total system that has the characteristics of immanent mind' (317). Reframed, he defines 'mind' as 'the ecology of ideas in systems' (339). In this ecological thinking, Bateson specifically focuses on the role of differentiation, such that the process of 'tree-eyes-brain-muscles-etc.' is not the monodimensional fact of each node in a status nexus, but the recognition of, and response to, difference. Within the working of the system, the recognition of difference triggers the response to variables as they arise and iterates a self-corrective action. As mentioned in the Introduction, it is this recognition of difference that catalyses the abductive

54 Rethinking the frame

inference, and in the response to difference is seen the gesture of making the index after the likeness of the prototype.

Bateson discusses this in the context of car engines, thermostats, alcoholics, and schizophrenics; and part of the beauty of Bateson's analytical framework of systems is the breadth of applications. In the context of art production, Bateson (1972, 128ff) attributes to each system (culture or style in this context) the striving for 'grace'. Grace, following Aldous Huxley, Bateson suggests, is 'a naïveté, a simplicity, which man has lost', but is shared by God and the animals. He argues that 'art is a part of man's quest for grace; sometimes his ecstasy in partial success, sometimes his rage and agony at failure' (129). Within art-like contexts of production, 'the problem of grace is fundamentally a problem of integration and that what is to be integrated is the diverse parts of the mind' (129). This integration is one between the conscious and the unconscious, which means that the mind – as the ecology of ideas in systems – is made manifest in the material index in a sequential removal of the difference that exists between the graceless material and the prototype as it exists in one part of the system.

The final point then, in returning to the question of looms, is that the material transference of the prototype from the individual mind of the artist to the apprentice, versus the same to the ivory punch-cards is – in both cases – the removal of difference from the new material. The young girl is taught over the course of years to 'hold' (in both mind and body) the pattern of the rug – including its gestures and sequences of weaving. The two kinds of processes of transferring the prototype from one material register to another, from the individual mind to the apprentice and from the artist-designer to the punch card, are not distinct. Rather, they are the same process radically changed because of the distinct qualities and affordances of the materials into which the prototype is being transferred as a pattern. As a result of the transfer of the prototype onto the material as visible pattern, what was an undifferentiated process can be understood as a series of sequential actions, which in turn can be expressed abstractly by numbers, colours, tones, or other arbitrary signs.

In terms of the intergenerational transmission of the image, the movement of the prototype may also be done via the artefactual form, rather than directly from person to person. For example, in the work of Jack Davy on miniaturisation among the First Nation Peoples of North America, the use of the miniaturised form is seen as a way to transmit sacred – and, following settler governmentality, illegal – knowledge. For example, miniature dolls, made in the likeness of a novice dancer, allowed the ritual movements of the body to be practiced and perfected in the artefactual form (Davy 2016, 2018). As Davy and Dixon (2019) highlight, people 'are inevitably drawn by their [the miniature's] haptic appeal, for there is an intrinsic desire to play with these tiny objects, to manipulate and rearrange them and to imagine ourselves, impossibly, inside or alongside them' (1). It is in this regard that Lévi-Strauss's (1966) observation rings true, in saying that the miniature, in its configuration of artefactual and social forms, is the origin of aesthetics (25). Davy (2019) suggests that 'miniaturisation [is] a component of communal cultural ownership

and transmission' wherein 'an artist makes a series of culturally informed, individually determined decisions in creating a miniature object which they then distribute to predetermined audiences to achieve an effect intended from the very conception of the miniature by its creator' (61). In this way, the miniature is seen as a specific type of cognitive tool, or mnemonic device, for the translation of the prototype through media across time.

Having examined the issue of prototype on a small scale, with individual artists and craft production, the chapter now shifts to consider larger social practices and the role of prototypes in these larger systems.

Australian Aboriginal art

There are few ethnographic case studies more pertinent to capture the relevance of inquiring into the prototype, its workings, and its social effects than the graphic system of Australian Aboriginal Peoples of Central Australia, first described by Nancy Munn (1973) in her path-breaking study of *Walbiri Iconography*.[1] Munn's lasting contribution is the insight that graphic designs and the myriad assemblages composed with them in drawings on media that extend from the surfaces of bodies to the surfaces of the land and of materials are not random. Rather, graphic systems follow a logic which itself is difficult to reconstruct, an idea that received attention in the work of Claude Lévi-Strauss's (1963) analysis of myths. Lévi-Strauss uncovered how myths can be both generative and transformative while sustaining a recognizable ordering of entities irrespective of how many times or across what distances myths are transmitted. Social practices and mythology followed, for Lévi-Strauss, patterns composed of non-random elements and rules for their combination governed by what he called the 'canonical formula', to which we will return in Chapters 7 and 12. In this chapter, we explore via the ethnography of Australian Aboriginal art how research on aboriginal society in Australia was forced to confront the workings of graphic systems that refused conventional analysis based on context or linguistic reference. Emerging at the same time as cybernetic discoveries, the analysis of Aboriginal art and its graphic system informed a debate on the nature of pattern and computational knowledge.

When Nancy Munn (1966) analysed the graphic system used at Yirrkalla in northern Australia in the mid-1960s, computing was in its infancy and the idea of a representational system that has open-ended combinatorial possibilities while being visually discrete was new. Drawn on bark, on bodies, and in sand in rapid

1 Munn's engagement with the graphic system of the Yirrkalla was through the work of Mountford referenced in Berndt (1964) and Elkin et al. (1950; see Munn 1966, 948, fn 3). In this paper, she draws a comparison between two distinct culture groups and their artistic media. The Walbiri made sand drawings while the people in Yirrkalla painted on bark. It is worth noting that: (a) Munn uses the spelling Walbiri, though the standard name of the community as it is used now is Warlpiri; and, (b) Yirrkalla (now spelled Yirrkala) is a community and town populated predominantly by Yolngu people – however, Munn never uses the ethnonym Yolngu, and uses the toponym to refer to the people and their artistic and linguistic practices. We follow Munn's spelling and usage.

56 Rethinking the frame

ever-changing compositions that trace stories as efficiently as stenography or other well-known systems of code, the visual systems of various Aboriginal peoples confound all expectations rehearsed in the European tradition in which visual categories invoke a continuum with linguistic concepts. At the same time, designs and stories associated with designs are identified with particular individuals and/or groups (Morphy 1992).

Comparing the visual systems of the Walbiri and Yirrkalla peoples, Munn presents two types of pictorial representations. The first are 'continuous', in that the motivic form is always recognisable as referring to a given thing, such as a car, tree, or tortoise. These elements, when drawn on the body or in the sand are recognisably discrete entities. Contrasting to these are what she calls

FIGURE 3.1 A sample of continuous and discontinuous forms, after 'Figure 1: Elementary Visual Categories' in Nancy Munn (1966, 938).

'discontinuous' representations. Discontinuous forms are more open ended in their representation and, as can be seen in Figure 3.1, can be representative of multiple narrative aspects, and may be representative of more than one aspect – such as a watering hole and a sitting spot – at the same time. Yirrkalla and Walbiri drawing segments and combines discontinuous visual categories in ways so as to depict connecting elements of a story into ever-transforming and yet recognizable assemblages, comparable to an algebraic system with rules for the combination of real numbers (Munn 1966). There are several such graphic elements, circles, straight lines, curvy lines, and so forth, each referring to self-similar features in the landscape that are thought to testify to the actions of ancestral beings invisible to human perception but for the traces they leave on the surface of the land as waterholes, ridges, paths, and living entities. Munn's (1966) article on the visual categories of the Yirrkalla and Walbiri showed that iconic elements and their combinatorial possibilities do not accompany verbal communication, much like stenography would have been used to record information delivered verbally, but to the contrary she presents a wholly separate system of far greater efficiency and speed than language. Munn's ethnographic account of the sign system itself explains how its elements and combinatorial rules are employed to generate a potentially unlimited set of specific designs, each with a specific informational capacity.

To understand the veracity of the graphic system and its enduring capacity across different media, it is useful to follow Munn's exploration of the sequencing underpinning biographical relation. Aboriginal kinship is so complex that it had long been thought that they had no kinship at all. In fact, Munn's ethnographic work in the 1950s among the Walbiri in central Australia showed that the graphic system manifests a pattern that allows people to conceptualise the non-random myriad possibilities of ways of relating.

The Walbiri, like all Australian Aborigines, were seminomadic hunters and gatherers before European contact, and the graphic designs map the complex biographical sequences (e.g. marriages, childbirth, initiation, death) that connect distinct local groups to one another as they circle the community's land in the vicinity of Yuendumu station northwest of Alice Springs, in sequences defined by the seasons. Prior to settlement in camps, the movements of these local groups overlapped as they moved from water hole to water hole, and the organization of the daily and seasonal cycles of activities and movements constitutes the dynamic of the Walbiri sign system. The family camp and the reciprocal exchanges of meat and nonmeat foods between husband and wife are extended to affinal relations between a man and his wife's family. These affinal relations form the pivotal concepts informing the graphic system, which records the complex relations of kinship defined by multiple divisions of society into halves (moieties) and their internal sub-sections. The kinship terminology derives its complexity from the combination of 'egocentric' categorisation, which means that the category of any individual depends on who the speaker is, and a sociocentric categorisation which aligns kinship terms into a set of eight names, depending on subsection allegiance, that changes in turn

58 Rethinking the frame

depending on the relational position of the speaker in a given context (Munn 1973, 17). The system thus allocates persons to different categories according to two intersecting underlying categories of gender and generational position.

To illustrate the workings of the kinship system whose organizational principles mirror the principles of multiplicity and assemblage informing the graphic system, an extended quotation from Munn is necessary. Munn (1973) describes the dynamic splitting of communities into unfolding and overlapping sections whose crossover is marked by the pathways of exchange:

> Ego finds his or her father and father's sister in a different subsection from his own, while his mother and mother's brother are in still another subsection which may intermarry with Ego's father's (but not his own) subsection. . . . Thus a man finds in his own subsection his male and female siblings, son's child and father's father and their siblings – that is, persons of his own and alternate generations who are linked through males. In his father's subsection he finds persons of adjacent generations to his own who are also linked to the kin of his subsection through males (as, for example, brother's child or father's sibling). Two father–son subsections constitute a patrilineal couple and define a semi-moiety.
>
> (1–19)

Munn goes on to explain how the division of patrimoieties into four cycles or couples of father–son named subsections (semimoieties) allows the position of any given group to be identified with a view to its relation to all other groups in the society. This ego-centric model of social relation allows for social and kin relations to extend well beyond the 'small scale' of 'small scale societies'. As Bird et al. (2019) note, the size of social organisation is related to larger ecological factors and human cognitive capacity allows for networks extending from the individual outward, linking 'individuals across their estates' via 'spatially explicit storehouses of ritual and relational wealth' (96). Rather than 'small scale', these societies are in fact large and complex, and form through maintaining expansive networks through social interaction. Within the cognitive apprehension of the expanded network/model, Bird et al. recognise the image as evidence for and incidental to the mental model; however, we argue that the image and its survival are fundamental to the inheritance of the model across generations.

Important for us here is Munn's identification of a 'subsection code' or grid within the image, which is the foundation to the image as an abstract geometric entity – or prototype – that permits individuals to be located in relation to other individuals and groups. In defining the prototype as an abstract geometric entity, we are making explicit a fuller elaboration of the concept of the prototype; the referent to which abduction moves the mind of the recipient is not necessarily a discrete source (e.g. the French king), but rather can be understood as the absolute configuration (e.g. the French state) made immanent in the indexical form (e.g. of the painting of the king).

The prototype and the model **59**

In this way, the subsection grid underpinning the image is composed of names that trace these spatially imagined, place-centric, yet genealogically shallow biographical relations. Critically, the system of names and the relations it maps onto space overlaps with another system that allows relations mapped in this way to be seen as continuous over time. This second system is composed of designs that reference the personified aspects of the environment, such as rain, honey ant, fire, wild orange, yam, and so on, which are associated with ancestors whose wanderings through the country created topographical features as they moved along tracks or circled within a narrowly defined region. Walbiri use the term *djugurba,* translatable as dream or story, to refer to ancestral events whose unfolding maps onto the country people inhabit today. Walbiri, says Munn, conceive of temporal continuity in the extended sense, from the ancestor to the present. Coextensive with the dividual[2] nature of space and time, there are two ways of conceiving of identity, one in terms of patrilineal descent, confirmed for a boy by initiation into his father's patrilineal group, and one in terms of ancestral descent, derived from the place where a person is thought to have been conceived. The bridging notion between the two sources of identity is the concept of *guruwari,* the basic Walbiri term for ancestral designs. A person is born with an 'inner' design based on the place where the person was conceived, and it is via the externalising of the 'inner' design in ritual that sensory contact with the ancestor takes place as the person is 'wearing the generative potency of the ancestor as the visible emblem of [his] ancestral identity' (Munn 1973, 29–30).

Designs thus are associated with ancestors and are forms external to individual subjectivity in that they are thought of as having originally been part of subjective experience, that is, of the interior vision (dream) of ancestors (Munn 1973, 33). The externalising of internal designs requires the accompaniment of singing, whether the design is thought to belong to a secret class of designs accessible only to initiated men or to an open class that is commonly painted on the bodies of women and children. Whether closed and secret or open and public, all designs have their ultimate origin in dreams and are charged with dream value that is directed to specific ends, whether this is the nourishing of children, attracting a lover, maintaining the fertility and supply of species, and so forth. This mediatory capacity of designs is derived from the fact that the designs are already given to experience as 'sources or cachements, of a motivating power that in its outward dynamic "thrust"' enables the designs to be causally effective, bringing about an intersecting of the coexisting planes of Walbiri life – the spatial and temporal as much as the particular and the communal (Munn 1973, 56). Designs are thus social forms external to the individual and yet simultaneously emergent from within the private and localised dream images locked within the body. Designs in this sense are prototypical elements that are detachable from the body in that they move between persons and groups and

2 We are using the term 'dividual' mindful of Strathern's (1988, 1991) use of it to speak to the mutually constitutive, but distinctly determinative, nature of two entities in relation.

60 Rethinking the frame

yet are bound back into bodily experience. Munn uses the term 'design' and the systematic way design forms are connected with one another (and to the ancestral dreaming) in much the same way as Gell would later use 'prototype'.

This coextensive external and internal quality of designs is intrinsic to the way designs are used outside of the ritual context in storytelling. Drawn in the sand as graphic elements, each of the 12 or 13 regularly used design elements cover a range of discrete meanings (Munn 1973, 65). The high degree of category generalisation – whereby a straight line can stand for anything that is regularly or occasionally upright and longitudinal – increases the number of different classes of things that can be conveyed in graphic form with a small repertoire of elements that are combined in innumerable different ways to trace scenes of evolving complexity as the story progresses.[3] Graphs emerge as attributes of the sand in close relation to, but detached from, the body of the speaker as part of a process in which information relating to the ancestral world is communicated. The formation of the assemblage of elements into graphs, their spatial expression, is absorbed into the temporal process of narration. Munn relates the principles of the sand story to her analysis of women's designs and men's ceremonial designs to show the doubleness of Walbiri thinking about designs and ancestral events in which 'designs are among the marks made by ancestors in the country and they also *represent* such marks' (Munn 1973, 126, emphasis in original).[4]

Where Nancy Munn's ethnography of ancestral designs in central Australia showed the combinatorial logic of a graphic system, later research elsewhere in Australia honed in on the elements and principles of combination, exploring how it is that they are recognized to reference place and yet be shared by everyone as part of an itinerary of a journey across time. For the Yolngu of Northern Arnhem Land, it is drawing on bark rather than in sand that is foregrounded in ceremonies. Graphic elements depicting aspects of the landscape, such as sand dunes, ridges, lake beds, or waterholes, that are themselves thought of as representations of the invisible and yet parallel world of ancestral spirits. Graphic elements that compose bark paintings can oscillate between figurative and abstract, but it would be a mistake to assume that the abstract is a version of the figurative as there is no sense that the figurative is in fact capturing what is visible in its own right. Howard Morphy (2007), who has worked among the Yolngu for several decades, thus concludes from the paradoxical manner in which graphic elements trace the junctures of an inner and an outer world, one invisible and the other visible, that bark paintings are 'mythological maps' of landscape (89). Bark paintings translate into 'loci' or place denominators of temporal

3 See also Knut Rio's (2005) 'Discussions around a sand-drawing' for an excellent example, from Vanuatu, of how graphic elements in a narrative can hold multiple significations within the development of a story, thereby implicating additional relational correlations between characters in the narrative, and subsequently show the narrative to be a multidimensional object for manipulation and contemplation, rather than textual script.

4 In this way, there is a distinct parallelism to be seen between the ancestors, the landscape topography, and the sand drawings, on the one hand, and the designer, the Jacquard punch-cards, and the textile, on the other.

events in 'dreamtime', with each bark painting referencing at least five such place markers via graphic signs that are themselves distinguished into outer and inner, public or secret, with the understanding that the most secret signs will not be made visible to non-initiated men and women (Morphy 1989). The distinction between background and foreground is effaced through an overlay of 'cross-hatching' lines that form geometric motives, the formal quality of which is recognized as mapping biographical relations, allowing bark paintings to convey information about kinship alongside place information.

Morphy (2007) discusses the transformational effect of cross-hatching whose shimmering (*bir'yun*) is the result of painting lines in red, white, yellow, and black over red ochre and yellow and black outlines of graphic elements. The interplay of graphic elements between foreground and background allows paintings within paintings to emerge in a generative kind of fashion illustrative of the ancestral power bark painting is thought to make manifest and to exude in its most potent, secret form (82). Cross-hatching as a technique lends itself to complex and multi-dimensional images that appear simultaneously above and below the surface, by redefining them at different stages of the process. Painting as capturing a process of 'becoming' is evidenced in the fact that while it is tempting to trace an association between geometric motifs created through cross-hatching and clan

FIGURE 3.2 A line drawing of an Aboriginal Australian hollow log coffin, detailing the cross-hatching design, after the object with accession number M.0079 in UCL's Ethnographic Collections.

62 Rethinking the frame

identities, any attempt to assign a simple referential quality to the geometric entities is undermined by their multi-referential qualities. Geometric motifs, such as diamond designs, for example, can represent turbulent waters, the ancestral fire, the marks on the crocodile's back, the cells of a beehive, and its colours can represent flames or burned wood, smoke or sparks, honey or foaming water (82–83). Morphy understands the painting to not be a literal representation of mythological events, but rather a form of meditation on them (103).[5]

However, calling back to mind Bateson's point about the immanence of mind within a system, and the consequential capacity to move the prototype from one source to another, the 'meditation' on the ancestors is representational not by design but by consequence of the prototype and the artists' participation therein. Morphy sees bark painting as strictly conceptual, and yet the idea is situated beyond language in the spatial mapping of temporal sequences the principles of which interconnect songs, names, and the geography of the landscape as seen through paintings. This allows him to attribute aesthetics of cross-hatching to social value rather than understand them as a consequence of the 'ecology of the mind' as immanent in material.

Morphy gives us a tantalizing glimpse of the way bark painting condenses and expresses complex relationships between things – between social groups, and in the seasonal cycle between fresh water and salt water, fire and water, between life and death, and male and female elements. Underlying all this is what he calls a 'template' of the ancestral past, its generative capacity revealed in actions that are causally attributed to the capturing of the template in painting and that show themselves in the continuing relationships between people, in the fertility of the land, and in the renewing and cleansing power of the wet season. The notion of template is taken from the printing press, and this reference, coupled with the use of the term 'loci' for the spatial referents of ancestral events, recalls Munn's understanding of the informational capabilities of the graphic system.

We learn that outlines of either figurative designs or abstract patterns are the surface manifestations of the relational and social nature of actions that unfold beneath the surface in a world that is at once invisible and yet visible, parallel and yet intersecting. We learn that the mnemonic capabilities of painting recall their own becoming as much as they recall images that arrest time in ways that allow the mind to navigate across time as easily as it journeys through space. The question remains, however, how is it possible that the recollection of design forms, which are themselves a representation of events taking place in dreamtime, accessible through

5 In fact, it is worth noting that this genre of art production, wherein the painted pieces of bark circulate outside the community within gallery spaces, is itself a result of engagement between local and settler populations, and thereby acts as a form of mediation. The historical development of the market for bark painting in Arnhem Land has been studied ethnographically by Luke Taylor (1996). He shows the way in which artistic apprenticeship involves social processes that produce and sustain regional variations through time, where senior men pass down to their pupils their innovations, which thereby come to spread across a regional group.

inner subjective experience, is distributed across Australian Aboriginal culture? That is, we are left wondering how it is possible that design elements can be both local and global, heterogeneous and infinitely variant, in their particularity and assemblage, and yet recognizable as a coherent and unified graphic system.

Critical to understanding the combinatorial logic informing similar and yet different assemblages of graphic elements is, as Barbara Glowczewski (1989) argues, the topological thinking inhering in image-making among the nomadic populations of central Australia. By focusing on kinship and the navigation of biographical events and relations that form the story of a life, Glowczewski explains the epistemic capacity of the graphic system to recall the particular as well as the general with its embedding in a geometry that belies the two-dimensional appearance of painting as it allows the three dimensional to be re-conceived and re-presented in terms of shadows cast by a fourth dimension. Taking these ideas forward to understand images made using digital media, Jennifer Deger's (2016) ethnographic work among the Yolngu has explored the Aboriginal use of digital media and shown how image-making using mobile phones emphasises layering and shininess to create composite images of biographies and relational maps in ways that recalls Nancy Munn's work on sand drawing. Multi-variant and multi-referential, the mobile-phone-generated memorial images of Yolngu are, like the drawings in sand and on bodies and other surfaces, second-order objects that re-present a pre-existing way of ordering subjective and simultaneously inherently relational, and thus social, experience.

This question of how the relational, and thus social, inheres in the work of those who become painters of culture in Australian Aboriginal society is followed up by the work of Fred Myers who, as part of his ethnographic research, has collected sketches of the Papunya-based painters Yanyatjarri Tjakamarra and Wuta Wuta Tjangala over several years (Myers 2002, 1999). The tracing of local histories of painting as a practice involves an acknowledgement of differences in the production of Pintupi painters, showing against expectation that what is produced under conditions of a burgeoning art market hungry for paintings of culture provided by Aboriginal Australia is the product of a serious engagement with painting that is deeply personal as well as profoundly social in its resonance.

Tracing the arrangement of graphic designs and their painterly assemblage in paintings over a sustained period, Myers shows that Yanyatjarri Tjakamarra and Wuta Wuta Tjangala are not interested in the differential aesthetic value the art market assigns to their paintings. Rather, drawing on Roman Jakobson's insight that imagines, much like Bateson and Mead (1942) in *Balinese Character,* that the aesthetic function is present in every situation of communication, Myers shows his informants are concerned with the virtuosity of handling the design vocabulary. The sketches record the position of graphic designs, and chart the use of figures across stories of different content and ritual form, and the variations in paintings of the same place and the same story. Tjakamarra's work shows the consistent use and development of a five-circle grid template and its transposition onto rectilinear images demanded by the large canvases. Myers (1999) observes how the

64 Rethinking the frame

painter uses the five-circle grid, modifying it to reference particular sites that play particular roles in the ritual sequences of initiation, while using it again and again (228). Different paintings thus travel around different sites and map the unfolding of distinct ancestral events, while drawing them together via the same underlying circular grid. The perspective of the unfolding sequence, rather than following the linear motion of the ancestor's journey narrated in the story, is de-centred while simultaneously enabling the illusion of an egocentric, relative, and transitive viewpoint while holding stable multiple perspectives on one and the same place. The five-circle grid thus contains within itself the possibility of extension via circles and lines to other places and other stories. These extensions in turn become the focal point for new grids so that eventually a network of relationships between sites, stories, and grids is created (233).

The multiplicity and magnitude of aggregation of circles in relation to one another are the consistent themes running through Myers's analysis of Tjakamarra's work to which are added rectilinear forms and path motives that appear around the same time as a major initiation ceremony takes place in the painter's ritual group. Large canvases that started to be used after the recording of the sequence of images led to the replication of motifs and their extension to other sites and in combination with dreamings from different places. In short, the complexity of paintings increased while the underlying grid structure remained the same. In comparison with Tjakamarra, Wuta Wuta's early paintings are less concerned with a virtuosic

Painting 20. *Wilkinkarra.*

Painting 48. *Wilkinkarra.*

Painting 62. *Kanaputa.*

Painting 115. *Yukurpanya*

Painting 163. *Wilkinkarra.*

FIGURE 3.3 A selection of the Wilkinkarra Series, after the sample provided by Fred Myers (2002, 110) in *Painting Culture.*

interest in form than in his own experience of a ritual re-enactment of a mythological sequence associated with a particular dreaming site that is of personal relevance to his identity prior to settlement. Wuta Wuta breaks up and reorganizes the plane of the picture itself into multiple line structures, with graphic forms associated with ritual actors and the unfurling of ritual sequence whose re-enactment the painting confirms as the cause and testimony of an identity with place, as surveyed by the painter.

Across these examples, we have a range of terms including template, design, and grid. Each of these, to varying degrees, points to the idea of something held cognitively before the image. In this way, they are each similar to 'prototype', however, the connotative possibilities in these terms is distinct. In taking a template from the context of the early printing press, for example, Morphy and Myers inadvertently divorce the art object from the mind, reifying the individual art object as an artefact of template-like production. The possibly quite unintentional implication arises because of the use of the word 'template', which has a technical connotation, in its association with the printing press. From the perspective of a template, the object is not a model, but rather a trace of the model. The technological mass production of printing allows for the template to be reproduced across any flat surface, as the sequencing of reproduction has been flattened to a simple act of substitutional representation. From the perspective of prototypicality, art production can be seen as patterned sequence. This relates first to the capacity of material (both human and otherwise) to hold mind, and, second, to the intrinsic relation between the dividuality of the artist and the index – as both are participant in the prototype. Taken together, we can see the index to be the immanent manifestation of the prototype.

Summary

This chapter has worked through a series of case studies in order to discuss the epistemology and prototypicality of objects as poetic systems. In discussing the prototype in more detail, we are working to make explicit an underlying core idea within *Art and Agency* that has received insufficient attention in even the most sophisticated of subsequent reflections on the work (e.g. Rampley 2005; van Eck 2010, 2015). This idea, made explicit in Gell's discussion of style (1998, ch. 8), is that the object does not have its primary referent in culture, but in itself and its underlying prototypical idea of which it is an index. Each index is a 'nuancing' (Damon 2012) of the prototype as it comes to reside in material form, are therefore in a 'constant state of adjustment and elaboration' (190).

For its part, the prototype is most clearly apprehended via an object, but exists more abstractly in the 'art of social forms' (de la Fuente 2008, following Georg Simmel) which consists of relational sequences of actions, which are intuitively recognised and collectively shared. In this sense, the reason for not approaching art via its cultural context comes clear, as it is the prototype, via its objects and social forms, that produce cultural context as an art of social forms. Simmel's insight

66 Rethinking the frame

regarding the necessity of aesthetics to social life, and the interplay between the social forms of art and art of social form that de la Fuente identifies in Simmel's work, was heavily influential in Gell's understanding of art and sociality. It is on this point, in fact, that his critique (Gell 1995b) of Coote's (1992) everyday aesthetics turns. It is not on the importance of aesthetics to quotidian social concern, per se, but the exclusivity of this within a reified category of art. The social forms that manifest the prototypicality of mind are much more widespread and readily available. The whole point of the prototype – its function, if you will – is to make the model immanent and apprehensible to society.

The next chapter moves this forward by exploring the theoretical consequences of recovering 'structuralist' insights for a paradigm shift in our understanding of the object-as-knowledge which allows it to exist as part of a system. We introduce the concept of 'representational immanence', tracing its history alongside the more commonly recognised substitutionary and mimetic representation. In so doing, we oppose the assumption of what Carl Einstein called 'optical naturalism' with a proposition of a non-anthropocentric understanding of representation.

4

IMMANENT RELATIONALITY AND ITS CONSEQUENCES

The previous three chapters build on the Introduction in which we highlight the intellectual tradition out of which Gell's theory arose and develop the theoretical implications of ideas germinating in his own writing. As this first section of the book draws to a close, this chapter introduces the concept of 'immanence', which we see to be implicit within Gell's theory of the prototype, as a kind of (re)presentation, and traces its history alongside the more commonly recognised types, namely, substitutionary and mimetic representation. Drawing on the art critic Carl Einstein, this chapter advances the idea of immanent representation as a way to oppose the assumptions of 'optical naturalism' that guide much of Euro-American science of the image.

The relational immanence of the object also has wider ramifications for the position of the object in institutional and political spheres. This is because the prototypicality of the index demands certain kinds of ethical action. The reality of tangible heritage as a highly political, contested, and protected realm is something that is now well established in the global geopolitical context, via initiatives such as UNESCO's scheme for recognising 'world heritage'. The arbitration of heritage, however, and the implications for who can – legally, ethically, authoritatively – speak about, access, or otherwise control objects is often highly contested. In his seminal work on the issue of 'cultural copyright', Michael Brown (1998) outlines a number of, effectively irresolvable, situations, and asks for what he calls 'situational pragmatism' and 'ethical realism' in approaching the double binds presented by heritage claims. He highlights, for example, the problem presented to the curatorial team at the Harvard Peabody Museum due to AM Tozzer's bequeathal of his collection of images of and writings about the Navajo. As a condition of the endowment, Harvard is responsible for the keeping of the collection and maintaining it as the legacy of Tozzer's life work. There is a clear ethical and legal commitment to Tozzer's legacy and the agreement made in accepting the endowment. However,

68 Rethinking the frame

due to NAGPRA[1] (The Native American Graves Protection and Repatriation Act, 1990) – which is US federal law governing materials excavated from burial sites (human remains and objects), but has wide-reaching implications into the rights of access to the tangible and intangible heritage of the Native American peoples – Harvard is also forbidden from showing, seeing, or indeed preserving the Navajo collection. Photographs in the Tozzer collection show sacred ritual elements, such as sand drawings, and are thus permissible for viewing only to initiated members of the Navajo tribe. The image's immanent relationality demands certain kinds of ethical action, and US federal law protects that right.

Part of what drives this claim and control of the prototype via its objects is what Simon Harrison (1999) identifies as the scarcity of identity. Written before the language of copyright and proprietary rights to heritage became standard, Harrison nonetheless articulated with great clarity the importance of certain claims to the exclusive use of and access to objects and cultural practices. Harrison cites some well-known examples – such as the petition by the Greek state for the repatriation of the Parthenon/Elgin Marbles – but also draws attention to less articulated, and in some ways more sinister, cases, such as the introduction of new national festivals to effectively erase ethnic minorities. Harrison outlines how the Turkish state, in the face of rising Kurdish nationalism in the 1990s, was forced to reorient their approach towards the ethnic minority. Whereas the Kurdish national colours – red, yellow, and green – had been made illegal as part of a wider effort to supress the Kurdish minority, Turkish policy shifted and encouraged the use of red, yellow, and green, particularly in the celebration of a new national holiday, Nevruz. Nevruz, celebrated to coincide with the near-homophonous Kurdish new year, *Newroz*, was arranged within the wider Turkish national identity in a way that facilitated the erasure of Kurdish exceptionality. Using the same colour scheme on the same day meant that, while not overtly engaging in an act of suppression, the Turkish state nonetheless facilitated the disenfranchisement of Kurdish identity. As Harrison (1999) says, 'the most radical challenge to a group's identity comes when another community claims, not simply rights to some of its practices and traditions, but exclusive rights, and tries literally to dispossess it of key symbols of its identity' (248). So, while Harrison's concern is framed in terms of the symbolic value of the objects and practices within the shared notion of collective identity, his work highlighted the very important reality of contestation and control, or even erasure, of various culture groups via the control and use of objects.

As seen in the case of the Parthenon Marbles, or the Tozzer collection, the role of museums as arbiters of and tactical means of representation and control is significant. In its ideal, the museum works as a 'contact zone', in the way described by James Clifford (1997), allowing knowledge transfer and a sense of mutuality to arise around the objects. This may be most well exemplified in the Torres Strait

1 For further reading on NAGPRA, see Nash and Colwell-Chanthaphonh (2010), Anderson and Geismar (2017), and Colwell (2017).

exhibition, held in Cambridge to mark the centenary of AC Haddon's 1898 scientific expedition to the Torres Strait Islands and Borneo (Herle and Rouse 1998). In its organisation, the exhibition brought the Cambridge curatorial team into partnership with Islanders, allowing for discussion, rediscovery, and collaboration driven by the ethnographic specimen and the archival records left by Haddon and his team. At its best, the museum as contact zone is a site for the access of knowledge and a catalyst for new relationships.[2] It allows for an object-orientated means of discovery and exchange between the institutions that own the objects and the source communities from whence the objects originally came, in a way that can bring other, third parties, into the conversation as well.

In the genealogy of the concept, however, the idea of a 'contact zone' belies a more deeply fraught reality.[3] As Robin Boast (2011) has outlined, the concept originally comes from the work of Mary Louise Pratt (1991), who uses the idea of the 'contact zone' to describe the colonial encounter in South America, whereby the Spanish authorities dominated and eventually destroyed the indigenous peoples and their cultures. In this light, it is apparent that a contact zone, at its very core, is a space that is inherently marked by power inequality and incompatible intentions. This should be of no surprise, as the intentionality of the objects, and the intentionality of the museum-frame as an object, is inscribed with their own relationality and resulting ethical requirements.

However, the immanent relationality of the object also affords the burgeoning of revitalisation movements, and in this way an increasing role of museums, especially amongst settler societies, is as repositories of cultural and intellectual property (Geismar 2013). For example, during the colonial period and the Christianisation of Oceania, many of the local island tattooing practices were lost, in some cases completely. However, within the personal accounts of explorers and early ethnographic accounts, descriptions of the practices and sketches of various tattoo motifs survived. Along with these textual references, a few tools also survived in various ethnographic collections. In the 1990s, as part of a wider growing interest in ancient Oceanic practice kindled by a group of Polynesian artists in Auckland known as the Pacific Sisters, a renewed interest in indigenous tattooing led to the rediscovery of museum artefacts and historical documentation. This led to a revival of tattooing patterns and associated practices across Pacific Islands. Even when brought together, the extant record does not provide a complete description; however, by making replicas of the tattooing instruments, tattooists were able to rediscover techniques and patterns (Galliot 2015). In a similar manner, a large war canoe was repatriated via digital means as the result of a collaboration between the British Museum and Islanders from Vella Lavella in New Georgia, Solomon Islands (Hess et al. 2009). This high-resolution digital copy was given to the Islanders, allowing for careful

2 For more on museums' collections and knowledge, see Bolton (2018), Burt and Bolton (2014), and Bolton et al. (2013).
3 For a wider discussion on the term 'contact zone' and its evolving and multiple interpretations, see also: Tsing (2015), Peers and Brown (2003), and Krmpotich and Peers (2013).

70 Rethinking the frame

analysis of the construction of the boat. The ability to see in detail the careful configuration of the joints by which the wooden structure was held together resulted in a reawakening of lost indigenous knowledge of woodworking. The joints were accomplished without metal, resulting in lighter hulls; the loss of this knowledge had resulted in heavy boats, with obvious ramifications to maritime navigation (Hess et al. 2009; Were 2019). In these two cases, as in many others, it can be seen that lost knowledge can be reinvigorated and used for new purposes when objects are encountered anew. Objects, even when encountered in foreign contexts of museums, are able to trigger songs, stories, memories, biographies, histories, and traditional social behaviour.

This capacity of the object 'to create novel and distinctive values and social orders' (Thomas 1999, 5) is fruitful for both the indigenous people and for the ethnographer. Objects, such as the *tiputa* from 19th-century Polynesia, became the point of conversation between Islanders and missionaries, and thereby facilitated the uptake of new materials and technologies of clothing in ways 'that made religious change, that is, conversion to Christianity, visible as a feature of people's behaviour and domestic life' (6). Thomas makes the comparison between various artefacts within a cultural narrative and the clues used by Sherlock Holmes in order to highlight the phenomenon of the ignored 'missing' and yet 'valuable object on which people's passions and aspirations are focussed' (6).

In Australian Aboriginal culture, the object of value upon which 'people's passions and aspirations are focused' (6) is at once both enduring in the landscape and ephemeral as temporal surfaces. Here we consider a case study taken from Australian Aboriginal documentary film, as shown in the work of Jennifer Deger (2006). We then look at theories of representation and magic, and then introduce in detail Carl Einstein's perspective on 'optical naturalism' and the 'totality' of the art-like object. To more fully illustrate and extrapolate the implications of this perspective, the chapter then works through a series of extended cases studies.

Ancestral water

In her work *Shimmering Screens*, Deger (2006) follows the filming and production of a documentary film made by Bangana, a member of the Yirritja moiety of the Yolngu, about the Gularri River. From its headwaters to the ocean, the film follows the sacred waters and highlights the relationships held in the ancestral waters to people and epic songs along the way. As the film opens: 'Light refracts through a clear shallow stream, patches of darkness and light highlighting the rippling patterns that form and disappear across the surface. The subtle, soothing sound of water trickles across the audio track' (157). Throughout the film, water holds the central focus. Repeatedly throughout the filming, Bangana would instruct the camera crew to shoot close-ups of the water. The camera crew, professionally trained with an eye for nature documentaries, insisted on scenic shots: shots of the landscape around the river as it changed in its seaward journey; trees and outcroppings of rocks that helped sculpt the path of the waterway; the hatching of baby turtles on the beach.

With all of this, Bangana played along, knowing that turtles would not make it into the final cut. Deger explains this exclusion as a matter of semiotic noise. The turtles – as are the trees and significant outcroppings of rocks – belong to different clans and would divert attention away from the point of the film: the water of Gularri. In addition, attention to sea turtles would also infringe on the proprietary rights of the clans to whom the totemic turtle belongs, hence, Bangana's repeated instruction to 'stick to the water'.

In the editing room, many of the shots of water were rejected. The crew had used rocks or low-hanging branches to frame the water. This contaminated the image and meant that the water was not the focus. In particular, it meant that the surface of the water, its undulating patterns of ripples and the glistening of the light atop its cresting ridges, could not be appreciated. Deger (2006) emphasises that:

> the watery images of *Gularri* do not represent, nor even simply demonstrate; rather, they *evoke* culture and *produce* identifications by offering the possibility for everyone to *see for themselves*. In combination with the [Yirritja moiety ritual specialist]'s ritual invocations, the camera works the spaces between the visible and the invisible, presencing the more *dhuyu* [secret/sacred] aspects while nonetheless keeping them concealed and securely contained within the opaque depths of the sparkling waters.
>
> (180f, emphasis in original)

There are two things happening with vision here that are important to highlight. The first is the kind of framing the professional camera crew know they should produce. In the standard practice of nature cinematography, the object (water) must exist within a frame of reference (the tree branch). This is partially to help make the scene interesting – and help the narrative development of the river as it moves through different kinds of flora in its downstream journey, but also to assist the viewer in recognising what the scene is. In this way, the cinematographic lens mimics the landscape giving fore- and background with an anticipated viewer, allowing for depth and the recognition of the three-dimensional space in the two-dimensional surface. The second kind of viewing, described by Deger, anticipates a knowledgeable viewer who, working from passing glimpses and clues on screen can 'see' things off screen. In 'the slow pans and static shots of the water and country' the viewer can 'zoom in to a particular rock or tree and thereby "see" the stories' of the ancestral and totemic landscape. More than the camera and director, it is the viewer who does the most work (174).

For the viewer who knows how to see, the extended close-ups of water

> asks them to see 'inside' the water into the depths where the sacra lie . . . it animates the connections between the visible and the invisible, activating ways of seeing for viewers with imaginations attuned to the recognition of patterning and the layering of meaning and associative resonances.
>
> (181)

72 Rethinking the frame

The pattern of the water, filling the entire frame, makes it an abstract moving image. The shots shimmer, as the pattern undulates on the screen and shows the power of 'something beyond representation' (190). Knowing how to see is, ultimately, knowing how to recognise patterns. And while the filmic medium is (was) new to the Australian Aboriginal context of ancestral dream stories, Bangana was not doing anything particularly new; what he did with the new medium was to capitalise on the possibility of film to show in animation the same 'similitudes in form and correspondences and pattern' (Deger 2006, 199) already existing in the 'still' paintings of older media.

Aboriginal art from Arnhem land is, among other characteristics, known for a repetitive cross-hatching pattern. As Morphy (1989) describes, ancestral images are first outlined, then filled in using a series of cross-hatched lines that produce a grid-like tessellation within the borders of specific ancestral motifs. While technically 'still', Deger (2006) admits, they are yet 'alive with movement. Pulsing. Shimmering', and she can 'see the correspondence between the patterns in the water and the criss-cross patterns in the rocks that mark Ancestral journeys' and 'the fine cross-hatching designs that produce the "*bir'yun* effect"' (224; viz. Morphy 1989). This kind of recognition – the ability to see the ancestral pattern showing through the physical world – is a cultivated ability, and one that works in both the 'art' context and across media. Like Bateson's 'double description', Deger (2006) shows that the Yolngu world is 'constituted through the bidirectional process of showing and recognising', where the pattern comes through in ritual signing and painting, but can also be seen in photographs that make clear a daughter having her father's nose (201, cf. Deger 2016, 2019).

This capacity to recognise the showing forth of ancestors is critical – both in 'art' and in kin – and demonstrates the immediacy of presence of the ancestral totemic essence. This is not representational, at least not in any normal sense, as Deger emphasises: 'For Yolngu of the Yirritja moiety, these waters are a foundational source: not only do they and their *rangga* [restricted sacred objects] come from Gularri: they *are* Gularri. Gularri does not simply represent them, it *is* them' (2006, 138, emphasis in original).

To say the river does 'not simply represent' is a loaded phrase, and warrants a closer look at the implications of representation.

Representation

In critical theory, representation is usually subdivided into two types that speak to the ways in which the representative object (as sign) is related to its cause. This pair appears in both art historical literature (e.g. Carlo Ginzburg 2001, 63ff, following Roger Chartier) and in the anthropological interpretation of magic, following James Frazier and Walter Benjamin (see Taussig 1993; Gell 1998, 100). The first type of representation is 'substitutionary', wherein the object stands in for the source in its absence. The second, 'mimetic', is where the object is made to look like (or to behave in) the pattern of its source, and thereby operates in its stead.

It is our contention, as mentioned before briefly, that there is a third kind of representation that needs to be acknowledged, which we call 'immanent representation'. Immanent representation can be found in the European tradition of art production, as may be attested by Bakhtin's (1984) *Rabelais and his World*, but had become quieted through the rise of humanism, modernity, and scientific rationalism. In the intellectual tradition of representation in Europe, which was heavily influenced by the theological discussion around the Christian Eucharist, the prevalence of 'immanent' objects was pushed out in favour of symbolic readings of the Eucharist. Whereas theologians in the first several centuries emphasised the symbolic quality of the ritual actions and the essential reality of the ritual substances, the scholastic tradition of Christianity in Europe made increasingly abstract the relationship between the Eucharist and Christ, eventually reading it as a symbol of substitutionary representation in the Protestant reformation.

Representational immanence remerges in the European context in an important way with the arrival of artefacts from around the world during the periods of 'exploration' and colonialism. When brought into the European context, artefacts from abroad were consolidated into institutions of experience – such as museums, rather than institutions of the natural sciences. In their source contexts, the objects, however, have the same acute importance as the sciences (viz. Lévi-Strauss 1955; Stengers 2010). As these new objects arrived, filling new museums that had been built in opposition to science museums, artists began to see that these objects opened up new avenues for what art objects are able to do as they showed forth in new ways the behaviour of complex systems.

In Deger's (2006) discussion of shimmering, she highlights that the classic anthropological understanding of *bir'yun*, made famous in the work of Howard Morphy (1989) amongst the Yolngu of Arnhem land, was not reaffirmed by her interlocutors. Bangana and others ascribed the word *bir'yun* to simply mean shining – like the sun does. However, they suggested that maybe *bir'yun* was used this way amongst the clans with whom Morphy worked; for them, the sacred was a matter of *malng'thun*: showing, appearing, or coming to light (Deger 2006, 190). The implication here is important, as the capacity to show forth implies the presence before the visibility. The ancestral is immanent in the landscape, the water, the shape of a nose, the moiety, etc. And in spaces of sacred enunciation, the pattern of the ancestral is, as Deger says, 'constituted through the bidirectional process of showing and recognising' (201). In this sense, we assert that this is a third kind of (re) presentation, one where the essence of the presentation is itself the representation.

Relational immanence

This approach to form, here called 'relational immanence', is – as we introduced in Chapter 1 – not new but has been a minor discourse throughout art historical and anthropological history. The dominant paradigm in the science of the image is best understood, following Carl Einstein, as 'optical naturalism' and assumes the position of the art object in relation to the viewer as frontal and distanced (Zeidler

74 Rethinking the frame

2004, 29; Einstein 2004a, 2004b). It is in this vein that the film crew, mentioned above, framed the water shots like landscapes. Einstein wrote during a period of art criticism framed by Hildebrand's arguments in favour of viewing three-dimensional art (like fountains and statues) from one static point, and Simmel's arguments concerning Rembrandt's work being viewed in the round. In both these (at the time) opposing views, Einstein marks their shared 'optical naturalism' as an issue of spatial distanciation. Extending this, we are specifically interested in the relational aspect of the piece and in the relationship distance creates via the work of art. Optical naturalism holds the art object as conduit between viewer and artist – that is, as representational substitution, implying the unimportance of the art object itself, except as mediator of symbolic meaning. In proposing relational immanence, we offer instead a perspective that allows us to think through peculiar phenomenon seen in the sacred 'art' of ethnographic collections and in contemporary art practice, as well.

In this understanding, we can then say that 'art' (images, objects, etc.) are part of systems that are indexical and, via their patterning, show forth complex relations between persons and persons and things. What is important to note, however, is that this 'showing forth' is not, in the first instance, representational of something beyond. Einstein makes the point that art, as a 'totality', 'makes possible concrete apprehension and by means of it every concrete object becomes transcendent' (2004b, 119–120). This 'transcendence', as Zeidler (2004) points out, 'is not a realm of pure ideas or forms that hover above the empirical world as its purified *summa*; transcendence is rather the immanence that knowledge must produce as outsider in order stabilize itself' (38). On this point, Einstein agrees with Simmel's argument on the centrality of the artificial – as expressed in the aesthetics of style, form, and custom – as necessary for sociability (cf. de la Fuente 2008). The comparison to Deger's description of the dreaming is uncanny; and, as Gell (1998) comments about Polynesian art, a 'tattooed *etua* [god figure] was protective of the person because it *was* an *etua*, right there on the body, not because it "looked like" an *etua* somewhere else' (191, emphasis in original). Art – as a category and as unique objects – cuts across existing trajectories within wider social and material domains. It is not a subsidiary category within a larger hierarchy of epistemological framing. Rather, in the sense that it is an index of relation and relationality, 'art transforms vision' and 'the individual work of art itself constitutes an act of knowing and of judgement' (Einstein 2004b, 116–117). This is not simply knowing *that* something is, but knowing *how* to be in the world is therefore dependent upon the artistic gesture and its objects. As such, art objects give form to new ideas and new modes of expression in the world.

Art, therefore, operates as a model for social knowledge and practice, and offers what Wagner (1986) calls '"paradigm certainty" for cultural motivation in general', enabling what he calls the 'invention of culture' (10). The capacity of paradigmatic patterns to be moved across genre and material – as shown above in Deger's description of the affordances of the cinematographic medium – opens up new developments in the knowing of the prototype as the material of the index shapes

the way it is shown forth. In this light, the shimmering surface of the water on the screen emerges as a model that enables 'confident "seeing" includ[ing] a restructuring of the model' through the choice of the material (Wagner 1986, 10).

We now turn to examine four brief case studies that illuminate this principle of how the modelling of the model, and specifically the choice of material used, works to show forth the prototype in a new immanent fashion. It is, in this manner, a re-presentation, as the artifice and the understanding of sociability that it allows is already a set of 'known and familiar relations and orderings' (Wagner 1986, 10). Each new gesture is both the 'artifice' that Simmel and Einstein affirm as the necessity of sociability and the 'invention' that Wagner identifies as the process by which the understanding of sociability is maintained.

Models as immanent

Limewood sculptures of Renaissance Germany are a perfect example for how the choice of a 'new' material for conventional purposes allows for a revolutionary, radically new understanding of relation between persons and persons and objects to become commonplace. The publication on these sculptures by art historian Michael Baxandall (1981) rivals the best ethnographic accounts of art, not because he perfectly illuminates the context of art production, but because he explores the complex web of intentions informing the choice of material and the epistemic consequences of a concretised idea of how to be in relation that has no precedent, while being intimately recognised. Produced between 1400 and 1500 in the then new mercantile centres of southern Germany, limewood sculptures were commissioned by local merchants in the newly emerging trading centres in an area that spans south from central Germany to northern Italy. There it was used for the carving of large, winded altarpieces, the most impressive of which are from the period 1475–1525, coinciding with the onset of the Reformation, and overlapping with Dürer's life. Dürer's watercolour of three lime trees figuring prominently at the start of Baxandall's exposition of the difference that the use of the wood from the broad-leaved Linden tree had made to carving, for the wood's fine-grained quality had made it possible to sculpt the surface of figures with an expressive and ornamental independence not possible previously. Altar pieces commissioned by churches had used types of hardwood known for durability rather than malleability, and the distinctive features of sculptures were elevated through painting, with different images of saints frequently being painted on top of one another. Limewood, itself a type of hardwood, is prone to spilt and warp if the core is not removed in its entirety, leaving a thin outer shell akin to a body's outer membrane. The carving of limewood, in fact, proceeds from the inside, defining the shapes visible on the outside from an oblique, internal perspective. The malleable surface of the wood made it possible to carve the folds of a dress or the lines on the skin of a face depicted with a lifelikeness that was revolutionary during the contemporary Italian world of the young Michelangelo and more akin to Dürer's two dimensional drawings.

76 Rethinking the frame

The statues that composed an altar relate to one another through posture, gesture, and even facial expression that is also turned inward, suggesting an idea of individual character and relatedness, which Baxandall shows to emerge in the culture of the time through the practice of letter writing and music. So, while the sculptures are, at one level, a normal example of mimetic substitution, being modelled in the likeness of saints and living persons, on a much more profound level, they model a new understanding of relation and ordering in the world. Relations of trade and commerce were, at the same time as the limewood carvings were commissioned, underpinned by letters executed in distinct handwriting and exaggerated flourish depending on the relation between writer and recipient. At the same time that letters connected relations across distance in sequences that punctuated the timing of trade as much as of daily life, the melodic elaboration of music was used to affirm relations that flourished into sustained mercantile relations connecting towns and regions with individual melodic elaborations being recognized and recalled by those who attended a performance.

Underpinning this attention to visual and acoustic accent was, according to Baxandall, the work of the Swiss alchemist Paracelsus, who had formulated an astronomical theory based on the notion of an 'inner light', an invisible and occult aspect of nature that pervaded and animated all material things. Paracelsus's theoretical system was in direct contradiction to the 17th-century materialism and mechanical philosophy that came to dominate natural philosophy in the wake of Descartes, emerging as the inspiration for a Romantic vision of a re-enchanted world (Porter 2005, 26).

The concern with what we now are calling relational immanence resurfaced again with the advent of the chemical revolution and its popular imagining in the late 18th century, captured by Johann Wolfgang von Goethe in his 1809 novel *Die Wahlverwandtschaften* (*Elective Affinities: A Novel*, 2008) in which he draws attention to an emerging understanding, aided by industrial forms of labour and loyalty, of relations independent of kinship. The limewood sculptures of Renaissance Germany did not only give succinct expression to this idea of relation, but made it manifest and therewith understandable and translatable into the building blocks of an economy of knowledge thriving on inter-subjective and empathic connections. Baxandall exposes the unfolding of an accentuation on what he calls the 'flourish' across activities ranging from handwriting to music to clothing, to sculpture and architecture, a 'period eye' that was further analysed in terms of its peculiar relational, differential logic by Gilles Deleuze in his work *The Fold* (1993), which will be more fully examined in Chapter 11.

A relational imagination and relationally conceived differential logic also informs a system of knotted cordage known as the *khipu* or *quipu* used by the Inka to transport politically and economically sensitive information across the Andes in an effort to integrate a vast empire (Ascher and Ascher 1981; Urton 2003, 2017). Gary Urton worked on the remaining collection of *khipu* used in the 15th and 16th centuries and explored it as a type of code, only instead of numbers or letters, the *khipu* is composed of distinct knots and combinations of numbers of knots and colours

on strings of varying length attached on pendant strings from a core cordage. The information recorded on *khipu* via the types and placements of knots was both statistical and narrative, consistent with evidence from other ancient writing systems that combined numerical signs with signs or graphemes indicating grammatical actors. This distribution of numerical and narrative types of information takes the form of decimal distributions of knots on the pendants of a *khipu* and non-decimal, anomalous knots and pendants (Urton 2003, 55).

The *khipu* is studied using a corpus of around 215 preserved *khipu* samples first worked on by Marcia and Robert Ascher in the *Code of the Quipu: Databook I and II* (1978, 1988). The systematic observations of certain features of the *khipu* have included the following: the colour of the main primary cord; the measurement along the primary cord to each pendant or top string; a sequential numbering of the pendants; and a measurement of the total length of the primary cord. Observations about the cord included: the number of knots in each location, the types of knots on the cord, the total length of the cord, the colour of the cord, the total decimal value of the number of knots on a cord, and the number and location of any subsidiary pendants attached to a cord.

Gary Urton (2003) added to the observations made by the Aschers, including: the material of which the cord is made; the particular combination of spinning, plying, and wrapping used in the construction of the primary code; the directionality of the spin and ply of each cord on a *khipu*; the direction – front and back – of attachments of each cord on the primary cord; and the directionality or manner of tying each knot on the cord (57). Urton identifies seven components and phases of construction and exposes a binary logic underpinning decision-making during construction involving the selection of materials, the spinning and plying of threads, handedness and direction of reading, the mode of attachment of strings to the primary cord, and knot directionality. Binary coding involved the construction of knots resulting in Z and S knots as well as the spatial division of pendants and knots on the *khipu* which, via the distribution of two knot types (Z and S), can be seen to be composed of quarters, with a non-random positioning of vertical and horizontal axes and a non-random placement of the two types of knots determined by the axis of division in the upper left-hand quadrant and lower right-hand quadrant (S knot), and the upper right-hand quadrant and lower left-hand quadrant (Z knots; Urton 2003, 84–85).

Urton shows that the *khipu*'s use of binary organisation to register numerical and potentially organisational qualities as information via the precise manipulation of strings also exposes an abstract, quintessentially relationally conceived, differential system of numbers and colours. Numbers in the Quechua language are organized as an alternation between two related social states of being: *ch'ulla* (old; alone) and *ch'ullantin* (even; pair; the odd one together with its natural partner; Urton 2003, 89). The most elementary numerical expression of this essential relation between *ch'ulla/ch'ullantin* is that between one (*ui*) and two (*iskay*), which is not expressed as an additive relation but as a sequence of integers in which sets are formed by linking each odd/*ch'ulla* number (1, 3, 5 . . .) together with its even/*ch'ullantin*

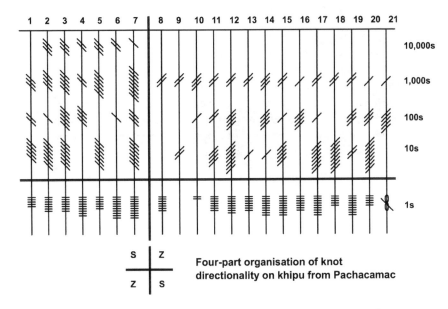

FIGURE 4.1 Diagram showing quadrants of the Khipu from Pachacamac, after Gary Urton's (2003) 'Figure 3.14 Four-part organization of knot directionality on khipu from Pachacamac' (87).

complement (2, 4, 6, . . .) to form complete number sets (Urton 2003, 89–90). Quechua numerical ontology also informed the organizing principle of decimal values registered in the *khipu* (Urton 1997; 2003, 90). To register such decimal values, three major sign types are used: figure-eight knots indicating ones (single units); long knots, signifying units from 2 to 9; and single knots, which, depending on their position on the string, signify any one of the full decimal units (10; 100s; 1,000s; or 10,000s). In line with the ordering principles of Quechua numeration, every knot is both an individual binary coded signifying unit and a component of a sum that could have been of administrative, calendrical, or even purely mathematical value for state record keepers.

In the first order, the *khipu* as records are a type of substitutionary representation; however, the importance of the string, and its capacity to model via its affordances to be manipulated into different types of cordage and knots, as well as colour, means that the prototypical information after which it is modelled is held in the artefact, not distanced from it. The prototypical information immanent in the *khipu* is the relational quality of sequences of numbers that are paradigmatic to the cosmological understanding of relations and principles of ordering. In this case, unlike with the introduction of limewood alongside the advent of new sociability, here the artificiality of the knotted cords reaffirmed the 'paradigm certainty' formative of the Inka state up until the moment of colonial intrusion.

Where the *khipu* can be seen to draw distributed data together in bundles of information via an algebraic system of numbers and rules expressed in the

differential and yet non-random manipulation of string, other well-known image systems accentuate relational thinking seemingly without recourse to algebraic systems. A well-known example is the Malanggan of New Ireland, Melanesia, which is a corpus of images carved from wood, woven from vines, or moulded into clay that shows forth the exchange of usufructuary land rights between households (Küchler 2002). The corpus of images is divided into distinct motifs and distinct modes of combination of which there are three recognized and named types, each with its own double.

In ways that are strikingly similar to a system of recording the lending of land rights in ancient Rome via the breaking of figurines, with each party receiving one part as a sign of the contract, every *malanggan* image carved is already a part of a more comprehensive whole that remains invisible and is recalled as a shared, acknowledged relation between lender and recipient of types of usufructuary relations that extend from the harvesting of trees, to the sharing of garden land and fishing rights in the lagoon, acknowledged in their comprehensiveness with the number of distinct motives composing a figure. The sharing of images transcends other co-existing political and economic relations and confers upon exchange relations a future potential of unfolding into other forms of contractual relations, such as marriage. The understanding that social relations follow from relations informing the making of images is further underscored by the fact that the relation between the three named image types and their doubles underpins the organisation of the ritual work for the dead whose culmination is marked by the carving of images from wood.

The sequence of rituals leading from burial to *malanggan* is divided into three stages, thematically distinguished by the removal of skin, the exposure of the soul, and its recapture in a new artificial body, the *malanggan*, treated during the final stage of the sequence as being alive. This final stage, witnessing the making, reveal, and exchange of the image of *malanggan*, is itself divided into three sequences, associated with the absorption, containment, and release of life-force, with a logic that informs the way motifs are combined. The logic of combinations relates parts of one type of image to another one at the same time as they serve to differentiate distinct types of images as instantiations of inherently related sequences. *Malanggan* images and the myriad of relations between parts and parts and their invisible wholes project an inside view of a logic of relation that allows for multiple perspectives to be held stable simultaneously, at the same time that connections between strands of images are changing. It is because of the systematic properties of the relations between motifs and their combinations that *malanggan* can serve to make visible in the public area the manifold contemporaneously held relations over land, although *malanggan* itself can only ever be known via its concretised parts that are carved to mark the closure of a life defined by biographical relations by becoming one with the principle of relation itself. The ritual cycle, which allows the entire social body to 'see' the image, and the subsequent removal of the self-significative image, guarantees the survival of the knowledge, and, in this sense, is a scientific method of modelling.

FIGURE 4.2 Malanggan funerary figure. Drawing after a figure collected by Alfred Bühler held in the Basel Museum of Cultures.

Fixing what is an apparently bewildering multiplicity of potential biographical relations into a dyadic pattern of genealogical relations, eastern Polynesian piecework coverlets hold in place biographies that are already completed before they begin. Known in Tahiti as *tifaifai* and the Cook Islands as *tivaivai*, coverlets are composed of iteratively assembled self-similar geometric or figurative, usually floral, patterns that are themselves assembled from self-similar, iteratively arranged geometric pieces (Küchler and Eimke 2009). While seemingly two dimensional and flat, the construction of the piecework coverlets is informed by a relational numerical ontology not too dissimilar to the ideas informing the Andean *khipu*. Historically, Cook Islanders did, in fact, also have a complex system of knotted cordage covering iteratively carved longshafts. At the advent of colonial Christianity, the male practice of ritual tying and untying of these carved figures was forbidden, and the practice ceased. However, in its absence, the women, who were taught stitching and sewing by the missionary wives, took up the same modelling in the new material of ready-coloured cloth and its potential to be sewn into ever-changing and yet diagrammatically 'correct' patterns (Küchler 2017). In the Cook Islands, where piecework making dominates the lives of women and the exchanges of a household, encode foreign and home-born ancestors, and it is the relation between the two that defines every individual in every generation, over and over again. Wrapped as shrouds around the dead, *tivaivai* are lowered into tombs, the superstructures of which resemble the houses that dot each of the islands on which *tivaivai* frame the lives of the inhabitants. The geometric patterns visible on the surface of the piecework coverlets form assemblages much

Immanent relationality **81**

like the graves seen from above, and both in their own way recall relations that are at once multiple and singular, foreign born and home grown, completed and just beginning.

The surface motif of the quilts, even when entirely abstract, is demonstratively a floral pattern. These flowers are not generic flora, but are specific and known flowers that, like the ancestors, are both imported and home grown. In this way, the capacity of the quilt to be an immanent representation of the prototypical person as simultaneously an apical ancestor and a living person, rests within the materials of the artefact as well as the symbolic modes of representation. Each coverlet, and indeed each index more widely, is a 'dramatized metaphor' as a 'dancing text, dazzling, concealing, revealing' (Wagner 1986, 11), even like the water of Gularri described by Deger.

Taking this in light of the argument presented in Chapter 2 – where we highlighted the complex interconnectedness of the wood of various trees, the *gwed* flowers, the villages, gendered roles, and seasonal cycle of gardening all as participants within the boat as index – we can now see more clearly how the immanence of the prototype works with the affordances of the material as well as the connotative affordances made ready through the forms of simple representation. Thus, the nature of affordances, following James Gibson (1979), is both the pre-discursive reality of the material and the particular social contexts of symbolic attribution. This wedding of the factual aspect of the material real and the conventional aspect of the ascribed representation is the place Wagner identifies as the cultural dialectic. It is, however, at this point, that Wagner's move to calling these 'symbols that stand for themselves' (Wagner 1986) can be seen as incomplete, because, ultimately, they are not symbols. They are objects of immanent presentation.

Summary

In this culminating chapter of Part I, we see that the capacity of the index is much more real and urgent than 'simple' representation, as the materials and motifs of the artifice work as the basis for the showing forth of the prototype as immanent in the object. It is because of this capacity to hold the prototype immanent within itself that the object is inherently relational – related first to the prototype and consequently to its own future becoming. Deger's work draws out the Yolngu understanding of the inherent relation between apparently unrelated artefacts and aesthetic practices, which brings to the fore an anthropological understanding of relation that many anthropologists working with the theoretical framework of a subject/object substitution fail to grasp.

If, however, we accept each object as a totality – following Einstein – and resist the temptation to categorise it within a hierarchy of types, then the object is, at once, both completely sufficient for the apprehension of the prototypical relations it presents and, via double description, an avenue to the entire extended network of related concepts, objects, and persons. Furthermore, as we discuss in more detail in Chapter 9, the constitutive role the material has within the prototypicality of

82 Rethinking the frame

the object means that the modelling capacity of the object is non-arbitrary. Rather it is produced in the pre-social material discourse between the mind as resident in bodies and the affordances of mind offered by the surface of the objects. It is this cooperation between mind in body and mind in object – and the isomorphy produced between the two kinds of media – that fosters 'confident seeing' (Deger 2006) and 'paradigm certainty' (Wagner 1986) allowing culture to be invented.

This relational immanence of the prototype has radical theoretical and methodological implications for anthropology and related social sciences. The impact of this paradigm shift is far reaching as it forces anthropology to return to the mathematical and geometric properties of the object that allow for the contemplation of the aesthetics of relation. This instinct is present as a germinating idea within *Art and Agency*, most explicitly apparent in Gell's chapter on style and culture (1998, ch. 8), but also present in his work on gardens and magic (1992b) and traps (1996). Building on this theoretical revelation, the next section – Part II of the volume – unpacks the methodological implications of this perspective. This next chapter revisits, with new insight, the idea of virtuosity and style.

PART II

Following the prototype

5

VIRTUOSITY AND STYLE

In the previous four chapters, the nature of the object has been reassessed to shift the frame away from 'simple' representation and, instead, to open up new avenues of thought around the object or image as the immanent presentation of prototypical minds. This chapter, building on this, works to consider the relationality of the object apart from the semiotic value(s) it may or may not have.

To do so, we must consider the qualities in the object, how these qualities arose, and what the systems of relations allow in terms of creating a niche for each unique presentation. This chapter looks first at the notion of 'virtuosity', and takes this forward, considering the formation of a canon of images. An important study in this regard is the art historian Walter Melion's work on the Dutch engraver and draftsman Hendrick Goltzius, who worked in Harlem between 1575 and 1617 (Melion 1991; Melion and Küchler 1990). Goltzius transformed the way in which images could be remembered, transmitted and discussed as a shared cultural canon, shaping a self-conscious historical construction and regional history of art new to northern Europe at the time. Melion shows that the public reputation won by the engraver whose perfect *handelinghen* (the variations of the technical movement of hand and instrument) of the burin (engraving tool) meant he could reproduce for rapid and mass dissemination in printed form images from contemporary artists, consolidating them in his engravings and canonizing an expanded range of pictorial manners encompassing the graphic works of Italian and Netherlandish schools. Through the medium of reproductive prints, the North could gather and disseminate its own canon and develop an authoritative tradition of pictorial paradigms that, via Goltzius's engravings, began to encompass the 15th and 16th centuries. Virtuosity is, in this regard, intimately linked with style and the intuitively recognisable and contemplatable similitude of the object, even in its own uniqueness.

86 Following the prototype

It is important to stress, however, that this similitude of the object, shared by images within a canon, are spread across genres of artefacts, not confined to a given category within a taxonomy of local material culture. As was highlighted in the Introduction, part of our concern is to break away from the methodological orthodoxy of categorisation. It has been argued by Karel Arnaut (2001) that in *Art and Agency* Gell (1998) is following in the line of thought from Konrad Theodor Preuss and Marcel Mauss concerning the 'gradual' development of the classificatory categories of art type – and thereby Gell's focus on visual art (15) as 'the context of theoretical perfection' (Arnaut 2001, 198). However, it is our contention that this is not the case. The development of Gell's (1998) theory across his published work shows commitment to his assertion in the opening page of *Art and Agency* that an anthropological theory of art, to be anthropological, must work for all art. And, just as he rejects the classificatory distinction between 'our own art' and that 'of those cultures who happened, once upon a time, to fall under the sway of colonialism' (1), so too his rapid movement between paintings, political acts of destruction, *'nkisi* fetishes, and land mines should dispel any illusion that Gell is interested in reifying classificatory genre. Rather, he is interested in *oeuvre* (Gell 1998, 232ff, 2013) and the stylistic and motivic aspects of indexes held together around an 'axis of coherence' by the 'principle of least difference' (Gell 1998, 218; Küchler 2013).

It is in this sense that we use the word canon: to refer to this set of immediately recognisable images that measure (or 'rule') the aligned set. A more established approach to a 'canon' sees it as a set of rules ordering iconic ideas 'decided by a dominant group or society as a whole' (Kaeppler, Kaufmann, and Newton 1997, 309). In this approach, canon is 'the conceptual model and the codification of the content' (278), and while we agree with the importance of the canon as it is related to abstract conceptual modelling, there are two important points of differentiation. The first is that 'canon' for Kaeppler and her colleagues is a set of artefacts realised via transmission, either mnemonic or artefactual, which creates and reaffirms the canon. Whereas for Gell – and us following Gell – the canon is an abstracted prototype that comes to articulate itself into the objects that cohere within a system. We take the word canon to refer to a set of abstract conceptualisations, or images of logical possibilities of relation (see below on the avian model, following Losche, or the triangle as discussed by Hauser-Schäublin), held in the mind.[1] The second point of difference follows from this in that the temporality of the canon is not representational of social importance, but rather forecasts and shapes the ongoing genesis of social forms and forms of art. And, it is our argument laid out in this chapter, that it is the virtuosity of the artists and objects, alike, that ensure the coherence of the canonical style. As such, after examining virtuosity, the chapter turns to unpack some of the importance of 'style', before exploring an extended case study of style and coherence across media and genres in the Abelam context.

1 In this way, the canon can also be thought of as a set of what Roy Wagner calls 'tropes' (1975, 1986).

Virtuosity

Franz Boas ([1927] 1955), working in a wide, pan-Pacific rim cross-comparative context, introduces the notion of 'technical virtuosity' as a way to speak to the quality of art-like objects and craft production. 'Virtuosity' is characterised by the 'beauty of form, the evenness of texture' (17) acquired 'through constant practice' (18); such that 'Virtuosity, complete control of technical process . . . means an automatic regularity of movement' (20). The technical, creative artist forms beautiful craft through the methodical and systematic deployment of specific technique. This technical virtuosity, and its basis in the systematic method of the craftsperson, was being developed around the same time as Marcel Mauss's 'techniques of the body'. Mauss, bothered by the narrow simplicity of bio-social models of the day in Anthropology, and the psycho-social models at the time prevalent in psychology, insisted on including the psychological factor alongside the biological and sociological in what he called the 'triple consideration' or 'triple viewpoint', by which 'total man' can be understood (Mauss [1935] 1973, 73). Techniques, for Mauss, are 'effective and traditional', and the body is 'man's first and most natural technical object' (75). This, Mauss argues elsewhere, also suggests that the person and their body is also an art-like object – or, as he says, 'the first plastic art' ([1947] 2007, 75). While, he argues, 'Not all techniques are arts, . . . plastic arts are all techniques' (74). Habitus, then, is characterised by a capacity for technical action in the cooperation of the biological, sociological, and psychological aspects of the human being. In this manner, if virtuosity is 'complete control of technical process' ([1935] 1973, 20), and habitus is the technical action of the body as first object, then we might see virtuosity to be a quality of the body techniques of persons, or artists, in completing their craft. As we saw in Chapter 3, long before the Moroccan weavers begin making carpets, their bodies are 'impregnated' (Naji 2009; see also Lechtman and Merrill 1977 and Dietler and Herbich 1998) with the model. Thus, the virtuosity of the master weaver is transferred into the novice, even as the same is materialised in the woven rug.

However, while Mauss is interested in the place of the body as instrument of person in society ([1935] 1973) and the gradual development of types of art ([1947] 2007; Arnaut 2001), Boas is interested in the implications of artistic practice for understanding the bio-psycho-social phenomenon of mankind. Much of his attention on art is given to the specific issues of decorative versus symbolic operation; however, this is a critical aspect of Boas's anthropology because of what it allows us to know about the mental and social aspects of humans. In this light, it becomes particularly noteworthy that, for Boas, virtuosity is not something that rests in the person alone. Rather, virtuosity becomes a quality of the object ([1927] 1955, 21), and artefacts lacking this 'regularity of form and surface pattern' are deemed by Boas to be 'meagre' and 'lacking in skill' (22). Boas's attention to the systematic deployment of specific techniques as skilled creation opens the anthropology of art, and the wider science of the image, to the importance of including the particle elements within a wider corpus. This is across genres, and in his writing

88 Following the prototype

on various topics one can see this arise in the medium of art, craft, language, and the human body. Throughout all of this, he is concerned with understanding the nature of composition and its constraints.

The scalar relationship between particle element and wider corpus is important both within one piece, as particle segments build off each other to compose the whole, and between the various particle artefacts within a cultural frame. Of particular importance here is the aspect of virtuosity that included, for Boas, the mastery of materials. When speaking of basketry among First Nations Peoples, he says:

> Virtuosity, complete control of technical processes, however, means an automatic regularity of movement. The basketmaker who manufactures a coiled basket, handles the fibres composing the coil is such a way that the greatest evenness of coil diameter results. In making her stitches and automatic control of the left hand that lays down the coil, and of the right that pulls the binding stitches over the coil brings it about that the distances between the stitches and the strength of pull are absolutely even so that the surface will be smooth and evenly rounded and that the stiches show a perfectly regular pattern, – in the same way as an experienced seamstress will make her stitches at regular intervals and with even pull, so they lie like beads on a string. The same observation may be made in twined basketry. In the handiwork of an expert the pull of the woof string will be so even that there is no distortion of the warp string and the twisted woof will lie in regularly arranged loops. Any lack of automatic control will bring about irregularities of surface pattern.
>
> (Boas [1927] 1955, 20)

Virtuosity, then, as a quality that can be apprehended and assessed, arises in an object when the artist is able to manipulate the materials in specific ways, capitalising on specific desirable qualities inherent in the raw material. In this light, virtuosity is not only autonomy of technical action, but also a visual and tactile quality of surfaces made such by capitalising on specific qualities of the material.

Taking this a step further, we can also see that if the virtuosity of the craftsperson is made visible and tactile in the surface of the object, such that the technical action of the body comes to be the aesthetic patternation of the object, we can also speak of the object as a receptacle of habitus. As with the 'first' object, so with the subsequent ones. It is in tracing the impact of virtuosity in objects that we see Gell's notion of enchantment or captivation coming to the fore. Captivation he defines as 'the demoralization produced by the spectacle of unimaginable virtuosity' (1998, 71). Of the Trobriand *kula* canoe prowboards, Gell says:

> The raw material of the work (wood) can be inferred from the finished product, and the basic technical steps – carving and painting; but not the critical path of specific technical processes along the way which actually effect the transformation from raw material to finished product.
>
> (71–72)

While the material is evident, the technical expertise is demonstrated yet impenetrable, producing captivation. In being captivated, the viewer is intuitively recognising something present and accountable in the object, yet abstracted from view. In this manner, made objects, like poetry – which themselves are objects of speech – allow us to have access to something understandable well beyond the elemental aspects of the form itself. This cannot be easily put into words, but is intersubjectively – and therefore, in its essence, a relationally efficacious phenomenon – experienced between the object and the person. In fact, one object is sufficient to show forth a whole world of style, and makes recognisable other objects (and indeed other graphic gestures) that share the same axis of coherence.

The problem that this poses for us is the relation of 'man' to the artefactual object. If the object is impenetrable, yet intuitively understandable and coherent, the question is what is informing this order. While the majority of scholastic humanities place 'man' as the centre of and arbiters of this order, this is a misalignment. Following in the lineage of Boas and Lévi-Strauss, the French philosopher and anthropologist Patrice Maniglier makes this point in his essay on Michel Foucault's *The Order of Things*. Maniglier argues that we have lost sight of Foucault's provocative idea that a representation may be thought of as 'something which is first of all *in itself* and then only *secondarily about something else*' (Maniglier 2013, 107, emphasis in original). Maniglier challenges us to take seriously the possibility that objects are thinkable and comparable on account of what they are, not in terms of what they represent as an organized system of relations that can be traced forwards and backwards in time. In this way, Maniglier's project (see also 2006) is not unlike that of Warburg as discussed by Didi-Huberman in the *Survival of the Image* (2017; see Introduction and below). The science of the image or object must be principally an investigation of the artefact and its relations, internal and external, not an investigation of the categories and epistemologies of 'man'.

In thinking about the relation between 'man' and the object, it is important to keep in mind what was outlined in Chapter 3 about Bateson's idea (1972, following Huxley) of 'grace' as a simple naïveté that man has lost, but is retained by God and the animals (128). In discussing grace, and the role of 'art' (broadly conceived) in the human quest for grace, Bateson, like Foucault, makes a distinction between 'the code' by which objects are formed and 'the message' (i.e. representation) they may point towards. He is interested in 'the code', or the 'rules of transformation'. To use these rules to 'translate the art object into mythology' for analysis would, he suggests, only be a neat trick to dodge the question of art. So, rather than looking for the meaning in the message, he advocates examining the 'meaning of the code chosen', and (somewhat controversially) defines 'meaning' here as 'an approximate synonym of pattern, redundancy, information, and "restraint", within a paradigm' (130). His use of 'meaning' in this way can be explained in light of the period in which he was writing, in dialogue with linguistics and digital coding; however, this aspect of his thought diverts attention away from the more important and lasting contribution around the capacity to intuitively and spontaneously grasp the constancy and variation within a code. This idea of pattern of the code, or what he

90 Following the prototype

implies is synonymous with 'style', is the means of maintaining memory concretised in the object, and thereby removed from culture – that is, it is made unsusceptible to the vagaries of social context.

The critical aspect is the affordance of style to be contemplated and give rise to new thoughts and actions. In how style works within a social context, Bateson and Mead (1942) demonstrate how 'character', in their case working in Bali, is manifest in the style of body technique, in both ritual and mundane contests, as well as artistic production. The similitude of style across genres and behaviour is immediately recognisable and produces the motivic whole of what Balinese character is as a coherent system. This idea of systemic coherence via style is a key element of Gell's explanation of how motivic elements are transposed within the artistic production within a set.

In his discussion of Marquesan sculpture and tattooing, Gell highlights the four basic modes of motivic production. Referencing the work of Dorothy Washburn and Donald Crowe (1988), he outlines four means of transposing a basic motivic element to produce a new variation or the illusion of motion (Gell 1998, 78ff). These are reflection, translation, rotation, and glide reflection. Taken at this level, it is evident that stylistic production is a highly rational and sequential practice, informed by logic of sequence and organisation, rather than classification. With this understanding of style, and the gestures of information, it is possible to move away from the idea of the object as representational and see the informational gesture as itself productive of relation, and ideas thereof.

Technique

In this proposed emphasis on technique and the importance of the informational gesture, one avenue of investigation is to focus on the process of making, following the Maussian tradition on 'technique'. Scholars such as Trevor Marchand and Tim Ingold focus on understanding the ways of life from within, 'by acquiring for ourselves some of the knowledge and skills required to practice them' (Ingold 2013, 2). For his part, Trevor Marchand (2009, 2010, 2012) outlines a theory of 'shared production', drawing on his work with craftspeople in Djenné, Mali, and in Yemen. He argues that knowledge is 'made' in the interaction between interlocutors and practitioners in what he calls a 'total environment'. The subjects in his early study are the master builders of mosques in Djenné, whose fantastical roofscapes and colossal towers make them into an architectural wonder. The towers that loom high above the roofscapes of the towns and villages are built without relying on plans and yet have structural and aesthetic features that are easily recognized across the region. It is thus that Marchand devoted his research to the question of the nature of training, securing the consistency of aesthetic and structural features across all the mosques in Djenné and the progression of young men into the trade so as to secure the ongoing stylistic features of the buildings.

Marchand's (2010) chosen method is one of apprenticeship, and this enabled him to gain insight into the role of the context and the wider environment in the

Virtuosity and style **91**

training of young men, impacting on the 'thoughts we think and the actions we produce' (S2). That which enters the process of making knowledge is seemingly infinite, from the tools used to the ground walked on and to the winds that blow as one journeys (S3). In his work on the Djenné mosque building, Marchand is more specific. There is, for example the material used for construction – mud, and its properties that make it vulnerable to erosion (Marchand 2009, 123). To counteract the material failure, 'creative experimentation' by master builders has led to a number of popular solutions, including a specific quantity of straw, dry rice husks, and cow manure mixed in with the mud to give it longevity and structural permanence. The inclusion of the organic matter is visible to all and thus recognizable after the fact as the colour of the adulated mud changes over time from a shade of ochre to dark grey.

The planning of structural features, such as the rooftop miters, equally draws on inter-subjectively held knowledge that calibrates and integrates an understanding of the environment drawn from daily and mundane interaction. Critical to the aesthetics of the rooftop is its proportion with the rest of the building, a fact that makes the advanced planning of every element critical to a harmonious and well-integrated composition (125). Marchand describes how two masons worked out the correct measurements in the absence of drawings, by using onsite tools and materials. 'Tonton', Marchand narrates:

> marked the total 4.60 meter width of the vestibule onto the concrete foundation with chalk, and Konamadou cut forty-centimeter length from a stick. Forty centimeters was the length of a standard . . . brick, and the stick therefore corresponded to the base of an average . . . miter that was one brick wide. They began by randomly choosing a spacing of twenty-five centimeters to separate each miter, and then proceeded to test this by alternating the cut stick with twenty-five-centimeter gaps, starting at one end and moving along the chalk line. This combination fell short of filling the total length, so they executed more trials, incrementally increasing and decreasing the spacing each time until they got it just right.
>
> (125)

Marchand concludes that while he himself arrived at the exact same spacing of eight evenly separated intervals of 20 centimetres to fill 4.60 meters in length using a mathematical formula, the masons had arrived at it through trial and error using their body as method. However, 'trial and error' can be further unpacked as the proportion can just as easily be understood in terms of the different approaches to understanding abstract geometric modelling. While Marchand's method renders the geometric question an algebraic one, the masons' method uses their body – as Mauss's 'first plastic art' – to embody the geometry.

The question of how learning, knowing, and practice concur and take shape – allowing us to understand not *what* humans know but *how* they know – has become the mantra of a cross-disciplinary concern with making. The theoreticians of making

92 Following the prototype

hone in on the constraints that impinge on the 'texturing', resulting in forms, as Tim Ingold (2010) has it, that are never complete. As craft, rather than 'art', objects are forever grounded in the humdrum of the everyday, constrained by the ecology and rawness of the environment and the inter-subjectivity of social life (Ingold 2012; Adamson 2007, 2013). The 'return to alchemy', in Ingold's (2013) words, is a method of getting close to 'a lifetime of intimate gestural and sensory engagement in a particular craft or trade' that allows material properties to be understood in terms of their material effects (28–29). Distinguishing 'form receiving passivity' from 'form taking activity' (28), Ingold imagines knowledge as an excess that flows from the interplay of the index, the intertextuality of the environment and the material conditions of making, and the texturing of form. This, he argues, is knowable as traces that 'remain in them [objects] after life has moved on' (28).

The relation between the temporality of the process of making and the 'texturing' of form is explicated in the work of Laurence Douny (2014) on the millet grain storage houses of the Dogon (Mali). Douny's ethnography shows that the temporality of the process of making impacts form in two ways. First, in terms of planning, the building process is timed to meet the needs of the impending harvest. Building, as is true in many places, is a seasonal activity. Second, in terms of construction, Douny (2014) emphasizes the 'rhythmic movement of bodies making the granary' (143), resulting in a metred practice. A rhythm of 'breath, heartbeats and exhaustion alleviated by songs' (143) enables the builder to shape' the building and leaves motivic traces on its surface (158), as the gestural composition of the granaries is done in harmony between members of a building team. Douny argues that the extraction, processing, and transformation of materials into matter through shared bodily rhythms are 'practical means to maximise and control resources' (44). The use of coordinated bodily rhythm thus extends beyond construction to other activities, such the pounding of the millet:

> I determined that it requires between forty-five minutes and one hour to pound 3 kg of millet. While the pounding is generally done by two or a maximum of three women, individual body rhythm responds to the other(s) by mimicking the gestures, in the case of an apprentice, but overall by listening to each other's sounds. Girls rapidly learn to pound millet from the age of six and may be able to pound like an adult from the age of 10. Hence, women spontaneously create a particular choreography and soundtrack for cooking, the daily rhythm of which is felt by the child that a woman may carry on her back, lulling it to sleep.
>
> (186)

This ability to spontaneously create a particular choreography touches on the 'materiality of practice', which, as Naji and Douny (2009, 413) note, is absent in Ingold's attention to perception and habitus. The British Social Anthropological approach to the process of making emphasises a 'progressive and continual adjustment of practitioners' perception and body movements in relation to their

environment' (413); this assumes that the social and physical environment in which movement takes place is the primary constraining factor, both in terms of the formation of the self and the production of objects. The French tradition, exemplified by Douny and Naji's work, pays attention to time and duration as shaping the materiality of practice – and thus the form of the object – and has produced certain research methodologies, such as the *Chaîne Opératoire*, which allow for the temporality of the process and its form-giving properties to be made visible and accessible to analysis.

A *Chaîne Opératoire* pays

> particular attention to the way things are made and physically used; that is, by documenting and analysing 'operational sequences' (*chaînes opératoires*) and their variations in space and time in an attempt to explain how particular aspects of a technical system are linked to some local characteristics of social organisation, ritual life, or systems of thought.
>
> (Lemonnier 2012, 16[2])

In this way, it aims to discover correspondences between various genres of social forms and material transformations, visible in object form. Conducting ethnographic work among the Ankave in mainland New Guinea, Pierre Lemonnier (2012) examines the similarities of temporal operation between underpinning different objects within one culture group, from fences to eel traps to drums. This comparison, both within and between cultural groups, Lemonnier summarises,

> reveals the peculiarities of their makers' and users' social organisation, ritual life, system of thought, etc., that are intimately linked with the shift of category we observe [that is, from one category of object to another], and which is often acknowledge in their own way by the people of whose material culture these things are a part. It is equally possible to understand why such pseudo-ordinary objects evoke what they refer to in the *material* way they do it.
>
> (15, emphasis in original)

For Lemonnier, as for Gell (1996), the trap epitomises what is at stake in this 'material way' objects work. The eel trap is carefully crafted in a series of stages producing a conical tube with a spring-loaded trap door and tree frogs are gathered as bait. In setting the trap, a cowry shell is placed in the tube, such that there is a payment exchange for the eel. Its various qualities, including the shape, ingredients, and elements of decoration, mimic the form and behaviour of the eel. As Gell (1996) argues in his work on traps, the form of the eel trap abducts the attention of the eel and places the eel and the trap in relation to the hunter's intention. What

2 For the genealogy of thought and interdisciplinary interpretation behind Lemonnier and Coupaye's work, see Coupaye (2013, 2021).

94 Following the prototype

arises is a triangular relation between the hunter as artist, the trap as index, and the prey as recipient. The temporality of the trap is most explicit in the spring mechanism – the most technologically sophisticated formal element of the trap – and it is in the spring mechanism that we find the material concretisation of the relationship between the hunter and the prey. Lemonnier's insights that it is the spring mechanism, which is critical to a contemplation of the relations of the trap, allows us to see that it is not just in the process of making that we find virtuosity actively giving shape to the prototype, but also in the shaping of the operational properties of the object and the associative environment its operative capability creates. The temporality of the trap now appears in a different guise as it is productive of a prodigious variety of self-similar and yet different traps, recognised and contemplated by attending to the technical properties of the trap's spring mechanism. For the hunter, the variations in traps form the subtext to an understanding of the nature and the norms of relations that come into play in hunting, intuitively and inter-subjectively recognized as part of a canonical style.

Another classic ethnographic case study that has utilized the methodological approach of the *chaîne opératoire* to expose the prototypical ideas underpinning a canon of images has centred on yam cultivation amongst the Abelam people in the Maprik area of the East Sepik Province, Papua New Guinea. Ludovic Coupaye (2009a, 2009b, 2013, 2017) shows in his ethnography of yam cultivation and social ontology a similar phenomenon in the *tëkët* of the yam mound, whose geometric shape is critical to the technical challenge of producing long yams for competitive display. The *tëkët,* which is a vertical structure that helps support the earthen mound in which the yam is cultivated, and thereby enabling it to grow to unusual lengths, finds a homologous expression in the architectural design of the gabled ceremonial house. While it is an architectonic necessity for the yam mound, it is a ornamentation in the house. In fact, Coupaye shows how the geometry of the *tëkët* is the constitutive of the long yam, which is, he argues, a manifestation of Abelam sociology. He goes further, arguing that this underlying sociology shapes the ordering of images found on its gabled front and its interior as well as on the yams decorated for display. These images, however, are not symbolic; rather, they are a canonical set of transformational and generative compositions whose geometry makes immanent the paradigm of relationality for the contemplation of those who pass by.

Style and self-referentiality

Anthony Forge (1973) had recognized that Abelam[3] art, famous in the greater Sepik River region in Papua New Guinea in which art style is commensurate with a

3 It is worth noting, as Nancy Lutkehaus (1990) argues, that Sepik art is not commensurate with the Sepik River region, as it is also practiced among its many tributaries and upland populations. However, for simplicity's sake, we follow Forge's designation in calling it the art of the Sepik region. For the larger debate on this, see Clark and Thomas (2017), Hauser-Schäublin (1996), Hauser-Schäublin and Stephenson (2016), Lipset and Roscoe (2011), Lutkehaus (1990), Moutu (2013), and Tuzin (1980, 1997).

Virtuosity and style **95**

FIGURE 5.1 Line drawing comparing the architectonic similitude between the Sepik initiation house and the yam trellis, after 'Figure 16. Seitenriß des korambo der nordwestlichen Abelam, Wewungge, Kuminimbis' in *Kulthäuser in Nordneuguinea* by Brigitta Hauser-Schäublin (1989a, 92) and field sketches provided to us by Ludovic Coupaye.

96 Following the prototype

regional system of exchange, is a self-referential system capturing not 'a representation *of* something in the natural or spirit world, but rather [is] *about* the relationship between things' (189, emphasis in original).

The Abelam village is dominated by the impressive, high gabled structure of a house that is the focal point of men's ritual activities. It is this house and its contents, from paintings to sculptures to masks and the decorated long yams displayed in the clearing in front of it, that is both testimony of and agent within the competitive exchanges that traverse the region defined by the undulating passage of the Sepik River. The artefacts of the various groups who live along the river and its many tributaries have a great diversity of stylistic features that are in fact shared by all groups. Any attempt to discern consistent combinations of design elements, however, is quickly defeated as the relatively small number of distinct graphic elements are combined in a myriad of ways so that not one artefact is the same as the other, while being made from the same set of elements. Sepik River iconography has, as Forge argued, an essentially ambiguous iconography in which graphic elements are not illustrative, but relational and open-endedly transformative in their combinatorial capability. The question of what kind of idea of relation it is that motivates the shaping of difference over the asserting of similarity, and what this may have to do, in turn, with the attention to growth in anything from yams, to houses, and to villages and their inhabitants has puzzled generations of scholars following in the footsteps of Anthony Forge.

Forge's idea that the composition of graphic elements follows rules that are independent of culture, while fashioning relations that come to form sociability in the course of their exposition and contemplation continued to inform the work of anthropologists working in the region – most notably the Swiss anthropologist Brigitta Hauser-Schäublin (1989a, 1989b, 1994).[4] Her (sadly un-translated) early work on *Leben in Linie, Muster un Farbe* (1989a) makes the observation that the emphasis on the line and its geometric potential traverses different media, from the ceremonial house front paintings, headdresses, palm leaf paintings and carvings through to looped net-bags and pottery. Straight lines become triangles and triangles become figures and enchained patterns of other geometric shapes; curved lines created by the interstitial spaces between and within triangles or within a circular assemblage of triangles become circles or ovals that take more or less representative forms in certain areas (heart or drop forms), while staying abstract in others, metamorphosing into spirals that obliquely appear as forms demanding recognition as leaves or birds. Ovals in fact are geometrically found within the triangle's long base when looking at it as a three-dimensional shape. The triangle, according to Hauser-Schäublin (1994), is thus a prototypical idea informing the shape of relations, mediating dualism and opposition, and generating images that are the springboard for associations extended outward. By means of the triangle, 'fundamental values

4 It is worth noting that Forge and Hauser-Schäublin were also heavily influential in the development of Gell's ideas on style in the Marquesan art (Gell 1998, ch. 8).

associated with gender, men and women, skull and vulva, killing/death/the creation of ancestors and women's sexuality, and women as in-marrying wives, as well as the generation of life, become expressed simultaneously' (133).

A notable contribution to Gell's interest in the nature of virtuosity and its implication for an understanding of how objects work and what they do (manifesting prototypical ideas and shaping canons of recognizable forms) has been the insightful work of the anthropologist Diane Losche (1995) on the Abelam house, which offers yet another explanation for the unfolding of the prototype. In her account, virtuosity takes on an even more abstract and ideational character, one that is manifesting an idea of translation reaching beyond the graphic system exposed in earlier analyses. Losche realized that the idea underpinning the relation between the forms given to objects and their capacity to morph into each other to create new ones is derived not from the social order itself, but is an analogous one found among birds that inhabit the densely forested landscape traversed by the Sepik.

Social imagination in the Sepik River region is concerned with finding a solution to the question of how to secure the regeneration of life, and birds inhabiting the threshold between the visible world of the living and the invisible world of ancestors are the model of choice for an explication of how this is to be achieved. It is an avian taxonomy, explains Diane Losche in her path-breaking essay titled 'The Sepik Gaze' (1995), whose order of similitude and difference is recounted in myth as the model for social order that secures life entirely through artificial means. Avian taxonomy explains, says Losche, the constrained nature of Sepik River social life that sees young men go through more than 38 initiation stages prior to reaching adulthood, severed them from their mothers at a young age and raised in the object-dominated world of men, and sees men and women inhabiting entirely different domains of life. Birds that generate life by externalising, in the laying of eggs, the hidden and invisible processes leading to differentiation, become the model for how social differentiation is brought about. The production of the art object is necessary for bringing about the social differentiation of each person as element of society. Art is not about differentiation, it *is* differentiation. Objects are not an anthropocentric domain, but an anthropogenic technology.

The metaphysical question of the nature of relation for the Abelam, and the inhabitants of the region more widely, is thus shown to be encapsulated in the virtuosity of the avian model[5] and thus in the assembled canon of difference and similarity. It is this virtuosity of the avian model that forces the question of 'how men can become like women who can be bird like' (Losche 1995, 50). Any artefact showing forth a combination of forms thus essentially serves as an index of a process or movement of transformation capable of producing difference, rather than representing a static image. Forms that unfurl or open out to display objects 'which the referent gives forth' (53) are associated with generativity and the capability to

5 It is worth noting that among residents of the region closer to the river, it is the crocodile that holds the importance as a model for wider social relations; see, for example Herle and Moutu (2004).

98 Following the prototype

effect differentiation without requiring similitude. The fern frond, the leg of pork, and the swirl of water may be different things, but from the point of view of this model, they all have the same function of generativity. Shapes such as the spiral design or circles serve as a trope associated with the capacity to reveal a multiplicity on the inside of a singular object or relationship, allowing for 'generativity to occur, states of being to be transformed and difference to be produced' (53).

Seemingly deeply entrenched in a highly involute and culturally specific model of life-giving processes and their activation via the cultural production of objects, Diane Losche's account of Sepik River epistemology could lead one to conclude that the esoteric nature of this model would defy comparative analysis and thus analytical veracity. However, in light of Maniglier's (2013) observations, it is necessary to emphasise the source of the generativity in the object that enabled a self-conscious and strategic intervention, shaping the course of events. During the period of German colonial presence in the Sepik River area, the Germans, intent on setting up a thriving plantation business, were captivated by the endless proliferation of decorative artefacts they acquired in great numbers by paying Sepik locals for any art produced (Buschmann 2009; O'Hanlon and Welsch 2000; Schindlebeck 2001). The lucrative nature of art production in turn prevented inhabitants of the Sepik from working on the plantations, leading to the demise of Germany's colonial plans in the area (Schindlebeck 2001). The endless possibility of yet more original pieces, all instantly identifiable and yet unique, speaks to the logic of the object as arising from the broad variety of bird species and their technical (both biological and mythological) properties – similar in type yet diverse in specificity. While Losche's explanation of generativity in the avian model goes a long way to explaining Abelam flat art, there are hints in her work – such as the excessive waste of extra yams – that generativity, while modelled on avian sociality, is also informed by other models.

Across Sepik ethnography, yam growth and exchange is a dominant paradigm of social life (Lutkehaus 1990). Gardens, spaced around the hamlet, are worked by brother–sister partnerships. The harvest, however, is taken by the woman and she distributes it to her male affinal kin. In the small yams, the point is a numbers game, where a large harvest ensures the capacity to trade out, and thus maintain key alliances, and also helps the village growth – good both for productivity in the long term and safety. It is an ideal situation, in fact, to have more yams than can be eaten, and a pile of rotting yams indicates surplus and generative capacity (Losche 1995). Alongside this cultivation of yams for consumption, there are high levels of attention given to the production of long yams – that is, yams, the scale of which is based on the size of the individual, not the quantity of the harvest. Coupaye's work on the Abelams' understanding that the growing of long yams is tantamount to the making of artworks par excellence presents us with an intriguing perspective on this logic of generativity, which involves not just multiplication but scale. No other artefact manifests the idea of inherent multiplicity and scalar transformation more poignantly than the long yams, grown to an astonishing length in deep trenches whose inverted triangular structure is shown by Coupaye (2009b, 2013) to

be covertly related via the *tëkët* to the triangular pitched gable of the men's house. Yams grown in this manner are only ever partially cooked and eaten, while the remainder are used to grow a new long yam, thus exhibiting the capacity to generate multiplicity and differentiation from a single tuber. Displayed and decorated like the men who grew them, what distinguishes them is not their form or shape, but their length as a manifestation of the inner, invisible qualities ascribed to men and yams alike.[6]

The virtuosity of the man who grows the tuber, his technical skill in magic and gardening, comes through into the length – and in some cases the bifurcation or other shapes – of the long yam. This virtuosity is not only indicative of the man as 'artist', but rather is generative of the next year's social exchange between hamlets through partnerships and competitive alliances across the region. Yams, as an articulation of the archetypal image, therefore, move both temporally – through their rhizomatic self-generation – and spatially through display and trade. The futurity of the long yam provokes a question concerning the temporality of the prototype and the process of its forward motion through time.

The way in which images travel temporally and geographically was highlighted in Aby Warburg's Mnemosyne atlas (2000, 2009), which pointed to the fact that images are not so much recalled as they impose themselves on memory via the subtle interplay of gesture, emotion, and expression in the images whose recognition is instantaneous and inter-subjective. Warburg's theory on the pathos formula explains how it is possible that images work in ways that transcend boundaries of time and space while being always of a place and a people. The image, he showed through his meticulous comparative studies, conjures up what is relational about action as it anchors understanding in the 'persistence of certain visible formations' that enable an escape from reality (Becker 2013, 6). Compared to his contemporary, Maurice Halbwachs, whose work on collective remembering was firmly grounded in the tradition of the French Annales School of History and who argued that memory was generated through interaction in social contexts, for Warburg recollection is intimately bound to contemplation of emotionally charged, commonly held canonical forms (Assmann 1995; Halbwachs [1941] 1992). The contemplation afforded by images that transcend culture is based on their grounding in rational thought and logic. The idea that the work done by images cannot be explained by their embeddedness in history and culture, but by subject matter that is capable of inciting a contemplative disposition, has enabled Warburg to occupy a leading position in a theoretically charged history and anthropology of art (Didi-Huberman 2017).

In light of Warburg's contribution, it becomes evident that the graphic gesture (of any kind, be it linguistic, plastic, or otherwise) accomplishes its work via the relational nature of action and the implicit direction of gesture. Warburg explicates

6 As a further hypothetical exploration, it could be productive to drive forward Losche's insight on the paradigm of differentiation encapsulated in the avian model in relation to the geometry of the *tëkët* as highlighted by Coupaye and the generativity of the triangle as argued by Hauser-Schäublin.

100 Following the prototype

his notion of the pathos formula with the image of Germania that carries with it the sense of 'them' and 'us' that imposes itself on all subsequent moments of crisis management. In the Abelam context, the image of the yam as rhizomatic and complimented by an avian model, itself also offering an indigenous biological understanding of self generation, becomes, as Coupaye (2013) observes, an indigenous sociology; the yam itself is a theory of socialisation and relation that is self-perpetuating and self-constraining. As he summarises, 'Abelam iconicity refers directly to the complexity of iconic relations, a complexity which in turn is what is revealed' and given to be seen (267). In this manner, the Abelam image is self-referential, an 'icon', Coupaye says in paraphrasing Wagner (1986), 'that stands for itself' (Coupaye 2013, 266).

Summary

This chapter examined the issue of virtuosity as a way to provoke further questions about immanence and the nature of what is intuitively grasped when presented with an object. The issue of style, as poetics of rhythm, technically achieved through any manner of making, whether via gestures of speech or action, comes to be seen as an arena of data from which one can investigate the larger questions of society and history. The elements of rhythm, as seen in the construction of mosques in Marchand's work, and the processing of millet, as discussed by Douny, build across a system and produce the visual surface and form of style. This visual and architectonic element, as discussed through the extended case study of Abelam plastic arts, shows forth the importance of the geometric modelling produced first in the body, and then in various genres of art. In each case, across genres and media, the consistent harmonising of virtuosity between the body, society, and objectival forms, renders the prototype as immanent and apprehensible. This discussion showed the influences, both ethnographic and theoretical, on Gell's thinking about style as separate to culture.

Reading Gell's insights concerning style in light of the emphasis in Forge and Hauser-Schäublin on the independence of the rules governing the composition of graphic elements, and in light of Mauss's and Boas's respective alignment between the biological, the psychological, and the social, helps unpack further the importance of the virtuosity of technical and motivic action, across media, and residing in the material of the body and object. In framing the phenomenon of mankind as bio-psycho-social, the analytical necessity of adding the material is imperative, lest we inadvertently deny what Alfred Irving Hallowell calls 'the object orientation' of humans (1955; see also Bredekamp 2008 on Leibniz's theory of mind). The object, or image, is a necessary dialogical extension of the human mind as an empty thing, existing only in its relation.

Methodologically, from an art-historical point of view, it is precisely the need for objects that is behind Didi-Huberman's survival of the image. While Warburg pinpoints this as relating to the pathos of the image, it becomes a necessity for anthropologists to unpack what the pathos is, and, in keeping the object at the forefront of investigation, how the pathos is in the object.

As the first chapter in Part II, which follows the theoretical and methodological implications of the prototype, unpacking the concept of virtuosity allows us to clarify the interconnectedness of material, craftsperson, and society in a way that forefronts the importance of the object as a model of and catalyst for social production. This interconnectedness of style and behaviour also drives forward the entangled issues of aesthetics and ethics, as discussed in the next chapter.

6

AESTHETICS AND THE ETHICS OF RELATION

Style and virtuosity – and the poetics of rhythm that result from them – are often fitted within the larger analytical structure of aesthetics. Aesthetics, maybe more than most terms, is readily open to radically different interpretations, but it is always linked at least loosely to the sensible world and the apprehension, judgement, and valuation via those senses. This chapter begins with a brief outline of some of the key thinkers on aesthetics, specifically as it progresses towards the issue of 'indigenous aesthetics' and the critique of aesthetics as a valid cross-cultural paradigm. The purpose here is not to give a history of ideas, but to highlight some of the key problems that feed into the ongoing theorisation about relations within and to art-like objects. In investigating the role of judgement and sense in aesthetics, and the structural parallelism that appears between the ethical boundedness of social practice and the aesthetic bounded material practice, the chapter also addresses the possibility of danger in the art object as action.

The science of sensible cognition

Aesthetics, as 'the science of sensible cognition', was offered by Alexander Gottlieb Baumgarten in the mid-18th century as a way to address the role of the senses – as opposed to rational cognition – in judgement or taste. Taking the term from the Greek for 'sensitive' or 'relating to sense perception', which had, up to that time, been used primarily to discuss the responsiveness to sensation, Baumgarten gives it an analytical weight that it had not had before. As a faculty of human cognition, 'the purpose of aesthetics is the perfection of sensible cognition, that is beauty; the imperfect is avoided, however, as it is deformity' (Baumgarten [1750] 1983, 10, authors' translation).

In a context that linked the high virtues of Truth and Goodness to Beauty, there are implications of moral superiority in beautiful things, and in the 'right' ability

Aesthetics and the ethics of relation 103

to appreciate this beauty. This tradition, including later philosophers like Immanuel Kant and Friedrich Schiller, were thus debating *how*, not *if*, exposure to beauty helped in the moral formation of people – especially children and the lower classes. It is in this context that many of the great collections were established as public institutions. As Kant ([1790] 2007) argued, the aesthetic judgement to see beauty caused pleasure, and was 'purposive without purpose' (see also Carroll 2021).

In the philosophical tradition of aesthetics, its role as a cognitive capacity of judgement always sat subordinate to the 'superior' rational cognition and filled a role as a 'handmaiden' to reason, being an intermediary between the pure insight of a rational mind and the problematic quagmire of the perceived world. In subsequent social science, the various aspects of this philosophical tradition have been emphasised to various degrees: with some following closely in a (post-)Kantian tradition of aesthetics as a subordinate cognitive process of sense perception and judgement; some focusing on aesthetics as relating to the somatic apprehension of the world around them; and some using it as a loose synonym for (especially perceived) 'beauty' or even style.

This narrowly European venture became increasingly problematic, however, as the classic link between moral virtue and external beauty became destabilised, first in the shift to interiority at the turn of the 20th century, and then with the post-modern unseating of European exceptionalism and the acknowledgement of global approaches to perception and cultural valuation. In the work of art historian Robert Farris Thompson (1973), for example, 'the aesthetic' came to mean a 'deeply and complexly motivated, consciously artistic, interweaving of elements serious and pleasurable, of responsibility and of play' (41). Farris Thompson ([1973] 2006) worked with 88 self-described and socially acknowledged Yoruba art 'critics' – that is, people who knew how to distinguish good pieces of Yoruba art. From these experts, he elicited a list of qualities typical of good Yoruba art. While no one piece might have all 18 contributing factors, Farris Thompson was able to demonstrate a given set of criteria in the Yoruba evaluative framework that were indicative of pieces highly valued by the Yoruba. The 18 contributing factors are primarily about ratio and harmony between design elements, and suggestive of culturally valued qualities, such as youth. The aesthetic object is, Farris Thompson (1973) argues, capable of 'aesthetic activation, turning ancient objects of thought into fresh sources of guidance and illumination' (67).

In advocating for an indigenous notion of aesthetics, and outlining the evaluative framework, Farris Thompson pushes back against the dominant functionalist interpretations of (especially 'ethnographic') art. While aesthetics does, for Farris Thompson, have an important role as 'fresh sources' for ongoing social production, this is much more in keeping with the 'purposive without purpose' idea of Kantian aesthetics. The functionalist presupposition that a given art object is 'for' some purpose was, he argues, born out of mutual distrust between the local native and the foreigner – specifically a distrust of the other's capacity to appreciate art. Functionalism, at least in art evaluation, then arises as a ruse to throw off the uninformed and uninformable.

FIGURE 6.1 Yoruba *Gelede* headdress, after Figure 14.7 of Robert Farris Thompson ([1973] 2006, 266).

Taken in this light, the question about how art works and what it 'does' hits on the sticking point of Gell's critique of aesthetics, as formulated in his early article on technology of 'enchantment' (1988, 1992b) and in the work produced later in response to Jeremy Coote (1992; Gell 1995b) and Howard Morphy (1992; Gell 1998). Contrary to the common misreading of *Art and Agency* (see, for example, the contributions in the volume *Beyond Aesthetics* edited by Pinney and Thomas 2001), aesthetics is an essential aspect to the abductive work that holds the nexus together. It is via aesthetics that one is able to contemplate the nature of relation, moving from the object outward along abductive strings of association (cf. Bateson 1979). While Gell overtly rejects aesthetics, he does so not because of what it is as an analytical practice, but because of its intellectual baggage, being mired in the project of European philosophy. The prejudice of thought seen in the aesthetisation of ethnographic art was anathema to Gell's sense of methodological philistinism. His first confrontation with the issue of aesthetics, the essay on technology of enchantment (published 1992b but written in 1985) was provoked by the publication of the catalogue of a paradigm-shifting show at the Museum of Modern Art that documented the influence of 'primitive art' on modernism (Rubin 1984). This show marked the end of the colonial project and the rising independence of the countries of origin. The aesthetisation of ethnographic collections, seen also in the establishment of the Hall of Masters in the Louvre, rapidly became a contested method used for exhibiting indigenous artefacts sterilised from their social, political, and historical contexts of production, use, and acquisition. In avoiding the term aesthetics in *Art and Agency*, he focuses on style and virtuosity as compelling the work of abduction. This is, to our reading, not a denial of aesthetics (in its original sense), but rather

Aesthetics and the ethics of relation **105**

an opening up of the concept, making explicit how it works and is put to work, to avoid the deeply problematic consequences of its reified philosophical form. Following in this reading of Gell's aesthetics, we examine aesthetics as the space of sensible apprehension of the purposive capacity of art as action. In moving away from a Eurocentric notion of aesthetics as the perceptual judgement of beauty, the question must then be framed more in terms of what does the perception of the purposive capacity of an object do in a given social context?

In contrasting the European interpretation of Yolngu art with their own understanding, Howard Morphy (1989) suggests that, 'at a general level what Europeans interpret as an aesthetic effect Yolngu interpret as a manifestation of ancestral power emanating from the ancestral past'. In this way, Morphy positions aesthetics as a partner to function, saying that

> The aesthetic effect may be complementary to some other kind of property of an object or necessary to its fulfilling some other function. For example, an object may be aesthetically pleasing to draw a person's attention to it so that some other function may be fulfilled or message communicated.
>
> (22)

This assistive role to function is not, however, one-dimensional, and Morphy highlights the role of skill in increasing the aesthetic capacity, and thereby ancestral effect, of a painting. Within a clan moiety, any number of individuals may have the right to paint a given motif. However, just as some people may be recognised to have a better singing voice, some are recognised as better painters, and so these skilled individuals take on the role of production. Morphy outlines three stages of aesthetic production: 1) the production of the correct pattern; 2) the production of the correct pattern capable of engendering ancestral power; and 3) the production of the pattern so as to make the decorated object more beautiful. In his understanding of ancestral power and *bir'yun* (as discussed in Chapter 4), it is the filling in of the pattern with the cross-hatched design that moves from stage 1 to stage 2, and if done by a skilled hand, allows for stage 3 of aesthetic production. As such, the function of the ritual may be achieved well before the full aesthetic effect of the emanating ancestral past comes through; there is, in this sense, an excess – and a dangerous excess, too – as the cross-hatching done in traditional ritual settings was never to be looked at directly. *Bir'yun*, or brilliance, as 'a particular visual effect' manifest in the hatch-marked design was smeared out after the ritual to subdue the brilliance and destabilise the likeness to the ancestral, thereby lessening its potency.

In the movement from traditional Aboriginal painting within ritual engagement with the ancestral dreaming to the acrylic paintings about the ancestral dreaming, the function of the art changes, but the purposive capacity of aesthetics still follows the same logic. For example, in Fred Myers's (2002) work with the artist Yanyatjarri, the relationship between periods of creative bursts of productivity and Yanyatjarri's visits to specific sites in the landscape highlight the generative capacity of the land within the artistic productivity. Myers provides, at

106 Following the prototype

great length, the details of the formal arrangement of each painting produced over a two-year period, highlighting the 'circle grid' and rectilinear shapes that are used in multiple variations to provide an ever-growing set of unique paintings, all within a very particular style. Expanding on Jakobson's observations about the 'poetic function' of language, going above and beyond the meaning of a given text, Myers argues for an 'aesthetic function' such that the virtuosic capacity of painters allows for something to be done (Myers uses communicate and render) beyond the representational account of a dream.

Taken in light of Farris Thompson's dismissal of 'function' as the product of mutual distrust and misunderstanding, the introduction of 'aesthetic function' seems to simply push the issue of misinterpretation further up into another level of abstraction. Indeed, this abstraction emerges in the distance between the artist and the intended audience. While the Yoruba objects that Farris Thompson examined are artefacts made for the creating society, the art work of Yanyatjarri and those like him are made for sale and circulation to distant galleries. In the first order, the function of the painting is to bring monetary compensation. However, in opening up the more abstracted level of aesthetic function, Myers is able to demonstrate the social and ritual importance of the paintings that are enacted before – and entirely separate from – the canvas as it hangs in a gallery. Highlighting the specific ways art works in the given context, Myers argues for localised art histories to give attention to the specific confluences and techniques that give rise to the specific art practices in different places. Without this specificity, Myers argues, the evaluative framework of art will be biased against cases that do not fit easily into the European expectations.

The 'work' of aesthetics

It is because of this bias, and the philosophical heritage of 'aesthetics', that Alfred Gell advanced the overt dismissal of aesthetics in his *Art and Agency*. In seeking to establish an anthropology of art firmly grounded in social anthropology, Gell takes issue with aesthetics as a disciplinary practice (i.e. of philosophy) and as an arbitrating practice of value judgement. So, while he had no real issue with aesthetics as such (and, in fact, openly uses it in some publications), he sustains in *Art and Agency* the argument that it is not suitable for use by anthropologists.

Instead, Anthropology's relation to aesthetics must be defined by the discipline's methodological philistinism (Gell 1992b), as it questions how forms under which human experience is presented come to be and what they do to the socialized mind. Gell (1996) went on to correct anthropologists' preoccupation with communication by redirecting it to understand how objects capture imagination by the way they work at a material-technical and epistemic level. What was at stake in anthropology's position towards aesthetics had become apparent during the first exhibition of African Art in New York in 1988. This exhibition, coming as it did on the back of the 1984 exhibition on Primitivism in Modern Art, which had detailed the influence of tribal art on modernism, contained one object that stood out from

Aesthetics and the ethics of relation **107**

the rest: a bundled up, dark brown, and undecorated Azande hunting net, showing signs of use, exhibited amidst carved and decorated objects.

The intentions of the curator, Susan Vogel, became the subject of fierce debates and the catalyst for a now famous printed dispute between the anthropologists James Faris (1988), the art historian Arthur Danto (1988), and the anthropologist Alfred Gell (1996). The classic position each author happened to take turned the debate into a manual for understanding the epistemological problem of aesthetics in the hermeneutic philosophy and sociology of art (Wolff 1975). James Faris (1988) argued on the basis of his ethnographic research on Nuba body painting that aesthetic effects are shaped by the attitude of the artist to values that are formative in society, a position that was taken further by Howard Morphy (1989, 1992) in his work on bark painting among the Yolngu of North-East Arnhem-land in Australia. Morphy's (1992) essay of Aesthetics in cross-cultural perspective argued for aesthetics as a symptom of a cultural system of value, the understanding of which requires the detailed study of ethnography, an argument supported by Jeremy Coote (1992) in his essay on cultural values supporting discrimination in the everyday based on his work among the Nilotic cattle herders. Alfred Gell (1995b) responded to the theory advanced by Coote of a 'cultural eye' as ignorant of the politically and economically charged intentions and interests within which distinctions operative in society are given expression via the training of the horns and the breeding of patterned coats of cattle, the economic resource par excellence among Nilotic peoples.

The notion of subjective intentions, grounded in cultural and social values, was rebutted by Arthur Danto (1988) who argued that the debate over the Azande hunting net could easily be ended with a rational inquiry as to whether the inclusion could be explained by the institutionalized context of its production and use. If validated by such a context, the object's double identity as both object of 'use and practice and as vessel of spirit and meaning' (29) could be certified. Danto espoused the virtues of ethnography that could show why pots among one group would be the kind of object to exhibit as artworks, while baskets may be the object of choice to represent the aesthetic of a neighbouring group. His argument, that the institutional context is formative of an aesthetic, was in many ways well known within the sociology of art to explain the capacity of 'found' objects placed into exhibitions to attract lasting attention, affected by expectations of seeing objects that are demanding of epistemic puzzlement within institutions devoted to art (Goodman 1968).

Silent all along had been the third position, outlined by Janet Wolff (1983) in her classic work on *Aesthetics and the Sociology of Art*. This position is represented in her essay by the sociology of Alfred Schütz (1967) whose thoughts on social construction of the lived-in world had espoused the importance of understanding the intersubjective and cognitive basis of recognition, laying the foundation for later sociological writing on art and cognition (Luhmann 2000). Schütz's position in turn had been informed by Georg Simmel's ([1916] 2005) equation of 'forms of social life and social forms of art', which he had formulated in his essay on Rembrandt in 1916. Simmel argued that understanding is not grounded in seeing

108 Following the prototype

alone, but in deducing via imagination and intuition the workings of the object and what it does in society. Just a year after the disastrous second exhibition of African Art, this time in London, in which tensions over the subjective and institutional framing of aesthetics had come to blows publicly, a response was formulated by Gell, by covertly taking the position of the sociology of cognition and appropriating it for anthropology.

In his article entitled 'Vogel's Net', harking back to the inclusion of the Zande hunting net by the curator Susan Vogel, Gell (1996) argued for the importance of understanding the 'cognitive stickiness' of artworks and of the understanding of the work of aesthetics in terms of what objects do, not what they are or pertain to be (Gell 1996). The crucial term marshalled in this paper is abduction. The concept of abduction was brought into anthropology by Gregory Bateson (1972) to throw light on the associative capacity of the human mind underpinning culture in all its variations. In 'Vogel's Net', Gell uses this concept to establish the argument that attention productive of associative thought is reliant upon objects made in such a manner so as to espouse abductive qualities. A made object, including music, thus abducts attention, said Gell, because it exudes a kind of co-presence that models upon other kinds of encounters in that it demands an engagement based on shared recognition and an imaginative anticipation of possible actions. The example he draws on to clarify how an object can serve as a tool for abduction and as a model of how abduction works is the trap. As an object constructed to attract and subvert attention, by ensnaring the victim attentive to uncovering what lies hidden within, the trap, says Gell, epitomizes the workings of the object whose aesthetic qualities motivate its classification as art. In the same way as the trap locates the hunter's knowledge and skill within its own workings in ways that extend beyond the presence of the hunter, so artworks effect the spontaneous recognition of a pattern of relation, between the hunter and the hunted, via an object. The most effective objects are those that turn those inner, covert workings inside out as a joke, enabling the spontaneous deducing of the underlying pattern in one fell swoop (see Clarke 2008 and Chapter 11 for further discussion of pattern and humour). Exhibitions of art, by ignoring the abductive quality of humour, are thus complicit in misrecognizing the conditions that allow aesthetics to be productive of understanding.

Aesthetics and the rejection of the viewer

However, not all traps are made equally, and some are designed – with relevance, for instance, to the height of the trigger – to lay 'dormant', as it were, for most potential pray that pass through the ensnarement. Similarly, aesthetics, when taken as the point of purposive pleasure not needing reduction to function, can be deeply selective at times, keeping at bay viewers that are not intended as audience. In 1966, the minimalist artist Carl Andre offered to viewers eight sets of bricks, each 120 in number, arranged in various configurations of height, length, and depth. Named *Equivalent I* through *VIII*, the rectangular prisms – set unostentatiously on the floor of the gallery space – were devoid of decoration, having only the geometric

Spring-hook fish trap

Spring-basket fish trap

FIGURE 6.2 After Captain JG Stedman's sketches of 'Manner of catching Fish by the Spring-Hook' and 'Manner of catching Fish by the Spring-Basket', in his *Narrative, of a five years' expedition against the Revolted Negroes of Surinam, in Guiana, on the Wild Coast of South America* (1813, 236–237; cf. Gell 1996, Figure 11).

grid produced of the bricks lined up alongside and atop each other. Choosing fire bricks,[1] sourced from the coal-mining towns of his youth, rather than commercial building bricks, the bricks were also themselves devoid of the decorative stamp of the maker's mark. In a manner, typical of the 'systemic' or 'ABC' art movement he

1 Different bricks were used for the original (1966) and the reproductions (1969); for more, see Ronald Alley (1981, 11–12).

110 Following the prototype

helped found, the use of a single material, devoid of distraction, forces a focus on the simplicity of the lines, the grids, and the irreducible components of the object's design. This is an art that is precise, austere, and cerebral, rather than accessible and easy to experience. It is an aesthetic that also intentionally limits – it is not for the masses, and it demands work by the viewer.

The set, *Equivalent I* through *VIII*, was disposed of after the show, but Tate subsequently acquired *Equivalent VIII* in 1972. This purchase went unnoticed, until Andre's work was exhibited in 1976 and was, at that time, hailed by both the popular press and respected arts publications, such as *Burlington Magazine*, as a 'pile of bricks', 'rubbish', and a waste of public funds. In Tate's defence, written by the curator Richard Morphet, Morphet (1976) argues for how Andre is speaking within a tradition (using what Gell outlines in 'Vogel's Net' as the 'institutional' definition of 'art') and says that *Equivalent VIII* will prove to be shown to be important in the future. In no small part because of the controversy,[2] it has proven important, and has become one of Tate's most visited items. Morphet also highlights the quality in Andre's work between the idea of the work and the physicality of the work. The high degree of divisibility of the number 120 allows for multiple mutations of the brick arrangement; the unassuming grids of the brick, and the ready possibility of rearrangement, subtly screams of the generative capacity of permutations that are each distinct and, as named, equivalent.

In naming it Equivalent, and using a minimalist, almost self-evidencing quality, Andre drew on the work of Alfred Stieglitz, who from the turn of the 19th century began to take photographs of clouds. Then, from the 1820s through the 1830s, Stieglitz continued to offer new prints of clouds, photographed in high contrast. This cloud photography was really the first in this new medium to move away from discernible subject matter and literal interpretation, moving away from strict representational photography to abstract works of art.[3] Stieglitz was working within a scene of increased artistic abstraction – including his close work with Georgia O'Keeffe, who was introduced to Stieglitz via her abstract, minimalist charcoal sketches. And while there are distinct differences between Andre, Stieglitz, and O'Keeffe, they are examples of certain movements towards simplicity, purity, and sincerity of form following in a tradition of Euro-American artistic production as centred around New York. Speaking into this movement towards simplicity, Andre's *Equivalent* series pushes the aesthetic so far beyond anything functional that the capacity of the art object as action rests in the duplicitous capacity to reject the viewer not willing to engage in the cerebral games of the systemic art school.

2 It is also important to note that *Equivalent VIII* has known several controversies, including a paint attack on it in 1976 and occasional protests at its current exhibition cite in TATE Modern, due to Andre's involvement in the death of his partner, the artist Ana Mendieta.

3 Alvin Langdon Coburn is often raised as a counterexample to this, however it is an important distinction that the abstraction in much of Coburn's work was done in the production room, almost more painting with light than camera work. Stieglitz's *Equivalent* series was more in line with what his mentee and contemporary, Paul Strand, would later call 'straight photography', but – with few exceptions – devoid of any clear orientation.

On one level, this sort of exclusivity can be explained in line with Pierre Bourdieu's (1984) insights into the role of taste and distinction. As he showed in his work with various social classes in France, the socioeconomic background of different groups frames the way an individual will appraise an image, for example, of old withered hands. On another level, however, the associative connections different people make with reference to a given image will shape the subsequent social actions. As Gell argued, it is the abduction of agency (that is, not agency necessarily in the 'factual' sense) that guides the recipient's response to an index. In this way, abduction is dangerous. If, as seen in Morphy and Myers's work – and even more explicitly in Deger's explanation of the water in Chapter 5, the motivic (meaning here both motif and motive) capacity of the art object to make manifest the ancestral prototype immanently means that the object is all too capable of abducting the viewer into real danger. For this reason, boundaries are maintained around the immanent prototype, either in the interartefactual relations of social custom (averting the eyes, using veils, etc.) or in the aesthetic gesture of the object itself.

Aesthetic work of replication

In ways that strike a fascinating resemblance with contemporary concerns with aesthetics as modelled upon knowledge and skill imbued in an object, early British anthropology had attended to the collection of working models to record aesthetic systems precisely in this manner. Of these, the early voyages of AC Haddon in 1888 and his Cambridge Expedition to the Torres Strait a decade later stand out as critical in shaping subsequent theoretical concerns. Originally trained in Zoology, Haddon's wide interests in Geology, Natural History, and Anthropology were combined with his rich accounts of south coast New Guinea practices (Herle and Rouse 1998). Based on Mabuiag Island during his first stay in 1888, Haddon acquired a large number of artefacts, mostly weapons and ornaments, in exchange for tobacco, tomahawks, knives, and calico. Following the Darwinist evolutionary school, Haddon applied an organic approach to the study of technology and decorative design, intending to map artefacts as elements of local systems. Instead of studying artefacts as isolated specimens, he plotted the geographic distribution of different object types and decorative patterns within specific regions, situating them within an ecological model of knowledge that embraced both the natural and the social environment. His early publications, published soon after returning to his chair of Zoology at the Royal College of Science in Dublin, *The Decorative Art of New Guinea* (1894) and *Evolution in Art: Illustrated by Life-Histories of Design* (1895), set out an approach that was to situate the study of art at the heart of anthropology. Such a study consisted in the documentation of variation, using a scientific method in which modelling and replication began to complement collecting as modes of documentation (Herle and Rouse 1998, 87).

The attention to objects as models of knowledge and skill, and thus of socially productive modalities of attention, was pivotal to the period of 19th century explorations, as shown in the publication of Gottfried Semper's ([1860] 2004) work

112 Following the prototype

on *Style in the Technical and Tectonic Arts* in 1860. Semper, who had travelled on one of the German trading house Godefroy & Son's ships to Palau in the Pacific, had returned to bring his understanding of the structural qualities inherent in the textility of making, the weaving and plaiting of surfaces, to building.[4] Building post-Semper is fashioned in the image of clothing, an idea that elevated the decorative folds of a building to its structural properties and abductive capabilities in ways that proved formative to the architecture of Le Corbusier and thus modernity, yet in a rather less straightforward manner (Wigley 1996). Walls, the banisters of staircases, shutters, and balcony railings wrought from steel in decorative fashions of the time, espoused Semper's idea of the building as clothing, turning relations held within inside out. And yet, Semper's insight that the structure of the building is found in the decoration, and it is decoration that builds, soon was given a new twist. Walls, in Semper's view, to be designed like the folds of a dress, structural and enclosing at the same time, came to be redefined as the building's outer layer, detached from the structure beneath like a veil. Architecture as a covering layer rather than material structure was formulated as the *Law of Dressing [Gesetz der Bekleidung]* in the work of Adolf Loos (1998). Now, the outer layer of a building needed to be visible as an accessory, not as structure or decoration. For Loos, the coat of paint, the layer of Ripolin – of whitewash newly mass produced – became the ideal solution to a detached dressing (Wigley 1996, 11). Architecture had thus literally begun to clothe the body politic as buildings were 'made to be worn', rather than being occupied, as paint came to replace textile as the detachable surface.

Modern architecture after the model of Le Corbusier is inseparable from the whiteness of its surfaces – however, seemingly inconspicuous, it is anything but neutral and silent. The white wall is precisely not blank,[5] its apparent passivity is 'but the curious effect of a whole set of coordinated actions about the discourse [on its quality]' (Wigley 1996, xiv). The whole moral, ethical, functional, and even technical superiority of modern architecture is seen to hang on its white surfaces that quickly began to be emulated by clothing, espousing especially the white shirt worn by men as a guide to dressing the body in the mechanized culture of the early 20th century. Mark Wigley (1996) in his *White Walls, Designer Fashion* shows that clothing at the start of the century began to communicate the principles and virtues of this new architecture shaped by an underpinning relation between architecture and fashion that continues to the present day. Architecture's preoccupation with the white surface emerged, so he argued, out of a largely suppressed engagement with the anti-fashion movement of clothing design that had begun to shun the decorative. Buildings, much like clothing displayed in the new department stores emerging at the start of the century across major cities, were now understood as objects, inhabited by being looked at, and the whitewash, standing for purification, was now such a fundamental part of the 'look' that it vanished from view as it was looked

4 Personal communication with Valerio Valeri, 1995.
5 The not-blankness of white is notably comparable to the non-silence of Cage's 4'33", or the second half of Yves Klein's Monophonic Symphony, as discussed in Chapter 11.

Aesthetics and the ethics of relation **113**

through. 'What is preserved by this strategic blindness', says Wigley (1996, 4), was the extended history of concepts of cleanliness, hygiene, and purity associated with whiteness, originating in a style of clothing and extended to attitudes to clothing in general. Linen garments, for example, that were once hidden beneath layers of clothing slowly came to the surface to represent the condition of the body that they no longer even touch. At the same time, white fabric came to articulate levels of social distinction by referencing an emerging social body and the submission of persons' lives and rights to person-transcending systems of institutions, offices, and rights.

The white surface, a screen between the body and the onlooker, interrupting the eyes' attempt to grasp the body, brackets the body out, but at the same time forces the body into the imaginary space transcending the mortal lives of persons. The whitewashing of the walls of buildings thus became an active mechanism of erasure despite counter-movements, such as the Art Nouveau movement started by Van de Velde in Belgium before exporting it to Germany and France, following the Arts and Crafts movement established by Semper and William Morris. For in the first few years of the new century, the emphasis on style reflecting social relations underpinning both clothing and architecture came under increasing attack as excessive (Wigley 1996, 71). Herman Multhesius's address to the International Congress of Architects in London in 1902, an outspoken critique of Van de Velde, painted fashion and thus the association of architecture with fashionable styles exemplified by women's dresses as degenerate, calling for a massive reduction of ornamentation in architecture and fashion. Architectural practice under the influence of Muthesius and another one of Van de Velde's critics, Adolf Loos, quickly accepted standardization and the creation of generic type forms enabled by mechanization.

Wigley's detailed examination of the battle over the dominant aesthetic paradigm defining the look of cities and clothing alike concludes with a perspective from painting. Citing Mondrian's essay in the first edition of the journal *De Stijl*, Wigley argues that the attempt to control colour had by the 1920s become explicitly about the control of the feminine and others aligned with excess. While paving the way for a discourse of liberation through colour and new forms of music, such as jazz, Mondrian's paintings show that the polychrome was from the beginning a matter of discipline and control, likening theories of the polychrome to theories of surveillance (Wigley 1996, 280). For Mondrian, the purity of abstract art, transforming three-dimensional material life into a calibrated two-dimensional surface, complemented surfaces of fashionable clothes. Fashion itself, detached from the body in clothes, was seen to transcend the bodily world. Fashion and the language of clothing, once so carefully outlined by Gottfried Semper, in fact had turned into a trap from which architecture could not disentangle itself until much later in the century, when, freed from ideas of control, both fashion and architecture could return to the ideas set out by Semper (Barthes 1983). Far from being critical, Mondrian further supported the prison that architecture and clothing had created for the human mind. This ethical commitment to bounded, externalized control,

114 Following the prototype

which permeated the quotidian mundane, is also clearly manifest in the aesthetics of Mondrian's 'high' art practice.

Yet, while the decolonized and disillusioned post-war world thought it had successfully left behind aesthetic paradigms dominating the 20th century, it quickly became apparent that a lack of understanding of the logic of the relation between clothing and building had consequences that disabled an understanding of new worlds that came to be known via art and tourism alike. The example we return to is again Australian Aboriginal Acrylic painting, which had taken the art market by storm soon after an art teacher, Geoffrey Bardon, had introduced acrylics to communities in Alice Springs in 1975. Soon different communities developed distinct styles, and the question that began to plague the art market was whether it could distinguish between 'good' and 'bad' Aboriginal art (Michaels 1994).[6] The communities on which the spotlight fell, Papunya Tula and Yuendumu, were most sought after by the art market, having established effective middlemen in the form of art advisors and institutions that served as quasi banks, giving credit to artists against their past and future earning potential. There arose two dominant styles, the abstract style of Papunya Tula – with its schematized dot paintings – and the more representational style of Yuendumu – bold, colourful, and gestural. A debate arose around the aesthetic valuation of these two styles and whether they reflected the aesthetics of Australian Aboriginal society or those of the art market. Because of Papunya Tula's popularity, the Australian bureau of art suggested that Yuendumu artists go learn from the Papunya Tula artists. In response, defenders of Yuendumu cast its style as both 'post-modern' and 'more traditional', at a time when, in 1988, post-modernity was having its heyday. This debate was fuelled by two contrasting responses to Acrylic painting in Australia (Coleman 2004).

One view held that painting in acrylic is part of traditional culture and yet eminently compatible with modernist aesthetics, while the other view stressed that an aesthetic response had to be based entirely on Aboriginal values and ideas. The question of whose aesthetic was to define the value assigned to artworks was given significance as the production of painting for sale had been a deliberate political act underscoring the desire for equality of status and above all the right to access and defend land. The assigning of aesthetic value to the paintings was part of this equality and yet it was undermined by the presumptions of the art market whose aesthetic preferences supported some but by no means all of artists' outputs. Some, like Eric Michaels (1994), who first noted the differential response of the art market to the paintings, argued that aesthetics could not serve as a guide to the art, as it was a symptom of contradictory, irreconcilable influences, of the art advisor and the art market on the one hand and ideas lodged 'in country' on the other (Coleman 2004, 237). The question of whether indigenous art could be discussed in terms of ideas independent of the art market, ideas that could be called 'authentic', invoking moral

6 For Bardon's perspective on his role in the growth of, and examples from the eventual success of, acrylic painting, see Bardon (1979, 1991) and Bardon and Bardon (2004).

judgements over rights to production and reproduction, became central to writings on the anthropology of art at the close of the century.

Summary

This chapter reviewed the relational aspects of aesthetics, and the role this plays in art as action. Drawing on the historical development of the idea of aesthetics and the discourse around decoration in fashion and architecture, we argue for structural parallelism between the ethical boundedness of social practice and the aesthetically bounded material form. The relation between aesthetics and the work of form in conjuring to mind ways of being in relations that unfold in social practice has implications for methodology, in terms of research orientation, but also within the ethnographic context as impetus towards and model of social action.

If, as Carroll (2021) argues elsewhere, aesthetics is the means to access the internal, intuitive geometries of logic and society, then the examination of the aesthetics of form – both social and material – must be central to the anthropological project. Furthermore, building on Gell's insight concerning aesthetics as the interworking of style, agency, and abduction, we see that the form of the artistic gesture, and the isomorphic structure of gestures and material across genres, suggests a system of logic materialised within the object ready for apprehension. However, as we highlight in reference to the cerebral work of Carl Andre, aesthetics – like the material dimensions of a selective trap – may be designed to only catch certain minds. This we have seen before, as with the motivic patterns on the Abelam initiation house, in Chapter 5, is readily visible to everyone; however, the longitudinal elaboration available to the initiated, via abduction, will far surpass that of the lay community member.

This exclusivity of the object, and the reification of social hierarchy that it implies, makes it a deeply political thing. The contestations of 'good' and 'bad' art in Australia, and the debate around the inclusion of the Azande hunting net are, on this level, akin to the issues of cultural copyright discussed in the previous chapter. In its capacity to differentiate, to include and exclude, the aesthetics of the object plays a role in the political arbitration of social cohesion. The abductive capacity of aesthetic form benefits those who already have the cultural capital to contemplate the object in all its productive abductions. To those who only have partial, or incorrect, knowledge, however, the aesthetic aspects of an art object as action will, in its own disinterested judgement, draw the recipient into diversions, rabbit holes, and cul-de-sacs of mind.

This next chapter further expands on the methodological implications of art as action, by exploding the *oeuvre* at individual and collectivised levels. Taken in this larger context, the individual art piece is understood as a generative, holographic thing. Each object offers an understanding of the whole and thus the possibility of invention. The embracing of transformation is critical to an understanding of bounded and dynamically fluid representations.

7

GENERATIVITY AND TRANSFORMATION

In the virtuosity of craft, there is the required skill for uniformity across the surface of one object and across the surfaces of the many objects making up any given set – be it the work produced by one artist or within a given society. There is an obvious issue of scale, and as one moves from the particular object to the increasingly larger sets, the specifics of the uniformity may be increasingly covert. But, in the analysis of style, and the aesthetic systems that style manifests, the permutations of the particular against the next in its sequence becomes the point of investigation for understanding the art object as action. This action, as outlined in the previous chapters, is future-focused, holding in its own self the possibility of future development. Given the relational immanence of the object, the possibility of differentiation is implicit in the permutations of its internally held relations. These permutations can be expressed abstractly in both artistic pattern and mathematical formula. Pattern is discussed at length in Chapter 11, however, in this chapter we unpack the generativity that is productive of pattern. To do this, we begin in this chapter to develop a language inspired by mathematics to model the relationality present in the object. This is done in following Gell's own method of explanation, and also with mind to Marcia Ascher's (2002) observation that the sociological idea of relation is best expressed mathematically. Gell's analytical work took forward the idea presented by Claude Lévi-Strauss in the 'canonical formula' (1963), in which an algebraic system is informed by rules of combination that reflect ideas of relation at work at the sociological level. This canonical formula is introduced further in this chapter.

Rendered in its mathematical simplicity, the gap between the Object N and Object N^{+1} gives rise to the possibility of Object N^{+2}. On one level, this is the principle of production that the Melanesianist Roy Wagner (1975) identified as the 'power of invention', wherein the unique iteration of each new gesture, speech act, or other sign is made fresh and original within the tension caught between the

specifics of living *in situ* (what he calls the 'controlling context') and the histor-ically and biographically contingent formulation of what signification is possible (what he calls the 'implicit context'). Each new invention is a unique and original act, precipitated by the implicit context of culture, and – once uttered – shapes the implicit context of the next invention. The seriality of creativity is, in terms of the shape and contour of sociality, far more important than the specific meaning of any given act of signification. This brings us to the second level, in that – as Bateson (1972) argues – for an anthropology of art, the code is more important than the message.

This chapter, building on the previous two, now focuses on this aspect of art as action and the generative capacity of any given object – as a concretisation of code – to drive forward the stylistic virtuosity of objects in their distributed sets. We start with the work of the architect Owen Jones, on ornamentation in design, then move to introduce Lévi-Strauss's canonical formula, revisit Gell's early work on the Umeda *ida* ritual, then, by considering the Wahgi wig, we explore the difference between Melanesian and Amerindian ideas of transformation and their articulation via objects, and finally expand the framework from the artefactual domain out to include the society as an art-like phenomenon within this model.

Grammar and message

In 1856, the architect and designer Owen Jones published a folio titled *The Grammar of Ornament*. In a somewhat haphazard manner, *Grammar* presented the reader with a series of chapters, each dedicated to one great period of design; each chapter included a short essay discussing distinct qualities and was accompanied by very lavish colour plates showing prime examples of the style. Chapters from Antiquity (e.g. Greeks, Egyptians, Assyrians) accompanied chapters from European eras (Romanesque, Elizabethan) and contemporary groups (Arabian, Oceania). Jones's stated purpose was to encourage contemporary students of design to be original, and not to copy previous designs. As such, the (admittedly incomplete) compendium he provided was *not* about the specific examples, but rather about the principles he saw derived from the sets. Preceding the chapters on the various 'civilisations', Jones provides a chapter composed of 37 Propositions – a sort of manifesto of good design. Some are specific to colour relations and many drive at a general romantic sense that good ornamentation is derived from nature, and follow certain kinds of harmonic ratios. Throughout his work, the logic that drives his admiration of certain styles rests upon the generative nature of derivative parts. For example styles that command 'universal admiration' are, he claims, always 'in accordance with the laws which regulate the distribution of form in nature' (2), and 'The Decorative Arts arise from, and should properly be attendant upon, Architecture', such that 'Construction should be decorated. Decoration should never be purposely constructed'; and, 'Beauty of form is produced by lines growing out one from the other in gradual undulations: there are no excrescences; nothing could be removed and leave the design equally good or better' (5).

118 Following the prototype

In this way, even in the highly ornate examples of Alhambra or Celtic illumination, Jones maintains a stance in support of simplicity in the level of, what Bateson calls, code. 'The secret of success in all ornament is', Jones argues, 'the production of a broad general effect by the repetition of a few simple elements; variety should rather be sought in the arrangement of the several portions of the design, than in the multiplicity of varied forms' (15). In this way, like with Gell's arguments about the four kinds of 'translation' (i.e. movement) within motivic production, the fundamental grammar (or code) of ornamentation comes through the virtuosic repetition of irreducibly simple morphemes in a syntax that allows for infinite variability within a distinct style.

What is particularly interesting is Jones's Proposition 36, that: 'The principles discovered in the works of the past belong to us; not so the results' (8). In his quest against the simple copying of past design, Jones articulates a relationship to past examples that allows the contemporary student of design to own the code, but forgo any message that may be therein. Throughout Jones's analysis is a stress upon the relations between parts, in terms of the harmony and implication of continuity, organic growth, or sequentially between the base of a design and any subsequent element or flourish (e.g. the stem of a floral motif and the leaf or flower). These are not, for Jones, only issues of style, but speak to larger social and cognitive aspects of the society producing the given design. For example Roman ornament – which he is not overly keen on – positions the branching leaves at exaggerated angles (i.e. not keeping with his notion of natural floral lines), and this discontinuity in the virtue of Roman style is, he argues, related to the Roman adaptation of Greek style. There is also, not explicitly in his argument, but apparent in how he discusses the different styles, a clear implication concerning the kinds of cognitive relation to aspects of production, such as additive or subtractive creation. There is also an important emphasis on closed and open designs. In these various contrasts, Jones highlights the implications in how civilisations think and the coherence of their internal logic. As such, the capacity of the ornamentation as action is twofold; in the original context, it concretises the logic of a society and, in relation to subsequent attending audiences, it can give rise to new designs through the principles undergirding this logic.[1]

This dual capacity of ornamentation to act in both the original context and into lasting fields of design echoes the distinction mentioned in the previous chapter in highlighting the implication of Myers's 'aesthetic function' as a way of pushing the issue of functionalist interpretations of objects into a higher level of abstraction. Myers's prolonged argument about the emergence of connoisseurship – on the part of whitefella and Euroamerican audiences – versus his ethnographic

1 For a contemporary case study that examines the capacity of ornamentation as action, see Schacter's (2014) *Ornament and Order: Graffiti, Street Art and the Parergon*. Here, in looking at the way graffiti is marked within territory in a given style that is immediately recognisable and places the artist in a sequence of locations echoing across the city, Schacter highlights the importance of ornamentation as a socialising force.

insight into the painterly action via the acrylic paintings suggests a figure-ground reversal between the object-as-ethnographic-object and the object-as-art-object. In a context devoid of the dreaming, the art connoisseur evaluates the art object along criteria of aesthetics much like Jones's Proposition 36 suggests, claiming the principles of Aboriginal art as their own and buying 'stronger' works (Myers, 1999, 258, quoting gallerist Christopher Hodges). In this context, aesthetic valuation is generative of discourses in the art market and gives space for new inventions within this sphere. However, in the context of the dreaming, the paintings are transformative acts that lay claim to specific geographically articulated notions of identity and 'show' (Myers 2002, 39) ritual in a vital act of social preservation and political claim. While a 'painting is not ritual' (52), the systematic displacement of the Aboriginal peoples in Western Australia left a precarious situation in the 1970s when many of the older (and thereby knowledgeable) generation was dying without access to the ritual land to which they belonged. The inability to induct the next generation into the lineages of specific dreamings gave rise to an urgent need to 'give the country' (49), and – particularly the ritually engaged older men, such as Yanyatjarri and Wuta Wuta – used the surface of the acrylic paintings as a way to manifest the dreamings so that they would not be lost.

Myers (2004) captures the essence of Aboriginal painting, saying it 'is not an idea. It is a material and social practice that brings into realization not simply the creativity of an artist (the fundamental property protected in copyright) but an image that has a distinctive history and is generative of social relationships' (6). The possibility of this kind of generativity is also linked, however, to access to the land – as seen in Wuta Wuta's increased painting of his own dreaming after a few trips were made to the region – and the *possibility* of access to the land – as seen in the similar increase 'when the prospect of a return to his country to live increased' (Myers 2002, 108). In an economy of belonging and dreaming where any individual may have claim to a variety of countries (where one was conceived, where grandparents were from and died, level of initiation, etc.), the act of painting is a proprietary claim; as one artist put it, 'If I don't paint this story some whitefella might come and steal my country' (Myers 2002, 170; cf. Crocker 1987). The issue of copyright, already discussed briefly in Chapter 4, is also important to this point, in terms of the possibility of transformation, and generativity of art as action is the point Myers makes about the basis of Yanyatjarri's virtuosity as an artist. He says, in a way that echoes Jones's sentiments about the elemental forms and grammars of combination, 'it is in the *recombination* of a limited number of formal elements that he succeeds, especially in bringing rectilinear and circular iconographies into communication— and in this activity one can discern his virtuosity, engaging so many possibilities' (Myers 1999, 244, emphasis in original). Yanyatjarri's virtuosity makes his work vital in both 'grounds' of the shift back and forth between the connoisseur's desire for 'stronger' works, and in the Pintupi context using his ritual knowledge to reveal something from the dreaming and enact his own rights to a place (Myers 2004, 31).

There is a degree to which the separation between the connoisseur whitefella context and the Aboriginal context is an artificial distinction. As Myers points out,

120 Following the prototype

there was no 'Aboriginal' people before the colonial administration grouped the Pintupi and all their neighbours into one classificatory group. And, as Povinelli (2011) argues, Aboriginal and white-settler Australia are caught in a relationship of incommensurability, but a relationship it is. Wuta Wuta's artistic action, then, is, on one level, enacted (or invented) within one (albeit heterogeneous) social context. The post-settler situation is one where the success of the painting to shape the implicit context of Aboriginality, in a way conducive to Wuta Wuta's hopes and goals, depends on his virtuosic ability to transform the basic motivic elements in a way that gives rise to the subsequent invention of – in his case – the Pintupi landscape.

Icon as interface

In a manner similar to the distinction Myers draws between the Aboriginal painting as 'art' and as ritual action, Orthodox Christian iconography is also often times moved from the ritual context of the liturgy into art arenas. In this case, however, there is also a distinction drawn between the icon as 'just a liturgical artefact' and the icon as an 'interface', bringing the sacred personage imaged in the icon into tactile and intimate relation with the devotee.

The Orthodox icon, in its most basic form, is a visual representation of a saint, sacred narrative or divine person. It is, in the Peircean sense, 'factual similarity' (cf. Carroll 2018, 105) that makes the religious image work in the way that it does, as a liturgical artefact and aid to prayer. However, it must be remembered that, as mentioned in Chapter 1, the visual form of the representation follows strict guidelines of stylistic and iconological composition, such that to those familiar with the genre, a depiction is immediately recognisable as a given persona. As a recognisable form, it is positioned within a nexus of Husserlian 'intentions', casting forwards and backwards the horizons of the temporal, experiential 'present' of participation. The Orthodox Christian devotee today participates in the self-similar act of veneration and communion along with generations of fellow Orthodox faithful in past centuries and in the anticipated future. In Orthodox theology of time, there is a notion of participation in events of the past (and future, cf. Loudovikos 2010) that is not dissimilar to Husserl's ideas of experience of the *ab original* moment of discovery via retention (Husserl 1989). In Orthodox liturgical practice, the concept of *anamnesis*, or remembrance, is central. However, this remembrance is not recollection, in the sense of calling to mind a historical detail or memory. Instead, anamnesis rests upon the Greek distinction between *chronos* (chronological, progressive time) and *kairos* (event based, qualitative time). History works in chronic time, ritual participation in past–future events works in kairotic time.

The icon, as an object, works in its capacity to bring the faithful into a tangible relationship with the imaged persona, without reference to the specific historicity of the person or event shown. The intuitive recognition of the event, and the act of veneration and participation with it, brings the person out of the temporality of mundane life, and positions them within the eternal and atemporal realm – as one

interlocutor reminded Carroll during his research, 'in the liturgy there is no such thing as time'.

Access to this kairotic participation within the event moment of divine revelation is based on the learned practice of relation within the liturgical rites. This aspect of recognition and the ability to know often evokes various terms, such as 'innate', 'intuitive', and 'learned' in order to frame how iconography requires the inculcation of novices and children to have the intuitive recognition of what an icon actually is. The process of conversion to Orthodoxy includes what is called 'acquiring the mind of the Church' (cf. Carroll 2018, 21, 40, 86ff). In the example of a young Persian woman converting to Orthodoxy, named Niyousha, this collective mind is recognised to a large degree by the growth of an instinctual response to icons. In discussion with some iconographers, there is a strong distinction between the icon as 'just a liturgical artefact' and the icon as an interface through which to access and fellowship with the saint in all their purity and truth. Some iconographers frame this as an increasing degree of being 'real', saying that the saints are more real than the icon, and the icon is more real than the living person. In framing it in this manner, the concept of 'real' corresponds to participation in the purity of God. In seeing an icon, even if the Christian cannot explain how it works or why it works, 'they are sensing something' in the icon, specifically what one called the 'line'. In traditional Byzantine iconography – and the other schools of practice derived from it – 'the line articulates something that is innate to the phenomena' of the interface between the person and the saint, located in the material offering of the icon. In relating to the 'reality' in the icon, and of the prototype accessed via the icon, the person is purified by participation in the purity of the kairotic event, and the object, in a synergistic relation between the material and the immaterial (cf. Carroll 2017). This produces a transformation in the person, making them an 'art like subject' (Carroll 2018). This transformation is generative of new social forms, such as Niyousha's newly made fictive kin relation with her godmother, and in her own likeness modelled to the Persian martyr, Christina, whose name she takes as her own.

Poetics and dynamism of form

The importance of a limited set of motivic elements, made manifold through the variability of patterned combination, is not limited to the artefactual domain. As evident in Jakobson's (1971) work on poetics, or indeed Propp's (1968) work on folkloric forms, or Lévi-Strauss's (1963) approaches to myth, the basic and deeply grammatical organisation of elemental forms is fundamental to the arts. What is of critical importance to us here is the degree to which the manipulation of the elemental motivic forms – that is, the transformation of pattern – is itself generative of subsequent gestural[2] actions, both in the same genre, and importantly, on larger scalar fields of social action.

Lévi-Strauss brought into anthropology methods that are rigorous, in terms of their systematic approach, without being quantitative (Morava 2005, 48). Those

2 We are using 'gesture' here in a broad sense, of any new invention (in Wagner's sense).

122 Following the prototype

methods are classically found in mathematics, specifically in the study of topology in which the structural stability of form and a formulaic understanding of the concept of relation is foregrounded (Thom 1975; Ascher 2002). Jack Morava (2003, 2005) who, as a mathematician, understands the intricacies of Lévi-Strauss's thinking about modelling systemic probability, argues that the cornerstone of his method is to be found in the classical Greek theory of proportions as a kind of calculus of analogies. This is because the emphasis on qualities rather than observable quantities is the critical feature of Lévi-Strauss's canonical formula. Applied to the analysis of myth (1963), and later to kinship (1969), Lévi-Strauss described his formula as a way of thinking in terms of analogies between analogies, evoking classical Greek geometry formulated without the modern notion of real numbers (which begins with the Renaissance). The core element of the canonical formula is thus an equation that places two objects of one type (circles P and Q) in relation to one another and equates them to the relation between objects of another type (squares R and S), such that:

P: Q:: R: S

The analogy between geometric objects and their relation to one another can be replaced by a numerical equation (e.g. 1: 2:: 5: 10) if and only if it is 'believed'[3] that the geometric object can be replaced by numbers, and this belief rests on what the mathematician René Thom (1975) has called the structural stability of forms. For anything to be stable it must be recognizable, allowing for the abduction of the probability that a shorthand can be used to express the relation between two objects, animals, or persons as recurrent and thus predictable. Thom calls stable forms 'attractors', and it is to the work of attractors that the canonical formula draws our attention.

The analogy, expressed by Lévi-Strauss, in the formula:

$$F_x(a) : F_y(b) :: F_x(b) : F_{a-1}(y)$$

was first shown to allow myth to be analysed as a series of transformations, rather than separate stories. This is because $F_x(a)$ represents the role ('function') played in a myth by an individual *a* in the context of attribute *x*. A figure from a structurally related mythic cycle is *a-1*. In each equation, the nomials are not general categories, but specific to '*certain* individuals in *certain* myths; such pivotal entities serve to link together myths in different cycles, and it is the role of the analyst to bring them to light' (Morava 2005, 54, emphasis in original). In one example,

3 Both Morava (2005) and Thom (1975) emphasise that the intersubjective intuitive recognisability of the elements combined in the formula is a prerequisite for the use of a shorthand. This is framed as a belief in the certainty of the objects and their intuitive recognition. This is a striking echo of the issues of 'paradigm certainty' and 'confident seeing' as discussed in Chapter 4 (cf. Deger 2006; Wagner 1986).

a is Goatsucker and *a-1* is Ovenbird, a figure from a structurally related cycle of North American myths. In another example, *a* is the frog, *b* is the bee [both 'animate count nouns'], *x* is water, *y* is honey [both 'inanimate mass nouns'], and *a-1* is the jaguar.

$$(54)$$

Symbols at the beginning of the alphabet denote individuals, while those from the end denote a higher-order abstraction, such as properties or attributes.

The formula thus allows symmetries to be exposed as underpinning a seemingly chaotic chain of characters and events, or as in Lévi-Strauss's later work, biographical relations. The matter is made more complicated by the fact that the formula allows 'entities to be abstracted as attributes and attributes to be personified as entities', this is also reflected in languages 'which associate noun-like substantives to adjectives, and correspondingly allow the construction of adjectival forms from nouns' (Morava 2005, 54–55; cf. Lambek 1958) the implication of this is that in the same way that different mythical cycles can be seen to be different transformations of each other, a single cycle also shows the generative capacity for transformation of entities and qualities into each other.

Morava identifies a coherent formal interpretation of the canonical formula to consist of a mathematical construct called the quaternion group of order eight, generalizing the Klein group of order four, which was given prominence in the analysis of biographical relations that came to constitute the cornerstone of the anthropological study of kinship. Setting aside the technicalities of the quaternion group underpinning the formula invoked by Lévi-Strauss (see Morava 2005, 55ff for details), the important fact to take on board is the ability of the quaternion group to allow for the translation of a formula into a rotational geometric object and back again, transforming it in consistent and predictable ways. The closest analogy between the canonical formula, based on the quaternion number system, is the Rubik's Cube that allows for predictable and recognizable transformation of coloured squares in relation to one another in ways that draws attention to the patterns of relation between squares rather than to the squares themselves.

The use of analogy to allow for the modelling of complex relations had in fact been invoked already in British Social Anthropology by Edmund Leach (1954), who used numerical relations to show the consistent and yet time-delayed relation between opposing types of organization in his work on the Kachin of Highland Burma. Drawing on mechanical metaphors of opening and closing, manifest in the irrigation system central to Kachin political and economic life, Leach showed that mathematics and geometry offer ways to imagine the behaviour of seemingly unpredictable phenomena. As we will see in Chapter 11, Lévi-Strauss was inspired to draw on algebra and its foundation in geometry, not by Leach's modelling alone, but by an earlier work by Arthur Bernard Deacon (1934) that has brought mathematical thinking to anthropology by virtue of coincidence. At this stage, however, let us examine more closely the transformation of entities into qualities and vice versa.

124 Following the prototype

Ida as transformation

An example of this transformation between entities and qualities, in relation to one another, is evident in Gell's (1975) early work on the Umeda *ida* fertility ritual. In this early work, Gell points to the basic motivic elements used in the body paintings done upon the skin of the ritual dancers. These motifs, arranged in distinct ways correlating with the respective roles of the cassowary, fish, bowman, and other key roles are, Gell notes, both deeply formulaic and open to variation, depending on the whim of the men painting each other. The painted bodies, dressed – depending on the role in the dance – in various kinds of penis gourds and elaborate headdresses then perform the dances of the *ida*, again in a manner deeply proscribed by tradition and open to the individual man's personal priorities. For example while the ritual is for the whole village, being timed before the rains and cycles of planting (and, Gell suggests, impregnation), the key dancers may also use their individual performance as a means to impress potential lovers and future wives.

In this sense, the artistic aspects of the ritual sit in tension between the fundamental architectonics of the genre and the ornamentation of the specific performance. This analysis of ritual, which he credits to influences drawn from Gregory Bateson (1936), Victor Turner (1967, 1969), and Anthony Forge (1967), is markedly different from later analysis, for example that of Bruce Kapferer (2005) on ritual aesthetics. Gell gives emphasis to the aesthetics of the ritual – such as the important rhythm maintained by the dancer thrusting his hips to swing his penis sheath in such a manner so as to concuss against his pig-bone belt in time with the music – which, like Kapferer argues, makes the ritual efficacy more fecund. Nonetheless, the attention of the analysis is focused on, what one might rather call, the aesthetics of structure.

The logic of the painting and the dances fits within a larger social orchestration of garden versus village residence, food and sex taboos, and kin dynamics. On one level, this is the beauty of structuralist analysis in its accounting for everything within a sociocultural context, even with its sometimes-strained attempts to make explanatory models for the absurdity of human variation. On a more profound level, the analysis offered by Gell draws the socio-political structuralism of Bateson and Turner into methodological analysis with Forge's grammar of form. In *Metamorphosis*, Gell (1975) gives strong weight to the symbolic meaning of the various forms, but admits that this is entirely absent in the Umeda self-understanding. For the Umeda, questions about representation and meaning elicit answers about essence and identity, as there is – at least for *ida* – no 'native exegesis'. Gell uses Turner's concept of the external exegesis as the 'observer's construct' and extends it, arguing that the native exegesis, where available, must be incorporated into this analysis. He does so by offering a model that aligns the painted forms, the types of penis sheaths and headdresses, amongst other elements of the ritual, in a comparative table – almost a schedule of the ritual – organised by time and character. By highlighting the timing of characters – for example the cassowary painted in all black and the *molnatamwa*

Generativity and transformation

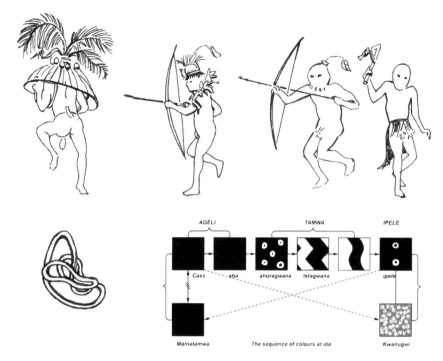

FIGURE 7.1 Line drawing of design of *ida* dancers used in the *ida* festival alongside the path traced in the clearing by the dancers, and the colour diagrammatic, showing move from black to red, after 'Figure 42 The transformation of mask-types' and 'Figure 46 The sequence of colours at *ida*' in Alfred Gell (1975, 299, 322–323).

(fish) in all red, leading eventually to the *ipele* (bowman) in red and black designs – Gell frames the passion of the *ida* to be as much about the colour dynamics as the symbolic exegesis of the animals. In fact, he argues that the man is not painted black to represent the cassowary, so much as the man is painted like a cassowary to be black. In this sense, the sequentiality of the *ida* comes to the fore as a passion play of alternating black and red, which, as Gell demonstrates in the wider social context, is identical to the dynamism of generationality, for example that played out between a mother's brother and a sister's son.

Person as artefactual

Elsewhere in the Melanesian context, Marilyn Strathern (1988, 1996) has established that composite and multi-authored relations immanent within persons are made manifest externally only partially and fleetingly as they are given form in objects. Objects in fact, Strathern argues, are the outcome of processes of decomposition, by which persons, constituted as multiple and partible, come to be singular for moments at a time. Forms thus achieve social effects as they instantiate

126 Following the prototype

the emerging of new 'dividual' persons and new social groups in a process that is as iterative and transitive as each new form is a refraction of all possible forms. Object forms in Melanesia thus behave like persons in that they are generative of their own relational nature, the existence of which they testify. It is because of the inherent relational nature of partible persons and objects that the study of formal relations between objects is capable, in Melanesia, to shed light on ideas of relation that may not be easily accessible through the study of social relations alone. The idea of social relation as captured in object relations is evident in the above example of the cassowary, as well as in Diane Losche's analysis of avian taxonomy in Sepik River art, as discussed in Chapter 5. Yet another classic example is the decoration of the body in the Highlands of mainland New Guinea, which has been formative in Strathern's own thinking on forms and their social effects (Strathern and Strathern 1971; O'Hanlon 1989).

In the Highlands of New Guinea, as well as in the lower hills of the Kaluli and the Jimi Valley, it is the human body itself that is transformed into an artwork through elaborate body decoration involving the construction of wigs, headdresses, and the painting and ornamentation of the body with pigments and shells. In the upland valley of the densely populated Wahgi in the Highlands, long wigs worn by dancers at the ceremonial exchanges turn the bodies into artworks par excellence (O'Hanlon 1989, 1993). Described as 'second skins', the wigs are made and worn during the Wahgi Pig Festival. This grand ritual cycle is focused on promoting the future fertility, growth, and well-being of the performing clan, and particularly of their pigs. Over the last century, clans' festivals have climaxed roughly once a generation. Beginning with a series of rites to precipitate pig growth, the festival involves the performing clan clearing a ceremonial ground and acquiring from extra-clan sources the costly plumes and decorations its members will need to mount a year of dramatic dances in front of allies, rivals, and enemies.

In addition to the wigs, as O'Hanlon (1993) shows, a miniature house is built in secret at night in the centre of the clan's dance-ground next to a decorated post. In O'Hanlon's reading, the house is a model, in the eyes of the Wahgi, of the structure of the clan. The house is made from wooden posts, which are dismantled after the ceremony and buried in a swampy area from which they are excavated and re-erected for every subsequent festival. In our understanding of this, with transformation and generativity in mind, we can see that the house in fact manifests the enduring temporality and autogenic capacity of the clan and its ability to engender its own reproduction by cutting itself off from other clans. The capacity of the house as a model to be extended to actions is demonstrated when men gorge on fat from their own pork, credited with miraculous powers of causing growth and linked metaphorically to semen, atop platforms erected at the festival. The perceived link between immortality and severance from inter-clan life is also reflected in the cocoon-like second skin of the wig and in the Wahgi's comparatively restricted practice of exchange, which proscribes actual sister exchange between clans who, over time, become virtually endogamous as a result of long-standing and repeated intermarriage.

Wigs are made for and worn by a small proportion of a festival-holding clan. They are a hereditary ceremonial property and are to be worn either by a vigorous young adult son or a younger brother of the man who wore it during the clan's previous festival a generation earlier. Alternatively, an unmarried daughter may wear the wig, although rights to it remain in her natal clan and do not follow her in marriage. Such an inheritance is a conceptual one, as wigs generally are not robust enough to withstand the test of time.

Wigs are technically demanding to make. The wig-maker will begin by constructing a circlet, closed with ties at the front of a vine, which sits on the intended wearer's head. Verticals of cane are then attached at regular intervals with raffia-like cords. These verticals are in turn tied at the bottom of the wig to a further horizontal bracing cane, moulded into a graceful even curve, lower at the front and back but rising over the wearer's arms. Over the course of one day, the wig's structure is built up so that it envelops most of the wearer's upper body. The frame is then covered with barkcloth and a further layer of burrs, onto which human hair is pressed. More recently, barkcloth, burrs, and hair have been replaced by store-bought fabric: red towelling or elasticated women's blouses are particularly favoured. Wearing the wig, a person should be unrecognizable from the rear and sides; its failure to fit properly on the wearer's head is attributed to internal problems within the clan, such as jealousy or grievances. In extreme cases, the wig will be dismantled and reassembled several times by the wearer's mother's brother. Yet still the wig is not finished, and the subsequent stage of production returns us – as it did with the *ida* dancers discussed above (Gell 1975) – to the issue of colour. A pause in construction, lasting for some weeks, sees the painting of the wig with hot gum of a naturally golden colour whose brightness is enhanced by stirring into it quantities of yellow powder paint used otherwise for facial decoration. The yellow colour, associated with female substance, indicates that the wig is in fact a second, maternally and exchange-derived skin, whose external, yet at once internal, contribution to the clan's growth is made manifest in this way.

The night before the wig's emergence on the festival ground for the first time, its wearer is busy enhancing the shininess of their skin. The wearers assemble the next morning, along with other decorated dancers from the clan, at the entrance to the ceremonial ground whose fence is ritually broken as they enter for the first of many times over the next weeks. Over the following months, until the Pig Festival's climax, the wigs are worn for dances, but also simply to parade around. The wigs are worn for a final time on the climactic day of the festival, when the clan as a whole charge onto their ceremonial ground. When the pigs are killed a day or two later, married women, mothers, and sisters of the men wearing the wigs, are given their own opportunity to decorate and dance in the men's finery. The wigs make a final collective appearance a few days later when, after the visitors have departed, the festival-holding clan gather to re-cook the pigs' heads around the model house erected on the ceremonial ground. Thereafter, the wigs are taken back to the house by their owners, where they are stored for some time in the hope to be able to sell them to passing tourists.

128 Following the prototype

The Wahgi wig thus brings to the fore, in its body-enveloping form, ideas of relation whose social effects are visible in the constitution of persons and social groups, the nature of which is synonymous with the fragile, composite, and body-centric structure of the object. In this light, it can thus be said that the Wahgi wig, like the house, is a model that allows the social body to be literally put on show, tested, and judged. This is a prime example of what we outlined above, in terms of the possibility of attributes being transformed into persons, and consequential generative capacity in wider social life, well beyond the confines of the ritual space.

It is instructive at this point to seek out a comparison with object worlds in Amazonia. The anthropologist Els Lagrou (2018) shows that, in contrast to Melanesia, object forms obviate and thus make relations invisible in a process that is as repetitive and generative of forms as it is of an ontology of connectedness that emerges from within the reversibility of all forms. In Amazonia and in Melanesia, patterned forms can be seen to attest to the constant process of becoming, yet while in Melanesia forms manifest relations and their visible social effects, in Amazonia patterns reveal, or suggest, the multiple fractal relations that constitute invisible social effects. Forms reveal relations in Amazonia, yet in ways that assigns functionality and contemplation to artefacts as conceptual tools and almost bodies in ways that allow the trajectories of bodies and artefacts to converge and aesthetic efficacy to act upon and thus create and transform the world (Lagrou 2018, 138[4]).

Amerindian art, says Lagrou, teaches us the possibility of a coexistence and superimposition of different worlds, which are not mutually exclusive. The patterns of shamanic songs guide the novice through an experience that connects one's embodied thoughts to the past as well as to the future, to the indigenous worlds of the ancestors and to the world of the white, and other manifestations of otherness. Forms are contemplated as outlining the possibility of becoming self by means of becoming other. It is this capability of forms to kindle thought in Amazonia that allow us to recognize what the anthropologist Viveiros de Castro (2014, 43) has called the ontological turnings through which we realize the fallacy of reducing human thought to a '*dispositif* of recognition'.

An example of the contemplative nature of forms that allow intra-relational processes of becoming through the obviation of relations invoking distinction and differentiation is the *molekana* of the Kuna of Panama (Margiotti 2013). *Molekana* are applique blouses made and used by Kuna women in ways that fashion a sociality that cuts across the visible and invisible domains of mundane life. Sewing a *mola* (the applique design) involves an additive process of layering fabric of contrasting colours, whereby patterns and figures are realized through a reverse applique technique, which sees the cutting out of shapes and their superimposition on a differently coloured fabric so that the emerging pattern can either be seen as emerging from the background or as laying in the foreground. This process is repeated as

4 Here, Lagrou is summarising an argument made at length in her 2009 *Arte indígena no Brasil: agência, alteridade e relação.*

many times as there are layers of differently coloured fabric while still allowing the patterns to emerge clearly. Women keep a stockpile of multi-coloured fabric leftovers to fill little spaces within designs and to make decorative motifs that are superimposed on the composite patterns. To understand the *mola* and the complex associations it evokes, relating fertility, the human life cycle, and everyday experiences, we thus need to bear in mind the overriding significance of an invisible, immaterial reality, underlying and intimately linked to the visible, material world (Margiotti 2013, 394–395).

The idea of the counterpart of the visible world in another invisible one underpins the understanding of conception, pregnancy, and birth in ways that foregrounds the mediatory role of design. Paolo Fortis (2010) shows design to be aligned to the amniotic sac, which bridges the two worlds and leaves an imprint on persons in the form of designs imprinted on the forehead at birth. Designs, emerging during gestation, are the gateway to the invisible counterpart of persons, and this is as relevant to the shamanic carvings of the Kuna as to Kuna women's stitched blouses. In fact, the multi-layering of the *mola* corresponds to the multiplicity of counterparts women have in the invisible, compared to the singular counterpart of Kuna men. Fortis (2012) captures the intrinsic relation between shamanism and art among the Kuna, where shaman or *nelekana* are born with the white remains of amniotic designs on their head that predispose them to vivid dreams during childhood. He describes the birth and childhood of *nelekana*, whose affinity with design, known as *kurkin* (meaning the amniotic sack, the caul, as well as brain, intelligence, skill, hat, and headdress) predisposes them to have access to relationships

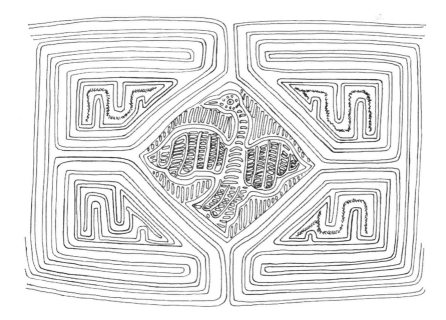

FIGURE 7.2 Line drawing of a *mola* design.

130 Following the prototype

with the invisible, both dangerous to them and their families and yet, when controlled in later life, full of potential.

The ability of a young *nele* to grow into a shaman or seer, able to locate and reconnect lost doubles in the invisible world with their visible counterparts, is dependent upon his ability to carve doubles or *nuchukana* from trees, which themselves are seen to display the capacities of humans to grow inner and outer identities. The Kuna seer can see within the human body and into other dimensions of the world, and the miniature figures are the critical tools that enable him to identify a person's invisible counterpart. Generic and yet individuated, these figures make manifest an idea of personhood that defines the continuous blending of the inner and outer, of the visible and invisible, in ways that, unlike in Melanesia, allow for a processual displacement of persons by designs that alone allow for the continuous unfolding of relations in a world spanning both the visible and invisible.

While done in radically different ways, the artefactual practices across Melanesia, Amazonia, and the Kuna of Panama each pull at the entanglement of bodily practice and artefactual articulations of generativity. The transformational techniques used in the artistic practices, and recognised in the 'natural' processes such as birth-giving, are indexical and productive of the ongoing capacity of society to endure through time. In this sense, the endurance of the image is fundamental to the endurance of society, and, in fact, it is safe to hazard the hypothesis that it is fundamental to the endurance of the species.

Changing the grammar: metacode

In the examples so far, the amount of variation in a system is within the realm of the (in)dividual's artistic style and virtuosity. The artist works within an explicit convention of painting or dance or applique make an infinite set of unique objects that never divert from the genre. Myers's point about the need for local art histories is well taken, because over the *longue durée* there may be noticeable shifts – as, for example Jones notes in the slow development (he says decline) of Egyptian ornamentation over the successive kingdoms. In some cases, change is markedly obvious, as with the advent of acrylic painting, when a new medium is introduced offering radically new expressions; however, even with this, the forms are clearly within the lineage of the implicit context – requiring the rights to dreaming, and the caution about which dreams can be painted, by whom, and for which audiences.

However, this begs the question of intentional culture change. For example in the work of the architect Christopher Alexander, there is a political drive to reform the sociality of the built environment, urban planning, and the structures of statecraft. In the four-volume *A Pattern Language* (Alexander, Ishikawa, and Silverstein 1977), co-authored with a team of researchers working with him, Alexander lays out the foundation of a new approach to design. *Pattern Language* grew out of a project – recorded in *The Oregon Experiment* (1975) – where, following protests at the University of Oregon, Alexander was hired to design a method of planning that allowed the community to actively plan their own environment. At a much

larger – even utopian – scale, *Pattern Language* expands the model of community self-determination from houses to cities. He makes explicit the 'patterns' of architectural form and urban planning that are available to the design of the built environment. He also provides a 'language', much like a basic protocol or algorithm, by which the patterns are arranged and give rise to the possibility of the next.

The generative capacity of pattern is axiomatic to the pattern language, as the 'open source' style arrangement for building and the cross-indexed form of each pattern allow anyone to come in and use it to design and build. It is this pattern language that is credited with being the basis upon which wikis were developed. Alexander's work is, much like the subsequent movements in wiki platforms, undergirded by a radical liberalism and drive to democratise the access to knowledge and design on every level, from making a family home to forming public policy for infrastructural development. His emphasis on localism and classical notions of liberalism – even to the point of calling for the disbanding of nation states in favour of smaller geographic polities – frames a sociology that appears throughout every aspect of the *Pattern Language* (its own kind of virtuosity of style).

In his overt intension, Alexander is working to change the way society builds the built environment. Houses would still be recognisably houses; roads, roads; etc., but the aerial view of a city or town would be substantially transformed, and the social dynamics of planning, and the politics of development, would be radically transformed. His is a project of intentional and explicit culture change. However, like with Gell's use of what we are calling aesthetic of structure, the radical innovation of the pattern language fits within a long convention of liberal humanism and empowerment through access to knowledge and communication. Taken in the context of the scale of action, the invention of *Pattern Language* is a gesture that is rendered overtly in urban planning, but most profoundly in politics. In this sense, the agentive design of Alexander's work pushes at the controlling context of architectural planning, radically reimagining the aesthetics of its structure, yet is perfectly conventional within the implicit context of the politics of devolution and localism.

Thus, as discussed in Chapter 1, where Duchamp moved through cubism and left painting all together, the *Dulcinea – Nude – Standard – Network* sequence makes a radical formal transformation in the qualities and entities of his *oeuvre*. However, just as the mathematical thinking of the canonical formula can open for us new avenues in thinking concerning the structure of mythic and kinship, so too can it bring to the fore the important inversion of time duration and artistic subject in a way that – we propose – sheds new light on the way Gell saw in Duchamp an example of the fourth dimension. It also models the same kind of radical departure that projects like that of Alexander have in mind in terms of the intentional design of culture change. While *Standard* and *Network* were radical in their departure of form and style, they constitute a formal, even formulaic, inversion of the same qualities found at the heart of *Dulcinea* and *Nude*. Thus, the politics of new forms, and particularly the possibility of them as a successful invention, rests in their relationship to the preceding gesture, and the capacity of the canon to carry forward the futurity of the design.

Summary

Art as action, as the gesture of invention shaping the contours of convention, is a generative, holographic thing. Each object offers an understanding of the whole and thus the possibility of invention. Taking seriously the object's role in facilitating transformation is critical to an understanding of bounded and dynamically fluid representations. In the generative capacity of objects, the sequentiality within an *oeuvre* is manifest in both the artefactual and social domains, as the human person is inculcated within that interartefactual seriality of action.

The isomorphic quality between persons and objects, already mentioned in previous chapters, is maybe most clearly salient here in thinking about generativity and transformation. As Gell notes, the *ida* is essential to the continuity of the whole project of social (and biological) regeneration. The totemic animals – like the dancers embodying them – are ultimately a colour sequence that makes immanent the intergenerationality of social continuity. The microcosmic view of transformation is demonstrably a motivic design within the macrocosmic generativity. Thus, like the 'temporal perches' Gell (1998, 250) uses to unpack artistic and cultural *oeuvre*, any given object may have the capacity to open the gap from its antecedent, and thereby give rise to its successor. This genealogical iteration is inherently transformational, but always within the variability of its own similarity.

The next chapter further explores the dynamic potential of transformation, unpacking how value can be moved from one medium to another. This affects society at each intersection, thus demonstrating the inherent socialness of art as action. The chapter unpacks the notion of agency, considering how objects and material gestures are able to impact the art of social forms, not simply as conduits of meaning but generative of intersubjective sociality.

8
AGENCY (SOCIAL)

It is now commonly acknowledged that the canonically held origin of the *Fountain* (1917) is false. While the creative genius behind R. Mutt's urinal has long been assumed to be that of Marcel Duchamp – an attribution of artistic agency that he readily accepted when André Breton granted it to him in 1935 – it is now more readily recognised to be the work of Baroness Elsa von Freytag-Loringhoven (Higgs 2015; Thompson 2015). It is also readily possible that the 'female friend', credited by Duchamp in a letter to his sister to have sent in the urinal was, in fact, Louise Norton who – along with several other people (including his sister Suzanne) – where engaged by Duchamp in his work of 'art at a distance', and happened to live at the same address as the enigmatic Mr. Mutt. In an article written by Norton decrying the rejection of Richard Mutt's submission to the 1917 exhibition, she – responding to the critique that the plumber, not Mutt, was the artist – argues that 'the *Fountain* was not made by a plumber but by the force of an imagination; and of imagination it has been said, "All men are shocked by it and some overthrown by it"'. In a winding argument, playing at the serious and the jocular as being non-mutually-exclusive, Norton ends her defence of the artistry of Mutt concluding 'with the most profound word in language and one which cannot be argued—a pacific Perhaps!' (Norton 1917).

While there is certainly value in recognising von Freytag-Loringhoven as the artist of the *Fountain* (1917) – for both socio-political reasons of representation within the arts and an accurate historiography of Western intellectualism – it is also necessary to admit that von Freytag-Loringhoven was no more the artist of the *Fountain* (1917) than Duchamp. If anything, particularly in light of the temporary loss of the urinal and Richard Mutt to the obscurity of the interbellum years, the art gesture having the most impact on the art historical tradition is actually that of *Duchamp's Fountain (1917)* by Breton (1935). The creative gesture of Norton in

defending the work of Richard Mutt (and indeed that of Duchamp in creating the gesture of *Richard Mutt, artist* [1917]) was, in many ways, entirely unremarkable (and unremarked). Certainly, these creative acts pale in comparison with the readymades of Duchamp, the 'found art' of von Freytag-Loringhoven, or indeed the literary and translation work of Louise Norton (better known by her subsequent name, Louise Varèse). Lost to the margins of the interartefactual project of art, *Fountain* in all its guises, exists as a case study today principally because of André Breton (and the singular photograph of Alfred Stieglitz). In his work, *Duchamp's Fountain (1917)*, Breton (1935) draws attention to a conceptual piece of rubbish, pulls it from the dumpster, and moves the valueless absence into the enduring icon of modernism that we know today.

This chapter explores the dynamic social potential of transformation. In thinking about how one thing can be made into another, and the associated creation (or destruction, or translation) of value, we are highlighting the ways in which this movement of value affect society at each intersection. In this way, the inherent socialness of art as action is brought to the fore. In thinking through the sociality of art, the chapter unpacks the notion of agency, considering how objects and material gestures are able to impact the art of social forms, not simply as conduits of meaning but generative of operative intersubjective sociality. First, we address the ideas of agency as intention versus as it is abducted, then we consider some theoretical interventions into the understanding of value transformation, and then we examine a series of case studies arising from both formal art contexts and wider social practice.

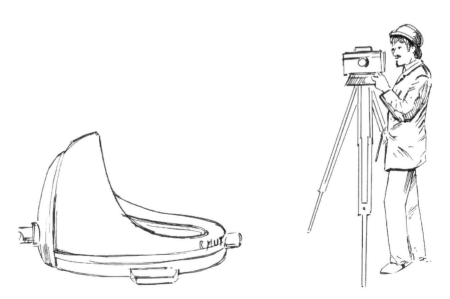

FIGURE 8.1 A dramatized rendering of Alfred Stieglitz photographing the *Fountain* by R. Mutt, 1917.

Agency

Encoded in the animal mind is the evolutionary adaptation to attribute to objects and natural phenomena the intelligence of intention and will. The attribution of intention to things in the world is a safe gamble, and so from the outset of even pre-human society, the possibility of the intentional 'other' has been foundational to how the mind comes to relate with objects in the world. Within the social sciences, the role of the object as an instigation of or catalyst for socio-cultural practice has been a continued realm of debate and interpretation. Similarly, the impact of human will to power over and against another (either as individual or collective) has held significant attention in especially political and ethical enquiry. In framing the interplay of cause and effect within social action, a number of important contributions, such as Latour's (1993) *Aramis* or Gell's (1998) *Art and Agency*, provoke questions concerning the place of objects and technical systems within human society. In *Art and Agency*, Gell offers a model of agency whereby the 'primary' agency from the force of human imagination can come to reside – literally, be made concrete – within indices. This renders them 'secondary agents', and grants to them the capacity to act in the world apart from – by either time or distance (or indeed intention of) – the 'artist'. Gell's model has been critiqued for removing the human too far from focus (Morphy 2009) and for granting too central a role to humans (Ingold 2010). At its most fundamental level, this is a disagreement about intentionality within action, and the degree to which human (and other) players within a scene may have or lack it.

As discussed briefly at the beginning of Chapter 1, agency, roughly defined, is the capacity to intentionally effect change. It belongs to entities (human or otherwise) who act in the world knowingly and intentionally. The term 'agent' – being the person or object acting with intention – sits alongside others, such as 'actor' or 'actant'. Each of these terms point at important implications in the context of the kind of action and the frame of intention. The distinction between actor and actant comes from the Russian folklorist Vladimir Propp (1968). In Propp's work, the actor and the actant were functional categories, designating the role of the character within the plot development of a given narrative. While actors were developed characters with personality traits and roles pivotal to the narrative arc, the actant was used to describe those other characters that provided context for interaction, but did not shape the arc directly. Loosely following this tradition, Latour (1993) employs 'actant' (both of human and nonhuman entities) to address the functional role of mediation or translation: moving something from one status to another. Agentive language differs from this approach by focusing on the role of intentional action or, as discussed further below in Gell's case, the social impact of the interpretation of intention.

Taken in the logic of temporal progress, the production of the object as action rests in the artist's knowledgeable (even magical, see Campbell 2002) capacity to enchant the object with the capacity for action. This action may be carried by iconic representation (e.g. a painting of a king) or by stored energy (e.g. a trap), but whatever the specific material formation, the object is held to be an agent because

136 Following the prototype

of the design intention of the artist. This puts the analytical focus on production and consumption cycles that anticipate human production filled with intention. In rejecting these models, scholars like Tim Ingold (2010) point out that many human actions are not done with overt design intention. More of human life is built on contingency and sequential processing of – what he calls – the generative flow of the world or, following Bateson (1972), what we contend is the learned and nuanced, recursive and incremental action within the ecological feedback loops.

This is a crucial distinction, and it moves the burden of agency from the causal force to the dynamism of feedback. Taken in its parts, this argument rests on the role of double description, and particularly the capacity of abduction to work backwards. On each scale (the artist with skilled gestures of painting or carving, the recipients viewing the index, the interartefactual domain and society, etc.) the social action and response to any given indexical object or action is not based on the intention of the artist. Causation is not known; it is assumed via the messy and instantaneous work of abductive reasoning. As we highlighted in the Introduction, the 'mind is empty' and 'the ideas are immanent, embodied in their examples' (Bateson 1979, 11). So, while the artist does, contra Ingold, often design a hylomorphic model with varying levels of intention (depending, more than the process itself, on the science of the art), and the virtuosity of the artist and their craft does help secure the knowability of the index and the immanence of the prototype, it is ultimately the recipient of action, not the cause of action, that decides if the gesture is agentive.

This interpretative act becomes very important in exploring what art and other forms of social action do. In terms of causal sequencing, it matters less what Person A intends to do to Person B than what Person B interprets Person A to have intended. In the immediacy of social interaction, Person B will respond to Person A based on their intuitive, immediate interpretation of Person A's action. It may or may not be 'correct', but it is this attribution of agency that guides the reaction. From the breadth of ethnographic data, it is clear that humans, in many varieties of ways, attribute agentive action to non-human entities; and that this social fact undergirds the transformations employed in object production. To make immanent in an object any given prototype can be seen as a gamble, wherein the production of value produced through the transformation of material into the new indexical form is done in anticipation of 'successful' (re)presentation to its audience(s). It is in this sense that failure happens 'when objectification ceases to adhere' (Carroll, Parkhurst, and Jeevendrampillai 2017, 2), as the anticipated role of the object crumbles, giving way to the gap before the next invention.

In this context, the drama of Richard Mutt makes more sense, as the failure of *Fountain* (or, alternatively, the failure of the art panel to accept *Fountain*) forced Duchamp to resign from the committee. His invention, his artistic gesture in initiating the art-at-a-distance of Norton's role as actant in Mr Mutt's submission, could not cohere to the art committee's convention. They denied the agentive capacity of Mutt-as-artist, and were blind to the agentive capacity of Duchamp-as-artist. It was not until Breton attributed to Duchamp the artistic agency of *Fountain* that it existed as an index of his artistic gesture.

Agency (social) **137**

Value transformation

The capacity of a urinal to become art is, to no small degree, contingent on the capacity – and here we mean social acceptability – of material form to be transferred or transformed into another form. There are, as Michael Thompson (1979) argues, two possible ways for transformations to occur within society. The first, what he calls an overt transfer, is a pathway of production that is openly accepted and visible within social protocol. This, for example is evident in the transformation of raw foodstuffs into a plated meal, or building material into a new house. The possibility of transformation in a material is the value of that material as the prerequisite for the product. Similarly, Thompson highlights the 'possible transfer' from what he calls the 'transient' category (items having limited and often decreasing value) to waste: for example the eating of an apple produces a core that is discarded. In those cases, such as the art world, where the process of production makes something that should never (at least in the lived memory of society) lose value, the possible transfer of materials from their various states into a 'durable' object produces value (social, economic, etc.) in a spectacular and highly celebrated fashion.

On the other side of social anticipation is what Thompson calls 'covert' or 'impossible transfers'. These processes do happen, all too often, but 'shouldn't', from the perspective of social propriety. He gives the example of the flooding of the Uffizi Gallery in Florence, and this can be seen in the public response to any destruction of tangible and intangible heritage: be it in war, vandalism, or natural disaster. The timeless, invaluable, 'durable' artefacts are proven to be transient and laid waste in a way that is deeply troubling for individuals and societies. However, Thompson also highlights other kinds of impossible transfers, for example the movement of items that are 'waste' to 'transient': the use of rubbish to make food, or as we will see below in Lucy Norris' work, the movement of highly personal items of clothing that – in the context of Hindu taboos around the movement of bodily fluids – 'cannot' leave the household once worn. These 'covert' transfers can be highly productive of value when they move material of zero worth to something of positive worth. But, however often a homeless person does scrounge for food in a dumpster, the possibility 'must' (for the continuation of the good of society) remain 'impossible'; and city ordinances and security measures are all too often put in place to make sure such transformations of value are impossible both in theory and practice.

The possibility and impossibility of value transformation is deeply political. The legitimacy of agentive action to make or destroy value (or conversely the delegitimisation of socially sanctioned acts of agency) filters up from the specific creative gesture of any given action into larger spheres of hegemony, governmentality, and surveillance (cf. Foucault 1977). What is particularly interesting in Thompson's (1979) 'rubbish theory' is the startling, and almost prophetic, alignment between the movement of rubbish within a society and their associated socio-political systems. He writes, in the context of new laws within Europe about commerce and trade, that 'If we assume that our legislators are not all party to a conspiracy aimed at converting us into an egalitarian caste society, we must conclude that they have little

138 Following the prototype

understanding of what they are doing' (128). In a legal context where all routes of production 'were assumed to end in consumption', rather than possibly in waste or durability, the use of value added tax and exemptions 'provides a strong incentive for the switching of goods from the durable to the transient categories and . . . disincentive to the transfers from transient to rubbish to durable' (128). As a result of all (or the vast majority of) material goods being transient consumables, this produces a political sphere where the rubbish category is diminished, and overtly made a raw resource for new production, and the durable category is diminished, making luxury items more widely attainable and consumable. There is, consequently, both lower competition for goods and lower political stratification; however, with the increasingly overt transfers of rubbish – in recycling, or concern about global rates of pollution and landfills – the transformation of value that had previously been covert and socially 'impossible' (and the people whose livelihood is in these covert spaces) are called into jeopardy. As Thompson says, 'the dynamics of the process that allocates people, things, and ideas to alternative cultural categories continually reacts upon the social system that provides its support, transforming it, [and] the social contexts of its constituent members' (129).

Critical to Thompson's theory of value transformation is the idea that materials are circulated via systems of regulation that are analogues of political and social forms. This is because the relation between objects (or raw materials) and value needs to be stable. As John Maynard Keynes (1936) stated in his work on probability theory, there must be some stable factor within an economy, 'the value of which, in terms of money is, if not fixed, at least sticky, to give us any stability of values in a monetary system' (304). Thus, removing both the durable and the rubbish categories disrupts the necessarily asymmetrical system of valuation and social stability. As Thompson notes, the production of value via the movement of durable and rubbish, work within covert transfers, along highly regulated and oblique avenues; as we describe above with the circulation of clothing outside the house via back-door trading with untouchables, in Lucy Norris's example. This setting works socially because the intentions of the parties involved are occluded from social discourse, and thus are not open to intentional intervention.

It is in the relation between intention and its occlusion, in the cognitive apprehension of intentionality, that the idea of stickiness gains traction in Gell's (1998) sense of the term. As he explains, an index entraps the mind via what he terms as 'cognitive stickiness of patterns', which produces a 'blockage in the cognitive process of reconstructing the intentionality embodied in artefacts' (86). The efficacy, that is agentive capacity, of the sticky index rests in the stability of an asymmetrical relation between the three aspects of agency. Developing Gell's theory of agency, we can thus see that agency is a vector, composed of three parts. These are:

1) the abductive inference of the object,
2) the 'stickiness' of the indexical form, and
3) the valuation of its prototypicality.

Agency (social) **139**

While agency arises because of the first element, its force is determined by the second, and its direction of movement is determined by the third. As we have discussed with reference to Nancy Munn's elaboration of value transformations in Gawa – as labour in the garden is transformed via food into noise-producing fame abroad – the possibility to make value, in the fiscal or commodity sense, rests on the possibility of 'stable' – that is, predictable and recognisable, even formulaic – transformation. As in canonical formula, this is a transformation across media of abstract *attributes* and specific *entities*.

Daniel Miller (2008), theorising about 'what value does', argues that 'values are not the plurality of value, but refers to inalienable as opposed to alienable value' (1123) and that the more inalienable something is, the more valuable it is. For Miller, what value does is work to make commensuration between different regimes; it 'create[s] a bridge between value as price and values as inalienable' (1123) such that 'value is most effectively created by its own use as a bridge between what otherwise would be regarded as distinct regimes of value' (1130). This somewhat tautological argument makes more sense in his summarising examples:

> I could compare the evidence [of Jamaican mobile phone use, see Horst and Miller (2006)] with a Greek friend who told me recently how Greek men prolong international telephone calls to lovers to show how they do not care about expenditure when it comes to someone they love. In Greece that represents a generous lover. In low-income Jamaica that same person would be regarded as an idiot, precisely because Jamaicans would have a very different idea about the appropriate forms of value within relationships. It follows that in Jamaica, the mobile phone has itself value [by comparison to landlines] in part because it is used to translate between forms of value i.e. in this case between relationships and costs. This ability to equate the personal relationship with money returned the phone from the aberration of a landline to what, for Jamaicans, was the normal commensurability of value as they understood it. We go on to show how this becomes instrumental in helping highly impoverished individuals and households turn relationships back into the funding they need to survive. . . . Just as securitization creates value by making something available for trade, or local government creates value by translating down tax receipts into specific services, value can be created by the very use of the term to reconcile its own spectrum of association which range from price to priceless, such that value is what value does.
>
> (1131)

The ability to translate between otherwise unequal registers of value is also a question of commensuration addressed by Michael Lambek (2008) in a short but informative article on value and virtue. Lambek argues that, while economic value deals with relative commensurable values – such that at any time one can check the exchange rate between dollars, pounds, and euros, or compare prices of various brands of pasta – this is not true of moral value. Rather, moral value deals with

140 Following the prototype

absolute and incommensurable values. Lambek offers the example of his family playing the board game *Careers* (first manufactured by Parker Brothers in 1955), where the player must, through various stages of a biography along different 'career paths', collect wealth, happiness, and fame points towards a combined goal of 60 total points. Lambek's mother, he tells us:

> inevitably placed her entire 60 points in the happiness category. Her reasoning was that happiness is all one needs or wants in life; if one were happy one would, by definition, be satisfied with whatever wealth or fame came one's way. Conversely, wealth or fame without happiness would be worth nothing. She was a very literal-minded person and it was never much fun playing with her.
>
> (141)

Thus, while Miller argues that values are made commensurable by valuation itself, Lambek argues that not all values are commensurable. In his understanding, a hierarchy of valuation exists, wherein values are arbitrated and made commensurable via their relation to a meta-value. This does not bring resolution, however, it simply pushes the incommensurability to a higher order, as meta-values are not directly commensurable with each other. The resolution, for Lambek, comes in sacrifice, as sacrifice works to bring commensurability. Drawing on Munn's work, he says, 'Sacrifice is a site for the production of meta-value, for the transformation of value into meta-value, and of relative value into absolute value. Indeed, sacrifice may come to index and iconically represent transvaluation itself' (Lambek 2008, 149–150). As a 'productive act', he continues, sacrifice 'exemplifies the power of transvaluation, in which the act of destroying something of one kind of value is actually productive of some other kind of value' (150).

Rubbish art

Within hierarchies of value and meta-values, the shifting political sphere in Euroamerica – brought on, no doubt, in part by the kind of commodity politics discussed by Thompson – the role of rubbish in often highly political acts of artistic production is noteworthy. The Kantian conviction that aesthetics can be Good and help in the improvement of people has taken a turn towards social action. The capacity of the beautiful to be 'purposive without purpose', which became instrumentalised in the Victorian desire to civilise the masses, is made all the more purposeful in the desire for social justice, achieved via representation and participation. This idea of art as social action has been harnessed both in art practice and in the anthropological theorisation of art, often deliberately clouding the distinction between the two (Schneider and Wright 2006; Flynn and Tinius 2015; Sansi 2014).[1]

1 For an alternative perspective, which outlines some of the close and productive partnership between anthropology and art curation, see Schacter (2021). In arguing for 'the curatorial' as anthropological method, Schacter offers a perspective that, in our reading, allows the anthropological enquiry itself to become part of the involute prototypicality of the exhibitions and individually commissioned pieces curated as part of anthropological research. In this sense, the works Schacter curates are prototypical models in their own right, both of anthropology and of the exhibition's subject.

Agency (social) **141**

This emphasis on practice and action in art interventions obviates the material in favour of the performance of social justice, thereby rendering the act of justice itself to be 'art', conflating the artistic and political spheres. The repercussions of this are particularly relevant in terms of the virtuosity of the artist and the object, as rendering 'justice' as 'art' shifts the technical skill and the register of valuation from the artefactual to the moral. It thereby removes the logic of the artefactual, placing the burden of efficacious action in the immediacy of social action. In this way, the de-artefactualisation of art, like in the rejection and disposal of *Fountain*, the art is lost. It is only in the photographic record and the eventual reproduction of *Fountain* in the 1950s and 1960s that Duchamp's conceptual art is known. This highlights the critical and dialogic relation between the material and the conceptual in the practice of art, which does not merely reflect society, nor act as catalyst, but rather demonstrates the resistance of the material to comply with intention. The material and the conceptual are related in such a way as to not allow one-to-one correspondence, while intention is always the work of bricolage (Lévi-Strauss 1966) in that it is limited by what it knows and the resources available; both materials and concepts are complex and unruly devices.

This can be seen, for example in the work of Vik Muniz, a New York-based artist from Brazil. In the documentary *Waste Land* (Walker, Jardim, and Harley 2010), the process of Muniz's art intervention is traced from inception through the various stages working with the *catadores* (who work in the landfill sorting recyclable material) and photographic practices, to the eventual gallery exhibition of large art-quality photographic prints. Each of these prints was a portrait of one of the *catadores*, framed as an homage to a famous work within the European classical art canon. In preparing one of these prints, *Marat (Sebastião)* (2008), we see a dialogue emerge between Muniz and the leader of the Association of Catadores (*Associação dos Catadores*), a young self-taught man named Sebastião Carlos dos Santos. After finding a bathtub amongst the mounds of rubbish in the Jardim Gramacho north of Rio de Janeiro, Muniz suggests dos Santos be 'made' into Jean-Paul Marat after the dramatic portrayal of his assassination seen in Jacques-Louis David's *La Mort de Marat* (1793).

In the first stage of *Marat (Sebastião)* (2008), dos Santos is dressed in a head wrap, and positioned with garbage bags and a scrap of paper in the bathtub, amidst the refuse of the landfill. Much like the pageant of masters, this performance-piece recreation of David's painting was then photographed by Muniz. Subsequently, Muniz had truckloads of rubbish from the Jardim moved into a large warehouse in which a recreation of the photograph was made on the floor of the room. This temporary installation, wrought on the floor-as-canvas of 12 by 18 metres, used dirt shading and various items of rubbish to paint the image from the first photograph such that it could be transferred into a second photographic image, taken from scaffolding 18 metres above the floor. This second photograph is what was then rendered as a digital C-print for gallery exhibition in Europe. In this way, the image moved from live-action recreation, through a standard SLR photograph, to a three-dimensional installation rendered in refuse, to an art-quality photograph made for exhibition.

142 Following the prototype

The movement between two- and three-dimensionality of the image is interesting, as is the purification of artistic form though the stages of transformation, but what is more interesting for our purposes here is that the refuse used to make the second image was returned to the landfill upon completion. While Muniz's work is overtly about rubbish, and making the worthless and forgotten visible and memorable, no actual trash ever left the Jardim. The prints sold in galleries, *Marat* selling for £28,000, and the money was given to Sebastião's association. In the ensuing years, faced with plans to close down the Jardim, Sebastião used the money to help relocate his colleagues into new places of employment. In the long run, the financial value created via Muniz's intervention was able to ensure that the *catadores* avoided the risk of unemployment. However, there is something striking in the parallel between the truckloads of rubbish being returned to the landfill and the *catadores* collaborators also returning to the landfill. While there are many examples of rubbish entering the gallery (and many examples of gallery cleaning staff returning it to rubbish), the fact that Muniz makes visible the social reality of the rubbish (each being a portrait of a *catador*) makes for a very purified transfer in terms of the material form that appears in the gallery. Ultimately, the digital print was in no way transgressive of societal conventions for art, nor was the social framework for the *catadores* transformed.

Circulating impossibilities

Take, by contrast, the account of social practices of covert transformation and the role of outside intervention seen in the work of anthropologist Lucy Norris. Norris tells a story of the resonance between discards and museum collections, both items that have been removed from circulation (Norris 2010, 89). Priya, a widow in her 80s, once living in a well-to-do household in the suburb of south Delhi, now lives with her divorced daughter. She is in possession of a much-worn richly embroidered waistcoat and wants to sell it to get a modern frying pan. She tries to exchange the item for a frying pan using the services of a doorstep trader, from the untouchable class, who usually manages such transactions, but the waistcoat was of lesser value than the frying pan. To alleviate the disappointment of her informant, Norris eventually purchases the item from her for the value equivalent to the metal threads embroidered into the garment and places it into an exhibit on Indian recycling and value.

The case of clothing in India shows that the invisible is not solely conceived in cosmological terms, as here the attention is directed to the qualities of fabric to absorb bodily substances that link a person indelibly to their clothing. Clothing here is in a permanent semiophoric state, as it links the inner, invisible, and hidden parts of persons with their outer appearances. It is, as a result of its inherent relational nature and transformational potential, that clothing is at once valued and feared in India, as Norris (2010) observes in her study of the attention directed to managing clothing both on and off the body. Cloth wealth is valued in India as the portable form of the dowry that offers women independence, at least theoretically,

as in practice the wardrobe's content of sari manifests the body politic of the household a woman is married into, its possession being subject to the complex relations comprising the household and its changing constitution over time (Tarlo 1996). For Norris, an 'archaeology' of the wardrobe in well-to-do Delhi households revealed not just the extent of the attention paid to the management and care of clothing kept behind the stainless-steel doors of wardrobes, but also to the undoing of the relations between cloth, the body of its wearer, and the social body of the household. Cloth, once worn on the body or used by the household, is not permitted to cross the threshold of the house. Cut into rags and literally ground down until only threads are left, the only other way that cloth can leave the house is via a covert exchange with stainless steel pots managed by persons from the untouchable class on the threshold to the house.

The transfer of used clothing from use to new product via a process of recycling is covert – that is, it is not publicized or commented on even by those within the household. The clothing taken by members of the untouchable caste from the doorstep re-emerges on the street in the hands of traders who separate it into three categories. There is 'foreign' clothing that can fetch a higher price, carefully washed, ironed, and restored to newness; clothing restored and sold to the poor; and clothing that is beyond restoring and taken to the wholesale market. Once there, clothing is sorted by colour; treated to remove silver threads, labels, and buttons; and prepared into new threads by giant machines, before being rewoven into new products, such as baby blankets and suits. The newness of the products hides the prior existence of their material, while the category of object selected for production from recycled fibre, associated with new life in different and yet analogous ways, reflects the association of fabric with renewal.

Clothing the world over is demanding of actions that draw attention to ideas of ways of being in relations that are immanent to the body politic. In Vanuatu, a group of islands in the southern extremities of the Bismarck Archipelago to the west of New Guinea, fabric-based clothing has continued to be associated with moments of transition (Bolton 2003a, 2003b, 2005). Weddings are the chief occasion for wearing voluminous and body-covering, floor-length dresses known as Mother Hubbard or Island dresses, yet the same dresses are shunned as unsuitable for everyday wear as they restrict women's movement, making participation in gardening and other actions that inform a tightknit system of labour and loyalty impossible. Fabric-based cloth and clothing is here decidedly bound up with events that mark the biographical lifespan of persons in ways that intersect with the mapping of time afforded by clocks and calendars and other time-sensitive instruments that arrived with missionaries. Like the dresses themselves that do not age or change in style, the time mapped by events at which dresses are worn is repetitive and recursive as it marks new beginnings that are marked by their uniformity. Cloth and clothing in Vanuatu, thus, are consigned to intersections of the body politic with the modern nation state. The choice of white reflective cloth and richly patterned cloth, both working in an apotropaic manner to deflect external forces while keeping the body beneath unaffected behind the voluminous folds of the cloth, is notably similar to

144 Following the prototype

other areas in the Pacific where missionary dress has been taken on as public attire (Colchester 2003).

The differential take-up of ready-coloured and printed cloth and clothing across island Pacific societies throws into sharp relief the understanding deduced from objects that force a consistent intersubjective engagement with their materiality and form. Consider the bark from the paper mulberry tree that furnished cloth-like materials prior to the arrival of woven cloth. As non-woven fabric, barkcloth was of brief interest to western science at the end of the 19th century when it seemed to promise a future of fabric beyond the loom. In fact, however, far from being generic, barkcloth from the Pacific is distinguished by how strips of bark are attached to one another to make larger fabric used as ceremonial wrap of bodies and objects destined for ritual performance. In Fiji, where barkcloth, called *masi*, is still produced today as the main staple for exchange and ceremonial use, strips of bark, once prepared through beating, are fastened to one another with a glue-like sap and covered thereafter with stencilled patterns that emphasize outer borders and internal partitioning.

In the Cook Islands of Eastern Polynesia where barkcloth has been wholly replaced by imported, ready-coloured cloth used for the production of large coverlets that are exchanged and wrapped around the dead in the grave, strips of barkcloth were beaten into each other so as to create a felted, seamless fabric. Barkcloth in Eastern Polynesia and especially in the Cook Islands was elaborately stained and hand painted or superimposed with a second layer of barkcloth with iteratively arranged geometric cut-outs. The manner of conjoining barkcloth in these two island societies resonates with diverging ideas of the nature of social relation. In Fiji, relations are associated with labour and loyalty and are thus thought to be additive in nature. Conversely, in the Cook Islands, relations are thought to be pre-hermeneutic, that is, conditioned by genealogy alone in ways that collapses the identity of a person with his or her apical ancestors. It is also notable that in Fiji the acoustic resonance of bark beating is foregrounded, matched only by the sound of Singer sewing machines, while in the Cook Islands where perfume for use in wider Polynesia is produced, the olfactory associations provoked by colour is attended to with equal vigour (Thomas 1995, 131–151).

The study of the take-up of cloth and clothing in the Pacific outlined above shows that, if there was any attempt by colonial and missionary forces to impose a new aesthetic via the distribution of pre-coloured and pre-patterned cloth, it quickly ran up against local understandings of how cloth works and what it does. These understandings, grounded as they were in Polynesia in practices of containing life-force or *mana* via the wrapping of the body in a second skin removed at death, informed the way cloth was acted upon. This way of acting upon cloth, selectively taking it up, combining it with existing cloth, or transforming it to harness its connective potential, in turn created an aesthetic that became the touchstone for new and recognizable ideas of ways of being in relations perfect for the transnational communities springing up in the Pacific diaspora. Wherever Fijians or Tongans go, so does their barkcloth (Addo 2013), and no Cook Islander would long be without

Agency (social) **145**

a *tivaivai* coverlet made from cut up and re-stitched pre-coloured, woven cloth (Küchler and Eimke 2009).

This, however, prompts us to consider the relationship between the capacity of people to act with intention – that is, their agency – and the materials through which and upon which they act within the larger socio-political frames of action.

Circulating possibilities

Whereas the understanding of 'art as social justice' rests in the assumption that the material is merely a mediator of social agency, the work of Fourth Nations Peoples, wherein their subaltern status means all action must be covert, produces a context that forefronts the material artefact as the driver of intention and change. Nelson Graburn (2004) makes this argument for Inuit art, which he argues to have reformulated an aesthetic imposed on the region by tourism into the Canadian North popular during Victorian times.[2] Inuit art has thus been able to express distinctiveness from the nation state and situate itself as emblematic of the Nation's identity within the world of nations. Moving on from his earlier writings on tourist art, Graburn uses Gell's idea of aesthetics as giving agency to objects to reappraise how post-colonial indigenous aesthetics mobilizes an active relation with the state via an art world of international artistic, economic, and political importance (Graburn 2004, cf. Graburn 1976). He shows how the Canadian Inuit were critically engaged in complex negotiations in addition to being the subject of many complex negotiations between many of the key administrative institutions that were stakeholders in the fashioning of the image of the modern nation, especially the Hudson's Bay Company and the Canadian Handicraft Guild. Not only did the art enable the Inuit to make money, but it also is the agent for fulfilling the desires of the intersecting personnel of these institutions, building discursive constructions around the objects they were producing, and commissioned to produce, constructing new social values in spite of the many misunderstandings and mishaps that happened along the way.

Such positive framing of the kind of work that art can do – even if made in conversation with a partially or wholly incompatible aesthetic – can be compared with earlier work by George Marcus and Fred Myers (1995) that had portrayed a negative and largely passive image of a 'traffic in culture'. Framing the trade in art as inspired by values inimical to the values born out of the societies from whence the art originated, Marcus and Myers framed an environment from which any respectable artist and ethnographer were advised to stay clear. One could object that they had not yet heard of the story of the Canadian artist James Houston, retold by Graburn, who 'discovered' Eskimo art, as it was called in the 1950s. Houston's interventions led to the creation of an 'industry' of Inuit art and the unfolding events during which a collaborative production of art came to emerge as testimony to successful

2 See, in fact, the whole special issue edited by Nelson Graburn and Aaron Glass (2004), in the *Journal of Material Culture*, Vol. 9, Issue 2.

146 Following the prototype

indigenous collaboration with outside agents, resulting in self-confidence gained from running cooperatives (Myers 2004).

Myers's (2002) own experience with comparable collaborative productions engaging with the art market in Australia had arguably painted a very different picture. Myers describes institutions set up in the Australian outback to support the production of indigenous artworks for sale that had left artists financially dependent and emotionally jarred, for here the socially shared ownership of ideas made manifest in artworks failed to gain institutional and state recognition. The economic and political traction that collaborative production and cooperative ownership brought with it in the Canadian North is strikingly absent from the narrative of the production of Australian Aboriginal Art. Arguably, partly because of the negative image indigenous collaborative productions and cooperative ventures with outside agents received as a result of Marcus's and Myers's depiction of such activities as 'traffic' passively suffered by indigenous peoples, a large-scale comparative study of models of collaborative production and cooperative institutions has not yet been undertaken. This, one could argue, further disenfranchises indigenous communities who see themselves forced to retrench into obscurity by obviating the agency of their productions.

One case of such obviation is seen in the *tivaivai* or *tifaifai* coverlets of eastern Polynesia. Here women had taken over the practices surrounding the secondary burial with the acceptance of Christianity, and, supported by missionary wives and aided by Chinese traders, begun to stitch huge coverlets, overtly for burying the dead, and covertly for exchange. Women in the Cook Islands today work in sewing bees that have their own bank accounts, used for purchasing the cloth required for the coverlets and for replenishing the households of women in the group, so much so that all interiors of houses inhabited by the members of a sewing bee look very much alike. There is no sense in the extended literature on the coverlets that there is an economic and even political side to the intensity with which sewing is attended to in these island societies (Poggioli 1988). The covertness with which the sewing translates into credit and coverlets translate into money even extends to women's own perception of their work, which they intensely protect from outsiders.

There are no *tivaivai* for sale on the local market on Rarotonga, in the Cook Islands, and the only trace of local patterns are unstitched cut-outs quickly fastened onto a background in the size of cushion covers. The control women exert over their productions and exchanges is total, and while the coverlets travel far and fast, following Cook Islanders wherever they go, there is simply no interest in opening up these exchanges to outsiders. A German-born fibre artist, resident in the islands for over 30 years, tried to train up women to sew items for the simple purpose of selling them to an overseas client base, yet found barely any resonance. One reason for this is of course that women in the Cook Islands are running hotels, shops, and most institutions, alongside sewing large *tivaivai* for competitive and family exchanges every free minute of the day and night. There is plenty of well-paid work to be had in the islands, and women simply do not see the point why they should sew in return for money, when sewing in fact works to operate a credit-bearing and credit-clearing system of great efficiency.

Tivaivai wrapped around the dead and deposited in the cemented and tiled tombs, positioned directly in front of the family home, are referred to by Cook Islanders as their 'bank account', thus inviting a comparison with the immobile large stone boulders situated in front of houses to signal credit worthiness among the Yap in Micronesia (Furness 1910). In this way, the object – be it the Yap stone money or the *tivaivai* or objects in the 'canonical art' world – are entities that move and extend value, and thus work as objects of commensuration between radically incommensurable regimes of monetary, ethical, and idealistic value. It is this value, and specifically the abductive inference of its future capacity, that allows agency to be enacted by objects.

Summary

The concepts of agency and theoretical approaches to the efficaciousness of art are numerous and problematic to varying degrees in terms of the assumptions implicit within their framework. While much of the debate has rested around the question of intention, placing intention completely in the social or denying its importance entirely, they assume egocentric and anthropomorphic impetus. The problem, however, is that the vector of action can only make sense, indeed can only come into being, within relation. It is not a vector, with point of origin and infinite direction, but rather a measure between two points: that of the artefact and that of the mind.

In recognising the vector-like qualities of agency – that it is born of the inference of intention, takes hold via the enchanting stickiness of the index, and has the valence of the prototypical immanence – the futurity of the object is more clearly understood. Like in the case of the Yap stones and the Cook Island *tivaivai*, the *regalia* of the French monarchy was saved from the same fate of the French aristocracy by the argument that the *regalia* should become the property of the French people, and, thereby, it would legitimise the new state as an entity (indeed, one with future credit-clearing capacity) amongst its European peers. It is some irony, then, that even as Thompson was writing his critique of the oncoming rise of an egalitarian caste system in Europe as the European common market was still in its growing pains, that we are now writing this as Greece has suggested that the Parthenon Marbles be returned to Greece as part of the post-Brexit EU–UK trade negotiations. The agency of the object is bound up within the future credit-bearing potential of whoever controls them.

The next chapter is also the opening of Part III. Part I situated the object as a relational thing and framed the theoretical basis for understanding the art object. Part II explored the methodological implications of this relational ontology, using ethnographic case studies to draw out further theoretical implications. Part III turns our attention back to the object, looking at the constituent parts of the object in the formation of its agency.

PART III

Rediscovering the object

9

MATERIAL AGENCY

As materials go, hair is a strange one. Readily available to (at least most) humans, it is characterised by various fashions and taboos, being something both inside and outside the body, deeply personal and easily modified, being intimately inalienable and yet easily partible. As a material with a natural sheen and certain strength, it also lends itself to artistry, both on and off the body. As a material of beauty and inalienable partibility, it also lends itself well to use in memorial jewellery. The making of hair jewellery, common in Euroamerica up through the beginning of the 20th century (when the luxurious locks of the Gibson Girl were shed in favour of a boyish bob), was done on both industrial and domestic scales. Jewellery companies advertised hair brooches, earrings, or bracelets alongside diamond work and gold pendants.[1] Ladies' journals ran articles discussing the virtue of hair as a memorial object, and offered helpful guidance on how to gather one's own hair from off a comb, then collect, wash, organize, and weave it at home during an evening in the parlour. Godey's Lady's Book, published in 19th-century Philadelphia, extolled the virtue of hair, saying: 'Hair is at once the most delicate and last of our materials and survives us like love. It is so light, so gentle, so escaping from the idea of death, that, with a lock of hair belonging to a child or friend we may almost look up to heaven and compare notes with angelic nature, may almost say, I have a piece of thee here, not unworthy of thy being now' (Godey's Lady's Book 1860). In the high-fashion market, vendors collected hair from European peasant women (Scandinavian blond was particularly popular), but as a personal token, the hair of family members was given to close kin. For example daughters leaving the home in marriage may give an item with their hair to parents, or a son leaving for war would give a brooch to his mother or a fiancée. One particularly interesting use of hair is in family

1 See for example the Bernhard & Co. Catalogue, New York, 1870.

152 Rediscovering the object

memorial wreaths, wherein hair – shaped as a bow or a flower – from each member of the family may be added to the memorial box as they die. These wreaths, usually kept in shadow boxes, literally kept the family together, over generations, in the family home.

With exuviae of loved ones, departed to war, or gone to heaven, the material is, as Godey's suggests, a deeply affective and intimate substance. The beautifully woven, delicate yet durable pieces of hair ornamentation work with the ready availability of hair – in a period when all women kept long hair – and offer a visual and tactile intimacy with the substance and likeness of the departed in a period when photography was still limited (and black and white). However, what we would like to suggest here is that it was not simply the convenience or ready availability of the material that allowed it to have such deep emotional, affectual, and memorial values attached to it. Rather, the material qualities of hair allowed it to become part of social practice in such a widely practiced and intimately relational way.

The chapters of Part II developed the relational and generative capacity of art, as the style and virtuosity of the object and artist, and the aesthetic judgements and perceptual framework of art, means that art is action. This agentive capacity of objects moves, as we showed in the previous chapter, the human intentions in diverse ways, playing on the capacities of the materials and forms being used. Now, in Part III, we attend closely to these capacities, investigating what it is about the material of art that allows it to do things. In this chapter, we begin by outlining some of the theoretical debate around the capacity of materials to be social actors, and attempt to bring a few divergent strands of theory together in a way to frame a coherent theory of material indexicality (Carroll 2018; cf. Küchler 2005b). The chapter discusses a number of case studies and perspectives to draw out the importance of materials for the concretisation of prototypical ideas.

Stickiness

We have, in previous chapters, outlined Gell's model of the art nexus and the importance of abduction within it. Within this framework, Gell (1998) highlights the importance of index's material in discussing the idea of 'cognitive stickiness', which is defined as the index's ability to create 'blockage in the cognitive process of reconstructing the intentionality *embodied in* artefacts' (86, emphasis added). In building on his theory of enchantment (1992b) and art as traps (1996), Gell describes how the viewer (recipient) of an object is able to abduce the artist, by way of the artist's virtuosity manifest in the materials they have worked. In some cases, such as the rice-flour *kolam* used as apotropaic designs in India (1998, 84ff), the index's cognitive stickiness rests in the formal quality of the motif; the continuous interloping line of soft powder laid out in even, smooth gestures catches the attention and holds it in the looping pattern. In other cases, though, Gell alludes to a more influential role of the material used in the index. In summarising his earlier work on captivation and enchantment, Gell argues that:

The raw material of the work (wood) can be *inferred* from the finished product, and the basic technical steps – carving and painting; but not the critical path of specific technical processes along the way which actually effect the transformation from raw material to finished product.

(71–72, emphasis added)

Captivation, which he defines as 'the demoralization produced by the spectacle of unimaginable *virtuosity*' (71, emphasis added), arises in the viewer in that while it is clear what material is used, and the technical expertise is clear, the object is impenetrable in terms of the specifics of how it was achieved. In using the words 'virtuosity', 'inferred', and 'embodied in', Gell lays the groundwork for further investigations into the specific capacities of materials in society.

We have, in Chapter 5, already discussed virtuosity at length. It is, in the work of Franz Boas, a quality of the artist/craftsperson that through their mastery and knowledgeable skill comes to rest in the form (most often surface) of an object. It is thus a quality of both the person and the artefact and, importantly, requires the automatic control of the medium of craft. The virtuoso knows the material and has intuitive command of its variable textures, strengths, permissions, and possibilities. Virtuosity as an apprehensible quality of an object arises when the craftsperson manipulates the media in specific ways that capitalise on the desirable qualities inherent in the raw materials. Thus, the visible face of the object evidences the virtuosity of its pedigree.

In this vein, it is important to stress that the ability of the artefact to do things is not attributed to the object, but rather arises from its material. In Küchler's (2005b) work on Cook Island quilts, discussed more at length below, she links the ontic (what something is) to the epistemic (what knowledge it elicits), highlighting how cloth (on and off the body) 'is uniquely capable of elucidating ideas about who we are and how we should behave' because threads 'are a frame for ideas whose enduring effects belie fibre's frequently ephemeral nature' (189). In discussing the shredded and stitched fabric of the *tivaivai*, she says:

> The material resonance of such shredded and restitched cloth with death and ideas of renewal shows most clearly that the iconic and the indexical is not just *ascribed* to generic cloth things, but is an intrinsic part of the fibrous, fragile, and transformative property of cloth made from introduced cotton which shrinks, tears and yet can be reassembled in ever differing ways.

(176, emphasis in original)

Fabric's unique materiality enables it to work in unique and critically important ways within the logic of social form; it does not simply represent, but demonstrates and makes manifest cosmological and epistemological operations (Küchler 2003, 2005b; Küchler and Eimke 2009). Fabric can be manipulated, perfumed, folded, draped, wrapped, and moved; each of these aspects lends itself towards being linked

154 Rediscovering the object

with images of life cycles, the dead, genealogical production, sacrosanct time/space, and the home (Carroll 2017).

The *intrinsic* quality of fabric's iconic and indexical social capacity, or what elsewhere is paraphrased as 'the indexical qualities inherent in the material' (Carroll 2018, 12), builds upon Gell's framework and its heavy reliance on the inferential abduction of qualities embodied in art-like objects. However, in the movement from Gell's 'embodied in' to Küchler's 'intrinsic', a shift in understanding can be seen. Küchler's 'intrinsic' edges towards the end of a continuum wherein non-human things are recognised to have a greater capacity for agency, separate from (and preceding) what is attributed to them by people. Put simply, materials have a pre-social quality, which they bring to human society (Drazin and Küchler 2015). This ontic quality of the material is of epistemic importance, as it motivates modes of thought and action – a correlation between meaning and action akin to Morphy's (2009) critique. The intrinsic qualities, however, do not determine the social action of the material; rather, the qualities 'allowed it to materially translate' ideas and performances (Küchler 2005b, 189). It is, for us as it is for Gell, still ultimately in the apprehension of the viewer (recipient) that the inherent indexicalities come to bear. Different materials, while having the same indexical qualities, may have different aspects brought to the fore to highlight or suppress particularly salient cultural modes of thought.

Material affordances

In shifting the locus of investigation from the role of human intention to that of material capacity, the language of agency becomes somewhat problematic because of the epistemological burden the word caries. As with 'actor' and 'actant' in the previous chapter, shifting to the language of 'properties' and 'affordances' of the objects and their materials allows for a discussion of the role of materials in society while avoiding some of the issues about intention and design.

The term 'affordance', coined by psychologist James Gibson (1979), describes what the object (and specifically the surface of the object) enables a person to do with it. A chair, because of its form and strength, affords someone to sit upon it. The properties of materials afford different kinds of action; two chairs, even if they look identical, may have different load-bearing capacities if made out of different materials. Properties, says Gibson, 'would be *physical* properties of a surface if they were measured with the scales and standard units used in physics. As an affordance of support for a species of animal, however, they have to be measured *relative to the animal*. They are unique for that animal' (127). This relationality at the heart of Gibson's notion of affordance becomes more complex when he moves from the ecological dynamics of animals to the 'modified' environment of humankind. Here Gibson aligns reciprocal affordances between, for example the male and female, the mother and child, the predator and prey (135).

In that 'what the male affords the female is reciprocal to what the female affords the male' (135) necessitates the perception 'of these mutual affordances',

some have read into Gibson the importance of the historically contingent and socially constituted nature of affordances. And while the possibility of an object to be recognised as a chair is contingent on social norms of what a chair is, it is important to remember Gibson's point that 'to perceive an affordance is not to classify an object' (134). Arguing that perception works on the level of affordances, not classification, Gibson emphasises the open possibility of what materials and objects may be able to achieve. In addition to what is achievable in the reciprocal affordance between person and person, person and object, or animal and environment, there is also the possibility of harm or 'negative affordances' (137). This is the possibility of poison, conflict, or death, which is also available in the meeting of surfaces. However, there is also the possibility of affordances that are unanticipated, unknown, unplanned, and – in Thompson's sense – 'impossible'. In this sense, Gibson's model needs to be expanded to allow for the 'figural excess' of materiality (Pinney 2005), which behaves in unexpected ways, and for the ways in which objects that have been chosen for specific affordances fail to cohere with the intended reciprocal actions (Carroll, Parkhurst, and Jeevendrampillai 2017). Any given material, then, may have a wide array of properties, with a variety of possible affordances, some known and some unknown. These affordances, when met with a person of virtuosity, become realised and enacted.

The apprehension of affordances in a material, and the subsequent use of an object based on the intuitive sense of what an object affords, is like Gell's theory of the abduction of agency in so far as the recipient of the index responds to the aspects of the object (or surface) that are deemed affordable. Shifting the focus to affordances, however, helps open up the terrain of what is 'inherent' and 'embodied in' the object. By highlighting both the physical and the relational registers of properties, Gibson gives us a more detailed framework by which to approach the object. In the period of time before abduction, the materials already exist in ecological relation, each with physical properties that coalesce in specific configurations, making surfaces for human engagement. It is into these configurations, or what Gell (1998) calls the 'causal milieu' (37f), that social agency is enacted, and the artist, acting with virtuosic intention, must be able to apprehend the properties and affordances of the materials at hand to render the index in a way that will make the prototype immanent in the presence of the recipient. But what this leaves to be unpacked is the way in which the choice of which specific materials to use is not one of symbolic attribution of value. Rather, there is the mutual recognition of affordance between the artist and the surface, allowing for the kind of transformations demanded in the relation between prototype and artist. The prototype puts certain constraints on the artist, and it is these constraints that guide the artist's choice of materials. As such, the relation between prototype and material is one of causal and logical relation, not socially constructed attribution. There is no external referent to the material; it is inherently indexical to its immanent prototype.

The rest of the chapter unpacks this complex idea of material indexicality through a series of case studies focusing on the materiality of surfaces within distinct social forms.

156 Rediscovering the object

Surfaces

We have, in the preceding chapters, already alluded to the proclivity of materials to exude what is relational about actions and their products. There is the hard wood chosen by the Kuna shaman to fabricate the portal, in the form of a miniature likeness to a human body, into the hidden realm populated by different beings and life forces that share the same soul or spirit, or rather have a common 'internal human form' (Viveiros de Castro 1998, 471; Fortis 2010, 483). It is via the wooden figurines that the shaman can access this hidden realm and restore relations between the inner and outer, the visible and invisible, and thus make a 'proper' human body resistant to metamorphosing in alternate subjectivities.

The body in Amerindian societies is the essential medium for the reproduction of human sociality and yet the body is not considered fully human at birth, requiring actions upon the body of the newborn to neutralize the predatory action of animals and spirits towards the baby (Lagrou 2007 in Fortis 2010). It is, as Fortis says, paraphrasing Viveiros de Castro (1979), 'society that creates the body' (Fortis 2010, 482). Processes of creating persons thus require the creation of human bodies first. Thus, social interventions on the external visual appearance of the body are to be understood as part of the creation of the body itself, and the fabrication of human bodies in turn is central to processes of creating persons. For the Kuna, Paolo Fortis shows how design, body, and personhood interlink in complex ways, logically connecting and foregrounding the potential of the wooden carved figurine (*nuchu*) and the applique fabric of women's blouses (*mola*) to restore the social body. His writing about the centrality of design in Amerindian social imagination draws out the logic inhering in materials that link the amniotic sac left as trace on the head of a newborn with enveloping materials that can be incised, cut, and stitched.

The inherent relation between fabrication of human and social bodies and their decoration has been a classic theme in anthropological theory drawing on Amerindian ethnography since Claude Lévi-Strauss's essay on Caduveo face painting (1955). Lévi-Strauss drew from this study the idea that the two-dimensional character of graphic designs imposed on the skin and the three-dimensional plastic form of the body are linked in societies where social persona and subjectivity unite. Gell (1998) later argued that this idea is likewise applicable to much of Polynesia and South America where skin decorations are an integral part of persons, indissolubly linked to their social and, thus, mortal condition (194–195). His own work on the epidemiology of tattooing in Polynesia (Gell 1993) explored the logical relation between the modality of the process of tattooing, the relative permanence of the tattooed skin, and the distinctive articulation of social hierarchy.

In Polynesia, as in Amerindian societies, the human skin is the material that binds as it envelops the subjective to the social and the invisible to the visible in ways that are accentuated by the decoration of the skin. Ann-Christine Taylor (1993; 2003) noted the importance of face designs for the Achuar of Ecuador in showing a person's association with an ancestral soul (*arutam*). Achuar people, who regard red face painting as a sign of prestige for men and women, keep the identity

of their mystical companion secret, as the 'inner double' is thought to 'intensify subjectivity' via enhanced health, fertility, and longevity (Taylor 2003, 238). For Melanesia, a similar observation about the importance of decorating the skin was made by Marilyn and Andrew Strathern (1971) in their work on body decoration in Mount Hagen. Yet, although the decorated skin is here also indicative of health, fertility, and longevity, its relational axis is directed outwardly to demarcate the social group rather than a hidden alter ego, as the orchestration of design across persons is emphasized rather than the internal and subjective state of the social person.

It is for reasons of the actions they permit that transform a generic surface into a pattern that certain materials, such as wood, bark, stone, and ready-woven and coloured fabric have affinities with the skin of the human body whose manipulation and marking is essential to the fabrication of the social body and the elicitation of ideas of personhood. Prefiguring this idea, the previous chapter showed how bark is worked differently in Melanesia and Polynesia to create cloth, as strips of bark are either glued together, creating large fractal and partible surfaces, or beaten together, creating equally large felted surfaces that cannot be divided. We showed that these two distinct modalities of action map ethnographically on distinct ways of envisioning the intergenerational constitution of persons and social groups, permitting or precluding the partibility of persons and the extendibility kinship. As also already mentioned in the last chapter, felted barkcloth, manifesting materially and visually an idea of non-partibility that extends genealogically from the named ancestor to the living persons and contemporaneously to all those able to trace a connection, genealogically speaking, to named ancestors, was substituted for in its ceremonial role by woven cloth only in Polynesia.

In Polynesia, from Hawaii to Tahiti and the Cook Islands, various techniques of cutting and stitching woven cloth lead to distinct types of coverlets known as *tifaifai* or *tivaivai* (Arkana 1986; Hammond 1986; Jones 1973; Poggioli 1988; Rongokea 1992). There are three distinct actions upon woven cloth, and their activation overlays neatly onto distinct ways of reckoning genealogical relations. In Hawaii and Tahiti, genealogical relation to divine ancestral power is a matter of birth alone, distinguishing younger from elder brothers, while succession to positions of rank is achieved, rather than acquired, through birth. Here, the double nature of subjectivity and social identity is manifest in cutting a pattern into folded cloth and sewing the resulting symmetrical design onto a differently coloured background, creating a visual illusion of pattern existing simultaneously as foreground and background.

In Tahiti and the Cook Islands, where contemporaneous relations between households of brothers and sisters form a significant political and economic unit, cloth is also cut into numerous, self-similar designs that are sewn onto a backing to form rotational patterns in applique-style coverlets. Only in the Cook Islands, where genealogical reckoning is made doubly complex by a second factor, added to that of birth – this being the path taken by an apical ancestor on arrival to the island – a third type of action upon cloth exists (Küchler 2017).

This third type of action consists in the shredding of cloth into longitudinal strips and the cutting of strips into identical geometric shapes that, in their thousands, are

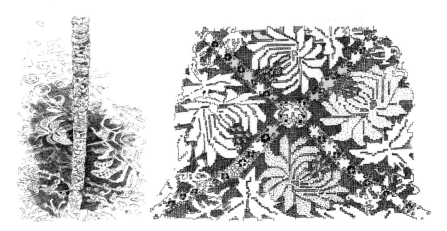

FIGURE 9.1 An example of a patterned *tivaivai* and the colour squares strung on a string, ready for assembly, after photos by Susanne Küchler.

being stitched into iteratively replicated and transitively arranged motivic elements to form a patchwork. Gifted during life, coverlets, wrapped around the dead and lowered into a tomb-like grave in a manner, underscore the unity of the dead and the living and the sense of the indivisible encompassing multiplicity manifest in the stitching of patchwork. The making of coverlets as shrouds for the dead started with the arrival of Chinese traders in Hawaii in late 1700 and moved from there alongside other ideas and practices, such as Christianity, to Tahiti and the Cook Islands. In the Cook Islands, woven cloth is still acquired from China, and the type of cloth that is preferred is course and roughly woven (Küchler and Eimke 2009).

Every island in the Cooks has its cloth store, multi-coloured threads for embroidery of applique coverlets and reams of different colours of cloth that is, and this may strike one as counter-intuitive, not colour-fast.[2] When purchasing cloth for the fabrication of a patchwork coverlet, women complain that cloth is no longer as good as it was in the 1970s when they started out as young women making patchwork coverlets. Then it had been so roughly woven that it could be ripped into thin strips that in turn could be cut into shapes and resewn into motives containing a greater number of coloured pieces than is possible today. But, at least, a sigh will follow, the cloth is still coloured. The idea that colour is actively worked into the cloth and thus should also come out again when washed, highlights a concern

2 As an interesting comparative aside, it is noteworthy that, similarly to the imported cloth seen here in the Cook Islands example, the Yap stones are fashioned from stone imported from distant islands (Furness 1910). While the stone money is so heavy as to be immobile, it is important to their capacity as credit-moving objects that movement is inherent in the exotic 'foreign' nature of the material on the island of Yap. Exactly the same case could be made for the heavy, almost immobile and ultimately sedentary coverlets, whose material is associated with the arrival of foreign trade, and the design is indicative of genealogical mobility.

with actions of laboriously staining barkcloth that (as mentioned in Chapter 8) was unique to the Cook Islands.

Colour, being taken from plant and earth pigments, is a crucial compound of olfaction and essential to the production of perfumes, which the Cook Islands still today supply all over the Pacific Islands. Pigmentation is thus logically associated with olfaction, and the testimony of water-damaged non-colour-fast coverlets is not a calamity but a confirmation of active properties inhering in the coverlets. That colour and, by definition, combinations of colours visible in a piecework coverlet are associated with olfactory compounds and recipes for their combination into perfumes in turn follows the practice for women working on a piecework coverlet to wear a band of cut flowers on their head, covering their hair. For both coverlet and hair connect the invisible with the visible in the making of the social body and the body of a person, and it is due to its perpetual proximity to death that both the body of persons and the social body require extensive camouflaging by making it smell 'like the dead'.

The covering of the hair is thus as important to preserve health and wellbeing as the stitching, gifting, and wrapping of coverlets is for the reproduction of a household. Inherently dangerous and polluting – as an index of relations that crosses the boundary into the realm of the invisible, the ancestral, and the divine (*mana*) – both hair and coverlets require containment at all times. Coverlets are kept in trunks in between moments of competitive display and exchange; hair is tied up, covered by flowers whenever out and about and by woven hats, made of pandanus leaves or preferably the inner spine of the coconut leave (*rito*), when entering spaces such as churches associated with divine, though not ancestral, power. The inner spine of the coconut leaf allows for particularly finely woven hats whose weave shows an openwork pattern symmetrically and iteratively repeated across the top and the rim of the hat.

Rito hats can be coloured, are treasured and buried with the dead, while pandanus leaf hats are generally transient in nature and are thrown away when old. A woman generally has several hats, including some that are made out of materials such as packaging tape, bread bags, or other plastic products bendable enough to be worked into shape. The same goes for baskets and fans that are necessary accessories for entering a church. That there is a gendered aspect to this is shown by the fact that men are prevented from marrying and cutting their hair until their female relatives perform a ceremony at which, sat on a piecework coverlet, their hair is tied in bunches with ribbons and cut, one by one, by women stepping forward and laying money onto the coverlet. The haircutting ceremony is the largest gathering of the family, rivalled only by the secondary burial, which sees the construction of the superstructure on top of the tomb of the dead.

We have mentioned above that in island Melanesia, where barkcloth is made using gluing as a joining method, it had stayed central to exchanges and ritual functions central to the life cycle despite the ready-patterned cloth being taken up for everyday clothing. While this is the case in Fiji, it is not further west towards mainland New Guinea, where barkcloth used to be the main material for ceremonial

160 Rediscovering the object

functions, yet was displaced, with some exceptions (see Welsch, Webb, and Haraha 2006), by figures carved from a particular type of soft wood, vines, and clay. This is the case on the island of New Ireland where the tradition of *malanggan* carving appears to have taken off, ceasing barkcloth production, in a move that followed the annexation of large stretches of coastal land for foreign-owned coconut plantations in the mid-19th century (Küchler 2002).

We know that the exchanges of images carved from wood bound people across villages and language groups into de facto landholding groups that loaned a complex structured system of rights to the use of the land to its members, thus overcoming the shortage of productive land in each village with a regional system of ownership (Küchler 2002). Yet not any kind of wood is for the figures, nor any kind of clay or vine. *Alstonia Scholaris*, grown in moist groves and tangled with vines right to the top of its tall stem, rarely catches sunlight. Hidden in the forest and away from garden land and secondary forest, the tree demarcates a place associated with spirits (*masalai*) of the unavenged dead that, roaming freely, are prone to metamorphosis and trickery. Yes, the wood is a perfect timber for carving, soft and pliable so as to permit the cutting of numerous perforations into the fretwork for which *malanggan* figures are famous, but the place where the timber is gown shows that there is more to the wood than mere functionality. For the associations provoked by this wood capture perfectly what *malanggan* as a system of images and exchange that transcends, transforms, and subverts government attempts at regulating land rights.

The ontological capacity of a material as it appears in the case of *malanggan* of island Melanesia can be explored in greater detail by turning to the use of pandanus in the making of fine mats in Tonga in western Polynesia (Addo 2013). Fibre products worn by Tongans reflect rank and status. Certain types of barkcloth and mat are categorized by Tongans as *koloa*, a term used to describe objects of considerable wealth. *Koloa* takes its most valuable form in woven pandanus mats (*ta'ovala*), which are as smooth as silk and fringed with red parrot feathers, worn wrapped around the waist. The relation between the mat and the status of the wearer becomes obvious when bearing in mind that patterns of ownership over pandanus are strictly confined to certain households in addition to being highly volatile, as the plant is prone to disease. Soft, smooth, and pliable mats show off the labour and forms of loyalty-based close kinship ties that have gone into the tending of the plants and the transformation of the tough leaves into silky threads ready for weaving.

The silkiness of the mat has attention drawn to it by overlaying it with a woven apron, called *sisi fale*, that is tied around the mat at the waist. The *sisi fale* is an intricate brown apron of intertwined coconut fibres woven into open lattice work like a basket, with strips of plaited fibre and a number of shell beads, carved pieces of ivory, and small read feathers attached to its grid-like structure (Küchler and Were 2005b). *Sisi fale* is associated with movement via its use of the husk of the coconut that drifts ashore on islands from afar and via its openwork lattice structure that is believed to aid navigation. No longer produced today, aprons are now crocheted from the inner bark of the hibiscus tree, and from discarded fibres, such as old

cloth, tinsel, or recycled flour bags. *Kiekie,* as these aprons on the quick are called, are worn daily over clothing and, when attending church or special occasions, over clothing layered with a fine mat, accentuating the movement of the mat and drawing attention to the ideas resonating with the body politic.

Transformative material substances

The idea that material substances are chosen because of the qualities and affordances they offer to abstract modelling is further developed in tracing the long history of uses of incense in medicine and religion. In the writings of Pedanius Dioscorides (c. 40–90 CE) and Galen of Pergamon (c. 129–210 CE), myrrh (*Commiphora myrrha*) and frankincense (*Boswellia sacra*) are medical substances with clearly delineated properties and applications. In his five-volume *De Materia Medica*, Dioscorides outlines various ways of processing botanicals and their medical applications. Myrrh 'is warming, rheum-closing, sleep-inducing, retaining, drying and astringent. It soothes and opens the closed vulva, and it expels the menstrual flow . . . Rubbed on with the flesh of a snail it cures broken ears and exposed bones, as well as pus in the ears and their inflammation with meconium, castorium and glaucium. It is rubbed on varicose veins with cassia and honey' (Dioscorides 2000, 81), and he continues. Frankincense is no less a miraculous cure-all, as 'it is able to warm and is an astringent . . . [it can] fill up the hollowness of ulcers and draw them to a scar, and to glue together bloody wounds', and the specific uses are listed at length (85–86).

Less colourful, but no less informative, are the entries in *Trease and Evans' Pharmacognasy* (Evans 2009), which confirms the antiseptic, astringent, and stimulant properties of myrrh and the anti-inflammatory qualities of frankincense. Research in the biochemical sciences shows that myrrh works as an antibacterial, killing gram-positive microbials (Shuaib et al. 2013; Omer, Adam, and Mohammed 2011), and suggests that this might explain the use of myrrh to treat various infections of the mouth and throat. For its part, frankincense has observable impact on some strains of human cancer cells (specifically their eradication via oxidative stress, Dozmorov et al. 2014) and mammalian emotion – being able, at least in mice, to open the neural pathways to stimulate the perception of warmth (Moussaieff et al 2008).

In antiquity, it was common for incense to be burned in the home and in public buildings. As a form of preventative medicine, it cleaned the air against disease; it drove away vermin – such as mice and snakes – and also served as prescribed medication against various ailments. It was also commonly burned in tombs, catacombs, and wakes. In some cases, the burning of incense in Mediterranean antiquity was not clearly delineated as either ritual or medicinal. They were not mutually exclusive domains. It drove away the stench, and freshened and purified the air. Hippocrates had taught that all disease was airborne, and while Dioscorides and Galen after him both rejected the exclusivity of the statement, the predominant understanding that disease was at least principally airborne carried on. While early Christians rejected the ritual use of incense as a sacrifice, they accepted the scientific and medical knowledge about it and maintained the cultural uses for it.

162 Rediscovering the object

Clement of Alexandria (c. 150–215), for example balances his warning against perfumes, flowers, oils, and incense with scientific knowledge of the time concerning the health benefits of olfactory regiments. After admitting the 'individual properties, some beneficial, some injurious, some also dangerous' of various plants, he summarises saying, 'we have showed that in the department of medicine, for healing, and sometimes also for moderate recreation, the delight derived from flowers, and the benefit derived from ointments and perfumes, are not to be overlooked' (Clement of Alexandria 2004, 411; see also Caseau 2007).

The first certain usage of incense in Christian liturgical practice is witnessed by the pilgrim Etheria (or Egeria) in Jerusalem (c. 381), where the tomb of the Holy Sepulchre is censed midway through the liturgy, likely as a ritual re-enactment (that is, anamnesis, see Chapter 1) of the pageantry of Christ's funeral, performed within the space of his burial (Gero 1977, 75), possibly with specific connection to the role of the myrrh-bearing women who, in the Gospel account, carried myrrh and costly spices to anoint Christ's body (Ashbrook Harvey 2006, 77). Jerusalem (and specifically the Holy Sepulchre) was an example of how the pageantry of liturgy and pilgrimage should be done elsewhere, and it fits with art historical evidence (Hahn 1997) that, even if it was not used in this way at the time, seeing incense used in the liturgy in Jerusalem would help the practice spread further afield.

Christian authors in the first four centuries tended to interpret the religious imagery of incense in an allegorical manner as the prayers of the faithful, and emphasised the purity of devotion and self-sacrifice over the religious use of incense. References in the mid to late 4th century are often unclear as to whether the incense spoken of is literal, metaphorical (as prayer), or both. Within this shift, a major influence in setting the tone for subsequent understanding is Ephrem the Syrian (306–373), whose hymnography is still sung in the Orthodox Christian churches today. Ephrem holds on to an older tradition, seeing God as pure fragrance, and calls Christ the 'Fragrance of Life'. But he also develops it in terms of how the material substance of the incense and perfume entangle the body, permeate it, and become united to/within it. His play with the images of fragrance and breath also moves forward the medical ideas about incense and pure air into a conception of the incense as purificatory for the soul. Christ, as perfume, permeates the person, body and soul, and even as the breath of life animated the lifeless body of Adam in the Genesis account of creation, so too did the inhalation of the fragrance of Christ bring (new) life and regeneration into the Christian. This kind of relationship to Christ via perfume (and specifically that of frankincense and myrrh) shapes contemporary perspectives on incense use and prayer.

Within Christian literature and liturgical practice, myrrh becomes a central ritual substance very quickly due to the use of myrrh by the women – Mary Magdalene and the others – who prepared Christ for burial. What is called holy myrrh, or sometimes myron, is fundamental to the initiation rituals of new Christians, as well as the consecration of bishops and the enthronement of emperors. Myron in this ritual context is not *Commiphora myrrha* alone, and over the years the recipe has become more complex, such that contemporary Greek practice uses 57 aromatic botanicals in the making of myron (Menevisoglou 2013).

In the making of each new batch of myron, the remainder of the previous batch is mixed in. Therefore, there is material continuity between the myron used today to anoint the newly baptised and the myron used in previous centuries. It is often highlighted to new converts that this is not only the same liturgical act (i.e. the ritual words of blessing and induction) but in fact the oil used on their forehead, eyes, nose, mouth, ears, chest, hands, and feet may contain molecules of oil from previous millennia. There is a physical continuity made by the bodily participation in the same substance.

In the Greek historical record, this practice of adding the old myron to the new batch is traced back to St Athanasius the Great of Alexandria in the 4th century – thus, it is sometimes taught in catechising new converts that the oil used in services today is the same oil used by St Athanasius. This is not just that it is the same recipe, like a favourite dessert handed down the generations, but the self-same oil. In the Coptic record, St Athanasius is recognised not as the source of this tradition, but for the standardisation of this practice.[3] According to Coptic historians, after the resurrection of Christ, while the apostles met in the house of St Mark, they gathered the spices used by Mary Magdalene and the other women and brewed the original holy myron, so that each could take with them a jug of oil containing the material substance of Christ's burial.

This suggested continuity to the body of Christ (i.e. that holy myrrh used across the Orthodox Churches today is a relic of Christ's burial) makes sense of the early Christian writings about myron. While there was liturgical variation across the early church in terms of when and how myrrh was used, they all agreed on the centrality of myron as a substance.

For example Cyril of Jerusalem (2000), in his third Mystagogical Catechism, tells the initiate:

> Beware of imagining that this is ordinary ointment. For just as after the invocation of the Holy Spirit the bread of the Eucharist is no longer ordinary bread but the body of Christ, so too with the invocation this holy *muron* is no longer ordinary or, so to say, common ointment, but Christ's grace which imparts to us his own divinity through the presence of the Holy Spirit. To symbolize this truth you are anointed on your forehead and on your other senses. Your body is anointed with visible *muron,* while your soul is sanctified by the life-giving Spirit.
>
> (177)

The holy myron is 'Christ's grace'. The ritual practice, namely the anointing, is symbolic, but the myrrh is consubstantial. This symbolic act of anointing is also, importantly, done to the places on the body associated with sensory perception.

3 This is from a Coptic Arabic source, by Abu l-Barakat Ibn Kabar, titled 'The Lamp of Darkness in Clarifying the Service'. A short summary of the key claim is seen in various sources online, for example:www.suscopts.org/resources/literature/539/the-holy-myron/

164 Rediscovering the object

The other thing we see in Cyril's meditation on myron is the dual nature of the substance. A distinction is made, just as it was for Ephrem, between the fragrance and the substances holding the fragrance. The incense was understood as a human offering given to God. Oil was a protective substance, given by the divine to mankind for her wellbeing – both health and safety. The fragrance itself, however, was divine. The scent of God was the somatic evidence of God's presence. This interplay of substances and odours became a model for understanding human–divine interaction, and offers us insight into how the early Christian understanding of materials worked. First of all, more important than the words of the ritual, or even the ritual action itself, is the substance of the myron. Secondly, the myrrh is seen to be oil and fragrance. Each of these properties offers a specific affordance for the Christian in terms of the penetration of Christ and the preparation for the athleticism of spiritual combat.

When speaking to people about the use of incense, clergy and laity alike tend to draw upon a couple sets of images for their explanation. The first is the imagistic language – as seen above in the tradition following the Apocalypse of John – likening incense as prayer. The metonymic link follows Psalm 141, which starts 'Let my prayer arise in thy sight as incense, and let the lifting up of my hands be an evening sacrifice'. This is a hymn sung throughout the period of Lent, and carries a strong overtone of supplicatory prayer. Drawing on this motif, people interpret the upward movement of the smoke as a visualisation of their prayer – or, at times, a visual reminder to pray.

The other explanation that is often given builds on the fact that the deacon, as he makes his rounds during the great censing, treats people and icons the same. Towards each he swings the censor, sending up a plume of smoke before their face. Within Orthodox Christianity, where iconographic images are everywhere, the understanding of the human as 'the image and likeness of God' takes a very direct form of correlation. As we have discussed in Chapter 1 and Chapter 7, self-cultivation in Orthodox Christian contexts can be understood within an arts framework, and in relation to icons and the personas depicted therein. Here, in the practice of censing, the Orthodox person is treated much the same as the (other) icons. As one informant told Carroll, 'When the deacon censes us, he is treating us as icons of God'. Later, she went on to clarify, 'It is like a reminder, cuz we're not holy, but we're called to be holy. "Be ye holy" [she quotes scripture[4]] "even as I AM holy", and so if we are icons, if we are living as images of Christ, then we are censed as icons. If we are not holy, then incense reminds us to be holy'. In Orthodox Christian thought, the principle of being holy is achieved through a process of purification and, ultimately, healing. While judicial language is sometimes used in Orthodox contexts around sin, the predominant metaphors of sin are that of illness.

4 Originally given as a command to the Hebrews in Leviticus 11:44, Peter also uses it as an exhortation in 1 Peter 1:16.

The use of ritual behaviour as means to heal both the soul and the body may be nowhere more explicit than when the Orthodox faithful approaches the priest to partake of the sacrament of Holy Unction. Each year, on the Wednesday evening preceding Pascha (the Feast of the Resurrection) a service is held for the consecration of sacramental oil, specifically for the use in healing Orthodox Christians. Throughout the service, the prayers draw explicitly on the imagery of Christ as a physician, calling him 'Physician and Help of those in sickness, Redeemer and Saviour of the infirm', asking him to 'grant healing to thine infirm servants' and 'Be clement, show mercy to those who have sinned much, and deliver them, O Christ, from their iniquities, that they may glorify thy might divine' (Rahal 2006, 297). The movement between bodily healing and soulish healing, such that each is being mentioned back and forth, even in the same breath, blurs the boundary between them. The sense of total healing accomplished through the anointing of oil, in fact, goes beyond just the body and soul:

> Through anointing with thine oil, and the touch of thy priests, O Lover of mankind, sanctify thy servants from on high. Free them from infirmities. Cleanse their spiritual defilements. Wash them, O Saviour, and deliver them from scandals manifold. Assuage their maladies. Banish their hindrances and destroy their afflictions; forasmuch as thou art Bountiful and Compassionate.
>
> (Rahal 2006, 305)

Such is the total care provided by, and achieved through, Christ, who 'art as incorruptible myrrh' (297).

It would be easy to say 'this is a symbol', and leave it at that. The ideas of illness and health map onto the feelings of remorse (or guilt, or shame), and the idea of Christ's role as mediator of forgiveness and restitution becomes bundled with symbols of physical healing on one side (as a physician) and spiritual purity and the smell of prayer (e.g. myrrh) on the other. However, this short-changes the issue. Humans find symbols compelling (cf. Geertz 1966), but to reduce it to symbolism is to lose out on what is so compelling about the substances of the sign.

Myrrh appears to have real analgesic properties. It is important to recognise the physical, chemical, etc. properties of materials and the potential contribution they have to human sociality. Moussaieff and associates (2008), running highly focused tests on the constituent elements of frankincense and their impact on pathways within mice brains, arrive at a startling and wonderful insight: frankincense seems to make mammals (or at least this specific kind of mice) feel warm and happy. The authors suggest that, with further study, frankincense may be a suitable option in addressing problems with anxiety and depression. This aspect of human–material interaction operates within human bodies even when the subject is unaware. The effect on mood and temperament may be noticed after the fact, but the social agency of the chemical must be acknowledged, and so too must the permeability of the human person.

166 Rediscovering the object

The other effect of frankincense, that is analogical instead of symbolic, is achieved through its transformation by burning, which thereby makes visible the invisible. Andrew Gould (2014), an expert in Byzantine liturgical arts, highlights the fact that incense is an architectural feature of the Byzantine temple. As the liturgical arts of the built environment developed, the importance of how light played within the temple was crucial. Each Orthodox temple is an icon of the universe, and particularly within monumental churches like Hagia Sophia in Constantinople, the placement of small windows circling the underside of the principle dome means that shafts of light shot down from the 'dome of heaven'. In Byzantine architectural practice, clay urns were set into the walls of many church buildings (Zakinthinos and Skarlatos 2007). These hollow cavities produce resonances, such that when the walls are met with sustained musical frequency, they (that is, the walls) begin to resonate. In such an environment, as the incense moves heavenward and catches the

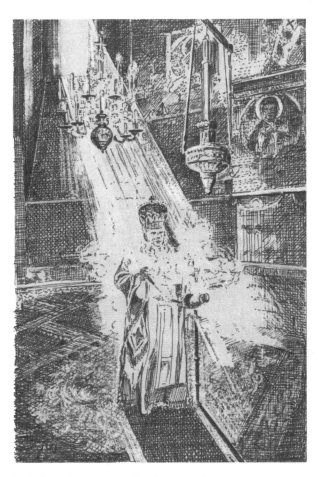

FIGURE 9.2 The light and incense smoke playing with each other within an Eastern Orthodox cathedral.

light making it visible in a startling and new way, the whole building would vibrate with sound and be illuminated with light. Light, itself a recurrent icon of Christ and divine presence, is made more visible via the incense smoke.

The position of the person as a material artefact within this remediation is crucial. The multisensory aspect of Orthodox use of incense builds on the understanding of the body as a site of encounter. As a theological position, the importance of the body has been at the heart of many Patristic writing. Cyril of Jerusalem, for example emphasises the body and its place in the divine economy. His teaching, spread throughout his Catechetical Lectures, focuses on the body as a perfectly created apparatus for meeting God through the senses (cf. Ashbrook Harvey 2006, 60). The human, with her somatic senses, and the porous nature of her body, such that odours, oils, and food may come into, and be infused and conjoined within, means she is a material being with the properties and affordances easily transformed via such materials like myrrh and frankincense.

What we see, then, in the materiality of medical substances taken up and used within Orthodox Christian ritual worship, is that the affordances of the *medica materia* map within the social framework of heath – both physical and spiritual – and are able to shape and transform these conceptions because of the material properties, joining to and being absorbed within the physical being of the human person.

In terms of the actual process of the material, it is important to note that burning incense is a transformation, turning the agent from one substance to another, rather than an act of destruction. (For more on this idea of destruction as means of transformation, see the work of Monika Wagner on materials in modern art: Wagner 2001; Wagner, Rügel, and Hackenschmidt 2002.) The medicinal qualities still adhere. In the production of the pungent odour of incense, there is also an element of transduction (Keane 2013), particularly in the context where the rising smoke is metonymic for prayer and the perfume is synecdochic for divine presence. Keane's use of transduction assumes a textual basis for the agentive power being moved through media. The writing of sacred scripture, moved via water-soluble ink into a drink, for example carries the potency of the spoken word through liquid into the body. However, the transduction of indexical qualities does not require a textual, communicative aspect. As a transformative act, the ignition of the incense activates the latent potential of the incense and brings it to life. The purified smoke travels heavenward as prayer; it is inhaled into the lungs, and the surface of the body and the surface of the incense become merged, and the qualities (and concomitant affordances) of the incense come fused into the person – body and soul.

Summary

The material, being the site and substance of surface, stands in an immediate relation to the prototype. The specific qualities of the material of the object therefore shape not so much the prototype itself, but how the prototype is manifested, and which attributes of the prototype are realised and made available for contemplation.

168 Rediscovering the object

It is on this level that the traditional and narrative history of the human relationship to the prototype is developed by the material world in which society is situated. The case studies discussed in this chapter focus on the often sensual and affective relationship to bodies to highlight the important intersubjective and interartefactual relations between the body as a material (or better, a set of materials; cf. Carroll and Parkhurst 2019) and the materials that are sought out by humans to facilitate the contemplation of the prototype. These are non-arbitrary choices that are made in choosing the media of presentation, as the material indexicality of the object drives its own range of abductive inferences, separate from but complementary to the formal aspects of design and style. This total social fact is what Gell is driving at in highlighting the virtuosity of design and the stickiness of the index.

At this point, Bateson's elucidation of the mind as a 'no-thing' and empty makes greater sense. As he says, 'Mind is empty; it is no-thing. It exists only in its ideas, and these again are no-things. Only the ideas are immanent, embodied in their examples' (Bateson 1979, 11). The idea – that is, the prototype – is immanent in the material of the index. Methodologically, this means that Anthropology must work much more closely to the natural, material, and medical sciences than has historically been the case.

The next two chapters continue unpacking the indexical capacity of the materiality of the object, specifically in terms of pattern and colour, respectively.

10

COLOUR, PALETTE, AND GESTALT

Material, as discussed in the previous chapter, is the substance of the object, and shapes the capacity of the object to hold and make present the prototype. Its surface, being the interface for engaging the prototype, is a critical importance in how it is met by the mind, and thus how the abductive inferences, and their subsequent social consequences, are formed. Surface is a field of possibility, as different materials are able to hold different colours, textures, and qualities as sensory elements.

It is notable how the renewed concern with coloured object worlds in the closing decade of the 20th century and beyond is found across disciplines, guided by scholars who themselves are synaesthesic and explore what colour does in culture and society. In the History of Art it is John Gage (1993, 1999), and in Anthropology Diana Young (2005, 2006, 2011), whose studies have radically transformed our understanding of the difference made by coloured objects in a coloured world to colour in culture and society.

John Gage brought together evidence of the use of colour in art and the relation between colour science and art across centuries of Western art. Illness cut short his interest in Australian Aboriginal art, which Diana Young had already begun to write about in terms of an ontology of colour that reaches deep into the cosmological and societal ideas, inflecting everyday practices and mundane decisions, such as what colour headband or what colour striped football socks to wear. Guided by her own synaesthesic abilities (linking colour and the pitch of sound), Young's ethnography of the Pitjantjatjara and Yankunytjatjara peoples in the western desert of Australia brought to the fore the pivotal role of a 'mutable' environment transformed in cyclical fashion by the coming of the rains. With the rains come a profusion of flowers and insects, and with these, birds and other animals migrate or become more active, too. Early signs of the seasons coming, such as the bright red and blue Leichhardt grasshopper (*alyurr*, meaning 'children of the lightning man'), bring about the knowledge of the season changing, such that colour brings about

170 Rediscovering the object

the seasons and is brought on by the changing of the seasons. The transformation of the landscape through colour and odour shapes what David Howes (1987) had called, with reference to Melanesia, the 'order of the soul', composed of a sequence of transformations whose nature informs the relation between people, living and dead, via objects (Young 2005, 2011).

Young's work on clothing and landscape and the dynamic relation between the two amidst a heightened attention to surfaces of all kinds as sites of efficacious action led her to see the intellectual potency of an object ignored by scores of anthropologists and art historians drawn to the Australian desert for its peoples' vibrant acyclic painting. Young, together with the curator Louise Hamby, showed that intricately patterned string objects threaded into necklaces, bracelets, wall hangings, mats, and fly curtains made visible the subtle relation between place and personhood in ways that scholarship had not yet touched upon (Hamby and Young 2001).

Made of nuts, small seashells, shark teeth, and bean tree seeds, the material of the string is resonant of place, and the rhythmic composition of colour painted as pattern on the beads captures the pitch inflected in local dialects. Women recognize where strings are coming from and who has made them, right down to the kinship relation they themselves may have with the wearer. In fact, the 'art' on string recalls the importance of string as clothing and relational object inflecting a concept of personhood that bears witness to one of the most complex kinship systems. The primary object of exchange, given in secret by a woman to her mother's brother in recognition of his pivotal position in an egocentric network of wealth spanning across the six sections of a kinship group, was in fact a string plaited from her hair.

Hair, as mentioned in the previous chapter, is an exuviae that is intimately connected to the essence of the person as it extends from within to the outside. In an Aboriginal context, where the substance of the body is synonymous with the substance of the ancestral beings, the length of hair, holding together the string of beads, is deeply analogous to the continuity of genealogical descent that 'runs through' each individual. Art on a string is thus evocative of ideas of relation central to the workings of society.

The relational capacity of colour also works in tandem with its name and the evocations that the colour, as a multisensorial entity, brings to mind. For example as Young (2011) mentions in her discussion of the shift from indigenous Pitjantjatjara/Yankunytjatjara terms to English colour terms, 'grandchildren correct their grandparents on the use of English colour words. For example (in 1998), Nungalka said of "cockies" (Major Mitchell cockatoos) that they had "red" under their white wings, whereas Inkajili, aged about 8, corrected her, [saying,] "pink"' (360). Young passes this comment without much more remark, but it is worth considering what might be held in a 'red under white', that is lost in 'pink'. It is our suggestion that being 'under white' is analogous to the ochre and other natural pigments (called 'special Aboriginal paints', 360) used in Aboriginal painting that are then partially covered by the white cross-hatching. A burst of colour within the landscape, Young notes, is important to the recognition of the ancestral power immanent throughout.

Colour, palette, and gestalt **171**

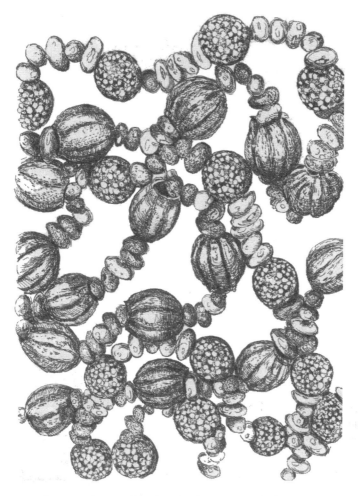

FIGURE 10.1 A close-up of painted beadwork, after an example from Louise Hamby and Diana Young (2001).

As she says, 'The capacity of a sacred site to become animated in this way, to become brightly coloured for a few minutes, appearing spatially expanded, highly visible and then invisible, confirms its Ancestral eminence' (367). While 'pink' is a foreign concept, with no link to the Ancestral beings that formed the landscape of Australia, red ochre (*karku*) is native, and deeply connected within the palette of ancestral dreaming. As such, when seeing the underside of a cockatoo, the grandmother sees a flash, or even a shimmer (cf. Morphy 1989, see Chapter 4), of the ancestral, while the granddaughter sees only 'pink'.

In her theoretical work on colour, informed by her ethnography in Aboriginal Australia, Young (2006) has argued that 'colour is a crucial but little analysed part of understanding how material things can constitute social relations' (173). Colours

172 Rediscovering the object

work in ways that are generally taken for granted. Most research on colour has been concerned with analysing and categorising colours in their relation to one another via a scientific method that assumes that colour is best equated with a wavelength of light. This approach based on optical physics has influenced social science's approach to colour as peripheral to understanding matters of social and cultural consequence. For disciplines for whom colour is a constant factor to be reckoned with, the equation of colour with wavelength of light has led to a dematerialization of colour, and to approaches that regard colour as *qualia,* a qualitative aspect of things.

As qualia, colour has remained inaccessible to social science working comparatively and with methods that foreground the role of language and of higher cognitive processes in the shaping of cultural and social worlds. This is because there is an enduring assumption that language is the key to understanding what colour is intended to do and mean. This in turn has led to the question how colour is divided up, conceptually and linguistically, in stable categories. The search for universal categories of colour dominated the post-war era in which the marketing of readily coloured product design drove much of the research on colour. Two opposing hypotheses thus framed research in the second part of the 20th century.

The first, called the Sapir–Whorf hypothesis, assumed that colour perception is created by language so that a missing colour term would be followed by a lack of ability to discriminate the colour whose categorisation is absent from language (Whorf 1956). The second hypothesis, an influential theory of Basic Colour Terms, argued to the contrary, claiming that all languages follow a universal pattern of colour-naming evolving from the basic colour pairing of black and white across four stages of increasing complexity and number of colours (Berlin and Kay 1969). Berlin and Kay's work gave rise to research in anthropology on focal colours used, as they are more attention-grabbing and thus more easily remembered. Rosch Heider (1972, 1978) based her work on this theory in her work among the Dany of western Papua in which she found that people's recognition of focal colours was unmediated by language. Recent follow-up research with neighbouring groups contradicted her findings claiming instead an 'extensive influence of language on colour categorisation' (Roberson, Davies, and Davidoff 2002). The question of whether colour language constitutes colour knowledge and constrains the ability to discriminate between hues has never really abated to the present day, informing a continuing search for ways by which colours can be said to have meanings that represent or communicate knowledge (Turner 1967; Tambiah 1968; Munn 1973; Sperber 1975; Morphy 1991).

A different and, for Anthropology, revolutionary approach emerged from advances in neuroscience that showed that colours are not just perceived in relation to one another, but can provoke cross-sensory associations and cognitive effects that cannot easily be captured in language (Baron-Cohen 1996). The study of the relational effects colours can have resonated with earlier work in Anthropology and History on what colours and their relation to other senses can tell us about relations between people and people and things. There is Alain Corbin's (1986) work on odour and the French social imagination, tracing the expulsion of odour as index

of disease alongside the reduction of colour to white from places associated with the restauration of the body (see also Batchelor 1999). There is also the work of the historian Constance Classen (1993) on the senses across cultures and across history, drawing out the social effects of cross-sensory relations she had identified in her now classic essay on sensory models in the Andes and the Amazon (Classen 1990). Sensory anthropology has become a distinct field of exploration because of the work of scholars such as David Howes (1987, 1988, 1991, 1992), Constance Classen (1990, 1993; Classen, Howes, and Synnott 1994), Steven Feld (1982; Feld and Basso 1996), Michael Jackson (1996), and Paul Stoller (1989). This work directs attention to the societal practices in which aroma, odour, sound, and colour come to relate to one another in varying and yet consistent ways. Neuroscience confirmed what ethnography had shown, namely, that there is a tendency for spontaneous cross-modal relation between colour and the sense of pitch that, while prevalent in individuals, is foregrounded in certain cultures and central to ritual practices.

Howes argues that, across the senses and in different cultural settings, there is unequal valorisation of the senses, and that this shapes affective mentalities in a totalising fashion. In the interrelation between the senses, there is no one-to-one correlation; the senses and the somatic apprehension of the senses may be radically different. Similarly, there is overlap between sense domains such that there is socio-cultural privileging of different correspondences. What this means is that, along with 'clinical' synaesthesia, where the biological wiring of the brain allows for the conflation (or, in fact, does not allow for the segregation) of sensorial input, there can be 'cultural' synaesthesia, too, wherein the socially learned associations between somatic apprehension links sense domains in meaningfully productive ways. Roland Barthes's (1997) discussion of the bright red of tomatoes seen in an advertisement – which work as qualisigns of freshness and quality – is a prime example of the movement from a specific hue of red to the connotative taste of Italian cuisine.

Alfred Gell (1979, cf. 1999), in his work on the Umeda of the Sepik River in Papua New Guinea, recognised early on the necessity to pay attention to the cross-sensorial relations in understanding representation. In his essay on the 'Umeda language poem' he analyses phonological iconism as a form of onomatopoeia that carries the sound of words, their pitch, into the semantic realm where it signifies spatial relations that are further indexed by colour combinations concretised in ritual architecture and artefacts. Howes (1988) in his little-known article on spatial representation and olfactory classification in eastern Indonesia and western Melanesia, observes that there is a consistent link between ritually distancing the dead from the living and the amplification of olfaction as ritual agent and its absence and the co-presence of the dead in the land of the living. A reduced or even absent emphasis on olfaction is also shown to correlate with a reduced emphasis on colour differentiation in artefacts that negotiate the relation between the invisible, signified by odour (recalling the absent object), and the visible. Attention to cross-sensory modalities in which colour serves as a trigger has enabled an object-centred approach to colour that studies how colours work in relation to one another and

174 Rediscovering the object

other senses and what the relational cross-modal tangles they provoke do in culture and society.

That coloured object worlds have transformative, sensorial, and spatial effects that became acutely relevant as the digital revolution made object worlds accessible in 2D and in standardized 'virtual' colour at the same time as access to coloured object worlds in which colour resonates with potential olfactory or acoustic properties of objects became restricted. The ending that virtual colour signalled, however, created a desire for and heightened awareness of material colour much in the same way an ending of a different kind at the start of the 20th century had fuelled attention to the relation between emotion and knowledge. At that time, Aby Warburg (1999, 2000)[1] sought to identify what he termed the 'pathos formula' that enables diverse images to be recognized as related to one another; Sigmund Freud (1923) developed the psychoanalytical method to uncover the complex systemic relations between ego and id intrinsic to the articulation of personhood; and Walter Benjamin (1996), in his essay on the *Task of the Translator,* directed attention to the onomatopoetic quality of names that connect concepts and material worlds in ways enabling him to identify arcades and play as agents of cultural resistance.

Coloured object worlds enable one to understand the multi-scalar and multi-sensorial nature of desire and its effects in ways that language alone cannot convey. This has become increasingly evident from the start of the 20th century, with the arrival of tens of thousands of artefacts from the new horizons of trade and imperialist expansion (Weiss 1995). Alongside botanical specimen, birds, reptiles, insects, and other amphibians that entered the newly created ethnographic museums, artefacts in their thousands were collected as evidence for the new disciplines of ethnology and anthropology. While Europe and America contributed to the emerging disciplines primarily through armchair ethnographies in the early decades of the century, Russia, with its own indigenous populations, supported direct research with communities.

The practice of Russian ethnology came, by a twist of fate, to inform perhaps the most radical formulation of the potential of object worlds, later framed by Walter Benjamin as the language of objects (Bracken 2002). The first indication of an incursion of the practice of Russian ethnology into European painting came in 1911 when Wassily Kandinsky exhibited his painting *Saint George vs Dragon* (1911), with St George astride a blue horse with golden flecks that associated St George with a Siberian shaman. The piebald colouring of the horse fits within an indigenous network of sacred shamanic imagery, ritual drumming, technical terminology, and notions of riding to produce metonymic and synesthetic properties that were harnessed by the Siberian shaman as conduit for transference between the inner and outer worlds. Kandinsky's study of ethnography in Russia, where Siberian shamanism had already been well studied and described, has been captured

1 Warburg develops this idea first in a series of lectures in 1905, and again in a posthumous publication *Mnemosyne Atlas* (Warburg 2009).

in his memoires, yet has been largely overlooked in favour of the more populist reception of his later work that translated synaesthetic, or cross-sensory experience, itself fundamental to Siberian shamanism, into painting (Weiss 1995).

Kandinsky became a member of the Russian Imperial Society of Friends of Natural History, Anthropology, and Ethnography while a student in Moscow in acknowledgement of an essay he wrote on a summer research trip to the then still remote region of Vologda province. The essay contains a wealth of ethnographic observations, largely untapped by art historians in search for influences on his later artistic development but of such quality to have been incorporated into ethnographic publications on Siberia (Weiss 1986, 45). As recalled in his memoirs (*Rückblicke*), it was not just shamanic practice that left a strong impression, but houses in which every wall was brightly painted, covered with lots of pictures 'like a painted folksong' (Weiss 1986, 44).

His interest in ethnology and in Siberia in particular had a personal motivation, as his father's family had come from the border of Russia and Mongolia, having settled there from west Siberia, near the region of Vologda province, which the family had to leave for political reasons (Weiss 1986, 44). Kandinsky's mother's family was from the German Baltic and, with this complex biographical history in mind, it is not difficult to see why Kandinsky would have continued to build on the resonances of coloured soundscape as means for and expression of translation across cultures long after leaving Moscow for Germany. These biographical insights are important to note in no small part because they highlight a much more diverse set of influences coming out of the practice of ethnography woven into the European art tradition. Kandinsky's ethnographic work and its impact on his paintings allow us to understand the possibilities he conjured up for coloured objects to capturing an idea of relation hidden in plain sight. Touching down in a coloured world revolutionized by ready-coloured objects made of bakerlite, Kandinsky's reminder of the synaesthesic qualities of colour and its relation to pitch, lost with the ending of storytelling as lamented by Walter Benjamin, proved formative for 20th-century art.

Object collections arriving in their thousands from far-flung corners of the world where colour was said to be part of the lived-in world became the encounter with ways of knowing and shaping the world. In Germany, *Die Brücke* artists Max Pechmann and Emil Nolde visited New Guinea and the island of Palau, respectively, influenced by Ernst Ludwig Kirchner who had first been exposed to Oceanic art in the Dresden Museum of Ethnology in 1904. For their part, the Munich-based *Blaue Reiter* group likewise used ethnographic museum collections as inspiration. Henri Matisse visited Morocco in 1912 and 1913, and Paul Klee, together with August Macke and Louis Moilliet, went to Tunisia in 1914, where they moved away from form to abstract colour compositions observed in fabrics and the environment, recreating them in the studio after observation *in situ*.

Matisse's early observations of the interplay between light and colour, the three-dimensional illusion on canvass and the folded and crumpled surface of textile, narrative description, and emotion, took on an acute ethnographic quality with the

176 Rediscovering the object

incorporation of Moroccan wall hangings, wallpaper, and fretwork (*Moorish Screen,* 1921). Beyond acute observation of the indexical qualities of colour compositions made manifest on canvas, Matisse was actively drawn to exploring the epistemic quality of the geometric thinking afforded by multi-coloured textiles, and it is this concern that led him to retrace the steps of Paul Gauguin in his visit to Tahiti during the 1930s. In the 1930s and 1940s sewing large patchwork *tifaifai* coverlets was culturally prominent in Tahiti and the presence of this distinctly geometric textile would have led him to look anew at Gauguin's polyphony of perspective depicted in his quasi sculptural Tahitian paintings and edgings (such as the *Nave Nave Fenua (Delightful Land)* woodcut in *Noa Noa,* 1894). Tahitian textile and its colour geometry inspired Matisse to translate three-dimensional shapes onto two-dimensional surfaces in his gouache collages (*The Snail* 1953) and his stained-glass windows (*Chappelle du Rosaire de Vence* 1948–1951).

In the visual bias that guides much of European thought, there has been an emphasis on surface as a visual place for colour; and, reasonably enough, colour is predominantly a visual phenomenon. However, colour is not only visual; in fact, it may not even be primarily visual. For example among the Abelam, colour works as a magical substance, and the entrance to the initiation house – lined with ochre pigment, and analogous to the birthing canal – is rubbed by the initiate as they enter into the building. Inside the initiation house it is pitch black, so the colouration as a visual phenomenon can hardly be justified. However, the ochre is nonetheless there, physically rubbed upon the shoulders and back of the young man, and as a highly potent substance it is of fundamental importance as an initial stage within the initiation rites. The 'birth' of the initiate, and the transfer of the magical (but unseen) colour, is worked in his passing through the narrow space. In this case, colour is not just visual; it is a type of material that brings with its inherent material affordances the possibility of transformation. Other colours – such as lapis lazuli, crimson, or white iron (Anderson 2012; Bucklow 2009, 2016) – throughout art history may similarly be seen to bring with them magical (or maybe better stated in the European context, alchemical) capacities to produce value and shape the material agency of the object.

In some settings, specific colours are understood to carry specific connotations (Gage 1999; Otsuji and Pennycook 2019), but more often it is the relation between colours, working within a palette, that is most important for their perception and contemplation. For example across Melanesia, the colour palette is almost universally red, black, and white. In a simple reading, red can be associated with the blood of pigs, and thus sacrifice; black with death and rot; and white with milk, and semen, and thus life sources. However, no clear one-to-one correlation exists. Rather, it is the predominance of one over the others within the motivic design of any given object that allows the provocation of contemplation to move in one direction or another. Trobriand yam houses, for example like the sail of a *kula* canoe, are decorated with white as the dominant colour – thus analogically associated as fortune-bearing, or even the sail of the village, as the mast is the yam house of the canoe (Mosko 2013). The dominant red in the *malanggan* of New Ireland is

Colour, palette, and gestalt **177**

evocative of the sacrificial blood of the pigs, which helps drive the circulation of ritual obligations between kin lines in relation to the deceased chieftain, in advance of the inheritance of the associated title and (consequently) resource rights.

However, the dominant colour can be a red herring, as the dominant white seen in the war shields in Mt Hagen is best understood as a de-emphasis of red and, consequently, a suppression of the sacrificial obligations tying the living to the dead. As a means of meta-valuation (see Chapter 8; Lambek 2008), sacrifice is the only way for relation to be maintained between the living and the dead. Thus the ratio of red, in proportion to white and black, is also indicative of the maintenance or passive relinquishing of active ties with the dead. For Trobriand Islanders, who keep their dead close, red is not a dominant colour within local style. For New Irelanders, for whom ritual sacrifice is a key element in intergenerational passage of usufruct rights, red plays a dominant role in the *malanggan*.

The other aspect of colour seen in the relation to the dead is its connections to scent. David Howes (1988) discusses how the 'odour of the soul', manifest in the burial practices and cosmology of the post-mortem life of the soul, impacts how colouration and perfumation are used in funerary rites. As seen in the previous chapter, with the importance of frankincense in funerary rights, and, via its fumigation, the connection to sight, the visual cannot be taken separate from the olfactory. In the Cook Islands (Thomas 1999), *tapa* – made from the paper mulberry tree – were elaborately stained with yellow turmeric and red ochre in a process that took months to build the potency of the *tapa* through the adherence of colour and odour. Even after the introduction of Chinese muslin, wherein the colour is already present, the extensive perfumation with flowers was continued to ensure the visual and olfactory sensation of the textile. The process to make the colour and the odour adhere to the textiles is one of constant pounding – which, like the tintinnabulation of incense burners as they swing – also means that the visual and olfactory scape is also an aural one. Thus, to take colour alone is an error.

In this chapter, we consider colour in its relations, both between one pigment and another, and also in the wider palette of sensorial experience. The mix of sensorial perception, known as synaesthesia, also brings to the fore the simple fact that things are far more than they are, and we consider the idea of gestalt in this context as well. We begin looking at the work of Mark Rothko, and then progress through a series of case studies that open up the phenomenon of colour and its relations as a place for analogical connections to be made apprehensible. This lays the groundwork for the subsequent chapter on pattern.

Colour as movement

Mark Rothko is most famous for his huge canvases with strong colours pushing against each other, filling the viewer's field of vision with colour, pure colour. His early work, however, was more figural, showing people in mundane situations, such as in the subway (*Underground Fantasy*, 1940), stretched in long, wanting poses. As he moved away from recognisable figural representation, he began to work with forms

178 Rediscovering the object

'as they appear in dreams', and his 1944 *Slow Swirl at the Edge of the Sea (Mell Ecstatic)* shows only the suggestive line of a feminine form – suspended – in front of the empty lack of context. 'I think of my pictures as dramas', Rothko said of his work in the late 1940s (Rothko 2006, 58), 'the shapes in the pictures are the performers. They have been created from the need for a group of actors who are able to move dramatically without embarrassment and execute gestures without shame'. Within the progression of his work, Rothko moved increasingly away from the representation towards the simplicity of colour, and then grey tones and black. In a way reminiscent of Gell's analysis of Duchamp's *oeuvre*, Rothko (2006), says,

> The progression of a painter's work, as it travels in time from point to point, will be toward clarity: toward the elimination of all obstacles between the painter and the idea, and between the idea and the observer. As examples of such obstacles, I give (among others) memory, history or geometry, which are swaps of generalization from which one might pull out parodies of ideas (which are ghosts) but never an idea in itself. To achieve this clarity is, inevitably, to be understood.
>
> (65)

In his quest for the elimination of obstacles, Rothko was influenced by artists like Adolph Gottlieb working in abstract expressionism. In a co-authored letter they sent to the art editor of the *New York Times* in June 1943, they capture the purpose of the school, saying

> We favor the simple expression of the complex thought. We are for the large shape because it has the impact of the unequivocal. We wish to reassert the picture plane. We are for flat forms because they destroy illusions and reveal truth.[2]

To facilitate this, Rothko used large canvases, and packed the gallery room full of them, to envelop and overwhelm the viewer. Ideally viewed from 18 inches (46 cm) away, the paintings fill the field of vision and overwhelm the viewer.

Because of his use of colour, much like Yves Klein's monochrome paintings discussed in Chapter 12, Rothko's work was often interpreted as some sort of decorative work of interior design. This, however, was not the purpose of the work. Rather, the use of colour was to create a total experience and impose it upon the viewing audience. In a letter to the curator, critic and art dealer Katharine Kuh in 1954, he says:

> 'Since my pictures are large, colorful and unframed, and since museum walls are usually immense and formidable, there is the danger that the pictures

2 The letter Rothko and Gottlieb sent to Jewell on 7 June 1943 is on file at the Museum of Modern Art, New York. It is also available online at: http://homepages.neiu.edu/~wbsieger/Art201/201Read/201-Rothko.pdf

relate themselves as decorative areas to the walls. This would be a distortion of their meaning, since the pictures are intimate and intense, and are the opposite of what is decorative; and have been painted in a scale of normal living rather than in institutional scale. I have on occasion successfully dealt with this problem by tending to crowd the show rather than making it sparse. By saturating the room with the feeling of the work, the walls are defeated and the poignancy of each single work . . . become[s] more visible'.

(Rothko 2006, 99)

In conversation in 1953, Rothko said,

Maybe you have noticed two characteristics about my paintings; either their surfaces are expansive and push outward in all directions, or their surfaces contract and rush inward in all directions. Between these two poles you can find everything I want to say.

(quoted in Breslin 2012, 301)

In another setting, he clarifies his work, saying, 'I'm not an abstract artist, I'm not interested in the relationship of colour or form or anything else. I'm interested only in expressing basic human emotions – tragedy, ecstasy, doom and so on'; and,

The fact that people break down and cry when confronted with my pictures shows that I *communicate* those basic human emotions . . . the people who weep before my pictures are having the same religious experience I had when painting them. And if you say you are moved only by their color relationships then you miss the point.

(Rothko 2006, 119, emphasis in original)

In Rothko's progression towards clarity, he eventually moved away from bright yellows and pinks, to deep hues of maroon or blue, towards grey and eventually black. In this dismissal of a colourful palette, it becomes clear that the pigment being used is not about the colour, but rather that colour is a surface in which movement – specifically in Rothko's case the pushing outward or rushing inward – plays out. The issue of movement is spoken of in more detail in the subsequent two chapters. It is important at this stage, however, to consider how movement is possible in the static form.

Not all reds are created equal

In his work *Concerning the Spiritual in Art*, Kandinsky ([1911] 2008) argues that 'Colour cannot stand alone; it cannot dispense with boundaries of some kind' (64). Red, for example must (a) possess some definite shade of the many that exist and (b) have a limited, bounded surface, divided off from the neighbours. The first of these conditions is subjective, and it is affected by the second, the objective aspect,

for the neighbouring colours affect the shade of red as it is perceived. In the introduction to a recent translation of Goethe's *Farbenlehre* (Colour Theory), originally published in 1810, Michael John Duck and Michael Petry (2016) make it clear that Johann Wolfgang von Goethe, although best known for his literary work, was also a scientist who took it on to test Isaac Newton's revelation that light is heterogeneous and not immutable. They argue that Goethe was not persuaded by Newton's theory because of his own belief in the spiritual nature of light which prevented him from thinking about light in purely physical terms, stressing instead the role of the senses and thus of experience and of empirical observation in shaping the differentiation of colour in terms of harmonies. Goethe, in his colour theory, highlights that what we see of an object depends upon the object, the lighting, and our perception. This is a tripartite relation of sight: the ego, the object, and the context. While Goethe's theory of colour has been discounted for its lack of scientific veracity, it is relevant in terms of its insight into the perceptual phenomenon of colour. Goethe sought to derive laws of colour harmony, based on the ways of characterizing physiological colours (how colours affect us) and subjective visual phenomena in general. Taken in this light, any given colour, like pitch, can be seen to require other qualities to be present within the assemblage. Colour, for Goethe, is highly subjective, contextual, and requires the arbitrating stability of framing. Mondrian's colour squares – marked and guarded as they are by strong black lines of perfect clarity – are an extreme example of this kind of framing. Rothko's fuzzy, pushed, and hazed blending of colour, however, troubles this kind of distinction between hues.

As we have stated above, Rothko uses pigment as the material of pushing out and rushing in. Similarly, Yves Klein's use of IKB (International Klein Blue, an artificial ultramarine pigment), pink and gold leaf was less about the colours themselves, as materials through which the artist's creative gesture could be rendered. Where Rothko was interested in movement in or out, Klein's use of materials as a means towards the 'immateriality' that he sought used pigment as the medium through which the traces of his creative gesture could be wrought. In both cases, like in the Abelam use of red ochre, the colour is most important not for its ability to arbitrate the visible spectrum of light, but as a material substance for the articulation and facilitation of movement.

Smelling and healing green

Elisabeth Hsu (2020), drawing on Diana Young's work on 'the smell of greenness' seen in the extensive use of tobacco leaves by young women, advances the implications of this relationality of colour in important ways. Hsu is interested in understanding the 'greenness' of twigs used in medical recipes from Song period China. In a fascinating movement of triangulation, Hsu brings Young's ethnography of green tobacco leaves, Song medical records, and the 'green sickness' of 18th-century England into fruitful comparison.

Hsu outlines how, at the turn of the 19th to 20th century, the 'Five Twig Powder' formula was used to treat consumption. Using the method of 'wayfaring through

Colour, palette, and gestalt **181**

a text', which is an 'immersive and interactive practice, and active and sensuous engagement with the text' (3), Hsu suggests a variation in the topography of the recipe's text, and suggests that the consumption being described is not the terminal disorder (i.e. tuberculosis), but rather a temporary and treatable 'dis-ease among adolescent girls' (9) in a world of gendered communication. She then outlines the five tree twigs that are called for: blue-green mulberry bark, pomegranate twig, peach twig, plum twig, and (mentioned later in the formula) sweet wormwood. Interested primarily in the first ingredient, Hsu (2020) explains:

> Unusual in this formula is that the mulberry twig, which is mentioned first, should be *qing* (green, bluegreen or brilliantgreen). Then, there is *qing hao* which means the 'green herb'. The greenness of both the orchard twig and the herb in this formula invokes freshness; combined with the scent of the fresh plants, the colour green synaesthetically reinforces the sense of freshness. Such freshness evidently was considered suited for treating the fatigue (*lao*) mentioned in the first line of the formula.
>
> (4)

The word *qing* (green) is also homophonous to 'pure and clean' and 'light', such that the 'fresh plant *qing hao* effuse many ethereal oils, its name connotes an ethereal quality of lightness' (4), and, she argues, phytocommunicability (the ability of plants to communicate) cannot be reduced to pheromone signalling nor to linguistic symbolism alone. There is a reciprocal relatedness between the plants and the people who use them. And, as Carroll and Parkhurst argue (2019), the symbolism in medical settings can be seen to rest upon and inform the chemical and biological qualities of the substances and objects in health contexts. Hsu demonstrates that this phytocommunicability is similarly a reciprocal entanglement of biochemical aspects of the plant's evolution and sociolinguistic aspects of human society.

Against this case study from Chinese medicine, Hsu outlines Young's explanation of the wild tobacco which grows after the first rains, and brings a burst of green and a fresh aroma to the landscape. The tobacco is chewed by women, who appreciate the scent of the herb and the vibrant green hue (*ukiri*) that stains their lips and skin. In highlighting the effect it has on the women, giving them endurance to sing during long rituals, Hsu emphasises the fact that, 'Diana Young does not mention nicotine here, as little as anyone would be explicit about the vitamin C contained in fresh shimmering green herbs, and yet these molecules can be seen as co-constitutive of the cultural synaesthesia' (5).

Hsu (2020) then outlines her third case study, that of the 'greene sycknesse' (cf. King 2004), also known as *chlorosis*, which appears to have had 'family resemblances' with what is known today as anorexia nervosa (7). Hsu highlights that *chlorosis* was a medical name given to the disease, and not what it was actually called (7). In its vernacular usage, the 'green' of 'green sickness' shares the same high sharp vowels as *qing* and *ukiri*; and, Hsu points out that ethnobotanists have long found non-arbitrary relations between plants and their names (6). Hsu suggests a gestalt quality

182 Rediscovering the object

of colours and their names (9). In contrasting the high sharp /i:/ sound of green, *qing*, and *ukiri* to the low round omega and omicron of *chlorosis*, Hsu highlights the difference between a taxonomy, such as the naming of diseases or any other scientific means of categorisation, and an 'illness taskonomy' (cf. Nichter 1996), which names the disease by the 'task' required for its remedy (Hsu 2020, 8). Hsu explains that 'popular and folk medical illness labels contain within them indications for the strategy of how to treat them, which Nichter rightly presents as socially more effective' (8).

In this light, it is noteworthy to point out that, as Helen King (2004) does in her book on the 'green sickness', the young women suffering from the 'disease of virgins' were not, as we might assume, symptomatically green. To the contrary, narrative accounts of those suffering from the disease describe the women as pale, yellow, or − after their examination by a male doctor − flushed and red (Hsu 2020, 7). Green is not a symptom, it is part of the cure − most likely an herbal remedy called *aghariqa* − but also evident in the festivities of wedding nuptials, which were the 'sovereign cure' for the 'greene sycknesse'. By attending to colour as an aspect of material practice, and paying attention to moments of cultural synaesthesia, Hsu (2020) concludes 'we have moved away from making claims about colour terms as disembodied universals' and, instead foreground 'distinctive social configurations and their perceived Gestalt' such that

> words, pronounced with a fronted and raised vowel, is co-constitutive of a synaesthetically comprehended Gestalt of treatment. The plants' greenness . . . is best comprehended as constitutive of specific human–plant configurations which have refreshing, uplifting and enlivening effects.
>
> *(9–10)*

Gestalt

The possibility that something is more than its parts, and particularly so in a context where the cognitive perception of sensory input can mix and associate different senses in productive conflation, has important implications for how an object is able to abductively draw the recipient into, sometimes wild, analogical associations. The role of language, as Hsu points out, is an interesting one, as it shapes the cognitive perception of the world. However, it is important to recognise language as being one medium of art-like objects − it is not wholly distinct from any other aspect of human society and creative production. This is true if for no other reason than the fact that language is a gesture of the material of the body-as-first-plastic-art, be that through the materiality of the voice or sign. Its artefactuality is much more temporally finite than something like stone, but both must be taken within the associated milieu of their interartefactual domain. It is within its milieu, and especially in the synaesthesic corroboration of multiple sense perceptions, that an object (or aspect thereof) is able to be recognised as more than its parts.

Colour, palette, and gestalt **183**

The idea of gestalt – that something is more than its parts – was advanced as an epistemic stance against the overly reductive nature of pure empiricism. Like in Goethe's resistance of Newtonian perspectives on colour and light, psychologists like Wolfgang Köhler argued in favour of a macro perspective, so as to recognise the gestalt (literally 'form', implying 'pattern') aspects of phenomena arising above and between their particle elements. Köhler was also interested in the (possibly universal) relation between sound and form – like, for example Hsu's argument resting on the /i:/ shared across the greens of *qing, ukiri,* and greene. Köhler (1970) says:

> Another example is of my own construction: when asked to match the nonsense words 'takete' and 'maluma' with the two patterns [one a jagged star shape, one a rounded cloud shape], most people answer without any hesitation. In primitive languages one actually finds evidence for the thesis that the names of things and events, which are visually or tactually perceived, have often originated on the basis of such resemblances. If this is admitted, we have taken an important step; we have recognized that subjective experiences have at least something in common with certain perceptual facts.
>
> (224)

This link between subjective experience and perceptual fact is a potentially dangerous one, as it pulls at the tension between cultural relativity and universality. While Köhler and those after him (e.g. Peterfalvi 1970) assume the near-universal link made between *takete* and the pointy shape is based on spatial isomorphy across visual-acoustic qualities via synaesthesia, Gell (1999) suggests rather that 'respondents [to Köhler's experiment] see the "takete-object" not as a silent, spiky, thing, but as an object which makes the sound "takete" (e.g. if one attempted to bowl it along the floor), and ditto for the soft, rubbery, maluma-object'; so, Gell (1999) concludes, *takete* and *maluma* are 'onomatopoeic, and respondents tended to identify them correctly, not on the basis of acoustic/visual associations, but because of sedimented (and cross-culturally uniform) knowledge of the kinds of sounds objects make' (249).

Gell's (1975, 1979) rejection of the visual-acoustic spatial isomorphy is, it seems, in large part due to the distinction he draws between 'sonic iconism' in languages like Umeda (and that he sees attested to in other highland Papuan languages: Feld 1982; Weiner 1991) and the more elemental kind surviving in European languages in onomatopoeia. It is our suggestion that while the imagined sonic quality of the *takete*-object versus the *maluma*-object may indeed evoke the name via onomatopoeic association, there is nothing in the images provided by Köhler to suggest that they should be bowled. The possibility that Gell assumes – namely that the visual object can be grasped – is highly indicative, however, and certainly true: either literally (if imagined) in Gell's interpretation, or conceptually as an object of thought in the contemplation of its spatial arrangement, which, in Köhler's explanation, allowed visual-acoustic gestalt. In this light, the surface of an object must be examined in

184 Rediscovering the object

terms of its form in such a way to allow for the cumulative and gestalt relations that, as Taussig shows in his work of indigo, go well beyond the colour.

Indigo

The anthropologist Michael Taussig (2008, 2009) presents us with another perspective on Goethe's theory of colour that reaches to the socio-historical context of trade of dyes, spices, and fabrics. Until the mid-19th century, says Taussig (2008), 'the colonial world was an emporium of colour to be shipped to Europe from plantations' (3). In this world, colour was in fact a 'polymorphous magical substance' – a 'substance capable of all manner of metamorphoses' (4). This is because dye stuffs had represented a major portion of the overall spice trade (Balfour-Paul 1997, 21) since the 13th century, as dyes, such as indigo, spices, and precious textiles flowed via the caravan routes connecting India and the Middle East to the ports of Venice and Genoa, Amalfi and Pisa. Pigments recovered from insects, saps, and resins were keenly sought after by artists and textile manufacturers, and chief among these pigments was indigo, a substance unique for its colour fastness and resistance to fading. In the years leading up to Goethe's publication on colour, the French colony of Saint Dominique (now Haiti and Santo Domingo) had some 1800 indigo slave plantations in its western province alone, and sugar came to be surpassed by indigo as the chief export for this colony. As Europe expanded into the New World and acquired vast colonies in Asia, so the cultivation of more than 300 varieties of the indigo plant, both tropical and temperate, became as important as sugar and opium, associated with the exploitation of Indians and Africans over centuries in Guatemala, Salvador, and Nicaragua. At the same time as the successful slave revolt in the French colony of Saint Dominique in 1891, India reasserted its prominence in the indigo trade with Europe. By the late 1800s, indigo's widespread availability and superior properties had allowed it to become the colour of choice for uniforms designed for workers and figureheads of authority.

If substances such as spices, known by texture, taste, and smell, can be said to form a colour palette that enables the spice trader to recognize and discriminate by sight alone, indigo demands an attention to the process of its production cultivated by experience and honed by sustained observation, as the blueness of the pigment depends on the timing of the transformation from plant into pigment. Indigo is produced by soaking sheaves of mature indigo plants in vats of water for 10 to 12 hours, allowing the plants to swell, with a blueish froth forming on the top of the water. Both the colour and the temperature indicate when the soaking is complete, by which time the fluid is drained into another vat known as the beating vat, with the colour now being orange and emitting a strong odour, transformed gradually into a bright raw green, covered with a lemon-coloured froth, ultimately changing to red and blue, indicating that the liquid is ready for beating, turning everything that comes into contact with it blue. The colour indigo, says Taussig (2008):

takes on a life of its own, as befits something in nature upon being transformed into commodity. Not only does it acquire a life of its own, but is it a life 'more perfectly developing itself', a life ever more lively such that, finally, as a product readying for the market, it comes to resemble the intense deep blue of the ocean in stormy weather. More than resemblance, even more than affinity, this connection to the ocean seems of kindred spirits. Our eyewitness does not say it is *like* the colour of the ocean but, as I engage with his language, it *is* the ocean.

(9, emphasis in original)

The story of blue, of indigo, which as substance could not be replaced by chemical means until 1904, is one Taussig sees as a story of the lost heterogeneity of colours in the face of chemically designed homogenous colours, the trace of a 'colonial exotic that informs all colour in the modern and not so modern world' (Taussig 2008, 10). Indigo, in fact, in its association with black and purple, had come to supplant colour during a widespread process of decolouration starting in the 14th century and accelerated by the Reformation, as the blues, greens, and yellows were banished in favour of black and, later, white clothing. Where indigo paved the way for black and white to distinguish and unite aristocracy against what Goethe had called the inarticulate bouquet of vivid colours associated with primitives, children, and southern European women, indigo also came to distinguish and unite the Euro-American working class, and, with a twist, the rising middle class in the form of denim, replacing imported Genoese material, which came to be the material of choice for indigo-died jeans. Denim, so it turned out, could only partially absorb the dye, giving the material a much-desired faded appearance, suggesting a multitude of successive actions of wearing and washing. The effect of the time-worn, faded appearance was further heightened when Germany invented an economically priced blue that came to replace indigo, in many ways working like a skeuomorphic as it recalled a pigment and the gamut of its association with relations of labour and loyalty associated with its production. Recalled and perhaps 'redeemed', in Taussig's words (2008), is 'the density and intimacy of the interaction with the inner-life of the object world, the harmonies and self-transforming movements of animating materials confined by the vat, exploding into obscene song and colour' (14).

What is recalled and perhaps redeemed via the reappraisal of indigo is also textile production itself, as it is textile that lies at the core of the craft of indigo dyeing. Harnessing the knowledge of substances used as dyes, women the world over have created cloth wealth and established themselves as entrepreneurs in a thriving commodities market in which textiles, portable and adaptable, reign chief among other goods. No one has written more eloquently about the intimate relation of the arts of dyeing in their association with managing of female sexuality and reproduction with the fears and resentments stoked by the financial opportunities that textile productions afford than Janet Hoskins (1989, 2007) in her work on indigo in Sumba, an island of Indonesia.

186 Rediscovering the object

Textile, known as Kodi cloth, produced on the island of Sumba, is known for its most extensive use of indigo dyes in men's and women's clothing. Men's cloth in East Sumba are composed of large panelled sections suffused with geometric images of a reticulated python, dyed in a mixture of indigo and rust (for aristocrats) or indigo and white (for commoners). In Kodi, men's cloth is an indigo plaid, and it is women's cloth that is covered with geometric images referencing goods exchanged in bridewealth. The production of indigo dyes is secret knowledge controlled by senior women alongside other knowledge surrounding the use of general and reproductive medicines. Dyeing is linked to the controlling of menstruation and thus fertility via the associations that indigo permits between the process of fermentation and procreation, extended to a wider association between the finished colour of indigo and medicines:

> The cloth 'child' is created in the womb like pot and brought to life by the addition of lime – made from crushed seashells or baked limestone – as the 'quickener' or the 'husband' of the reddish mud bath, which 'brings the indigo to life', as a foetus is a blood clot (*manubo*) 'brought to life' by an infusion of semen.
>
> (Hoskins 2007, 105)

Like the medicines produced by the Kodi from herbal mixtures, indigo involves knowledge of the reactive interrelation between a number of ingredients – notably indigo leaves, rice, straw, wildflower roots, and stems from a number of coastal plants – with the woman responsible for the mixture touching, tasting and smelling the concoction at every stage of the production of the dye. The knowledge of the exact relations between the ingredients and the stages of the production of indigo is handed down the matriline across generations and as an extension of the intimate relation between the making of indigo and the making of bodies, girls are tattooed with indigo designs upon reaching sexual maturity, a process that moves progressively from the arms to the thighs as a sign of reproductive achievement.

Summary

This chapter examined the material properties of colour, as substance and as an immediately apprehensible aspect of an object. How colour relates to itself within a palette, and how colour may be taken as light or tangible matter, produces larger ramifications for social form. We worked through a series of case studies that link colour with other senses and cognitive associations, showing how the relational capacity of colour is critical to its role within objects. While this does sometimes work on lines of symbolic association, it goes well beyond semiotics and reveals that colour is best seen as a material that resists purification. Colour's capacity for mutability affords suggestive ways of understanding and making visible the invisible and the not yet conceived.

On a fundamental level, this chapter on colour, synaesthesia and gestalt is an extension of the previous one on material. Rather than thinking of colour as a separate optical phenomenon, it must be recognised as a motivic element of the surface of the object. As a motivic element it motivates lateral inferences (that is, abducts) across not only the interartefactual domain (as we saw in the previous chapter with the shared colours of cassowaries and dancers) but also across the various sense modalities. Synaesthesia is, obviously, a type of aesthetic apprehension. If we limit colour (or indeed any of the senses) to one domain (such as taking colour as only related to light) we limit the kinds of relations made immanent by the indexicality of the material. However, while in some cases colour shares overt similitude to material – such as when it is pigment in the initiation house of the Abelam – at other times the optic properties of colour mean that it is perceived principally as surface, and specifically as the means to denote differentiation within the design of surface. On this level, colour then is best understood as a fundamental basis to pattern – which is addressed in the next chapter.

Taken in total, colour cannot stand alone, and even in art expressions – such as Rothko, Klein, or Anish Kapoor in their various gestures towards the isolation of a colour – the Janus-like quality of colour takes the recipient in a cascading torque (Pinney 2005) of elaboration. With such 'figural excess' (Pinney 2005) of the object, it is easy to understand how the mind feels full, despite Bateson's claim to it as an empty 'no thing'. In the rapid, synaesthetic and gestalt double-description of colour in all its relations, the mind is flooded with constant images. In the next chapter we attend to this idea of sequence, and unpack the means by which the noise is excluded in order to make clear the geometric, ideational patternation of the prototype.

11

PATTERNS AND THEIR TRANSPOSITION

The previous two chapters both end with reference to Bateson's idea of the mind as an empty no-thing. However, there is the danger of reading Bateson's statement as an erasure of the mind, just as there is danger in reading Gibson's emphasis on the relationality of affordance as a denial of the inherent capacity of the object. In emphasising the prototype as immanent in the material, it is necessary to reassert the ecology of the index, situating the object in its interartefactual and social sequence.

This chapter addresses the sequentiality of immanent prototypicality by examining its relations, specifically the idea of pattern. As Gell argued in the context of traps, the object's potential to ensnare is requisite on the artist's anticipation of the audience's mind. Thus, it is not simply an emptiness relying only on the immanence of the idea in the object (as implied by Bateson) nor a duality of paired affordances (as argued by Gibson), rather the index is a triangulating point in a nexus that pushes and pulls the prototype and the recipient into mutual perception. The artist, as mastermind of the virtuosic creation of the immanent presentation of the indexical prototype must, via the inherent capacities of the material, form the index into the likeness of the social and relational patterns governing any specific encounter. Framed in another way, the gesture of invention, which inscribes the art-like object, is a meeting point of the implicit and controlling contexts (Wagner 1975); whether the gesture masks or obviates the previous invention, the sequenciality of the self-significative sign demands that the artefact be situated in its relation (Wagner 1986). In Gell's reading, the index fills the role of 'thirdness', creating the 'space' of social space; the 'third' is the concretisation of the relation between two relata, it is the distance between two points. Any given index will act as 'third' between its relational pair, depending on the perspective of the recipient.

In the relation between the 'third' and its pair is also the possibility – even necessity – of extension out through to the 'fourth', as its own 'third' in relation to the initial pair and the first third. Like the Golden Curve, the fixity of parts on one level

Patterns and their transposition **189**

begets the continuity (and self-replication) into the subsequent iteration (which, in the case of the Golden Curve, is also into a larger scale) along the self-governing rules of ratio and proportion. In this regard, it is also essential to map out the relation between sequence and pattern, and think through the possibilities of generative growth in patternation. In his work on the importance of pattern to humour, the evolutionary theorist Alastair Clarke highlights the importance of pattern, saying

> it is the recognition of the pattern that evokes a humorous response, not the content, although content is still necessary for us to be able to decipher the pattern beneath it. Without content there can be no pattern, yet once the content exists, the pattern is the level at which humour operates.
>
> (Clarke 2008, 19)

Pattern is recognisable only via its content, but humour is only present in the arrangement of the underpinning pattern. And, we contend, the crucial underpinning of pattern is also true in other social domains (see, e.g. the political implications of clowning in Hereniko 1994). The social impact of the index, as it is implicit in Gell's *Art and Agency*, thus rests not in the context but in the geometric arrangement of the gesture.

Clarke (2008) outlines (as seen in Figure 11.1), a set of terms, including 'element' (a discrete motivic part), 'term or unit' (the series of elements in one repetition of the pattern, e.g. the 'theme' in musical arrangements), 'sequence' and 'pattern'. Distinguishing between these last two, Clarke clarifies that he refers to 'the collection of terms [or elements] as a *sequence* if we fail to discern repetition, the collection of terms as a *pattern* if we discern repetition' (21, emphasis in original). The recognition of the pattern is contingent on the recognition of the 'criterion of repetition' (22), be it one of the 'basic motions of pattern formation' (Gell 1998, 78, see Chapter 5) or a more complex 'rule' of creation, such as $N_x + N_{x-1}$, as with the Golden Curve.[1] In the development of motivic patterns from one element (e.g. a string of dots) to more complex arrangements, patterns with a tripartite structure stand as an important part of humour, as well as rhetoric (Clarke 2008, 26) and social behaviour more broadly. In the space between the first and second elements exists a gap, the ontology of which is unknown; however, 'the third term closes this gap and confirms the identity of the operative criterion' and thereby confirms the pattern as an anticipated, subsequently fulfilled, and thereby knowable set of relations and distantiations. The third, he continues, is 'the first multiplicity that allows the repetition of the criterion rather than the simple unit' (26).

In its spatiality, the pattern also commands the futurity of subsequent action, just as a spring-loaded trap anticipates and perpetrates causal sequence by the gap facilitated between the huntsman and the passage of prey. The efficacy of humour,

1 It is worth noting, however, that even the iterative nature of the Curve can be seen as a slide translation of the golden ratio.

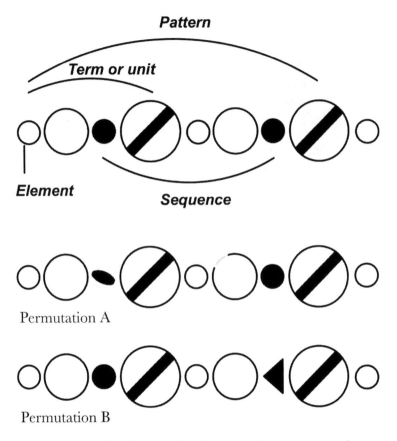

FIGURE 11.1 Pattern, and its elements, after Figure 4, and permutations and degradations of the pattern, after Figures 15 and 16 from Alastair Clarke (2008, 21, 30).

and we contend sociality more broadly, is contingent on the 'pattern fidelity', as the 'more accurate the repetition, the more exact the pattern' (29), the greater the impact of the inversion as comedy or the invention as continuity. However, as Wagner (1975) points out with the success of each invention, it rests in the dialectic between the controlling context of the immediate situation and the implicit context of the socio-cultural milieu. In this way, to run with Clarke's example, the joke will only work if its fidelity to the pattern is faithful to the knowledge of both contexts and can invert the one in line with the pattern fidelity of the other. Humour is not arbitrary unsettling of pattern, it is the disquieting of the anticipation of pattern according to the pattern of a higher order; it, like art more broadly, is a game played in the navigation between pattern and meta-pattern. If, as we have said, the distance between any pair is unresolved until its third comes into place, and this third both articulates the nature of the distance between 1 and 2, and becomes a pair to the first set, inviting yet another to articulate the continuation of sequence and close the pattern, then the relation between motivic elements is also motivation

in the open sequentiality of social form. Each gap – the negative space in a motif and the unanticipated silence in social protocol – asks for closure, and in its closure, there is space for the subsequent iteration.

Pattern, then, as the formal quality of and between objects, is the 'code' (following Bateson) and form of this relational ontology of material that allows for the gestalt phenomena of multisensorial association (i.e. context) and, subsequently (as discussed in the last chapter), life itself. To help clarify this theoretical perspective, we now turn to Gell's theory of tattooing and political hierarchy in Polynesia; in this case study, it becomes clear that the line drawn between two points concretises relationality and models sociality.

Tattoos

In Polynesian cosmology, where the night (*po*) and day (*ao*) are set in a bicameral world ordered into a 'nested arrangement of shells ('*apu*), each associated with a particular cosmogonic episode of separation' (Gell 1995a, 21), the act of bringing distinction between parts of an otherwise undifferentiated whole is 'permeated with procreative symbolism' (35). All living entities, both objects and persons, are *tapu* – meaning the 'quality of personal, sacred distinctiveness, which was continually subject to dispersion' (35), such that '*tapu* is "difference" in the sense that any thing or person is non-substitutable' (36) – to the degree that their *po*- and *atua*-derived attributes, held 'immanent' in them, was not liable to dispersion. 'Immanent sacredness can be localized and preserved only via isolation from non-sacred things' (35). In this manner, sacredness is not conferred upon the *tapu*, but immanent and pre-existing in the person, object, or activity. Carving, tattooing, canoe-building, and other creative activities of making lines or hollowing out were sacred because the crafting technique was godlike.[2]

In examining tattoos in Polynesia, therefore, the capacity of the motivic pattern on the skin is only one dimension of the total system of patternation. The visual pattern is a concretisation of larger systems of cosmological, political, and social sequencing, whereby the attention to the tattoo can elucidate the total pattern and art of social form.

In *Wrapping in Images*, Gell (1993) works systematically through the archival and ethnographic literature by region across Polynesia showing how there is a different accent on tattooing as temporary bloodletting, the marking of flesh, and the enduring image of the mark. Drawing upon Terence Turner's argument about the skin as 'a boundary of peculiarly complex kind, which simultaneously separates domains lying on either side of it and conflates different levels of social, individual and intra-psychic meaning. The skin (and hair) are the concrete boundary between

2 For wider reading on this topic, see Firth and London School of Economics and Political Science (1940), Hermkens and Lepani (2017), Hooper (2006), Mallon (2002), Mallon and Galliot (2018), and Thomas, Douglas, and Cole (2005).

192 Rediscovering the object

the self and the other, between the individual and society' (Turner 1980, 139; Gell 1993, 24).

Gell shows that tattooing practices of Polynesian societies were not randomly distributed, but causally precipitated by social contexts encompassing kinship systems, political hierarchy, religion, and economy. Different regimes of social reproduction in traditional Polynesian societies exploited the thematic possibilities of the basic scheme of tattooing in different ways so as to give rise to a complex pattern of relation between the differential accent placed on the technical aspects of tattooing, including its placement on the body and its motivic articulation and the psychosocial context.

We are summarizing the relation between tattooing and social forms here in some detail to get across the idea that pattern is the result of the societal take-up of a technical schema. Gell's analytical project leans heavily on the work of the cognitive anthropologist Dan Sperber (1985) who argued that ideas catch on like viruses. This gives rise to the interesting question as to why certain ideas touch down in certain ways in certain social forms. The project of looking at the voluminous and yet never comprehensively analysed data on Polynesian tattooing was born. The idea of conducting an epidemiology of representation was to develop into a complex geometric figuration that detailed the variable and yet logically conclusive nature of the intricate relations between the practice of tattooing, as it presents itself logically to us as a technique of the body, the idea of how tattooing works and the social referent of this idea in the formal articulation of the social body in the body politic.

While each tattooing practice by necessity includes all three aspects of its technical schema, the social importance of the tattoo relates to whichever aspect in the technical schema of tattooing was given primary emphasis. The technical schema of tattooing (as a technique of the body) has, as Gell shows, an invariant processual contour in which wounding is followed by bleeding and the insertion of pigment; followed by scab formation, scarring, and healing; and finally the acquisition of an indelible mark that is frequently ornamental. Gell shows that tattooing was read differently depending on which moments of the tattooing process were focalized, and that the variations of political systems found in traditional Polynesian societies were complemented by the symbolic potential of the tattooing process.

In settings where the bloodletting was most important, exemplified by the Society Islands (Gell 1993, 133ff), the technical schema of tattooing was enmeshed within an extensive series of analogies with other ritual procedures for the control of *tapu* and desacralisation, involving marriage, ritual friendship, as well as ritually significant physiological events. Tattooing here set the seal of finality on the crucial blood transactions underpinning the formation and reproduction of the body politic. The body politic in question was defined by a lack of hierarchy, with society permanently poised between continuity and discontinuity as only ritual prohibitions and a socially dictated reading of the tattooing process could regulate the mutual hierarchization of kin congregations.

In settings where the importance is placed on the scab formation, scarring, and healing, exemplified by Samoa (Gell 1993, 53ff), emphasis is on the endurance of

Patterns and their transposition **193**

the tattooing process, which is conducted all at once, rather than in stages. The Samoan tattoo was primarily an aesthetic form that completed the initiation of a young warrior. Rather than being concerned with bloodletting as a form of ritual exchange as in the Society islands, in Samoa men underwent tattooing to become whole again as part of rituals of warriorhood. Tattooing became a substitute for initiation as it allowed the dramatization of political loyalty and indebtedness via the collective sharing of the pain and glory. The hierarchical distinction between chiefs and the subordinate warrior class upon which the stability of the Samoan political regime rested was thus reinforced by the ritualization of subjection framed as service and as protection. As such, tattooing motifs were coverings, wrappings, and architectural barriers, acquiring an artefactual character that was reinforced by the payment of tattooing with mats and other transactable wealth items.

The politicization of tattooing that Gell observes in societies with a marked hierarchical differentiation takes on a radically different articulation in Polynesian societies characterised by the fragmentation of hierarchy, political instability, and ritual masking, including the overt ritual defiance of the chief (Hereniko 1994). In these societies, a tattoo becomes a ritual artefact or a functional mask, as in the form of the Māori facial tattoo, the *moko*, defined by graphic elaboration and high visibility. Tattooing in these systems was individually idiosyncratic, decoupled from age or status, allowing tattoos to be added at any stage in life, while taking what Gell calls the core-Polynesian conception of tattooing as control of *tapu* via the device of closure, protection, and defensive multiplicity to its logical extreme. Tattooing here is a trophy of individual achievement, a biographical marker, unconcerned with rituals of social observance of any kind.

Gell observes that there were further variations in the reading of the tattooing schema, allowing for political differentiation between societies otherwise markedly similar. There was the disarticulation of the social and political implications of tattooing, as found in Hawaii, where tattooing began to take on foreign images and to develop an international style. In Tonga, where a feudal system existed, with pronounced hierarchy, tattooing was practiced in an almost identical form to Samoa, with an emphasis on the preparation for warriorhood, but with a twist that emphasized the first stage of bleeding with the importance given to masochistic subjection (Gell 1993, 107f).

Working with this explication of tattoo typology, Gell aligns the use of tattooing with the spatial geography of the island and its formation of socio-political systems. In doing so, he draws upon the geometry of polities, wherein the three vectors of graphic image, spatial arrangement, and social form are 'the only arrangement which permits the representation in two (graphic) dimensions of the theoretical postulate that Polynesian societies do not fall on a continuum, but are mutually opposed along a plurality of dimensions' (290). 'Space', he continues, 'should itself be multidimensional, but this cannot be graphically represented', thus the use of the tattoo to make immanent what the land does not have the capacity to achieve in and of itself. The literature on Polynesia, Gell summarises, has always shown how there are three types of political systems, and his 'synoptic visualisation' (290)

194 Rediscovering the object

of the Polynesian's own spatial orientation within the social and 'natural' milieu demonstrates the importance of the properties and affordances of materials in the formation of social practice. The limited spatial capacity of islands produces a limited array of social differentiation, such that to afford social differentiation on small islands, the affordances of tattoos must be used to reinforce distantiation through visual form.

From the wider literature on Polynesian tattooing, we know that – as has been shown in earlier chapters with Owen Jones's work on ornamentation, Fred Myers's observation of Tjakamarra's paintings, and Nancy Munn's Walbiri continuous and discontinuous visual forms – the complex whole of the motif is comprised by a limited and infinitely variable set of motivic elements. In the ornamentation of the skin, the possibility of arranging specific grammars of visual form allows the 'motifs of coverings, wrappings, architectural barriers, etc.' that have implications of protection to 'take on independent character of a valuable, and as a transactable wealth-item it enters the flows of valuables which sustained the large-scale integration of western Polynesian society both horizontally and vertically' (Gell 1993, 309), and fit within the same exchange network of fine mats, which underpinned the political structure that connected diverse societies, such as Samoa and Tonga, through political alliance and intermarriage. Thus, tattooing, in its 'protective' articulation, is key to the encompassing nature of western Polynesia hierarchy.

Polynesian hierarchy depends on the creative activity of closure, and specifically a kind of closure that requires severance. As Gell points out, Polynesian ritual is 'precisely the inverse sense to Christian communion, i.e. the intention was to cause the divinity to leave (some part of) the world, rather than to induce the divinity to enter (some part of) it' (1995a, 25). With the possible collapse of distinction, the immanence that pervades the world and constitutes it is always in danger of absorbing and collapsing the structures of differentiation. In this context, the hierarchy is never stable in and of itself, but must always be demarcated. It is in this way that the jester or ritual clown is an integral part, alongside tattoos, of the whole political structure, whereby the jokes and defamation of the chief project the pattern in a transformed manner, such that the anticipation of the canonical form is called to mind in the audience, but troubled in the performance. This abrogation of the pattern, in the joking performance of the jester, is also a creative act of cutting, making a closure around the *tapu* of the chief, who cannot make error, thus reaffirming his sacred position.

Cognitive spatialisation

The joke, like the tattoo, is an articulation of a larger abstract geometry of related elements, whose spatial and cognitive arrangements hold together in their relatedness a set of coordinates by which the quotidian life is lived. What is the relation between the medium in which we think and the medium in which we talk? This is a question asked by Stephen Levinson (1997) in his work on spatial cognition and language. The medium in which we think, says Levinson, is at heart a

spatial one, defined by an intuitively recognized and inherently memorable, inter-subjectively shared coordinate system composed of a mental model of a geometric object that is independent of one's imagined position in it (Levinson 2003). The coordinate system is dependent on a consistent relation between points and is thus founded on logic and mathematical ideas. That the idea of relation is universally expressed mathematically and that the media in which we think are thus insep-arable from numbers and rules for their combination universally translated into geometric patterns has been the driving force behind the work of an American ethno-mathematician Marcia Ascher (1991, 2002). Ascher's formative thinking on the topic of why humans decorate their world with patterned objects has been almost completely ignored by social and cultural anthropology, shown by Levinson (1997) to be overly reliant on an anthropocentric bias that assumes the canonical nature of the upright position to shape spatial cognition.

Levinson's research on spatial cognition and language makes use of ethnographic data on kinship to show coordinate systems in action. His work invokes the intri-guing possibility that objects are used for instruction in ways that sustain social systems of great reach, complexity, and resilience by enabling individuals to engage with ideas of relation knowledgeably (Starr 2013). An example of an object that is overtly used to instruct persons to calibrate multiple levels of action and geometric-ally complex ideas of relation is a stick chart (*matang*) used by Marshallese navigators. Made of sticks, threads, and shells, these objects are in fact coordinate maps that visualize the relation between underwater elevations, currents, surface-wave crests, winds, and of course islands – used prior to electronic navigation tools for long-distance navigation (Ascher 2002). Three types used to exist: an abstract chart for instruction showing relations between above- and below-surface articulations and their consequences; and two charts corresponding to actual locations in specific islands – one showing confluence of water around an island, one highlighting landing site. These make reference to the vicinity of the island and landing sites, enable the recognition of sequences of swells visible on the surface of the ocean, and aid the understanding of the topological relation between reference points that are only ever partially visible (Ascher 2002, 89–125). While we would imagine a vessel's navigation to be oriented by what is visible to the eye, the object gives shape to the idea that the canoe itself is stationary, with iterative and repetitive sequences of surface swells moving past until a certain sequence and articulation of waves finally enables the recognition of the anticipated island (Hutchins 1995, 118). Rather than voyaging being simply a mere temporal process, the time passing as the canoe journeys between islands is mapped spatially as continuous and yet locally discrete on the patterned surface of the stick chart.

The example of the stick chart allows us to recognize that objects are used for contemplation and incantation, to show forth relations that can only be accessed as knowledge via remembering, rather than making visible what can be known by other means (Ginzburg 2001). The pattern on the surface of the stick chart may deceive us into thinking we see a representation of the spatial position of islands in relation to one another, while in fact it enables the navigator to 'hold multiple levels

of action in view at once' (Riles 1998, 379). Within an environment dominated by seascape and other undulated surfaces in which the invisible is as important as the visible, it is perhaps not surprising that the topological understandings of a coordinate system prevail (cf. Glowczewski 1989). Yet, what may be surprising is that the complex systems of kinship, land use, and genealogy that are known to prevail in such environments are reliant on objects. How such objects do this has not been systematically investigated, let alone answered (Küchler and Were 2005b).

Pattern thus presents itself to us as a technical object par excellence. The result of reversible action, the sequences of which are engaged with systematically, pattern offers the kind of independent geometry Levinson has argued to enable spatial cognition to be inter-subjectively shared and stable over time. There are, as it were, two ways of conceptualizing the geometry of space – one is as a straight line and the other is as curvature. The Euclidean geometry of linear space is graphically represented via fractal patterns, the partitioning of which is homogeneous, with a general disregard of the exact measure of each part. The graphic representation of curved space is less obvious, yet it can be seen to underpin patchwork-like assemblages of heterogeneous parts whose overall integration is subject to an underlying measure applied to the composition as a whole. Below we will find ethnographic case studies of these two graphic representations of the geometry of the line, yet first we take a detour into the theoretical implication of these ideas in the work of Gilles Deleuze and Felix Guattari and their application in the analysis of Mongolian kinship.

Gilles Deleuze and Felix Guattari (1987) distinguish, in their epic treatise of types of affective assemblages, between smooth and striated space. Striated space refers to a landscape with distinct points or sites that can be traversed via a single line that connects these points in a manner that allows a standardized apportioning of time to spatial distance. Rather than residing in place, people move *through* striated space from one point or location to the next (see Ingold 2011). In contrast, smooth space has indefinite extensions. People move *in* this space, both simultaneously and sequentially, rather than to fixed points along a trajectory. Smooth space is akin to cinematography in that it is filled with heterogeneous multiplicities that are intuitively recognized and integrated into one. Deleuze's interest in smooth space is shaped by his understanding of the mathematics of curved surfaces, which had informed his work on the aesthetics of the 'fold' in Baroque style (Deleuze 1993; Duffy 2013). Spatial cognition, which draws on an assemblage of points in space that vary in relation to one another depending on a multiplicity of potential perspectives, has been described using the language of topology and differential geometry. Rather than stretched out along a spatial continuum, time in topology is literally folded into space, becoming space and thus allowing the mapping of time by the measure that defines the relation between points in manifold ways.

Rebecca Empson (2007, 2011) makes use of these ideas in her work on the dual dynamic of kinship in Mongolia, which simultaneously separates and contains persons. Striated space, she shows, allows for containment, permanence, and renewal over time, reflected in photographic montages of portraits of deceased patrilineal

elders and constructed places in the landscape, such as *oboos*, which pile high on mountaintops and sacred trees that emerge with fluttering ribbons from dark ravines. Her work shows that these sites are made to visibly accumulate and grow in order to allow for people to attend to networks that may be drawn upon in various configurations throughout a person's lifetime. As people attend to these places, they merge into groups that are fixed, passed on, and contained over generations (Empson 2007, 150).

The conception of smooth space, conversely, finds its importance in the nomadic lifestyle of the Mongolian household that has to negotiate an inevitable series of movements and transitions as it moves from place to place without a fixed centre, returning along the same route. Empson refers to the concretisation of smooth space as synonymous with cloth objects hidden inside the chest as temporary vessels where relations based on the premise of separation and movement may temporarily reside (150). Both of unlimited extendibility and yet uncertain, the chest and its contents capture the permanently endangered and yet productive potency of this latter conception of relations of kinship that Empson sees encapsulated in the idea of fortune, which drives much of decision-making in daily life (Empson 2011).

Rebecca Empson's work shows that both types of geometries are available to think with at all times, leaving one varyingly accentuated over the other in ways that create a crucial difference in the articulation of the body politic. One such accentuation, on the conception of linear space underpinning a fractal geometry, is shown by the anthropologist Ron Eglash (1999) to inform the making of houses, settlements, hairstyles, and objects associated with bodies and the body politic across Africa. The logic of the line and its uniform partitioning resonates ideas, the philosophical basis of which are undoubtedly not fully understood as yet, given the difficulties of conducting a comparative study in the multi-lingual setting. Using computing to undertake a visual comparative study on a large scale, Eglash is able to show a consistent pattern of variation that informs actions and action representation across a number of domains of social life, even if he is not quite showing the difference this pattern makes to society and culture.

The other accentuation, on the conception of curved space underpinning a patchwork-like assemblage quaternion geometry, is shown by Küchler to give rise to *tivaivai* and inform the tombs and their position in relation to one another in the Cook Islands. Here, the precise measure of the individual piece stitched into the overall composition of pattern visible on the surface of the coverlet is significant as it defines the size of the core motive and the number of times it is repeated iteratively across the surface. Küchler (2017; Küchler and Eimke 2009) shows how the translation of number sequences into geometric patterns underpins the construction of the coverlets, drawing out multi-variant perspectives of a rotatable object imaged in the shape of a flower, and how this externalisation of number sequences enables the transmission of complex genealogical knowledge. While she shows how coverlets work and what they do based on the analysis of individual objects, further work using computing could show how patterns composed of number sequences underpin music, dance, and the variations of patterns visible on the surfaces of

198 Rediscovering the object

coverlets associated with individual households, allowing us to understand how specific genealogical references are recognized and engaged with knowledgeably.

In the case of the coverlets, the use of 'natural' floral patterning is done in a non-random articulation of highly geometric configurations of genealogical relations. The creative capacity to render nature in the image of society works to articulate elements and units within the patterning of both so as to articulate each. By comparison, the navigation of the 'natural' world moves in the opposite direction, but does the same mutual articulation. As seen in the Marshallese navigation via *matang* (stick charts) maps, the 'chaos' of seascapes – with currents, unseen and changing water elevation, tide, winds, and random arrangement of islands and atolls – is made knowable, navigable, and memorable by articulating it as a complex geometric model, the pattern of which makes knowable the unseen via the parts perceivable.

Navigating as pattern recognition

In navigating sequentiality, it is the knowability of the complete 'unit' (in Clarke's sense) that allows the subject to traverse space and arrive at the appropriate and anticipated place. This is true of both social and geolocative space, arriving at both informational and geographical place. In his paper on mental maps, Gell makes a strong distinction between mental images and mental maps, aligning these to what he calls token-indexical beliefs and non-token-indexical beliefs, respectively. A map, as one might experience in an atlas, is non-token-indexical. Its truth value is the same no matter the position of the navigating subject. (Being useful is different; a map of Madrid is useless when navigating London, but is no less true.) Token-indexical information, such as 'London is to the north', is only true when one is south of London.

A map, such as those used by maritime navigators, may be non-token-indexical in terms of space, but token-indexical in terms of time if, for example the channels of navigation shift with the tides. All 'perceptual judgements' are, he suggests, token-indexical beliefs (Gell 1985, 279), as their veracity rests in the position (spatio-temporal, emotional, etc.) of the observer. In the process of navigating between points A and B, the map is useful only insofar as it is faithful to the specific elements within that 'unit'. While the specific geometry of the distance between A and B is not, itself, a pattern, the possibility of the navigating subject to follow in the path of those who have gone before (i.e. the cartographer, amongst others) renders the subject as a(n anticipated) fulfilment of the sequence as pattern. As with the heroic journeys of return (cf. Eliade 1954; Campbell 1949), the pattern's 'unit' is already set, and the navigating subject can rest in the certainty of its heroic completion to be promise of their own immanent arrival.

For Gell, the function of a map is to create images, that is: the non-token-indexical evokes token-indexical beliefs that are used for verifying the successful continuity of the path of navigation.[3] A landfall image, as in Figure 10.2b, is useful for the navigator only if they are approaching the island from the north, as the

3 This is, for example, the movement between the map and street view in applications like Google Maps.

Patterns and their transposition **199**

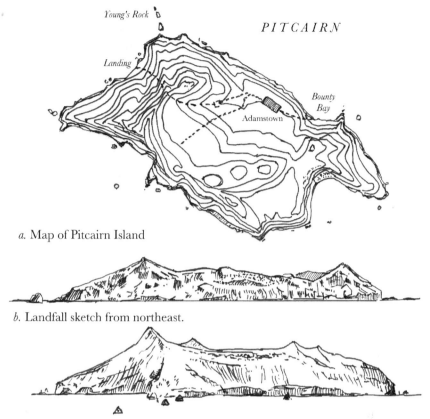

a. Map of Pitcairn Island

b. Landfall sketch from northeast.

c. Landfall sketch imagined by Gell from the southwest.

FIGURE 11.2 A map of Pitcairn, a landfall image, and one proposed by Alfred Gell, after Figure 2 of Gell's 'How to Read a Map' (1985, 281).

landfall image is sketched from position 'X' in the map (Figure 10.2a). Having the map, however, one is able to imagine the appearance of landfall from the opposite side (Figure 10.2c). As Deleuze argues in his discussion of Leibniz's insights on 'point of view as jurisprudence or the art of judgement', indicative images operate as anamorphosis, where the subject is left with chaos when outside the deictic position of perceptual verification (Deleuze 1993, 21f). The non-token-indexical beliefs, however, allow the subject to creatively imagine the elements along the path between A and B, verifying progress by the sequential perception of each landmark or stage as anamorphosis.

It is in this sense that knowing a pattern will allow navigation of new terrain. In the use of *matang* and the navigation in reference to an (unseen) *etak* (meaning 'refuge') island (Gell 1985, 284), the sailors navigate the voyage between two islands in reference to a third island. While this *etak* may be below the horizon, its position is rendered in reference to the movement of the stars, rising and setting

200 Rediscovering the object

over the assumed *etak* position. This form of abduction, or what Gell in this context calls 'dead reckoning', takes the astral pattern and renders it as the stages of the maritime journey as the island of destination moves towards the boat. On its own, the boat makes a journey of hundreds of kilometres across an open ocean. However, by rendering the boat amidst a geometry of unseen islands, the swells and currents of the seascape, and known star paths, the sailors are able to produce token-indexical images of the world moving past the boat and thereby bring the destination into view.

There is a danger, in emphasising pattern at such an all-encompassing social scale, to edge towards social determinism. While the navigation of the subject as they move through the patternation of social form is, to a large degree, a process (if for the most part intuitive and subconscious) of pattern recognition and replication, it is crucial to, as does Wagner, render each gesture a novel invention. The dialogue, identified by Wagner, between controlling and implicit contexts is likewise a movement between pattern and metapattern, as identified by Clarke. With this in mind, we turn to a final extended case study on pattern. And, while song and poetry are both deeply patterned things, our focus is on the overarching pattern of song, rather than the specifics of harmony, tempo, and lyrical configuration.

Ka Mate, Ka Ora

As a final case study, this chapter now turns to consider the Ka Mate *haka*,[4] made famous by the All Blacks New Zealand rugby team. While the All Blacks have been using Ka Mate (meaning 'I died') on and off since 1897, it has a much longer, even ancient, history. The Ka Mate, as it is sung now, is actually the last stanza of a longer haka called Kikiki (meaning 'I stutter or quiver'). In its full version, it tells the sojourn of Māui as he – a great trickster and hero of Polynesian folklore – harnessed the sun to tame and regulate the cycle and duration (that is, the pattern) of its journey across the sky. In the olden days, the story goes, the sun moved quickly and irregularly. It did not allow the crops to know their seasons, and days did not come with regularity. Māui and his brothers proposed to harness the sun and set forth to find the pit in which the sun rested at night. Finding it and trapping it, Māui tamed

4 It is worth noting that this case study is open to much interpretation, and many divergent elaborations of its history exist. We are working primarily from the account of John Archer, the folklorist and compiler of Māori folk songs and chants, who has worked for over a decade researching the history of various haka. As he says, 'I have found that stock phrases of old works have been rearranged and given new meanings to make compositions that fit new situations. By looking at a sequence of old chants and their place in history, we can postulate how the present-day versions of Ka Mate came into being' (Archer 2009, 2). Like other media, different lines of a song, as elements within a sequence, may be moved and reused. As such, we present this case study not as the definitive understanding of the Ka Mate, but as one reasonable explanation, working with what information is available. For wider literature on the importance of the *haka* and its related issue of copyright, see Frankel (2014), Dreyfuss and Ginsburg (2014), Hapeta, Palmer, and Kuroda (2018), Kāretu (1993), Rosanowski (2015), and Sweetman and Zemke (2019).

Patterns and their transposition **201**

the sun and made it run its regular pattern. Capturing the harrowing deed and the mighty contest, the song speaks from the perspective of Māui, saying:

> I'm jabbering and quivering,
> stuttering, shaking and naked
> as my belly is brushed
> by a cleft mound, a pulsating cavern!
> Forbidden mysteries are revealed;
> banter and intimacy, your flushed face:
> I am caught in your noose.
> I'm scared but fully alert.
> Who is this man with thrusting penis
> Investigating the thigh-girt depths,
> The squirming pungent depths below? It's me!
> Oh! Oh! I'm dying!
> No, I'm alive, fully alive!
> A virile man
> Who is bringing harmony and peace!
> Together, side by side, we can make the sun shine![5]

It is a classic hero's tale, with sacrifice and triumph, with the movement from uncertainty and risk to peace and prosperity. The overt sexual references, however, also speak to the use of the song in other contexts, such as in the preparation for marriage. The folklorist John Archer (2009) outlines the historical context of political marriages in Māori culture, highlighting what was called a 'greenstone door' (*tatau pounamu*), being permanent, beautiful, and highly valued (11; Mead 2003). In situations where there had been war between tribes, peace was achieved through marriage alliances that became permanent only at the birth of children. Such a *tatau pounamu* ensured the enduring peace between two tribes, as the child born of the marriage – being of both tribes – acted as mediator and resolution.

Working from historical records, Archer notes the regular paring of Ka Mate with another chant, Kumea Mai. Kumea Mai, a canoe-hauling chant, has the rhythm necessary to coordinate the beaching of canoes. Following the beaching, the Ka Mate, also called 'the peace making song' (Daily Southern Cross 1857, cited in Archer 2009, 4), worked as a meeting between two parties: the host and the foreign delegation. In this capacity, the Ka Mate also appears in several accounts concerning the visits of British delegations – such as the 150-strong performance led by James Carroll, the Minister of Native Affairs, upon the arrival of the Duke of Cornwall (George V) in 1901. It was, as Archer (2009) says, 'an ancient and universal haka that binds different groups together' (18).

5 Translation by John Archer (2009, 12).

202 Rediscovering the object

In light of this, it is interesting that in the Waitangi Tribunal the rights to Ka Mate were recognised as belonging to only one tribe: Ngāti Toa. The Waitangi Tribunal is a permanent commission, established in New Zealand, that makes recommendations on claims brought by Māori relating to claims concerning, amongst other things, the loss of tangible and intangible heritage. In a letter from the Office of Honourable Christopher Finlayson, Minister for the Treaty of the Waitangi Negotiations, dated 11 February 2009, the Tribunal, acting on behalf of the Crown, recognised 'the authorship and significance of the haka Ka Mate to Ngāti Toa', and promises the Crown's cooperation in addressing their concerns in balancing their rights and those of the wider public.[6] The claim for tribal ownership by Ngāti Toa rests on one occasion[7] in the biography of Te Rauparaha (a chief of Ngāti Toa) in the early 19th century. Somewhere around 1810, Te Rauparaha was forced to seek aid and refuge from a distant relative, Te Heu Heu II Mananui, as he fled from a Ngāti Te Aho war party seeking revenge upon Te Rauparaha. Te Heu Heu instructed Te Rauparaha to hide in a pit dug for storing potatoes and instructed his wife, Te Rangikoaea, to sit atop it, covering the opening with her skirts. In this way, the Ngāti Te Aho war party was tricked into pursuing Te Rauparaha further afield, and – arising out of the dark pit – he chanted to his cousin and host the lines that are now known as the Ka Mate, starting from the lines 'I'm dying, no, I'm alive' (ka mate, ka mate, ka ora, ka ora).

The notion of 'authorship and significance', cited in the Waitangi decision, is interesting considering the fact that Te Rauparaha did not, in fact, author the Ka Mate, but rather took the last stanza of an existing folk song and sang it out of context. What is evident, however, is that in taking a peacemaking song, rife with explicit sexual imagery, Te Rauparaha reinvented the haka making comedic and triumphant the humiliating and awkward situation to which he had been subjected, hiding beneath the skirts of his cousin's wife. In explaining the attribution, Archer (2009) draws a useful (if stereotypical) distinction between the 'left-brain' 'painstakingly logical and tediously slow' method of European thought and the 'right-brain' and intuitive thinking of pre-European Māori (17–18). He argues:

> [A]s a piece of poetry, [Ka Mate is] metaphorical and elliptical. Right-brained intuitive processes are needed to comprehend a piece of Māori poetry. Any line in it may have connections to several other pieces of Māori literature. The particular connections that are made, and the connotations formed, depend on the context in which Ka Mate was chanted in on that particular occasion.
> (17–18)

6 This letter is available via the New Zealand government's website (see Finlayson, Key, and Sharples 2009).
7 The official governmental account (Haka Ka Mate Attribution Act 2014 Guidelines 2014) records the subsequent narrative as happening closer to 1820; Archer places this closer to 1810 and records a second use in 1820, when Te Rauparaha used a different elaboration of Kikiki, changing almost every line to match the specific situation of he and his men under siege.

Patterns and their transposition **203**

This intertextual quality of Māori chant means that any specific stanza or line from one haka may be reworked and mixed into another. The language, being highly connotative, also allows a wide range of possible meanings from a given song, and thus the ironic and comedic quality of the haka as Te Rauparaha sang it, particularly given the importance of Te Rauparaha within the ongoing history of Ngāti Toa, establish Ka Mate as part of their cultural heritage.

We contend that the intuitive thinking Archer deems necessary to understand Māori poetry is none less than the abductive inferences outlined earlier in this book. The 'particular connections' made and 'connotations formed' are dependent on context, but are themselves the geometric pattern that makes intertextuality – or, if we consider the chant as an artefact instead of a text, interartefactuality – possible. Te Rauparaha's ability – in the midst of his immanent death – to recast an erotic peacemaking song as one of personal triumph shows a virtuosic command of mana. His artful gesture of (re)composition worked no doubt in part because of the personal hero account of Māui held in the original song of maritime landfall.

In thinking about the interartefactual quality of haka, it is important to remember that these are not songs that are simply sung. Rather, they are taonga (sacred objects) and rituals; 'when we take part in a performance of Ka Mate', Archer (2009) explains, 'we are able to experience this fundamental experience of life' (19). While not explicitly stated as such, Archer's elaboration is reminiscent of Eliade's (1954) 'time machine' quality of ritual, or indeed Husserl's phenomenology of time, as discussed in his paper on geometry, wherein the participant is able to, by 'retention' participate in the aboriginal moment of discovery (Husserl 1989). In participating in the haka, the Māori performer participates in the same creative moment of Te Rauparaha.

The other component to the interartefactual aspect of the haka is that the physical stance taken by the dancers – knees bent, arms abrasively positioned across the front of the torso, jaw distended, tongue extended, and eyes wide – is the same type of physical form shown in the carving of the Māori wooden taonga. Much like the formal parallelism between body comportment and artistic representation shown by Bateson and Mead (1942), a recognisable pattern is evident between the ancestral figures seen, for example in the Māori meetinghouses and the body posture taken when dancing a haka. It is an interartefactual domain that draws the human body, the carved artefactual form, and the multisensory performance into the same patternation.

In this vein, the argument advanced by Gell at the end of *Art and Agency*, concerning the concretisation of mind in the Māori meetinghouse, can be re-examined in new light. Gell, working in part from Husserl's phenomenology of time, shows how various longhouses are built in relation to each other. Any new build may draw upon aspects of those before it (participating in that aspect as a retention) and may also point forward (as, what Gell following Husserl calls, a protention) to subsequent projects. These retentions and protentions (what Husserl

204 Rediscovering the object

classes together as intentions) tie a collective together across time and space. In his closing paragraph, Gell describes the meetinghouses as:

> a cognitive process writ large, a movement of inner *durée* as well as a collection of existing objects, and documents appertaining to objects which time has obliterated. The Māori meeting house (in its totalized form) is an object which we are able to trace as movement of thought, a movement of memory reaching down into the past and a movement of aspiration, probing towards an unrealized, and perhaps unrealizable futurity. Through the study of these artefacts, we are able to grasp 'mind' as an external (and eternal) disposition of public acts of objectification, and simultaneously as the evolving consciousness of a collectivity, transcending the individual *cogito* and the coordinates of any particular here and now.
>
> (Gell 1998, 258)

It is evident that what Gell here says about the meetinghouse is also true of the haka. It is a cognitive process writ large, a movement, a collection; it is both historically constituted and aspirational even perlocutionary (Austin 1962) of a certain future. This is also in no way exclusive to the Māori context. As mind is extended into the artefactual, the capacity of the index to transcend the individual and the specific 'coordinates' of context rests upon the recognition of that context as coordinates.[8]

This is to say that, like the refuge island – hidden behind the horizon, but used for navigation in reference to the star path – the specific elements in a hero narrative, like Māui's harnessing of the sun, work as points within a geometric configuration allowing for the navigation in and through space. Knowing the 'unit' of a pattern, or the theme of a song, allows the subject to invent new artistic gestures that work as token-indexical images of their own relationality. This also allows masters of their art to, as Damon (2012) has argued, make 'intelligent adjustment' and 'to offset one relatively imprecise form with another that can make up for it' (186). When these artistic gestures are then used, or performed, by later generations, they fix themselves within the intentions of those same relations. It is in this sense, in that the coordination of the geometry of navigational pattern is concretised in the artefact, that the prototype can be said to be immanent in the index.

Summary

Pattern is the predictable completion of a unit of elements. Without the recognition of pattern, it is simply sequence. To discern between pattern and sequence not only requires knowledge of the unit, but also the ability to differentiate between the pattern and noise. Knowing the pattern, and the possible meta-patterns that may be

8 For a similar argument, applied to wider issues of materials innovation and take-up in society, see Graeme Were's (2019) insight that 'how a material emerges in society is as much shaped by social, economic and political environments as it is by its transformational capacity' (72).

Patterns and their transposition **205**

playing atop each other, allows for recognition of error, or humour, or novelty. In the orientation within the pattern, as a subject moves from points A to B, or from the start to the end of a ritual, the ability to situate oneself within the geometric configuration of concrete elements, as well as mythical and ephemeral elements, depends on the intuitive apprehension of and relation towards the various elements and their internal relationality.

Without recognising the pattern within the elements of the sequence, the navigating parties will be lost. Like a joke that goes over the head of someone not in the know, or the austere exclusivity of Carl Andre's *Equivalent VIII*, access and accessibility are not the same thing. (Or, phrased another way: You can lead a horse to culture but you can't make her think.) However, the ontic shift that comes in moving from seeing sequence to recognising pattern also brings with it – at least a certain degree of – order. Even when hidden, the refuge island moves past the boat, as if watching to keep the sailors safe; even when blindfolded, the champion can solve a Rubik's Cube in mere seconds; even when cornered and humiliated, Te Rauparaha can seize upon the opportunity to make himself like Māui. It is an ontic shift that, removing the noise from the system, finds the intention within the design, and works with that animating quality of intentional action.

12

MOTILE ANIMACY

This chapter expands upon the notions of pattern and transposition, taking forward the movement implicit in such sequencing. The possibility of movement, within the static form, opens the possibility of movement within the conceptual frame. Movement in this sense is an issue of translation, the movement of content via its form across different media and registers. This translation is also, by necessity, a transformation, producing something new and original that is always self-similar, within a stylistic pattern and logic of progression. Translation can be both a transposition and a metamorphosis. While translation is normally conceived of as a verbal action, it is, as Walter Benjamin recognised (1996; Bracken 2002), fundamentally a material one. The transpositional and metamorphic quality of the materiality of translation plays on the associative possibility of relationships within and between objects. As the abductive inferences of cognitive recognition are triggered by the aesthetic form of the artistic gesture, the movement is manifest as animation. Through animation, via the material, colour, and patterns, abstract ideas and entities are made immanent within the object. This process happens prior to and independent of language, and yet is subject to the same logic from which language also emerges.

For example as Jerome Lewis has argued, in the context of music amongst the Congolese hunter-gatherer society, the BaYaka, music is a foundational structure, or schema, of BaYaka society. Lewis (2013) argues that this schema underpinning music has 'aesthetic, incorporative, adaptive, and stylistic qualities which ensure continuity despite change. . . . [T]he schemas survive, even when language, technology, and geographical location all change' (64). It is the aesthetic qualities of the music – that is, the polyphonic and polyrhythmic harmony – that allow it special significance within the cognitive process of transmission. By contrast, Lewis argues, language 'is more concerned with the immediate contingencies of current human interaction; music is adapted to long-term orientations that determine the aesthetics

or culturally appropriate forms that this interaction can take' (64).[1] We contend that, like music, the artefactual domain drives the logic underpinning social relations. As we have shown in the last chapter in reference to the haka and Gell's discussion of the Māori meetinghouse, the material gesture concretises the extension of the mind. The exact thing being extended is the abstract geometric coordinates of the logics of relation.

This chapter works through a series of case studies to draw out the interartefactuality of mind and proposes a new interpretation of Gell's arguments about agency. It is our contention that the secondary agency of objects, as advanced by Gell in the first few chapters of *Art and Agency*, is the result of, and simply a rephrasing of, the idea of the distributed mind as advanced in the last chapter of *Art and Agency*. While too many of the critical works on Gell's *oeuvre* have merely considered the first half of the book,[2] in which he situates arts within the theory of objectification and gift exchange, which allows the object to be understood as standing in for subject, the proper understanding of *Art and Agency* demands a recognition of the second part, as equal to the first. The second half of *Art and Agency* explores objectification as sequence instead of substitution. It is likely that he was silently drawing on the work of Anthony Wallace on a small Pennsylvanian village at the start of industrialisation called *Rockdale* (1978; Küchler 2020). In Wallace's work, the drawing of the working parts of the machine allow the machinists to attend to and thus improve the connection and functionality of the constituent parts. The attention to sequence, instead of classification, found resonance with the Melanesianist theories of Gregory Bateson, Roy Wagner, and Marilyn Strathern. The overt theorisation of the object as a time-bound informational gesture in the second half of *Art and Agency* has been met with little attention, in part because it feels like a different book than the first half. The simple logic of the first half is met with a complex theorisation in the second half. However, it is our understanding that the two must be read together, like a musical score. It is only in the polyphonic harmony of the book, when the two halves are read together, that the full implications of his insights are seen.

From substitution to sequence

As discussed in the previous chapter, whereas tattooing is most often approached within a referential framework, the tattooing practices of Polynesia fit within a larger complex network of political, cosmological, and artefactual relations. As a prime example of how the motivic pattern in the two-dimensional fits within the patternation of the abstract geometry of cognitive spatialisation, the tattooing also

1 For a wider literature on ritual speech and song, see Keane (1997, 2003) and Kuipers (1990, 1998).
2 See, for example the work of Layton (2003), Arnaut (2001), Pinney and Thomas (2001), Chua and Elliott (2013), Morphy (2009), Bowden (2004), and Lipset (2005).

208 Rediscovering the object

exemplifies the ways that the translation seen on the motivic level can be understood to drive – both making possible and directing the pathway of – social interaction, or even life itself. In this way, tattooing is not just substitutive of persons, but attends to (and helps drive) the sequencing of social relations that make up the biographies of persons and polities, alike.

Take, for example the tattooing done in the pre-contact Society Islands. Working from historical documentation and using some inferential reasoning to fill in a few missing bits of information, Gell is able to demonstrate that the most prevalent tattoo motif was that of the 'national' deity, 'Oro. This motif consisted of a blackened posterior (and likely blackened genital region as well) and lines of patterned sequences arching from the top of the sacrum to the side of the hip and was used widely by members of the Maohi people of Tahiti and the surrounding islands. What is striking is the visual form of eyes placed upon the lower back in a manner likened by Gell to the artefactual representations of 'Oro. In his analysis of Maohi tattooing, Gell describes in depth the strict hierarchy of the titled classification of people, descended from the gods by pure or mixed lines of descent, and ranked by birth order. In a system where a child takes the title from the parent, and thus outranks the parent, the child-god is a highly potent, and thus dangerous, being full of primal power that can make and destroy. To control this dangerous raw presence of the sacred, a series of ceremonies exists to desacralize the child at various stages of their development. In each case, this desacralization rests upon the practice of bloodletting.

As a form of bloodletting, tattooing then held a role in signalling the closure of the sacred being, protecting the divine (*tapu*, being composed of a *po/ao*, or darkness/light, duality) and mundane (*noa*) from each other. Extant testimony of the ancient practice places the timing for gaining this tattoo at the age of sexual maturation (at the start of it for girls, at the end of it for boys), and first-hand accounts of meetings between unrelated adults testify to a full display of the pubic tattoo before the commencement of even secular, business transactions. While, as Serge Tcherkézoff (2004) notes more widely in the history of Polynesian 'first contact', the experience is recorded by European witnesses with overt sexual overtones, there is no reason within the Polynesian context to see the systematic disrobing and display of the loins as sexual; in fact, it is better seen, Gell argues, as showing the tattoo as a certificate of assurance. The woman, though ranked and titled as a sacred deity, had, in her pubescence, been desacralized and was thus safe to engage with in mundane social relations with those more *noa* than herself.

A simple band, or mark, or emblem on an arm or foot could easily designate the ritual desacralization of the child-god. In the placement of the motif and the fact that the design is the face of the deity, however, two other aspects come to the fore. Across Polynesia, the back (*tua*) was a place of darkness (*po*) and power. In some islands, prohibitions existed against sitting back to back, and diverse genres of objects and ritual practice play on the positioning of figures back to back (Gell 1995a). Within these artefactual forms exist an assortment of Janus-like figures, with its two faces positioned to face in opposite directions. Placing 'Oro over the

FIGURE 12.1 The face of a god, 'Oro, tattooed on the posterior of a Tahitian, after Alfred Gell's interpretation of Sydney Parkinson's eye-witness sketches from the Cook expedition in 1769.

posterior, then, made the human into a similarly oriented Janiform figure. This brought closer – as it made the dark unknown backside into a front side – and tamed the potent danger of the *po* into the abstracted but knowable face of god.

In this manner, the face tattooed upon the butt closes the open (and thus dangerous) pattern of the god-child in a way that opens up into possibility a whole range of subsequent actions. The danger of having a god present restricts actions – such that even the parents cannot eat before the first desacralization ceremony. However, upon completing the sequence of desacralization, the title-holding individual is made sufficiently *noa* that they can enter into mundane relations and pursue, for example trade with European men. The tattoo, and like it the wider artefactual patternation, is, therefore, primarily about the future, not the past or even the present. It is, subsequently, not a vehicle for remembering or for information transfer, but rather the movement of life forward into its next form.

The question of movement and form brings us back to the question of aesthetics. If, taking Kant's point about aesthetics as 'purposive without purpose' as a starting point, the function of the artefact (as a technical object or tool) is separate from its aesthetic functioning as an item that, as Simmel would describe it, was

210 Rediscovering the object

pushed beyond the 'aesthetic threshold', the gesture takes on more than is necessary in the pure simplicity of pragmatic function. It takes on, however, a shared harmony with the resonances of the complex abstract geometry in which it sits and relates. Within a set of nodes (i.e. artefacts and people in relation), the orchestrated harmony resonates on the level of their shared theme, each working to bring closure to the others. In this closure, as with the role of a third to its alternate pair, we have the possibility of subsequent sequentiality. As Gell (1995a) notes in his argument about closure and multiplicity in Polynesia, the dynamic oscillation between the *ao* and *po*, and their closure in each shell or other dividing artefact, is the genesis of the subsequent movement in the underlying theme or pattern. In the causal interrelatedness of any given artefact or social gesture, the individuation of each is a matter of analytical distinction not pure autonomy. In their shared qualities, the elements within the artefactual domain allow for the movement of shared signification across media. A prime example of this is seen in Nancy Munn's (1986) discussion of the qualisigns of value, in her work on Gawan Islanders' conception of fame and value.

Analogical qualisigns

Transformations involving food constitute what Munn, leaning on Peirce, calls 'qualisigns', icons 'that exhibit something other than themselves *in* themselves' (Munn 1986, 74). Food, in the Gawan Islands, is the ultimate arbiter of bodily states as acts that separate food from, or identify with, the body maintain bodily motion and activity. The controls on the ideal state of a light body in a constant state of motion are set by values that regulate the symbiotic relation between the garden and the body, linked through acts of eating. The land is heavy and identified with a downward movement as opposed to the mobile, slippery, and buoyantly upward motion of the sea. Gardens can easily lose their heaviness, allowing food to flow out unhindered, causing bodies to eat too much and become heavy and unproductive just as the gardens themselves empty. To stem the cycle of hunger breeding hunger, ritual work is required to keep gardens' weight down. This is done with spells that call a long-necked crane to eat the crops in the garden, depleting its produce and restricting the amount of food it produces.

The same effect is also achieved by using stones whose hardness epitomizes the ideal states of heaviness and durability. The heaviness of the garden thus assured offers the potential for the desired movement of crops when planted, involving not just the swelling of the tuber, but its upward growth. The unfurling leaf of the taro tuber is referred to analogically as being like the wings of a bird spreading out in flight, made possible by the immobility of stones that hold down the roots of the tuber as it propels its protruding stem and foliage upwards through the eye of the root-crop. The productiveness of the garden and the mobility of bodies likened to the sea are thus dependent upon one another in a causal nexus that attends to acts of eating as offering a measure of control.

Gardens become 'hungry' when people hungrily eat too much, as much as people go hungry when gardens are empty. Hunger is thus a relational state

mediated by controlling consumption, as when food flows swiftly into the body it is thought to also flow swiftly out of the garden. Food, in fact, should always be so plenty that it rots, an idea that is exemplified by the storage houses that are as beautifully decorated as the *kula* canoes and, in fact, serve as their counterpart on land. The long-term reproductive potential of land, which is guaranteed by keeping things inside and fixing them in place, is a fundamental counterpart, one associated with the continuity of matrilineal identity over time, of the ideal vital state of persons in perpetual motion.

Actions, such as the washing of bodies at dawn and the sweeping of communal areas in the hamlet, are likewise associated with assuring the maintenance of mobility and vitality, as are the maintenance of food taboos and body decoration, both ensuring that the body is light and able to move swiftly. The synaesthesia of light associated with colours that are shimmering and body tempo associated with food taboos are equally critical aspects of the qualisign. For example to ensure a productive voyage, and the *kula* trader's success while abroad, the man slashes himself with slippery, shiny fish. This transfers the sleek, mobile lightness (both as weight and luminescence) to the body, ensuring their own control of these qualities, and thus safeguarding the anticipated success (Munn 1986, 101–102). These qualities ensure the 'vital beauty', which is, as Munn highlights, 'the persuasiveness of the body' (102). Aesthetics is not just an effect, but is the qualities of the workings of the sequences of actions. In the view of the whole abstract form, aesthetics is the coordinating logic of the system of operations, whose abstract qualities sit outside of didactic erudition. They can be known only by analogy, and contemplated via the object. In the same manner that the 'vital beauty *is* the persuasiveness of the body' (102, emphasis added), the aesthetic virtue is what makes the gesture effective.

Movement and materialisation

This effect can also be seen in how the relation between certain qualities within one medium or domain are moved – or translated from the abstract into the concrete. This is evident in the attention given to the 'immaterial' and its appearance in the material, as can be seen in the work of Yves Klein, particularly his multimedia production of his blue period. Originally conceived in 1947–1948 (at the same time as Cage's 4'33", though with no influence one way or the other) Yves Klein's (2007) *Monotone-Silent Symphony* was performed for the first time in March 1960. Originally written for a 70-strong vocal and orchestral arrangement, it was débuted with only ten musicians, conducted by Klein himself. Alongside the musicians, Klein also orchestrated a careful context for, and as part of, the performance.

Klein invited 100 guests to the Galerie International d'Art Contemporain in Paris, and accompanying the music was a live production of the *Anthropometries in Blue*.[3]

3 Video footage of this is available via the website for the TATE Gallery, at www.tate.org.uk/art/artists/ yves-klein-1418/yves-klein-anthropometries.

212 Rediscovering the object

Using Klein's synthetic ultramarine pigment, which he patented two months later as IKB (International Klein Blue), three models covered themselves and each other in blue paint and pressed their otherwise nude form against artist paper hung on the walls, and dragged each other across paper laid out on the floor. This visual performance accompanied only the first half of the symphony, which constitutes a single note (a D major chord) sustained without variation, vibrato, or rest for 20 minutes. The note starts, full force, abruptly, and ends halfway through the symphony, abruptly. The subsequent half of the symphony is silence. During this silence, Klein, the musicians, and the models remained still. The exhibition space, attendees noted, had no air circulation, and the space became warm with the 100-plus bodies fit tightly into the space.

Klein's artistic project was a movement towards immateriality and gesture. His decision to use a single colour and his partnership with the models, who he would at times direct but largely leave to their own performance, was a conscious effort on his part towards immateriality via the removal of the artist from the artwork. Klein's mix of live performance, sound, warmth, colour, and other human bodies pushed the boundaries of art at a time before 'conceptual art' was a recognised genre. His own descriptions of the symphony suggest that the unwaveringly sustained singular sound of the *Monotone-Silent Symphony* was 'free from the phenomenology of time'. The effect upon the hearing audience is striking. Many who have attended subsequent performances note the emotional impact, and the array of insights and nuances experienced in the art. The archivist for Klein's estate, Daniel Moquay, highlights the impact of the silence, particularly, saying 'You get into the deepness of silence and you realise that silence is not nothing'. As Pwyll ap Stifin (2017) argues, silence is a material thing, achieved through the aggregation of specific conditions and intentions. Klein's movement to blue followed disappointment in the reception of his earlier monochrome paintings where each was a unique size and colour. Audiences attempted to find meaning in the works, linking a colour to a biographical aspect of Klein's life or suggesting the works were *avant-garde* interior design.

This mode of representation was not, however, Klein's aim. Rather, Klein was working towards the (re)presentation of the immaterial with his art. The pieces themselves – hung on the gallery wall – were, in his own words, 'the ashes of my art'. This performative gesture of art itself was, for Klein, an act of impregnation. Sponges, having the capacity to draw into themselves the pigmentation of IKB, became important in his pursuit of immateriality, as did gold, which, Klein explained, as an elemental source of light 'impregnates the painting and gives it eternal life'. The capacity of art can, therefore, be seen to bring into the audience's (and art practitioner's) experience something that is not representational, that is not mimetic, but impregnated with, and therefore is, something beyond – that is, the prototypical immanent within the indexical form. As index of gesture, the blue canvases and anthropometries are, like the sponges, full of their ontogenic form. That fullness, or impregnation, operates on an analogical level wherein the 'ashes' are only as worthless as the silence is nothing. By pushing the limits of

his art beyond the absurdity of the singular description of representation, Klein demonstrated that his work, rather than being *avant-garde* interior design, was a gesture of translating gesture itself to artefact. Thus, the movement visible in the form of the anthropometries casts forward, even as Klein directed the models, the animacy of fluid motion.

The key aspect here is that the object is not about memory, but rather about the possibility of moving forward without losing the coherence of the pattern and the potential of its aesthetic effect. As Marilyn Strathern (1990) has suggested, the historical moment of 'first contact' in Papua New Guinea was not a surprise to the Melanesians, as the potential of the 'new' was already present in the ritual image that forecasts itself. 'Images', she argues,

> that contain within them both past and future time do not have to be placed into a historical context, for they embody history themselves. It follows that people do not therefore have to explain such images by reference to events outside them: the images contain events.
>
> (25)

This is not to deny the historical dimension of the object, but to emphasise that the object is historical, not in the sense of historicity, but, as Husserl (1989) argues, in the sense that the retentions allow for the participation in the originary moment. In participating in the retentions present in an object or gesture, the self is also fulfilling the aspect of that object as a protention and affirming its futurity. To read the object as a scribe of history is to deny the ongoing revelation of its intentionality.

The tendency in anthropology to interpret objects to be only records of the past, and thus useful only as objects of recollection, is due in large part to Durkheim's interpretation of material culture. As has been noted (Latour 1993; Pinney 2021) the causal order set out by Durkheim is one in which objects and images are terminal deposits for prior thought, and to become a social scientist is to ignore the inner properties of the object. As Didi-Huberman argues, the endurance of the image is to a large degree reliant on the futurity of the image. Aby Warburg was trying to identify what it was about images that allowed them to be protentions, forecasting their own subsequent endurance. The resolution to the question of the endurance of the image is made possible when we recognise, as we have outlined above, the iterative opening and closing of a theme in its patterned sequentiality. This means that the image is not merely a repository of cultural production, but is a stopping point within an ongoing emergence of time. This stoppage of time, produced through the folding of time into the object (Deleuze [1988] 1993), is, as Henriette Groenewegen-Frankfort (1951) says with reference to ancient Egyptian painting, an issue of 'arrest and movement'.[4]

4 'Human beings and animals—we shall consider vegetable forms later—are potentially mobile, their posture and gestures must imply a moment of transient activity or equally transient repose. Therefore, a choice of moment, no less than a choice of viewpoint, determines the pose of

214 Rediscovering the object

In fact, the whole world can be seen as a stoppage of time. As Lévi-Strauss (1963) makes clear in his work on Totemism, citing the Dakotan chief, saying:

> Everything as it moves, now and then, here and there, makes stops. The bird as it flies stops in one place to make its nest, and in another to rest in its flight. A man when he goes forth stops when he wills. So the god has stopped.
>
> (171)

To stop time, or better, to fold time into the object – natural or artificial – fills the object with time, making it a 'figural excess' that 'torques' in nonlinear directions (Pinney 2005). To return to the concrete example of Gawan Gardens, the slow growth of the crops in the gardens makes possible the plentiful food necessary for feasts given upon the arrival of overseas trade partners. In this way, male movement and fame – traditionally seen as linked to the *kula* trade – is driven by the women's labour in the garden and the controlled consumption of produce. Food, it is reasoned, makes noise only if it is eaten by an outsider.[5] If the locals eat the food, it makes no noise, but when it fills the bellies of the visiting men it produces songs sung in honour of the feasts long after the tradesmen have moved to other islands. In this way, the noise of the garden produces fame. The movement from food to noise is a product of the garden's temporality being compressed (folded) into the feast, enabling its translation into fame.

One example of figural excess is the musical production of a third voice, discussed, for example by Carlo Severi (2016) in the context of Fang epic poetry. For Severi, this third voice works as a critique of the importance of the author in European thought; however, the presence of authority without author opens an important vantage point into understanding the index.

The autonomous voice

Among the Fang of Central Africa, there exists a corpus of poetry and song accompanied by a four-stringed harp called the *mvet*. The poet singer learns a complex

functional rendering and the implicit transitoriness of that pose is quite independent of the fact that either a phase of movement or rigid immobility may be chosen, for organic immobility is never absolute. The term "corporeality" has in connection with such figures a temporal connotation and the term "spaced", denoting the surrounding void, a dynamic one—it is the space in which movement may occur. But in this pregnant sense the terms are applicable only where the inner coherence of organic form is left intact; in other words, where the autonomy of movement as well as the autocracy of form is respected and not destroyed by a more or less wilful arrangement of different parts which would obviate their interdependence' (Groenewegen-Frankfort 1951, 5–6).

5 Munn (1986) quotes a Gawan man, saying: 'When someone eats a lot of food it makes his stomach swell; he does nothing but eat and lie down; but when we give food to someone else, when an overseas visitor eats pig, vegetable food, chews betel, then he will take away its noise, its fame. If we ourselves eat, there is no noise, no fame, it will disappear, rubbish, it will default. If we give to visitors, they praise us, it is fine. If not, there is no fame; Gawa would have no kula shells, no *guyaw* (man of high standing), no kula fame' (49).

array of epic ballads and performs them to musical accompaniment. The *mvet* is formed in two halves, with the fret positioned in the middle of the instrument and each arm extending out from the central base. The four strings are strung from end to end such that eight notes are situated upon the four strings, four on either side of the fret. The *mvet* is then played by both hands, the left and the right playing different melodic arrangements simultaneously. Drawing on the ethnographic description provided by Pascal Boyer, Severi analyses the Fang balladeering to show that the important, even divine, song is not the melody played by the poet's right or left hand, but rather the 'third voice' that is heard in the song that emerges from the two being played together.

While the tradition is based on a long-established lineage of masters, stretching back to the original divine source, the rudimentary practicalities of learning the words and musical arrangements are not the primary concern. Rather, the aspiring musician must establish their own unique relationship with the music, the instrument, and the songs to find their own voice. This rests, ultimately, on a paradoxical principle, the nature of which remains unknown. It is, at least to some understandings, a supernatural substance (*evur*) that resides in the pit of one's stomach, that results from undergoing a precise form of initiation. 'The *mvet* itself (qua 'sung epic') is understood in terms of these substances, which represent in mysterious but physical form the song's veracity, efficacy and faithfulness to a tradition' (Severi 2016, 138). What Severi does not elaborate, however, is the importance of temporality of the initiation and the *mvet* harp. As is widely recognised, initiation is time outside of time (Turner 1967, 1969) and also episodic (van Gennep 1960). As such, *evur* is likewise a fold of temporality, much like the 'Oro tattoo and the Gawan feast. So, too, is the *mvet*, as the sonic spatiality (i.e. harmonic arrangement of temporal elements), concretised in the physical form of the *mvet* as *evur*.

The emergence of the third voice, therefore, arises out of the folds of time itself – present in both the object and the artist. Thus, while Severi's argument about the lack of the author is true insofar as the Fang song lacks a singular point of origin, we would contend that it is clearly authored from multiple sources of the same prototype. The disagreement here rests in the question of the author (or artist) as (singular) person. In Severi's argumentation, he starts with the idea of the author(ity) arising from the lexigraphic act of scripting Roman law. He uses the exposition of the *mvet*'s third voice to complement a discussion of the '*nkisi* which, framed against Gell's own discussion of the '*nkisi* in *Art and Agency*, is used to critique Gell's notion of agency. Reviewing the complex means by which the hunter, priest, sacrificial victim, tree, and legal supplicant are all participants in the rite of making and using the '*nkisi*, Severi (2016) argues that the authority of the '*nkisi*, like that of the harp, emerges due to the 'creation of a series of relations of identification' that 'are serially articulated around a single connotation', but 'always partial' (147). He juxtaposes this against 'a one-to-one, binomial relation' that he sees in Gell's understanding of agency. However, we suggest that this is too narrow a read of *Art and Agency*, and does not take into account the wider *oeuvre* of Gell's writing.

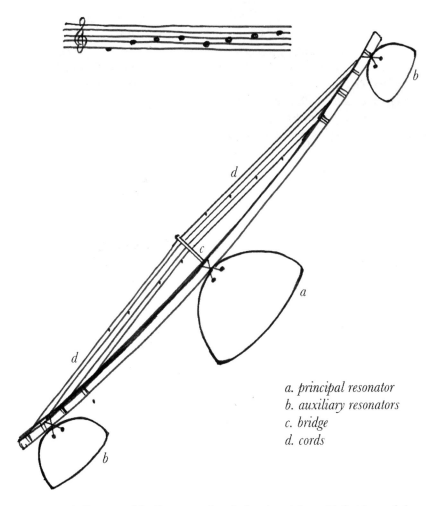

FIGURE 12.2 A diagram of the Fang *mvet* (harp), showing right and left sides, and the musical notes achieved with each string, after 'Figure 1 The Fang harp', from Boyer (1988) in 'Authorless authority' by Carlo Severi (2016, 138).

Gell's insight into the social agency mediated in and about an object is deeply situated in the Melanesian and Polynesian cosmologies through which he formed and articulated much of his insight. In this light, it is worth considering the relation between agency and patiency as akin to the duality of *ao* and *po*.[6] This is not

6 It is worth noting an almost certainly accidental parallelism between the two dualities. The shared initials (agency and *ao*, patience and *po*) are complimented by Gell's use of the arrow (→) to connote the relational movement from the 'a' to the 'p' in both. Agency → patient in *Art and Agency* (1998), particularly in the contexts of hierarchically ensconced shells of involution, and *ao* → *po* in *Wrapping in Images* (1993, 133). While it is unlikely that this was a conscious didactic choice, it is evidence of the kind of analogical thinking we are concerned with in this chapter. The *ao* → *po* shell is, within Gell's *oeuvre*, a protention of the agent → patient relation.

a one-to-one, binomial relation, but rather a dynamism held within each level (or 'shell') of cosmogenesis – and, to emphasise the obvious, the archetypical artist is the creator god. In the Tahitian context, it was Ta'aroa, 'the sever-er', who cut his own body to establish the cosmic shells. In his act of cutting, he also separated the *ao* and the *po*. As outlined above, the *ao* and *po* operate in a dynamic oscillation, being the two composite elements of *tapu*. It is in this sense that agency and patiency must also be seen. Similar to how affordances, as outlined by Gibson, rest in the mutual reciprocation of oppositions, agency and patiency require each other, being two elements of the same gesture. Taken in this context, agency is not one-to-one, and is much better termed – following Gell's description of Polynesian cosmology – as 'bi-cameral' (1995a, 21) rather than binomial.

Severi's emphasis on the monologic of the one-to-one is born out of his concern with what he identifies as a European understanding of authority based in text. With this as a starting premise, he reads into Gell's idea of agency the need for the artist to be a similarly authoring scripter, and thereby source of the index's power. To some degree, this relates the larger question of how human is the social agency of art. However, the complex levels of interplaying agency that Gell outlines in objects, like the *'nkisi*, belies the fact that authorial intent does not need to come from a human source. In his description of the 'involute hierarchical structure' of the index (1998, 54), the interplay of multiple humans (e.g. in an acrobatic tower) or of other actors (e.g. Venus) is explicit. What is evident in reading Gell's theory of agency in light of the argument about distributed mind, as advanced at the end of the same work, is that the source of intention does not need arise from one human artist, but rather emerges from the corpus itself – as protentions and retentions – as the movement of mind is arrested in what Gell exemplifies, using Duchamp, as a 'network of stoppages'. In discussing the layered composition of Duchamp's *Network of Stoppages* (1914), Gell suggests that the

> sum total of the infinitely transformable network of internal references (protentions and retentions) uniting the *oeuvre* from *all* of these temporal 'perches'—which we can only, in fact, adopt serially, is the unrepresentable but very *conceptualizable* and by no means 'mystic' fourth dimension.
>
> <div align="right">(Gell 1998, 250, emphasis in original)</div>

The internal referentiality of a network, whereby all the perches are seen in relation to each other, is a critical aspect in how a system works. This next section considers fugues as a musical form to further elucidate this referentiality. This is done, in part, due to the role of music in the development of Gell's ideas towards the end of this life as he composed *Art and Agency*. He was a self-taught pianist and intellectually inspired by Alfred Schütz's essay 'Making music together' (1964).

Canons and fugues

In their basic form, canons and fugues are musical compositions that take a sequence of notes – the theme, or subject – and play that theme upon and against

218 Rediscovering the object

itself in various ways. Through repeating the theme at different pitches, at different tempos, or inverting it to be played backwards, or in counterpoint, a fugue is an often playful way of taking an, at times, beguilingly simple theme and making a very complex musical arrangement. While a canon is typically based on direct imitation (i.e. a second voice will sing the same melody as the first), a fugue will usually have four or more voices working on a more open or complex set of rules and augmentations. (Though, especially historically, the distinction is not rigorously guarded.) The word 'canon', meaning law or rule, speaks of the rules of composition, whereby the timing and manner (tempo, augmentation, etc.) of each subsequent introduction of the theme is directed. Thus, while a fugue can be written as a full musical score, it can also, at least in some cases, be presented as a riddle. Most notably, the 'riddle fugues', written as part of Johann Sebastian Bach's *Musical Offering* for King Frederick the Great of Prussia, appeared on the page only as the theme and an inscription in Latin instructing the king on how to play the piece. In this way, the older name for a fugue, ricercar (from the Italian for 'to seek'), suggests some of the wayfaring necessary to complete the piece, and come to its 'resolution'.

In his work on the mathematics of thought, Douglas Hofstadter (1979) draws particular attention to one of the canons in the *Musical Offering*. He says:

> There is one canon in the *Musical Offering* which is particularly unusual. Labeled simply 'Canon per Tonos', it has three voices. The uppermost voice sings a variant of the Royal Theme [composed by King Frederick himself], while underneath it, two voices provide a canonic harmonization based on a second theme. The lower of this pair sings its theme in C minor (which is the key of the canon as a whole), and the upper of the pair sings the same theme displaced upwards in pitch by an interval of a fifth. What makes this canon different from any other, however, is that when it concludes—or, rather, *seems* to conclude—it is no longer in the key of C minor, but now is in D minor. Somehow Bach has contrived to *modulate* (change keys) right under the listener's nose. And it is so constructed that this 'ending' ties smoothly onto the beginning again; thus one can repeat the process and return to the key of E, only to join again to the beginning. These successive modulations lead the ear to increasingly remote provinces of tonality, so that after several of them, one would expect to be hopelessly far away from the starting key. And yet magically, after exactly six such modulations, the original key of C minor has been restored! All the voices are exactly one octave higher than they were at the beginning, and here the piece may be broken off in a musically agreeable way. Such, one imagines, was Bach's intention; but Bach indubitably also relished the implication that this process could go on ad infinitum, which is perhaps why he wrote in the margin 'As the modulation rises, so may the King's Glory'.
>
> (10, emphasis in original)

There are two things to note, the first is the mathematical aspect of his description of how the voices relate. Even without understanding the specific musical implications of the description, it is clear that a set of relationships are established around notions of geometric and arithmetic transitions of the theme[7]; what he identifies as an 'information-preserving transformation', or 'isomorphism', whereby 'every type of "copy" preserves all the information in the original' (9). This is generally true of canons and fugues. The second thing to note, specific to this rising modulation, is what he identifies as a 'strange loop', wherein 'by moving upwards (or downwards) through the levels of some hierarchical system, we unexpectedly find ourselves right back where we started' (10).

The strange loop, for Hofstadter (1979) is a type of paradox. Taken in the classical tradition, the simplest loop is the Cretan philosopher Epimenides's statement 'All Cretans are liars'. Taken in a yet simpler form: 'This statement is false'. It can be expanded to include two gestures:

> The following statement is true.
> The preceding statement is false.

The strangely looped paradox can grow with ever more successive levels — as is beautifully exemplified in the art of MC Escher. However, past the initial one-dimensional look — where fallacy is inherent in the form itself — the 'problem' of paradox does not rest in any one part. There is, for example nothing 'wrong' with either the first or second sentence in the two-part loop. The problem arises only in the attempt to close the referentiality of the loop. Hofstadter outlines how the presence of paradox (readily available in 'natural' language) troubled the mathematicians and logicians, particularly at the turn of the 20th century. At its core, the problem of paradox is one of categorisation and hierarchy. Each sentence, if seen as the 'superior' to the other is fine. Its referentiality is valid and encloses the other under its indicative gesture. The logical conflict arises only when both claim to contain the other as referent. This problem became more acute for logic when it was evident that a paradox lay at the heart of categorisation of sets, where a set is composed of any definable collection. For example what became known as Russell's paradox proceeds as follows:

> Let R be the set of all sets that are not members of themselves. Is R a member of itself? If it is, it fails to satisfy its membership criterion and hense is not a member of itself. If it is not, then R does satisfy its membership criterion and

7 For another example, find the video of Glenn Gould playing and discussing Bach's *Fugue in E Major* with Bruno Monsaingeon. At time of writing, it is available on YouTube, titled 'Glenn Gould talks about E Major Fugue from Well Tempered Clavier Book 2 HD', at www.youtube.com/watch?v=iFOqX3JGERo.

220 Rediscovering the object

hence is a member of itself. Thus, R is a member of itself if and only if R is not a member of itself.

(Waghorn 2014, 60)

Thus, set theory, or the relation between types and tokens, became a central concern for mathematics and logic (and anthropology, see Lucien Levy-Bruhl [1928] 1966). In their work, *Principia Mathematica*, Bertrand Russell and Alfred North Whitehead (1910–1913) outlined the complete logic of mathematics and its hierarchies (that is, metamathematics), and offered it as a pure and complete expression of mathematical propositions using symbolic logic and, thereby, solved the problem of paradoxical set inclusion.

This worked for a few years until, in 1931, the mathematician Kurt Gödel proposed his Incompleteness Theorem,[8] paraphrased by Hofstadter (1979) as 'All consistent axiomatic formulations of number theory include undecidable propositions' (17). What this suggests, simply put, is that no system can verify the truth of each of its own aspects. 'In short', says Hofstadter, 'Gödel showed that provability is a weaker notion than truth, no matter what axiomatic system is involved' (19). That is to say, there will always be true things that are knowable but not provable. Logic, or at least the rigidity of formal correlation, can verify the elements of a system, but never the system as a whole.

In his extended exposition of strange loops in logic, music, and art, Hofstadter arrives at the proposition that consciousness itself rests upon strange loops. The hierarchical structure of the brain is built upon the higher-order functions resting on their subordinate functions and feeding back to control those same functions. Similarly, any hierarchical system has within it a feedback loop that at each step makes sense in a clear line of causation, but when viewed as a whole, presents the same paradox of the strange loop. In the same manner in which the Canon per Tonos rises and finds its own origin again, the permutations of social form progress through self-producing sequentiality. This notion, described in Claude Lévi-Strauss's canonical formula, fundamentally shows how social phenomena can be explained as an algorithmic system of combination and interaction of elements, such as real numbers, mythical characters, and motivic forms. The canonical formula is expressed as:

$$F_x(a): F_y(b) \sim F_x(b): F_{a-1}(y)$$

It is composed of two parts, expressing a relation of transformational movement, wherein each contains the completion of the other. While it reads on paper as a linear equation, the critical potential in the formula is in the fact that it represents a four-dimensional permutation. As the mathematician Morava (2005) explains, the

8 'To every ω-consistent recursive class κ of *formulae* there correspond recursive *class-signs* r, such that neither ν Gen r nor Neg (ν Gen r) belongs to Flg (κ) (where ν is the *free variable* of r)' (Hofstadter 1979, 17).

canonical formula is based on the logic of the Klein group, wherein the type of relations (i.e. communicative versus noncommunicative) dictates how the elements move in relation to each other. A common example of this is found in the Rubik's Cube, wherein the colour pattern visible on the front side of the cube is indicative of the arrangement on the back (hidden) side of the same cube. In this way, Klein groups, or indeed the functions in the Canonical Formula, make intuitively comprehensible and predictable that which is hidden. This is the same analogical thinking that allows the refuge island to govern Polynesian navigation.

This sequentiality and analogy rests upon isomorphy of structure. What Hofstadter identifies as isomorphism in the canon, where each 'copy' contains the information of the original, is the same as what Gell describes as isomorphy of structure in his discussion of Marquesan tattooing. As he describes, the basic form of *etua* (a deity) is transformed and repositioned in manifold arrangements within Marquesan style. The coherence of the style is bounded by what he calls 'the principle of least difference', whereby new forms are composed within the strict logic of serial permutation. The use of the canonical formula by Lévi-Strauss to help explain variation within a culture group and the variation of forms of kinship and mythology shared across neighbouring culture groups is isomorphic to Gell's understanding of how it is manifested in the interartefactual domain.

When an object is situated within its relations, the dynamic means of formation are made more evident. It is telling that Gell uses the term 'involute' for the hierarchical structure of the index. Involution, which can describe the coiling nature of the shell, is also related to the mathematic of curves. An involute curve, also called an evolvent curve, is one whose shape is reliant upon the shape of another neighbouring curve. In this way, the new curve is indexical – in the true sense of causal effect – in that it follows on from the preceding curve. In using this terminology, Gell is indicating that the index – situated within the interartefactual domain – is evolvent upon the preceding indexical forms, of which it is isomorphic. In the looping quality of this coherence, it can also then be said that the index is evolvent upon itself. At this point, then, it becomes clear that the hierarchy is collapsed into the token, as the early twentieth-century art critic Carl Einstein (2004b) argued. Einstein's argument concerning the 'totality' of the object, having in itself no referent to a higher category or set, situates the object as a thing in itself.

This collapse is seen explicitly in the A'a, a carved chest (hypothesised to have contained the bones of an ancestor) from Rurutu. As Gell (1998) describes, the A'a corresponds to the kinship units comprising Rurutan society (see also Hooper 2007). It is a humanoid figure, with small homunculi 'sprouting' all over the surface, composing the body of the larger figure. These are arranged in a self-similar manner at different scales of magnification and minification (Gell 1998, 137). The box contained at least 24 smaller figures, corresponding to the kinship units. What is of particular importance is 'the explicit way in which this image of a "singular" divinity represents divinity as an assemblage of relations between (literally) homunculi. In so doing, the A'a obviates the contrast between one and many and also between inner and outer' (139).

222 Rediscovering the object

The A'a is hierarchy. This statement is an abstract idea of logical analogy. The A'a, and thereby the hierarchy and its abstraction, and social implication, is apprehended as an object. In this regard, it is the same as the canonical formula, as an apprehensible object that can move thought and action. It is inherently transformable and productive of itself, like the Russian doll or the layers of an onion, always giving rise to itself in another iteration on a different scale.

It is the containment of the abstractions of hierarchy *in* the object, not behind or above it, that Einstein makes clear in his elucidation on the totality of form and exemplifies in his work on African statuary. The presence of the *etua* upon the body, or the kinship hierarchy in the A'a – among the many examples in this chapter and book – speaks to the immanence of social relations in the index. Gell's framing of the anthropology of art as pertaining to the social relations in and around the object is therefore an expansive and liberating statement. It affirms the centrality of the idea of relation, but does so via examining its logical qualities that are immanent within the object.

Summary

The socialness of relation emerges from externalising (or concretising, in Gell's usage) the abstract idea, which is the canonical formula, into a motile nexus of transformational objects of all kinds: myths, music, artefacts, gestures, and speech. Once it is externalised, it can be apprehended, comprehended, and innovated. Thereby, the diversity of relations is created, seen in the diversity of human societies, which is the subject matter of anthropology. It is not coincidental that Einstein's critique of hierarchical abstraction of set theory, as it pertains to the art object, happened at the same time mathematicians were concerned with set theory and the problem of paradox in logic. Similar to the attention to the object given by Gell and Lévi-Strauss, Einstein's disavowal of the hierarchical sets, to which art history habitually assigned artefacts, focused the attention on the form itself. This emphasis on tokens, rather than types, allows the shift in attention away from the shared qualities of the set to which an object belongs, and highlights the transformative movements that bring each individual object as evolvent. It is at this point that the movement and animation of the object is most evolvent, as the stoppage makes apprehensible the biographic inherency of temporal progression.

AFTERWORD

The kinetic sculptures of Alexander Calder, named mobiles, in fact, by Duchamp, play in open space, moving with air currents. However, their movement is more indicative of the stable motile animation of the asymmetrical relations between elements arranged in involute hierarchy. Calder came from a family of artists (sculptors on his father's side, and his mother was a portrait artist), was formally trained as a mechanical engineer, and excelled in mathematics. The highly mathematical quality of the mobiles, characterised by balance and the extended reaching trajectory of counterbalancing arms and paddles, requires patience of the audience. Like his earlier *Cirque Calder* (1926–1931), made of wire-framed animals, unicyclists, and tightrope walkers – which he himself performed for audiences – the mobiles are performances. There is a playful quality to Calder's work, albeit a serious sort of play, and it is helpful to think of 'mobiles' in both senses of Duchamp's French pun: indicating both movement and motivation. While many reviews of Calder's work note the influence of Mondrian on Calder, in terms of the possibilities of abstraction, Mondrian rejected Calder's suggestion to make his bold bright shapes move (Calder 1937). The movement and the expansive gesture of the slow, swinging arms of Calder's mobiles make visible (and in some cases, such as *Antennae with Red and Blue Dots 1953*, audible) the relations between parts of balance and counterbalance. The slow stir of wind within a gallery space propels a gentle oscillation, and the audience is caught gazing at the movement, entrapped by the stickiness of the object's stable yet obviational movement of its parts. Each piece is never the same twice; this is because, while the architectonics of the piece is always the same, the movement within the branches makes the configuration of nodes always changing. As such, the interiority of the piece is always in flux, while the exterior experiences both stasis and motility.

Both Duchamp and Calder, like Freud and Klimt (Kandel 2012), draw out the difference between the interior and the exterior, highlighting the place of the

224 Afterword

invisible as constitutive of complex and intersecting modalities of experience. Like the semiophores described by Pomian (1990), the movement from invisibility to visibility is itself productive of value; it, like Lambek's transvaluation, is transformation of an abstract attribute to a distinct element. This shift in position, however, does nothing to trouble the inviolability of its relation. As each stage of transformation happens, the rotating movement of each transfer produces a coiling topology. The idea of the knot, as a topological form that is isometric to itself, yet affords dimensional transformation, which is most explicitly seen in the material form of the *khipu*, as described in Chapter 4, and is also seen in the looping steps of the cassowary dancer's movements across the village clearing, as described in Chapter 7. In all of these cases, the social productivity of the artistic form is achieved via the transvaluation of the stable relations between internal and external (or overt and covert) elements in a social milieu.

This book has traced and exposed the inner workings of Gell's ideas, highlighting how these ideas – some explicit and some implicitly germinating within Gell's *oeuvre* – have developed in some key texts following the publication of *Art and Agency*. In so doing, we also drive forward the importance of inferential thinking and have argued for the necessity of viewing the object as a materialisation of the abstract geometric model of relations within a material, artefactual form. In returning to the object, we emphasise the importance of the material of the artefactual form not as an arbitrary means for symbolic articulation of culture, but as a constitutive aspect of how the prototypical relations are made immanent in the object and made accessible for contemplation. There are four related outcomes of this argument.

First, the paradigmatic nature of prototypical ideas, which is a matter of belief, allows for the probable effect of the actions associated with the prototype. The immanent availability of the prototype within the object – making it tangible and manipulatable – offers certainty in the efficacy of the relational and transformational capacities of the paradigm. As we have argued, the certainty of belief in a knowable and known prototype affords the invention of ongoing social relations. The immanence of the prototype in objects of all kinds – gestures, plastic art, speech, etc. – thereby is the source of culture and the idea of biographical relation, unfolding over time, with an *oeuvre*. As such, biographical relations can be mapped not only in events but also in the artefacts related over time, creating a set of objects that are each in themselves a totality and yet fit together in a sequence of relations that, together, offer certainty on a higher order as pattern and metapattern emerge within the interartefactual domain.

Second, at its basic level, the abstract idea of the prototype is commensurate with the canonical formula, externalised in the motile nexus of transformational objects of all kinds. The prototype is not the object, or indeed a singular concept, but rather the abstract and motile nexus of relations that unfolds itself in very predictable, even canonical and formulaic, ways. This understanding allows Anthropology to study art (and objectival form more broadly) objectively, much like kinship. Lévi-Strauss was able to create a theoretical model for the study of social relations, which we now

call kinship, based on the canonical formula he derived from the study of transformational objects. The recovery of this shared theoretical understanding around the nature of biographical relation and transformational objects alike was arguably Gell's greatest contribution. The full implications of this, however, have yet to be explored, and – we suggest – its ramifications into wider Anthropological and social theory are no less important that those following Lévi-Strauss.

Third, the implicit argument of the Anthropology of Art is that it can be studied objectively as a system of relations, much as kinship. This is because, like kinship, it is based on an algebraic and geometric logic with rules for the combination of elements. There has been a longstanding problem reconciling the agency of the artist and their artistic intention with the abducted agency of the prototype, as received by the recipient. If read incorrectly, to emphasise the agency of the object has the danger of being overly deterministic, as the hylomorphic design intention of the artist is made secondary to the agency abducted by the recipient. However, the virtuosity of the artist, and the 'focused experience, observation, and intelligent adjustment' that Damon (2012, 191) describes helps resolve this problem. As Damon makes clear, each gesture is only and ever can be partial; the mastery of art creation is the ability to measure and recast subsequent gestures to counterbalance previous partiality. The dead reckoning of the navigation, as discussed in Chapter 11, via the stars and a hidden island, is akin to this same experience, observation, and intelligent adjustment. Any 'error' in navigation, or a slip of the knife in carving, can be overcome by the next gesture – it is not reactive to the previous move, but adjudicates, via nuance, the technical process to the final hylomorphic outcome. The 'error' stops being an error and becomes part of a sequence of balance (and gestalt) that bespeaks the magic and mastery of the artist. This clarification of how the intentional, agentive labour of making is connected via the object to the wider social context helps map forward how the geometries of art may properly be theorised. Art is thus not based on culture but on a system of relations external to, but implicit within, culture. Art objects, therefore, in all their varieties, are fundamentally transformational objects that drive the generativity and translational work of human society.

Fourth, in that art has the same theoretical veracity as the study of kinship, both grounded on the objective study of social relations, there are consequences for how we teach Anthropology, and especially the Anthropology of Art, and how we conduct ethnographic research mindful of the theoretical importance of objects. The methodological imperative in the return to the object demands that we attend to the object in its concrescence. This can be done via drawing, which has traditionally been part of anthropological research (Geismar 2014; Gell 1999); drawing, however, only works in so far as it re-manipulates the prototypical relations immanent in the research context into another object, more easily apprehended by the ethnographer and their reader. Anthropology also needs to include both algebra and geometry as part of our methodological tooling to wrestle with the prototypical relations immanent within the object. In the same way that Lévi-Strauss relied on early computing to demonstrate that models of kinship can be objectively studied, the use of mathematical thinking – which itself is a language of logical relationality – can unpack

226 Afterword

the involute structure of objects and their transformation capabilities because of the means by which it helps to move the inapprehensible into discrete elements of data. Gell has offered us the tooling to re-approach the issue of the endurance of the image, in that he shows that the image endures because of the futurity of the relational possibility of transformation, immanent in each object.

As one stands and observes, for example, one of Calder's mobiles, the object is a concretisation of the stable yet motile relations between parts made available for contemplation. The exteriorisation of the logic of the mathematical relation manifest in the mobile eludes complete understanding. It is always almost graspable, yet can never fully be reconstructed. However, in its undulating stickiness, it draws the viewer in, provoking abductive interferences that give rise to both an understanding of the nature of relation in the image of which social worlds are shaped. It is the object's refusal of complete description that, when met by the 'emptiness of mind' (Bateson 1979), gives rise to manifold abduction and the possibility of 'invention' (Wagner 1975). In the same way, 'ethnographic objects' belie total comprehension, yet demand contemplation. Each object, in its own right – and within the sequentialisation of its interartefactual relations – foists upon the recipient the prototypical forms held within.

BIBLIOGRAPHY

Adamson, Glenn. 2007. *Thinking Through Craft*. Oxford: Berg.

Adamson, Glenn. 2013. *The Invention of Craft*. London: Bloomsbury.

Addo, Ping-Ann. 2013. *Creating a Nation with Cloth: Women, Wealth, and Tradition in the Tongan Diaspora*. Oxford: Berghahn.

Alexander, Christopher, Sara Ishikawa, and Murray Silverstein. 1977. *A Pattern Language: Towns, Buildings, Construction*. New York: Oxford University Press.

Alexander, Christopher, Murray Silverstein, Shlomo Angel, Sara Ishikawa, and Denny Abrams. 1975. *The Oregon Experiment*. New York: Oxford University Press.

Alley, Ronald. 1981. *Catalogue of the Tate Gallery's Collection of Modern Art other than Works by British Artists*. London: Tate Gallery and Sotheby Parke-Bernet.

Anderson, Christabel Helena. 2012. "The Role of Matter in Iconography & the Liturgical Arts." *Orthodox Arts Journal*. www.orthodoxartsjournal.org/the-role-of-matter-in-iconography-the-liturgical-arts/.

Anderson, Jane L., and Haidy Geismar, eds. 2017. *The Routledge Companion to Cultural Property*. London: Routledge.

ap Stifin, Pwyll. 2017. "The Materiality of Silence: Assembling the Absence of Sound and the Memory of 9/11." In *Material Culture of Failure: When Things Do Wrong*, edited by Timothy Carroll, David Jeevendrampillai, Aaron Parkhurst, and Julie Shackelford, 177–195. London: Bloomsbury.

Archer, John. 2009. *Ka Mate: Its Origins, Development, and Significance*. Self-published paper. www.academia.edu/6216273/Ka_Mate_its_origins_development_and_significance_Introduction

Arkana, Elizabeth. 1986. *Hawaiian Quilting: A Fine Art*. Honolulu: Hawaiian Children's Society.

Arnaut, Karel. 2001. "A Pragmatic Impulse in the Anthropology of Art? Gell and Semiotics." *Journal des africanistes* 71 (2): 191–208.

Arnheim, Rudolf. 1974. *Art and Visual Perception: A Psychology of the Creative Eye. The New Version*. Berkeley: University of California Press.

Ascher, Marcia. 1991. *Ethnomathematics: A Multicultural View of Mathematical Ideas*. Belmont, CA: Brook-Cole.

Bibliography

Ascher, Marcia. 2002. "Reading Khipu: Labels, Structure and Format." In *Narrative Threads: Accounting and Recounting in Andean Khipu*, edited by Jeffrey Quilter and Gary Urton, 87–102. Austin: University of Texas Press.

Ascher, Marcia, and Robert Ascher. 1978. *Code of the Quipu: Databook*. Ann Arbor, MI: University Microfilms International.

Ascher, Marcia, and Robert Ascher. 1981. *Code of the Quipu: A Study in Media, Mathematics and Culture.* Ann Arbor, MI: University of Michigan Press.

Ascher, Marcia, and Robert Ascher. 1988. *Code of the Quipu: Databook II.* Self-published.

Ashbrook Harvey, Susan. 2006. *Scenting Salvation: Ancient Christianity and the Olfactory Imagination.* Berkeley: University of California Press.

Assmann, Jan. 1995. "Collective Memory and Cultural Identity." Translated by John Czaplicka. *New German Critique* 65: 125–133.

Austin, J.L. 1962. *How to Do Things with Words: The William James Lectures delivered at Harvard University in 1955.* Oxford: Clarendon Press.

Bakhtin, Mikhail. 1984. *Rabelais and His World.* Bloomington: Indiana University Press.

Balfour-Paul, Jenny. 1997. *Indigo in the Arab World.* Richmond, VA: Curzon.

Bardon, Geoffrey. 1979. *Aboriginal Art of the Western Desert.* Adelaide: Rigby Publishers.

Bardon, Geoffrey. 1991. *Papunya Tula: Art of the Western Desert.* Sydney: McPhee Gribble.

Bardon, Geoffrey, and James Bardon. 2004. *Papunya: A Place Made After the Story: The Beginnings of the Western Desert Painting Movement.* Victoria: Miegunya Press.

Baron-Cohen, Simon, and John Harrison, eds. 1996. *Synaesthesia: Classic and Contemporary Readings.* Hoboken, NJ: John Wiley & Sons.

Barth, Fredrik. 1990. "The Guru and the Conjurer: Transactions in Knowledge and the Shaping of Culture in Southeast Asia and Melanesia." *Man* 25 (4): 640–653.

Barthes, Roland. 1983. *Empire of Signs.* London: Anchor Books.

Barthes, Roland. 1997. "Rhetoric of the Image." In *Image Music Text*, edited by Roland Barthes, 32–51. London: Fontana Press.

Batchelor, David. 1999. *Chromophobia.* London: Reaktion Books.

Bateson, Gregory. 1936. *Naven: A Survey of the Problems suggested by a Composite Picture of the Culture of a New Guinea Tribe drawn from Three Points of View.* Cambridge, UK: Cambridge University Press.

Bateson, Gregory. 1972. *Steps to an Ecology of Mind: Collected Essays in Anthropology, Psychiatry, Evolution, and Epistemology.* Chicago: University of Chicago Press.

Bateson, Gregory. 1979. *Mind and Nature: A Necessary Unity.* New York: E.P. Dutton.

Bateson, Gregory, and Margaret Mead. 1942. *Balinese Character: A Photographic Analysis.* New York: New York Academy of Sciences.

Bateson, Gregory, and Mary Catherine Bateson. 1988. *Angels Fear: Toward an Epistemology of the Sacred.* New York: Bantam.

Battaglia, Debbora. 1990. *On the Bones of the Serpent: Person, Memory and Mortality among Sabarl Islanders of Papua New Guinea.* Chicago: University of Chicago Press.

Baumgarten, Alexander Gottlieb. (1750) 1983. *Theoretische Ästhetik: Die grundlegenden Abschnitte aus der 'Aesthetica' 1750/58: Lateinisch-Deutsch.* Translated by Hans Rudolph Schweizer . Hamburg: Meiner.

Baxandall, Michael. 1981. *Limewood Sculpture in Renaissance Germany.* New Haven, CT: Yale University Press.

Becker, Colleen. 2013. "Aby Warburg's *Pathosformel* as methodological paradigm." *Journal of Art Historiography* 9: 1–25.

Benjamin, Walter. 1996. *Walter Benjamin Selected Writings, 1: 1913–1926.* Edited by Marcus Bullock and Michael Jennings. Cambridge, MA: Harvard University Press.

Berlin, Brent, and Paul Kay. 1969. *Basic Colour Terms: Their Universality and Evolution.* Berkeley: University of California Press.

Berndt, R. M. 1964. *Australian Aboriginal Art.* Sydney: Ure Smith.

Bird, Douglas, Rebecca Bird, Brian Codding, and David Zeanah. 2019. "Variability in the Organization and Size of Hunter-Gatherer Groups: Foragers Do Not Live in Small-Scale Societies." *Journal of Human Evolution* 131: 96–108.

Boas, Franz. 1891. "Physical Characteristics of the Indians of the North Pacific Coast." *The American Anthropologist* 4: 25–32.

Boas, Franz. 1897. "The Decorative Art of the Indians of the North Pacific Coast." *Bulletin of the AMNH* 9 (10): 123–176.

Boas, Franz. 1898. "The Growth of Toronto Children. Chapter XXXIV." *Education Report 1896–97.* Washington, DC: Government Printing Office.

Boas, Franz. 1915. *Race and Nationality.* New York: American Association for International Conciliation.

Boas, Franz. 1916. "Representative Art of Primitive People." In *Holmes Anniversary Volume; Anthropological Essays Presented to William Henry Holmes in Honor of his Seventieth Birthday, December 1, 1916,* edited by Frederick Webb Hodge, 18–23. Washington, DC: J.W. Bryan Press.

Boas, Franz. (1927) 1955. *Primitive Art.* Toronto: Dover Publications, Inc.

Boast, Robin. 2011. "Neocolonial Collaboration: Museum as Contact Zone Revisited." *Museum Anthropology* 34 (1): 56–70.

Bolton, Lissant. 2003a. "Gender, Status, and Introduced Clothing in Vanuatu." In *Clothing the Pacific,* edited by Chloë Colchester, 119–139. Oxford: Berg.

Bolton, Lissant. 2003b. *Unfolding the Moon: Enacting Women's Kastom in Vanuatu.* Honolulu: University of Hawaii Press.

Bolton, Lissant. 2003c. "The Object in View: Aborigines, Melanesians and Museums." In *Museums and Source Communities,* edited by Laura Peers and Alison Brown, 42–55. London: Routledge.

Bolton, Lissant. 2005. "Dressing for Transition: Weddings, Clothing and Change in Vanuatu." In *The Art of Clothing: A Pacific Experience,* edited by Susanne Küchler and Graeme Were, 19–31. London: UCL Press.

Bolton, Lissant. 2007. "'Island Dress That Belongs to Us All': Mission Dresses and the Innovation of Tradition in Vanuatu." In *Body Arts and Modernity,* edited by Elizabeth Ewart and Michael O'Hanlon, 165–182. Herefordshire, UK: Sean Kingston Publishing.

Bolton, Lissant. 2018. "A tale of Two Figures: Knowledge Around Objects in Museum Collections." *Journal de la Société des Océanistes,* 2018/1 (146): 85–98.

Bolton, Lissant, Nicholas Thomas, Elizabeth Bonshek, Julie Adams, and Ben Burt, eds. 2013. *Melanesia: Art and Encounter.* London: British Museum Press.

Bourdieu, Pierre. 1977. *Outline of a Theory of Practice.* Cambridge, UK: Cambridge University Press.

Bourdieu, Pierre. 1984. *Distinction: A Social Critique of the Judgement of Taste.* Translated by Richard Nice. Cambridge, MA: Harvard University Press.

Bowden, Ross. 2004. "A Critique of Alfred Gell on *Art and Agency.*" *Oceania* 74 (4): 309–324.

Boyer, Pascal. 1988. *Barricades Mysterieuses et Pièges à Penser: Introduction à L'analyse des Épopées Fang.* Paris: Société d'ethnologie.

Bracken, Christopher. 2002. "The Language of Things: On Benjamin's Primitive Thought." *Semiotica* 138 (1/4): 321–349.

Bredekamp, Horst. 2008. *Die Fenster Der Monade: Gottfried Wilhem Leibniz' Theater Der Natur Und Kunst.* Berlin: Walter de Gruyter.

Breslin, James. 2012. *Mark Rothko: A Biography*. Chicago: University of Chicago Press.

Breton, André. 1935. "La Phare de la mariée," *Minotaure*, 2 (6): 45–49; published in English in 1945 as "Lighthouse of the Bride," *View*, 5 (1), 6–10, 13.

Brown, Michael. 1998. "Can Culture be Copyrighted?" *Current Anthropology* 39 (2): 193–222.

Buchli, Victor. 2013. *An Anthropology of Architecture*. London: Bloomsbury.

Bucklow, Spike. 2009. *The Alchemy of Paint: Art, Science and Secrets from the Middle Ages*. London: Marion Boyars

Bucklow, Spike. 2016. *Red: The Art and Science of a Colour*. London: Reaktion Books.

Burt, Ben, and Lissant Bolton, eds. 2014. *The Things We Value: Culture and History in Solomon Islands*. Herefordshire, UK: Sean Kingston Publishing.

Buschmann, Ranier. 2009. *Anthropology's Global Histories: The Ethnographic Frontier in German New Guinea, 1870–1935*. Honolulu: University of Hawaii Press.

Calder, Alexander. 1937. "Mobiles." In *The Painter's Object*, edited by Myfanwy Evans, 62–67. London: Gerold Howe.

Caldwell, Duncan. 2018. "The Magic Trumpeter: A Bakongo Nkisi Nkondi and its Links with World War I, the Harlem Hellfighters, and Jazz." *Res: Anthropology and Aesthetics* 69–70: 269–293.

Campbell, Joseph. 1949. *The Hero with a Thousand Faces*. New York: Pantheon Books.

Campbell, Shirley. 2001. "The Captivating Agency of Art: Many Ways of Seeing." In *Beyond Aesthetics: Art and the Technologies of Enchantment*, edited by Christopher Pinney and Nicholas Thomas, 117–136. Oxford: Berg.

Campbell, Shirley. 2002. *The Art of Kula*. Oxford: Berg.

Carroll, Timothy. 2015. "An Ancient Modernity: Ikons and the Reemergence of Orthodox Britain." In *Material Religion in Modern Britain: The Spirit of Things*, edited by Lucinda Matthews-Jones and Timothy Jones, 185–207. London: Palgrave Macmillan.

Carroll, Timothy. 2016. "Architectural renovations of body-as-temple." *New BioEthics* 22 (2): 119–132.

Carroll, Timothy. 2017. "Textiles and the making of sacred space." *Textile History* 48 (2): 192–210.

Carroll, Timothy. 2018. *Orthodox Christian Material Culture: Of People and Things in the Making of Heaven*. London: Routledge.

Carroll, Timothy. 2021. "Aesthetics." In *Cambridge Handbook of Material Culture Studies*, edited by Lu Ann De Cunzo and Catharine Dann Roeber. Cambridge, UK: Cambridge University Press.

Carroll, Timothy, and Aaron Parkhurst. 2019. "Introduction: A genealogy of medical materialities." In *Medical Materialities: Toward a Material Culture of Medical Anthropology*, edited by Aaron Parkhurst and Timothy Carroll, 1–20. London: Routledge.

Carroll, Timothy, Aaron Parkhurst, and David Jeevendrampillai. 2017. "Introduction: Toward a General Theory of Failure." In *Material Culture of Failure: When Things Do Wrong*, edited by Timothy Carroll, Aaron Parkhurst, David Jeevendrampillai, and Julie Shackelford, 1–20. London: Bloomsbury.

Caseau, Beatrice. 2007. "Incense and Fragrances: From House to Church. A Study of the Introduction of Incense in the Early Byzantine Christian Churches." In *Material Culture and Well-being in Byzantium 400–1453*, edited by Michael Grünbart, Ewald Kislinger, Anna Muthesius, and Dionysios Stathakopoulos, 75–92. Wein, Austria: Österreichische Akademie der Wissenschaften.

Chua, Liana, and Mark Elliot, eds. 2013. *Distributed Objects: Meaning and Mattering after Alfred Gell*. Oxford: Berghahn.

Clark, Alison, and Nicholas Thomas, eds. 2017. *Style and Meaning: Essays on the Anthropology of Art, Pacific Presences*. Leiden, The Netherlands: Sidestone Press.

Clarke, Alastair. 2008. *The Pattern Recognition Theory of Humour*. Cumbria, UK: Pyrrhic House.

Classen, Constance. 1990. "Sweet Colours, Fragrant Songs: Sensory Models of the Andes and the Amazon." *American Ethnologist* 17 (4): 722–735.

Classen, Constance. 1993. *Worlds of Sense: Exploring the Senses in History and Across Cultures*. London: Routledge.

Classen, Constance, David Howes, and Anthony Synnott. 1994. *Aroma: The Cultural History of Smell*. London: Routledge.

Clement of Alexandria. 2004. "The Instructor." In *Ante-Nicene Fathers, Vol 2*. Translated by Philip Schaff, 207–299. Grand Rapids, MI: Christian Classics Ethereal Library.

Clifford, James. 1997. "Museums as Contact Zones." In *Routes: Travel and Translation in the Late Twentieth Century*, edited by James Clifford, 188–219. Cambridge, MA: Harvard University Press.

Colchester, Chloë. 2003. *Clothing the Pacific*. Oxford: Berg.

Coleman, Elizabeth B. 2004. "Appreciating 'Traditional' Aboriginal Painting Aesthetically." *The Journal of Aesthetics and Art Criticism* 62 (3): 235–247.

Colwell, Chip. 2017. *Plundered Skulls and Stolen Spirits: Inside the Fight to Reclaim Native America's Culture*. Chicago: University of Chicago Press.

Coote, Jeremy. 1992. "Marvels of Everyday Vision: The Anthropology of Aesthetics and the Cattle Keeping Nilotes." In *Anthropology, Art & Aesthetics*, edited by Jeremy Coote and Anthony Shelton, 245–273. Oxford: Oxford University Press.

Corbin, Alain. 1986. *The Foul and the Fragrant: Odour and the French Social Imagination*. Cambridge, MA: Harvard University Press.

Coupaye, Ludovic. 2009a. "Experiencing Space." *Arts & Cultures* 2009: 210–225.

Coupaye, Ludovic. 2009b. "Ways of Enchanting." *Journal of Material Culture* 14 (4): 433–458.

Coupaye, Ludovic. 2013. *Growing Artefacts, Displaying Relationships: Yams, Art and Technology amongst the Nyamikum Abelam of Papua New Guinea*. Oxford: Berghahn.

Coupaye, Ludovic. 2017. "The problem of agency in art." In *Style and Meaning: Essays on the Anthropology of Art: Anthony Forge*, edited by Alison Clark and Nicholas Thomas, 243–302. Leiden, The Netherlands: Sidestone Press.

Coupaye, Ludovic. 2021. "Making 'Technology' Visible: Technical Activities and the Chaîne Opératoire." In The Handbook of Anthropology of Technology, edited by Maja Hojer Bruun and Ayo Wahlberg. New York: Palgrave Handbooks.

Crocker, Andrew. 1987. *Charlie Tjaruru Tjungurrayi, a Retrospective, 1970–1986*. Orange: Orange Regional Gallery.

Cyril of Jerusalem. 2000. "Mystagogic Catechesis 3." In *Cyril of Jerusalem*, edited by Edward Yarold, 176–178. London: Routledge.

Cummings, Maggie. 2013. "Looking Good: The Cultural Politics of Island Dress for Young Women in Vanuatu." *The Contemporary Pacific*, 25 (1): 33–65.

Damon, Frederick. 1980. "The Kula and Generalised Exchange: Considering Some Unconsidered Aspects of The Elementary Structures of Kinship." *Man* 15 (2): 267–293.

Damon, Frederick. 1983. "What Moves the Kula: Opening and Closing Gifts on Woodlark Island." In *THE KULA: New Perspectives on Massim Exch*ange, edited by J.W. Leach and E.R. Leach, 309–342. Cambridge, UK: Cambridge University Press.

Damon, Frederick. 1990. *From Muyuw to the Trobriands: Transformations Along the Northern Side of the Kula Ring*. Tucson: University of Arizona Press.

Damon, Frederick. 2012. "'Labour Processes' Across the Indo-Pacific: Towards a Comparative Analysis of Civilisational Necessities." *The Asia Pacific Journal of Anthropology*, 13 (2): 170–198.

Damon, Frederick. 2016. *Trees, Knots and the Outrigger: Environmental Knowledge in the Northeast Kula Ring*. Oxford: Berghahn.

232 Bibliography

Danto, Arthur. 1988. *"'Artefact and Art' in Art / Artefact: African Art in Anthropological Collections."* New York: Center for African Art & Prestel Verlag.

Davy, Jack. 2016. "Miniaturisation: A Study of a Material Culture Practice Among the Indigenous Peoples of the Pacific Northwest." Ph.D. diss., University College London.

Davy, Jack. 2018. "The 'Idiot Sticks': Kwakwaka'wakw Carving and Cultural Resistance in Commercial Art Production on the Northwest Coast." *American Indian Culture and Research Journal* 42 (3): 27–46.

Davy, Jack. 2019. "Miniaturisation among the Makah." In *Worlds in Miniature: Contemplating Miniaturisation in Global Material Culture*, edited by Jack Davy and Charlotte Dixon, 61–81. London: UCL Press.

Davy, Jack, and Charlotte Dixon, eds. 2019. *Worlds in Miniature: Contemplating Miniaturisation in Global Material Culture*. London: UCL Press.

Deacon, Arthur Bernard. 1934. "Geometric Drawings from Malekula and Other Islands of the New Hebrides." *Journal of the Royal Anthropological Institute* 64: 129–175.

Deger, Jennifer. 2006. *Shimmering Screens: Making Media in an Aboriginal Community*. Minneapolis: University of Minnesota Press.

Deger, Jennifer. 2016. "Thick Photography." *Journal of Material Culture* 21 (10): 111–132.

Deger, Jennifer. 2019. *Phone & Spear: A Yuta Anthropology*. London: Goldsmiths Press.

Deleuze, Gilles. 1993. *The Fold: Leibniz and the Baroque*. Translated by Tom Conley. London: Athlone Press.

Deleuze, Gilles, and Felix Guattari. 1987. *A Thousand Plateaus: Capitalism and Schizophrenia*. London: Continuum.

Didi-Huberman, Georges. 2017. *The Surviving Image: Phantoms of Time and Time of Phantoms, Aby Warburg's History of Art*. Translated by Harvey Mendelsohn. State College: Pennsylvania State University Press.

Dietler, Michael, and Ingrid Herbich. 1998. "Habitus, Techniques, Style: An Integrated Approach to the Social Understanding of Material Culture and Boundaries." In *The Archaeology of Social Boundaries*, edited by M.T. Stark, 232–263. Washington and London: Smithsonian Institution Press.

Dioscorides, Pedanius. 2000. *De Materia Medica: Book One–Aromatics*. Translated by T.A. Osbaldenston. Johannesburg: IBIDIS Press.

Douny, Laurence. 2014. *Living in a Landscape of Scarcity: Materiality and Cosmology in West Africa*. Walnut Creek, CA: Left Coast Press.

Dozmorov, Mikhail G., Qing Yang, Weijuan Wu, Jonathan Wren, Mahmoud M. Suhail, Cole L. Wooley, D. Gary Young, Kar-Ming Fung, and Hsuey-Kung Lin. 2014. "Differential Effects of Selective Frankincense Ru Xiang. Essential Oil versus Non-Selective Sandalwood Tan Xiang. Essential Oil on Cultured Bladder Cancer Cells: A Microarray and Bioinformatics Study." *Chinese Medicine* 9: 18.

Dreyfuss, Rochelle, and Jane Ginsburg, eds. 2014. *Intellectual Property at the Edge: The Contested Contours of Intellectual Property*. Cambridge, UK: Cambridge University Press.

Duck, Michael J., and Michael Petry. 2016. *Goethe's "Exposure Of Newton's Theory": A Polemic on Newton's Theory of Light and Colour*. London: Imperial College Press.

Duffy, Simon. 2013. *Deleuze and the History of Mathematics: In Defense of the "New."* London: Bloomsbury.

Eglash, Ron. 1999. *African Fractals: Modern Computing and Indigenous Design*. New Brunswick, NJ: Rutgers University Press.

Einstein, Carl. 2004a. "Negro Sculpture." *October* 107: 122–138.

Einstein, Carl. 2004b. "Totality." *October* 107: 115–121.

Eliade, Mircea. 1954. *Cosmos and History: The Myth of the Eternal Return*. New York: Harper Torchbooks.

Bibliography **233**

Elkin, A.P., R.M. Berndt, and C.M. Berndt. 1950. *Art in Arnhem Land*. Melbourne: Cheshire.

Empson, Rebecca. 2007. "Separating and containing people and things in Mongolia." In *Thinking Through Things: Theorising Artefacts Ethnographically*, edited by Henare, et al., 113–140. London: Routledge.

Empson, Rebecca. 2011. *Harnessing Fortune: Personhood, Memory, and Place in Mongolia*. Oxford: Oxford University Press.

Evans, William Charles. 2009. *Trease and Evans: Pharmacognosy*. London: Saunders.

Fann, K.T. 1970. *Peirce's Theory of Abduction*. The Hague: Martinus Nijhoff.

Faris, James. 1988. "Art/Artifact: On the Museum and Anthropology." *Current Anthropology* 29 (5): 775–9

Farris Thompson, Robert. 1973. "The Aesthetics of the Cool." *African Arts* 7 (1): 40–91.

Farris Thompson, Robert. (1973) 2006. "Yoruba Artistic Criticism." In *The Anthropology of Art: A Reader*, edited by Howard Morphy and Morgan Perkins, 242–269. Oxford: Blackwell Publishing.

Faubion, James. 2011. *An Anthropology of Ethics*. Cambridge, UK: Cambridge University Press.

Feld, Steven. 1982. *Sound and Sentiment: Birds, Weeping, Poetics and Song in Kaluli Expression*. Philadelphia: University of Pennsylvania Press.

Feld, Steven, and Keith H. Basso, eds. 1996. *Senses of Place*. Santa Fe: School of American Research Press.

Findlen, Paula. 1991. "The Economy of Scientific Exchange in Early Modern Italy." In *Patronage and Institutions: Science, Technology, and Medicine at the European Court, 1500–1750*, edited by Bruce Moran, 5–24. Rochester, NY: Boydell Press.

Findlen, Paula. 1996. *Possessing Nature: Museums, Collecting, and Scientific Culture in Early Modern Italy*. Berkeley: University of California Press.

Finlayson, Chris, John Key, and Pita Sharples. 2009. "Letter of Agreement. Signed in New Zealand Parliament, 11 February 2009." www.govt.nz/assets/Documents/OTS/Ngati-Toa-Rangatira/Ngati-Toa-Rangatira-Letter-of-Agreement-11-Feb-2009.pdf

Firth, Raymond, and London School of Economics and Political Science. 1940. *The Work of the Gods in Tikopia*. London: P. Lund, Humphries & Co., Ltd.

Flannery, Tim. 1994. *The Future Eaters: An Ecological History of the Australasian Lands and People*. New South Wales, Australia: Reed Books.

Flynn, Alex, and Jonas Tinius. 2015. *Anthropology, Theatre, and Development: The Transformative Potential of Performance*. London: Palgrave Macmillan.

Forge, Anthony. 1960. *Three Regions of Melanesian Art*. New York: The Museum of Primitive Art.

Forge, Anthony. 1967. "The Abelam Artist." In *Social Organization: Essays Presented to Raymond Firth*, edited by M. Freedman, 65–84. London: Cass.

Forge, Anthony. 1973. "Style and Meaning in Sepik Art." In *Primitive Art and Society*, edited by Anthony Forge, 169–192. Oxford: Oxford University Press.

Fortis, Paolo. 2010. "The Birth of Design: A Kuna Theory of Body and Personhood." *JRAI* 16: 480–495.

Fortis, Paolo. 2012. *Kuna Art and Shamanism: An Ethnographic Approach*. Austin: University of Texas Press.

Forty, Adrian. 1986. *Objects of Desire: Design and Society 1750–1980*. London: Thames & Hudson.

Foucault, Michel. 1970. *The Order of Things: An Archaeology of the Human Sciences*. London: Tavistock Publications.

Foucault, Michel. 1977. *Discipline and Punish: The Birth of the Prison*. New York: Pantheon Books.

Frankel, Susy. 2014. "'Ka Mate Ka Mate' and the Protection of Traditional Knowledge." In *Intellectual Property at the Edge: The Contested Contours of Intellectual Property*, edited

234 Bibliography

by Rochelle Dreyfuss and Jane Ginsburg, 193–294. Cambridge, UK: Cambridge University Press.

Freedberg, David. 1989. *The Power of Images*. Chicago: University of Chicago Press.

Freud, Sigmund. 1923. *The Ego and the Id*. New York: W.W. Norton & Co.

Fuente, Eduardo de la. 2008. "The Art of Social Form and the Social Forms of Art: The Sociology-Aesthetics Nexus in Georg Simmel's Thought." *Sociological Theory* 26 (4): 344–363.

Fuller, Chris. 1997. "Obituary: Alfred Gell." *Independent*, February 1, 1997. www.independent.co.uk/news/obituaries/obituary-alfred-gell-1276255.html.

Furness, W.H. 1910. *The Island of Stone Money, Yap of the Carolines*. New York: J.B. Lippincott Company.

Gage, John. 1993. *Colour and Culture: Practice and Meaning from Antiquity to Abstraction*. London: Thames & Hudson.

Gage, John. 1999. *Color and Meaning: Art, Science, and Symbolism*. Berkeley: University of California Press.

Gallese, Vittorio. 2001. "The 'Shared Manifold' Hypothesis: From Mirror Neurons to Empathy." *Journal of Consciousness Studies* 8 (5–7): 33–50.

Galliot, Sébastien. 2015. "Ritual Efficacy in the Making." *Journal of Material Culture* 20 (2): 101–125.

Geertz, Clifford. 1966. "Religion as a Cultural System." In *Anthropological Approaches to the Study of Religion*, edited by M Banton, 1–46 . London: Routledge.

Geismar, Haidy. 2013. *Treasured Possessions: Indigenous Interventions into Cultural and Intellectual Property*. Durham, NC: Duke University Press.

Geismar, Haidy. 2014. "Drawing it Out." *Visual Anthropology Review* 30 (2): 97–113.

Gell, Alfred. 1975. *Metamorphosis of the Cassowaries: Umeda Society, Language and Ritual*. London: Althone.

Gell, Alfred. 1979. "The Umeda Language-Poem." *Canberra Anthropology*, 2 (1): 44–62.

Gell, Alfred. 1985. "How to Read a Map: Remarks on the Practical Logic of Navigation." *Man, New Series*, 20 (2): 271–286.

Gell, Alfred. 1988. "Technology and Magic." *Anthropology Today*, 4 (2): 6–9.

Gell, Alfred. 1992a. *The Anthropology of Time*. London: Bloomsbury.

Gell, Alfred. 1992b. "The Technology of Enchantment and the Enchantment of Technology." In *Anthropology, Art and Aesthetics*, edited by Jeremy Coote and Anthony Shelton, 40–63. Oxford: Clarendon.

Gell, Alfred. 1993. *Wrapping in Images: Tattooing in Polynesia*. Oxford: Clarendon Press.

Gell, Alfred. 1995a. "Closure and Multiplication: An Essay on Polynesian Cosmology and Ritual." In *Cosmos and Society in Oceania*, edited by Daniel de Coppet and Andre Itenau, 21–53. Oxford: Berg.

Gell, Alfred. 1995b. "On Coote's 'Marvels of Everyday Vision.'" *Social Analysis* 38: 18–30.

Gell, Alfred. 1996. "Vogel's Net: Traps as Artworks and Artworks as Traps." in *Journal of Material Culture* 1 (1): 15–38.

Gell, Alfred. 1998. *Art and Agency. An Anthropological Theory*. Oxford: Clarendon Press.

Gell, Alfred. 1999. "The Language of the Forest: Landscape and Phonological Iconism in Umeda." In *The Art of Anthropology: Essays and Diagrams*, edited by Alfred Gell, 232–258. Oxford: Berg.

Gell, Alfred. 2013. "The Network of Standard Stoppages c. 1985." In *Distributed Objects: Meaning and Mattering after Alfred Gell*, edited by Liana Chua and Mark Elliot, 88–113. Oxford: Berghahn.

Gennep, Arnold Van. 1960. *The Rites of Passage*. Chicago: University of Chicago.

Gero, Stephen. 1977. "The So-Called Ointment Prayer in the Coptic Version of the Didache: A Re-Evaluation." *Harvard Theological Review* 79 (1–2): 67–84.

Gibson, James. 1979. *The Ecological Approach to Visual Perception*. Boston: Houghton Mifflin Harcourt.

Ginzburg, Carlo. 2001. *Wooden Eyes: Nine Reflections on Distance*. New York: Columbia University Press.

Glowczewski, Barbara. 1989. "A Topological Approach to Australian Cosmology and Social Organisation." *Mankind* 19 (3): 227–240.

Godey's Lady's Book. 1860. "Godey's Arm-Chair." *Godey's Lady's Book and Magazine* 61 (10): 373.

Goethe, Johann Wolfgang von. 1810. "Zur Farbenlehre Anzeige und Übersicht des Goethischen Werkes zur Farbenlehre: Selbstanzeige." *Morgenblatt für gebildete Stände* 6 June 1810.

Goethe, Johann Wolfgang von. 2008. *Elective Affinities: A Novel*. Translated by David Constantine. Oxford: Oxford University Press.

Goodman, Nelson. 1968. *Languages of Art. An Approach to a Theory of Symbols*. Indianapolis, IN: Bobbs-Merrill.

Gould, Andrew. 2014. "An Icon of the Kingdom of God: The Integrated Expression of all the Liturgical Arts–Part 12: Incense–Heavenly Fragrance and Transfigured Light." *Orthodox Arts Journal*. www.orthodoxartsjournal.org/icon-kingdom-god-integrated-expression-liturgical-arts-part-12-incense-heav enly-fragrance-transfigured-light/.

Graburn, Nelson. 1976. *Ethnic and Tourist Arts: Cultural Expressions from the Fourth World*. Berkeley: University of California Press.

Graburn, Nelson. 2004. "Authentic Inuit Art: Creation and Exclusion in the Canadian North." *Journal of Material Culture* 9 (2): 141–159.

Graburn, Nelson, and Aaron Glass, eds. 2004. "Beyond Art/Artifact/Tourist Art: Social Agency and the Cultural Values of the Aestheticized Object." Special issue of the *Journal of Material Culture* 9 (2).

Groenewegen-Frankfort, Henriette. 1951. *Arrest and Movement: An Essay on Space and Time in the Representational Art of the Ancient Near East*. London: Faber and Faber.

Guthrie, Stewart. 1993. *Faces in the Clouds: A New Theory of Religion*. Oxford: Oxford University Press.

Haddon, Alfred Cort. 1894. *The Decorative Art of British New Guinea: A Study in Papuan Ethnography*. Dublin: Academy House.

Haddon, Alfred Cort. 1895. *Evolution in Art: As Illustrated by the Life Histories of Designs*. London: Walter Scott Press.

Haddon, Alfred Cort. 1901. *Reports of the Cambridge Anthropological Expedition to Torres Straits*. Cambridge, UK: Cambridge University Press.

Hahn, Cynthia. 1997. "Seeing and Believing: The Construction of Sanctity in Early-Medieval Saints' Shrines." *Speculum* 72 (4): 1079–1106.

Halbwachs, Maurice. (1941) 1992. *On Collective Memory*. Translated by Lewis Coser. Chicago: University of Chicago Press.

Hallowell, Alfred Irving. 1955. *Culture and Experience*. Philadelphia: University of Philadelphia Press.

Hamby, Louise, and Diana Young. 2001. *Art on a String: Aboriginal Threaded Objects from the Central Desert and Arnhem Land*. South Australia: Ernabella Arts.

Hammond, Joyce. 1986. "Polynesian Women and Tifaifai Fabrications of Identity." *The Journal of American Folklore* 99 (393): 259–279.

Hapeta, Jeremy, Farah Palmer, and Yusuke Kuroda. 2018. "KA MATEA commodity to trade or taonga to treasure?" *Mai Journal* 7 (2): 171–185.

236 Bibliography

Harrison, Simon. 1999. "Identity as a scarce resource." *Social Anthropology* 7 (3), 239–251.

Harrison, Simon. 2005. *Fracturing Resemblances: Identity and Mimetic Conflict in Melanesia and the West*. Oxford: Berghahn.

Hauser-Schäublin, Brigitta. 1989a. *Kulthäuser in Nordneuguinea*. Berlin: Akademie Verlag.

Hauser-Schäublin, Brigitta. 1989b. *Leben in Linie Muster und Farbe*. Basle: Birkhäuser.

Hauser-Schäublin, Brigitta. 1994. "The Track of the Triangle: Form and Meaning in the Sepik, Papua New Guinea." *Pacific Studies* 17 (3): 133–170.

Hauser-Schäublin, Brigitta. 1996. "The Thrill of the Line, the String, and the Frond, or Why the Abelam are a Non-Cloth Culture." *Oceania* 67 (2): 81–106.

Hauser-Schäublin, Brigitta, Nigel Stephenson, and PNG National Museum. 2016. *Ceremonial Houses of the Abelam, Papua New Guinea: Architecture and Ritual - A Passage to the Ancestors*. Goolwa, Australia: Crawford House Publishing; in association with the Papua New Guinea National Museum & Art Gallery.

Henare, Amiria, Martin Holbraad, and Sari Wastell, eds. 2007. *Thinking Through Things: Theorising Artefacts Ethnographically*. London: Routledge.

Herder, Johann Gottfried. 2002. *Sculpture: Some Observations on Shape and Form from Pygmalion's Creative Dream*. Translated by Jason Gaiger. Chicago: University of Chicago Press.

Hereniko, Vilsoni. 1994. "Clowning as Political Commentary: Polynesia, Then and Now." *The Contemporary Pacific* 6 (1): 1–28.

Herle, Anita, and Andrew Moutu. 2004. *Paired Brothers: Concealment and Revelation. Iatmul Ritual Art from the Sepik, Papua New Guinea*. Cambridge, UK: University of Cambridge Museum of Archaeology and Anthropology.

Herle, Anita , and Sandra Rouse, eds. 1998. *Cambridge and the Torres Strait: Centenary Essays on the 1898 Anthropological Expedition*. Cambridge, UK: Cambridge University Press.

Hermkens, Anna-Karina, and Katherine Lepani, eds. 2017. *Sinuous Objects: Revaluing Women's Wealth in the Contemporary Pacific*. Acton, Australia: ANU Press.

Hess, Mona, Stuart Robson, Francesca Simon Millar, Graeme Were, Edvard Hviding, and Arne Cato Berg. 2009. "Niabara: The Western Solomon Islands War Canoe at the British Museum–3D Documentation, Virtual Reconstruction and Digital Repatriation." In the *15th International Conference on Virtual Systems and Multimedia Proceedings VSMM 2009*, edited by R. Sablatnig, and M. Kampel, and M. Lettner, 41–46. Piscataway, NJ: IEEE Computer SOC.

Higgs, John. 2015. *Stranger than We can Imagine: An Alternative History of the 20th Century*. London: Weidenfeld & Nicolson.

Hirschfeld, Lawrence, and Susan Gelman. 1994. *Mapping the Mind: Domain Specificity in Cognition and Culture*. Cambridge, UK: Cambridge University Press.

Hofstadter, Douglas. 1979. *Gödel, Escher, Back: An Eternal Golden Braid*. New York: Basic Books.

Hooper, Steven. 2006. *Pacific Encounters: Art & Divinity in Polynesia, 1760–1860*. Wellington: Te Papa Press.

Hooper, Steven. 2007. "Embodying Divinity: The Life of A'a." *JPS* 116 (2): 131–180.

Hoskins, Janet. 1989. "Why Do Ladies Sing the Blues? Indigo, Cloth Production and Gender Symbolism in Kodi." In *Cloth and Human Experience*, edited by Annette Weiner and Jane Schneider, 141–164. Washington, DC: Smithsonian Institution Press.

Horst, Heather, and Daniel Miller. 2006. *The Cell Phone: An Anthropology of Communication*. Oxford: Berg.

Hoskins, Janet. 2007. "In the Realm of the Indigo Queen; Dyeing, Exchange Magic and the Elusive Tourist Dollar on Sumba." In *What's the Use of Art? Asian Visual and Material Culture in Context*, edited by Jan Mrázek and Morgan Pitelka, 141–175. Honolulu: University of Hawaii.

Howes, David. 1987. "Olfaction and Transition: An Essay on the Ritual Uses of Smell." *The Canadian Review of Sociology and Anthropology* 24 (3): 398–416.

Howes, David. 1988. "On the Odour of the Soul: Spatial Representation and Olfactory Classification in Eastern Indonesia and Western Melanesia." *Bijdragen Tot de Taal-land-en Volkenkunde* 144: 84–113.

Howes, David. 1991. *Varieties of Sensory Experience: A Sourcebook in the Anthropology of the Senses.* Toronto: University of Toronto Press.

Howes, David. 1992. *The Bounds of Sense: An Inquiry into the Sensory Orders of Western and Melanesian Society.* Montreal: University of Montreal.

Hsu, Elisabeth. 2020. "The Healing Green, Cultural Synaesthesia and Triangular Comparativism." *Ethnos.* DOI: 10.1080/00141844.2020.1768137

Husserl, Edmund. 1989. "The Origin of Geometry." Translated by David Carr. In *Edmund Husserl's Origin of Geometry: An Introduction*, edited by Jacques Derrida, 155–180. Lincoln: University of Nebraska Press.

Husserl, Edmund. 1991. *On the Phenomenology of the Consciousness of Internal Time 1893–1917.* London: Kluwer Academic Publishers.

Hutchins, Edwin. 1995. *Cognition in the Wild.* Cambridge, MA: MIT Press.

Ingold, Tim. 2010. "The Textility of Making." *Cambridge Journal of Economics* 34 (1): 91–102.

Ingold, Tim. 2011. *Being Alive: Essays on Movement, Knowledge and Description.* London: Taylor and Francis.

Ingold, Tim. 2012. "Toward an Ecology of Materials." *Annual Review of Anthropology*, 41: 427–442.

Ingold, Tim. 2013. *Making: Anthropology, Archaeology, Art and Architecture.* London: Routledge.

Ingold, Tim. 2017. *Anthropology and/as Education.* New York: Routledge

Jackson, Michael, ed. 1996. *Things As They Are: New Directions in Phenomenological Anthropology.* Bloomington: Indiana University Press.

Jakobson, Roman. 1971. "Language in Relation to other Communication Systems." In *Selected Writings Vol II: Word and Language*, edited by Roman Jakobson, 697–710. The Hague: Mouton.

Jones, Owen. 1856. *The Grammar of Ornament: Illustrated by Examples from Various Styles of Ornament.* London: Day and Son.

Jones, Stella. 1973. *Hawaiian Quilts.* Honolulu: Hawaii University Press.

Kaeppler, Adrienne, Christian Kaufmann, and Douglas Newton. 1997. *Oceanic Art.* Translated from French by Nora Scott and Sabine Bouladon in collaboration with Fiona Leibrick. New York: Harry N. Adams.

Kandel, Eric. 2012. *The Age of Insight: The Quest to Understand the Unconscious in Art, Mind, and Brain, from Vienna 1900 to the Present.* New York: Random House.

Kandinsky, Wassily. (1911) 2008. *Concerning the Spiritual in Art.* Translated by Michael Sadler. Auckland, New Zealand: The Floating Press.

Kant, Immanuel. (1790) 2007. *The Critique of Judgement*, revised ed., edited by Nicholas Walker and translated by James Creed Meredith. Oxford, UK: Oxford University Press.

Kapferer, Bruce. 2005. "Sorcery and the Beautiful: A Discourse on the Aesthetics of Ritual." In *Aesthetics in Performance: Formations of Symbolic Construction and Experience*, edited by Angela Hobart and Bruce Kapferer, 129–160. Oxford: Berghahn.

Käretu, Timoti. 1993. *Haka: The Dance of a Noble People.* Auckland, New Zealand: Reed.

Keane, Webb. 1997. *Signs of Recognition: Powers and Hazards of Representation in an Indonesian Society.* Berkeley: University of California Press.

Keane, Webb. 2003. "Semiotics and the Social Analysis of Material Things." *Language & Communication* 23: 409–425.

238 Bibliography

Keane, Webb. 2007. *Christian Moderns: Freedom and Fetish in the Mission Encounter.* Berkeley: University of California Press.

Keane, Webb. 2013. "On Spirit Writing: Materialities of Language and the Religious Work of Transduction." *Journal of the American Institute of Planners* 19 (1): 1–17.

Keynes, John Maynard. 1936. *The General Theory of Employment, Interest and Money.* London: Macmillan & Co.

King, Helen. 2004. *The Disease of Virgins: Green Sickness, Chlorosis and the Problems of Puberty.* London: Routledge.

Klein, Yves. 2007. *Overcoming the Problems of Art: The Writings of Yves Klein.* Washington, DC: Spring Publications.

Knappett, Carl. 2002. "Photograph, Skeuomorphs and Marionettes: Some Thoughts on Mind, Agency and Object." *Journal of Material Culture* 7 (1): 97–117.

Knappett, Carl. 2005. *Thinking Through Material Culture: An Interdisciplinary Perspective.* Philadelphia: University of Pennsylvania Press.

Köhler, W. G. 1970. *Gestalt Psychology.* New York: Liveright Publishing Corp.

Krmpotich, Cara Ann, and Laura L. Peers. 2013. *This is Our Life: Haida Material Heritage and Changing Museum Practice.* Vancouver: UBC Press.

Küchler, Susanne. 2002. *Malanggan: Art, Memory and Sacrifice.* Oxford: Berg.

Küchler, Susanne. 2003. "Imaging the Body Politic: The Knot in the Pacific Imagination." *L'Homme Revue Française d'anthropologie* 165: 205–222.

Küchler, Susanne. 2005a. "Materiality and Cognition: The Changing Face of Things." In *Materiality*, edited by Daniel Miller. Durham, NC: Duke University Press. DOI: 10.1215/9780822386711-009.

Küchler, Susanne. 2005b. "Why are there Quilts in Polynesia?" In *Clothing as Material Culture*, edited by Susanne Küchler and Daniel Miller, 175–191. Oxford: Berg.

Küchler, Susanne. 2013. "Threads of Thought: Reflections on *Art and Agency*." In *Distributed Objects: Meaning and Mattering after Alfred Gell*, edited by Liana Chua and Mark Elliot, 25–38. Oxford: Berghahn.

Küchler, Susanne. 2017. "Differential Geometry, the Informational Surface and Oceanic Art: The Role of Pattern in Knowledge Economies." *Theory, Culture and Society* 34 (7–8): 75–97.

Küchler, Susanne. 2021. "Rethinking Objectification and its Consequences: From Substitution to Sequence." In *Lineages and Advancements in Material Culture Studies: Perspectives from UCL Anthropology*, edited by Timothy Carroll, Antonia Walford and Shireen Walton. London: Routledge.

Küchler, Susanne, and Andrea Eimke. 2009. *Tivaivai: The Social Fabric of the Cook Islands.* London: British Museum Press.

Küchler, Susanne, and Graeme Were. 2005a. *The Art of Clothing: A Pacific Experience.* London: Routledge.

Küchler, Susanne, and Graeme Were. 2005b. *Pacific Pattern.* London: Thames and Hudson.

Kuehling, Susanne. 2005. *Dobu: Ethics of Exchange on a Massim Island, Papua New Guinea.* Honolulu: University of Hawaii Press.

Kuipers, Joel. 1990. *Power in Performance: The Creation of Textual Authority in Weyewa Ritual Speech.* Philadelphia: University of Pennsylvania Press.

Kuipers, Joel. 1998. *Language, Identity, and Marginality in Indonesia: The Changing Nature of Ritual Speech on the Island of Sumba.* Cambridge, UK: Cambridge University Press.

Lagrou, Els. 2007. *A Fluidez da Forma: Arte, Alteridade e Agência em uma Sociedade Amazônica.* Rio de Janeiro: Topbooks.

Lagrou, Els. 2009. *Arte indígena no Brasil: Agência, alteridade e relação.* Belo Horizonte, Brazil: C/Arte.

Lagrou, Els. 2018. "Copernicus in the Amazon: Ontological Turnings from the Perspective of Amerindian Ethnologies." *Sociologia & Antropologia* 18 (1): 133–167.

Lambek, Joachim. 1958. "The Mathematics of Sentence Structure." *American Mathematical Monthly* 65 (3): 154–170.

Lambek, Michael. 2008. "Value and Virtue." *Anthropological Theory* 8 (2): 133–157.

Latour, Bruno. 1993. *Aramis, or the Love of Technology*. Cambridge, MA: Harvard University Press.

Layton, Robert. 2003. "Art and Agency: A Reassessment." *Journal of the Royal Anthropological Institute* 9 (3): 447–463.

Leach, Edmund. 1954. *Political Systems of Highland Burma: A Study of Kachin Social Structure*. London: G. Bell & Son.

Leach, Edmund, and Jerry W. Leach, eds. 1983. *The Kula: New Perspectives on Massim Exchange*. Cambridge, UK: Cambridge University Press.

Lechtman, Heather, and Robert S. Merrill. 1977. "Material Culture: Styles, Organization, and Dynamics of Technology." St. Paul, MN: West Publishing Company.

Lemonnier, Pierre. 2012. *Mundane Objects: Materiality and Non-Verbal Communication*. Walnut Creek, CA: Left Coast.

Levinson, Stephen. 1997. "Language and Cognition: The Cognitive Consequences of Spatial Description in Guugu Yimithirr." *Journal of Linguistic Anthropology* 7 (1): 98–131.

Levinson, Stephen. 2003. *Space in Language and Cognition: Explorations in Cognitive Diversity*. Cambridge, UK: Cambridge University Press.

Lévi-Strauss, Claude. 1955. *Tristes Tropiques*. Paris: Collection Terra Humaine.

Lévi-Strauss, Claude. 1963. *Structural Anthropology, Vol. 1*. Translated by C. Jacobson. New York: Basic Books.

Lévi-Strauss, Claude. 1966. *The Savage Mind*. Chicago: University of Chicago Press.

Lévi-Strauss, Claude. 1969. *The Elementary Structures of Kinship*. Boston: Beacon Press.

Levy-Bruhl, Lucien. (1928) 1966. *The "Soul" of the Primitive*. Washington, DC: Henry Regnery Company.

Lewis, Jerome. 2013. "A Cross-Cultural Perspective on the Significance of Music and Dance to Culture and Society: Insights from the BaYaka Pygmies." In *Language, Music, and the Brain: A Mysterious Relationship*, edited by Michael Arbib. Cambridge, MA: MIT Press. DOI: 10.7551/mitpress/9780262018104.001.0001.

Lipset, David. 2005. "Dead Canoes: The Fate of Agency in Twentieth-Century Murik Art." *Social Analysis* 49 (1): 109–140.

Lipset, David, and Paul Roscoe. 2011. *Echoes of The Tambaran: Masculinity, History and the Subject in the Work of Donald F. Tuzin*. Canberra: ANU Press.

Loos, Adolf. 1998. *Ornament and Crime: Selected Essays*. Translated by Adolf Opel. Riverside, CA: Ariadne Press.

Losche, Diane. 1995. "The Sepik Gaze: Iconographic Interpretation of Abelam Form." *Social Analysis,* 38: 47–60.

Loudovikos, Nikolaos. 2010. *A Eucharistic Ontology: Maximus the Confessor's Eschatological Ontology of Being as Dialogical Reciprocity*. Translated by Elizabeth Theokritoff. Brookline, MA: Holy Cross Orthodox Press.

Luhmann, Niklas. 2000. *Art as a Social System*. Stanford, CA: Stanford University Press.

Lutkehaus, Nancy, ed. 1990. *Sepik Heritage: Tradition and Change in Papua New Guinea*. Durham, NC: Carolina Academic Press.

MacCarthy, Michelle. 2016. *Making the Modern Primitive: Cultural Tourism in the Trobriand Islands*. Honolulu: University of Hawaii Press.

MacGaffey, Wyatt. 2000. *Kongo Political Culture: The Conceptual Challenge of the Particular*. Bloomington: Indiana University Press.

240 Bibliography

Mack, John. 2011. "Fetish? Magic Figures in Central Africa." *Journal of Art Historiography* 5: 53–65.

Malafouris, Lambros. 2013. *How Things Shape the Mind: A Theory of Material Engagement.* Cambridge, MA: MIT Press.

Malinowski, Bronisław. 1922. *Argonauts of the Western Pacific: An Account of Native Enterprise and Adventure in the Archipelagoes of Melanesian New Guinea.* London: Routledge.

Mallon, Sean. 2002. *Samoan Art and Artists: O Measina a Samoa.* Honolulu: University of Hawaii Press.

Mallon, Sean, and Sébastien Galliot. 2018. *Tatau: A Cultural History of Samoan Tattooing.* Honolulu: University of Hawaii Press.

Maniglier, Patrice. 2006. *La Vie Enigmatique des Signes: Saussure et du Structuralisme. La Naissance.* Paris: Editions Leo Scheer.

Maniglier, Patrice. 2013. "The Order of Things." In *A Companion to Foucault*, edited by Christopher Falzon, Timothy O'Leary, and Jana Sawicki, , 104–121. Hoboken, NJ: Blackwell Publishing.

Marchand, Trevor. 2009. *The Masons of Djenné.* Bloomington: Indiana University Press.

Marchand, Trevor. 2010. "Making Knowledge: Explorations of the Indissoluble Relation between Mind, Body and Environment." *Journal of the Royal Anthropological Institute* 16 (S1–S21).

Marchand, Trevor. 2012. *Minaret Building and Apprenticeship in Yemen.* London: Routledge.

Marcus, George, and Fred Myers. 1995. *The Traffic in Art and Culture. Refiguring Art and Anthropology.* Berkeley: University of California Press.

Margiotti, Margherita. 2013. "Clothing Sociality: Materiality and the Everyday among the Kuna of Panama." *Journal of Material Culture* 18 (4): 389–407.

Martin, Felix. 2014. *Money: The Unauthorised Biography.* London: Vintage Books.

Mauss, Marcel. (1935) 1973. "Techniques of the Body." *Economy and Society*, 2 (1): 70–88.

Mauss, Marcel. 1967. *The Gift: Forms and Functions of Exchange in Archaic Societies.* Translated by Ian Gunnison. New York: Norton Library.

Mauss, Marcel. (1947) 2007. *Manual of Ethnography.* Translated by Dominique Lussier. New York: Durkheim Press.

Mead, Hirini Moko. 2003. *Tikanga Māori: Living by Māori Values.* Wellington: Huia.

Melion, Walter. 1991. *Shaping the Netherlandish Canon: Karel Van Mander's Schilder Boeck.* Chicago: Chicago University Press.

Melion, Walter, and Susanne Küchler. 1990. "Introduction: Memory, Cognition, and Image Production." In *Images of Memory: On Remembering and Representation*, edited by Susanne Küchler and Walter Melion, 1–47. Washington, DC: Smithsonian Institution Press.

Menevisoglou, Pavlos. 2013. "Historical Overview of the Sanctification of the Holy Myrrh in the Orthodox Church." The Ecumenical Patriarchate of Constantinople. Accessed January 22, 2013. www.patriarchate.org/patriarchate/holymyron/history.

Mertz, Elizabeth. 2007. "Semiotic Anthropology." *Annual Review of Anthropology* 36: 337–353.

Michaels, Eric. 1994. *Bad Aboriginal Art: Tradition, Media, and Technological Horizons.* Minneapolis: University of Minnesota Press.

Miller, Daniel. 2008. "The uses of Value." *Geoforum* 39 (3): 1122–1132.

Miller, George, & Philip Johnson-Laird. 1976. *Language and Perception.* Cambridge, MA: Harvard University Press.

Mol, Annemarie, Ingunn Moser, and Jeannette Pols, eds. 2010. *Care: On Tinkering in Clinics, Homes and Farms.* Bielefeld, Germany: Transcript Verlag.

Morava, Jack. 2003. "On the Canonical Formula of C. Lévi-Strauss." arxiv.org/abs/math/0306174v2

Bibliography **241**

Morava, Jack. 2005. "From Lévi-Strauss to Chaos and Complexity." In *On the Order of Chaos: Social Anthropology and the Science of Chaos*, edited by Mark Mosko and Frederick Damon, 47–63. Oxford: Berghahn.

Morphet, Richard. 1976. "Carl Andre's Bricks." *The Burlington Magazine* 118 (884): 762–767.

Morphy, Howard. 1989. "From Dull to Brilliant: The Aesthetics of Spiritual Power Among the Yolngu." *Man* 14 (1): 21–41.

Morphy, Howard. 1991. *Ancestral Connections: Art and an Aboriginal System of Knowledge*. Chicago: University of Chicago Press.

Morphy, Howard. 1992. "Aesthetics in cross-cultural Perspective." *JASO* 23 (1).

Morphy, Howard. 2007. *Becoming Art: Exploring Cross-Cultural Categories*. Oxford: Berg Publishers.

Morphy, Howard. 2009. "Art as a Mode of Action: Some Problems with Gell's Art and Agency." *Journal of Material Culture* 14 (1): 5–27.

Mosko, Mark. 2013. "Omarakana Revisited, or 'Do Dual Organizations Exist?' in the Trobriands." *JRAI* 19: 482–509.

Moussaieff, Arieh, Neta Rimmerman, Tatianah Bregman, Alex Straiker, Christian C. Felder, Shai Shoham, Yoel Kashman et al. 2008. "Incensole Acetate, an Incense Component, Elicits Psychoactivity by Activating TRPV3 Channels in the Brain." *The FASEB Journal* 22 (8): 3024–3034.

Moutu, Andrew. 2013. *Names are Thicker than Blood: Kinship and Ownership Amongst the Iatmul*. London: British Academy.

Munn, Nancy. 1966. "Visual Categories: An Approach to the Study of Representational Systems." *American Anthropologist* 68: 936–950.

Munn, Nancy. 1973. *Walbiri Iconography: Graphic Representation and Cultural Symbolism in a Central Australian Society*. Ithaca, NY: Cornell University Press.

Munn, Nancy. 1977. "The Spatiotemporal Transformations of Gawa Canoes." *Journal de la Société des Océanistes* 33 (54–55): 39–51.

Munn, Nancy. 1986. *The Fame of Gawa: A Symbolic Study of Value Transformation in a Massim Papua New Guinea. Society*. Durham, NC: Duke University Press.

Munn, Nancy. 1996. "Excluded Spaces: The Figure in the Australian Aboriginal Landscape." *Critical Inquiry* 22 (3): 446–465.

Myers, Fred. 1999. "Aesthetics and Practice: A Local Art History of Pintupi Painting." In *Art from the Land: Dialogues with the Kluge–Ruhe Collection of Australian Aboriginal Art*, edited by Howard Morphy and Margo Smith Boles, 219–259. Charlottesville: University of Virginia Press.

Myers, Fred. 2002. *Painting Culture. The Making of an Aboriginal High Art*. Durham, NC: Duke University Press.

Myers, Fred. 2004. "Social Agency and the Cultural Values of the Art Object." *Journal of Material Culture* 9 (2): 205–213.

Naji, Myriem, and Laurence Douny. 2009. "Editorial." *Journal of Material Culture* 14 (4): 411–432.

Naji, Myriem. 2009. "Le fil de la pensée tisserande: "Affordances" de la matière et des corps dans le tissage." *Techniques & Culture* 52–53: 68–89.

Nash, Stephen E., and Chip Colwell-Chanthaphonh. 2010. "NAGPRA after Two Decades." *Museum Anthropology* 33 (2): 99–251.

Nichter, Mark. (1989) 1996. "Health Social Science Research on the Study of Diarrheal Disease: A Focus on Dysentery." In *Anthropology and International Health: South Asian Case Studies*, edited by Mark Nichter and Mimi Nichter, 111–134. Amsterdam: Overseas Publishers Association.

Norris, Lucy. 2010. *Recycling Indian Clothing: Global Contexts of Reuse and Value*. Bloomington: Indiana University Press.

Norton, Louise. 1917. "The Richard Mutt Case." *The Blind Man*, 2, 5-6.

O'Hanlon, Michael. 1989. *Reading the Skin: Adornment, Display and Society Among the Wahgi*. London: British Museum Publications.

O'Hanlon, Michael. 1993. *Paradise: Portraying the New Guinea Highlands*. London: British Museum Press.

O'Hanlon, Michael, and Robert Louis Welsch. 2000. *Hunting the Gatherers: Ethnographic Collectors, Agents and Agency in Melanesia, 1870s–1930s*. Oxford: Berghahn.

Omer, S.A., S.E.I. Adam, and O.B. Mohammed. 2011. "Antimicrobial Activity of Commiphora Myrrha Against Some Bacteria and Candid Albicans Isolated from Gazelles at King Khalid Wildlife Research Centre." *Research Journal of Medicinal Plants* 5 (1): 65–71.

Otsuji, Emi, and Alastair Pennycook. 2019. "Sydney's Metrolingual Assemblages: Yellow Matters." In *Multilingual Sydney*, edited by Alice Chik, Phil Benson and Robyn Moloney, 40–50. London: Routledge.

Panofsky, Erwin. 1939. *Studies in Iconology: Humanistic Themes in the Art of the Renaissance*. Oxford: Oxford University Press.

Peers, Laura L., and Alison K. Brown. 2003. *Museums and Source Communities: A Routledge Reader*. London: Routledge.

Peirce, Charles Sanders. 1931. *Collected Papers of Charles Sanders Peirce*, edited by Charles Hartshorne and Paul Weiss. Cambridge, MA: Harvard University Press.

Peterfalvi, Jean-Michel. 1970. *Recherches expérimentales sur le symbolisme phonétique*. Paris: CNRS.

Pinney, Christopher. 2005. "Things Happen: Or, From Which Moment Does that Object Come." In *Materiality*, edited by Daniel Miller, 256–272. Durham, NC: Duke University Press.

Pinney, Christopher. 2021. "Prophetic Pictures: Or, What Time is the Visual?" In *Lineages and Advancements in Material Culture Studies: Perspectives from UCL Anthropology*, edited by Timothy Carroll, Antonia Walford, and Shireen Walton. London: Routledge.

Pinney, Christopher, and Nicholas Thomas, eds. 2001. *Beyond Aesthetics: Art and the Technologies of Enchantment*. Oxford: Berg.

Poggioli, Vicki. 1988. *Patterns from Paradise: The Art of Tahitian Quilting*. Pittstown, NJ: Main Street Press.

Pomian, Krzysztof. 1990. *Collectors and Curiosities: Paris and Venice, 1500–1800*. Cambridge, UK: Polity Press.

Porter, Martin. 2005. *Windows of the Soul: The Art of Physiognomy in European Culture 1470–1780*. Oxford: Clarendon.

Povinelli, Elizabeth. 2011. *Economies of Abandonment: Social Belonging and Endurance in Late Liberalism*. Durham, NC: Duke University Press.

Pratt, Mary Louise. 1991. "Arts of the Contact Zone." *Profession* 1991: 33–40.

Propp, Vladimir. 1968. *Morphology of the Folktale*. Translated Laurence Scott; revised by Louis A. Wagner. Austin: University of Texas Press.

Rahal, Joseph. 2006. *The Services of Great and Holy Week and Pascha: According to the Use of the Self-Ruled Antiochian Orthodox Christian Archdiocese of North America*. New York: Antakya Press.

Rampley, Matthew. 2005. "Art History and Cultural Difference: Alfred Gell's Anthropology of Art." *Art History* 28 (4): 524–551.

Riles, Annelise. 1998. "Infinity Within the Brackets." *American Ethnologist* 25 (3): 378–398.

Rio, Knut. 2005. "Discussions Around a Sand-Drawing: Creations of Agency and Society in Melanesia." *JRAI* 11: 401–423.

Rio, Knut. 2009. "Subject and Object in a Vanuatu Social Ontology: A Local Vision of Dialectics." *Journal of Material Culture* 14 (3): 283–308.

Roberson, Debi, Ian Davies, and Jules Davidoff. 2002. "Colour Categories are Not Universal: Replications and New Evidence." In *Theories Technologies Instrumentalities of Color: Anthropological and Historiographic Perspectives*, edited by Barbara Saunders and Jaap van Brakel, 25–36. Lanham, MD: University Press of America.

Rongokea, Lynnsay. 1992. *The Art of Tivaevae: Traditional Cook Islands Quilting.* Honolulu: University of Hawaii Press.

Rosanowski, Sarah. 2015. "Protection of Traditional Cultural Expressions within the New Zealand Intellectual Property Framework: A Case Study of the Ka Mate Haka." In *Indigenous Intellectual Property A Handbook of Contemporary Research*, edited by M. Rimmer, 264–288. Cheltenham, UK: Edward Elgar.

Rosch Heider, Eleanor. 1972. "Probabilities, Sampling and Ethnographic Method: The Case of Dani Colour Names." *Man* 7 (3): 448–466.

Rosch Heider, Eleanor. 1978. "Color Categorisation." In *Cognition and Categorisation*, edited by Eleanor Rosch and B. Lloyd, 29–49. Hillsdale, NJ: Erlbaum.

Rothko, Mark. 2006. *Writings on Art.* New Haven, CT: Yale University Press.

Rubin, William. 1984. *Primitivism in Twentieth Century Art.* New York: Museum of Modern Art.

Sansi, Roger. 2014. *Art, Anthropology and the Gift.* London: Bloomsbury.

Sartre, Jean-Paul. 1967. *Search for a Method.* New York: Alfred A. Knopf.

Saussure, Ferdinand de. 1960. *Course in General Linguistics.* London: Peter Owen.

Schacter, Rafael. 2014. *Ornament and Order: Graffiti, Street Art and the Parergon.* London: Ashgate.

Schacter, Rafael. 2021. "A Curatorial Methodology for Anthropology." In *Lineages and Advancements in Material Culture Studies: Perspectives from UCL Anthropology,* edited by Timothy Carroll, Antonia Walford, and Shireen Walton. London: Routledge.

Schindlebeck, Markus. 2001. "Deutsche wissenschaftliche Expeditionen und Forschungen in der Südsee bi 1914." In *Die Deutsche Südsee 1884–1914,* edited by H.J. Hiery, 132–150. Paderborn, Germany: Ferdinand Schöning.

Schneider, Arnd, and Christopher Wright, eds. 2006. *Contemporary Art and Anthropology.* Oxford: Berg.

Schütz, Alfred. 1964. "Making Music Together: A Study in Social Relationship." In *Alfred Schütz Collected Papers II: Studies in Social Theory*, edited by Arvid Brodersen, 159–178. The Hague: Martinus Nijhoff.

Schütz, Alfred. l967. *Collected Papers, Vol. I.* The Hague: Martinus Nijhoff.

Scoditti, Giancarlo. 1990. *Kitawa: A Linguistic and Aesthetic Analysis of Visual Art in Melanesia.* Berlin: Mouton De Gruyter.

Semper, Gottfried. (1860) 2004. *Style in the Technical and Tectonic Arts, Or, Practical Aesthetics.* Translated by Harry Francis Mallgrave and Michael Robinson. Los Angeles: Getty Publications

Severi, Carlo. 2016. "Authorless Authority: A Proposal on Agency and Ritual Artefacts." *Journal of Material Culture* 21 (1): 133–150.

Shuaib, Mohd, Abuzer Ali, Mohd Ali, Bibhu Prasad Panda, and Mohd Imtiyaz Ahmad. 2013. "Antibacterial Activity of Resin Rich Plant Extracts." *Journal of Pharmacy & BioAllied Sciences* 5 (4): 265–269.

Simmel, Georg. (1916) 2005. *Rembrandt: An Essay in the Philosophy of Art.* Translated by Alan Scott and Helmut Staubmann. London: Routledge.

Singer, Milton. 1980. "Signs of the Self: An Exploration in Semiotic Anthropology." *American Anthropologist* 82 (3): 485–507.

Sperber, Dan. 1975. *Rethinking Symbolism*. Cambridge, UK: Cambridge University Press.

Sperber, Dan. 1985. "Epidemiology of Representation." *Man* 20 (1): 73–89.

Sperber, Dan. 1996. *Explaining Culture: A Naturalistic Approach*. Oxford, UK: Blackwell Publishers.

Stafford, Barbara Maria. 2007. *Echo Objects: The Cognitive Work of Images*. Chicago: University of Chicago Press.

Starr, Gabrielle. 2013. *Feeling Beauty: The Neuroscience of Aesthetic Experience*. Cambridge, MA: MIT Press.

Stedman, J.G. 1813. *Narrative, of a Five Years' Expedition Against the Revolted Negroes of Surinam, in Guiana, on the Wild Coast of South America*. London: J. Johnson.

Stengers, Isabelle. 2010. *Cosmopolitics I*. Translated by Robert Bononno. Minneapolis: University of Minnesota Press.

Stoller, Paul. 1989. *The Taste of Ethnographic Things: The Senses in Anthropology*. Philadelphia: University of Pennsylvania Press.

Strathern, Marilyn. 1979. "The Self in Self-decoration." *Oceania* 49 (4): 241–257.

Strathern, Marilyn. 1988. *The Gender of the Gift*. Berkeley: University of California Press.

Strathern, Marilyn. 1990. "Artifacts of History: Events and the Interpretation of Images." In *Culture and History in the Pacific*, edited by Jukka Siikala, 25–44. Helsinki: Transactions of the Finnish Anthropological Society.

Strathern, Marilyn. 1991. *Partial Connections*. Lanham, MD: AltaMira.

Strathern, Marilyn. 1996. "Cutting the Network." *Journal of the Royal Anthropological Institute* 2 (3): 517–535.

Strathern, Andrew, and Marilyn Strathern. 1971. *Self-Decoration in Mount Hagen*. London: Duckworth.

Sweetman, Lauren E., and Kirsten Zemke. 2019. "Claiming Ka Mate: Māori Cultural Property and the Nation's Stake." In *The Oxford Handbook of Musical Repatriation*, edited by Frank Gunderson, Robert C. Lancefield, and Bret Woods. Oxford: Oxford University Press.

Tambiah, Stanley. 1968. "The Magical Power of Words." *Man* 2: 172–208.

Tanner, Jeremy. 2013. "Figuring Out Death: Sculpture and Agency at the Mausoleum of Halicarnassus and the Tomb of the First Emperor of China." In *Distributed Objects: Meaning and Mattering after Alfred Gell*, edited by Liana Chua and Mark Elliot, 58–87. Oxford: Berghahn.

Tarlo, Emma. 1996. *Clothing Matters: Dress and Identity in India*. London: Hurst & Company.

Taussig, Michael. 1993. *Mimesis and Alterity*. London: Routledge.

Taussig, Michael. 2008. "Redeeming Indigo." *Theory, Culture and Society* 25 (3): 1–15.

Taussig, Michael. 2009. *What Colour is the Sacred?* Chicago: University of Chicago Press.

Taylor, Anne Christine. 1993. "Remembering to Forget: Identity, Mourning and Memory Among the Jivaro." *Man* 28 (4): 653–678.

Taylor, Anne Christine. 2003. "The Masks of Memory: On Body-Painting among the Jivaro (Shuar) of Western Amazonia." *L'Homme* 165: 223–248.

Taylor, Luke. 1996. *Seeing the Inside: Bark Painting in Western Arnhem Land*. Oxford: Clarendon Press.

Tcherkézoff, Serge. 2004. *"First Contacts" in Polynesia*. Canberra: ANU Press.

The Times. 1914. "National Gallery Outrage. The Rokeby Venus. Suffragist Prisoner in Court. Extent of the Damage." *The Times*, March 11, 1914. Accessed August 5, 2019. www.heretical.com/suffrage/1914tms2.html.

Thom, René. 1975. *Structural Stability and Morphogenesis: An Outline of a General Theory of Models*. Translated by D.H. Fowler. Reading, PA: W.A. Benjamin.

Thomas, Nicholas. 1991. *Entangled Objects: Exchange, Material Culture, and Colonialism in the Pacific*. Cambridge, MA: Harvard University Press.

Thomas, Nicholas. 1995. *Oceanic Art*. London: Thames and Hudson.

Thomas, Nicholas. 1999. "The Case of the Misplaced Ponchos: Speculations Concerning the History of Cloth in Polynesia." *Journal of Material Culture* 4 (5): 5–20.

Thomas, Nicholas, Bronwen Douglas, and Anna Cole. 2005. *Tattoo: Bodies, Art and Exchange in the Pacific and the West*. London: Reaktion Books.

Thompson, Glyn. 2015. *Duchamp's Urinal? The Facts Behind the Façade*. London: Wild Pansy Press.

Thompson, Michael. 1979. *Rubbish Theory. The Creation and Destruction of Value*. Oxford: Oxford University Press.

Tsing, Anna. 2015. *The Mushroom at the End of the World: On the Possibility of Life in Capitalist Ruins*. Princeton, NJ: Princeton University Press.

Turner, Terence. 1980. "The Social Skin." In *Not Work Alone*, edited by J. Cherfas and R. Lewin, 111–140. London: Temple Smith.

Turner, Victor. 1967. *The Forest of Symbols: Aspects of Ndembu Ritual*. Ithaca, NY: Cornell University Press.

Turner, Victor. 1969. *The Ritual Process: Structure and Anti-Structure*. New Brunswick: Aldine Transaction Publishers.

Tuzin, D.F. 1980. *The Voice of the Tambaran: Truth and Illusion in Ilahita Arapesh Religion*. Berkeley: University of California Press.

Tuzin, D.F. 1997. *The Cassowary's Revenge: The Life and Death of Masculinity in a New Guinea Society*. Chicago: University of Chicago Press.

Ucko, Peter. 1969. Penis Sheaths: A Comparative Study. *Proceedings of the RAI* 1969: 24–67.

Urton, Gary. 1997. *The Social Life of Numbers: A Quechua Ontology of Numbers and Philosophy of Arithmetic*. Austin: University of Texas Press.

Urton, Gary. 2003. *Signs of the Inka Khipu: Binary Coding in the Andean Knotted-String Records*. Austin: University of Texas Press.

Urton, Gary. 2017. *Inka History in Knots: Reading Khipus as Primary Sources*. Austin: University of Texas Press.

van Eck, Caroline. 2010. "Living Statues: Alfred Gell's *Art and Agency*, Living Presence Response and the Sublime." *Art History* 33 (4): 642–659.

van Eck, Caroline. 2015. *Art, Agency and Living Presence: From the Animated Image to the Excessive Object*. Leiden, The Netherlands: De Gruyter.

Vanhee, Hein. 2000. "Agents of Order and Disorder: Kongo Minkisi." In *Re-Visions: New Perspectives on African Collections of the Horniman Museum*, edited by Karel Arnaut, 89–106. Horniman Museum and Gardens & Museu Antropólogico da Universidade de Coimbra.

Viveiros de Castro, Eduardo. 1979. "A Fabricação do Corpo na Sociedade Xinguana." *Boletim do Museu Nacional* 32, 40–49.

Viveiros de Castro, Eduardo. 1998. "Cosmological Deixis and Amerindian Perspectivism." *Journal of the Royal Anthropological Institute* 4 (3): 469–488.

Viveiros de Castro, Eduardo. 2014. *Cannibal Metaphysics: For a Post-Structural Anthropology*. Minneapolis: Univocal.

Volavkova, Zdenka. 1972. "Nkisi Figures of the Lower Congo." *African Arts* 5: 52–89.

Waghorn, Nicholas. 2014. *Nothingness and the Meaning of Life: Philosophical Approaches to Ultimate Meaning Through Nothing and Reflexivity*. London: Bloomsbury.

Wagner, Monika. 2001. *Das Material der Kunst: Eine andere Geschichte der Moderne*. Münich: C.H. Beck.

246 Bibliography

Wagner, Monika, Dietmar Rügel, and Sebastian Hackenschmidt, eds. 2002. *Lexikon des künstlerischen Materials. Werkstoffe der modernen Kunst von Abfall bis Zinn.* Münich: Verlag C.H. Beck.

Wagner, Roy. 1975. *The Invention of Culture.* Chicago: University of Chicago Press

Wagner, Roy. 1986. *Symbols that Stand for Themselves.* Chicago: University of Chicago Press.

Walker, Lucy, João Jardim, Karen Harley, dirs. 2010. *Waste Land.* Los Angeles: Arthouse Films.

Wallace, Anthony. 1978. *Rockdale: The Growth of an American Village in the early Industrial Revolution.* New York: Alfred Knopf Inc. and Random House.

Warburg, Aby. 1999. *The Renewal of Pagan Antiquity: Contributions to the Cultural History of the European Renaissance Texts & Documents..* Translated by David Britt. Los Angeles: Getty Research Institute for the History of Art and the Humanities.

Warburg, Aby. 2000. *Der Bilderatlas: Mnemosyne,* edited by Martin Warnke and Claudia Brink. Berlin: Akademie Verlag.

Warburg, Aby. 2009. "The Absorption of the Expressive Values of the Past." *Art in Translation* 12: 273–283.

Washburn, Dorothy, and Donald Crowe. 1988. *Symmetries of Culture: Theory and Practice of Plane Pattern Analysis.* Seattle: University of Washington Press.

Wassmann, Jürg. 1994. "The Yupno as Post-Newtonian Scientists: The Question of What is 'Natural' in Spatial Description." *Man, New Series* 29 (3): 645–666.

Weiner, Annette. 1976. *Women of Value, Men of Renown: New Perspectives In Trobriand Exchange.* Austin: University of Texas Press.

Weiner, Annette. 1989. "Why Cloth? Wealth, Gender, and Power in Oceania." In *Cloth and Human Experience,* edited by Annette B. Weiner and Jane Schneider, 33–72. Washington, DC: Smithsonian Books.

Weiner, Annette. 1992. *Inalienable Possessions: The Paradox of Keeping While Giving.* Berkeley: University of California Press.

Weiner, James. 1991. *The Empty Place: Poetry, Space and Being among the Foi of Papua New Guinea.* Bloomington: Indiana University Press.

Weiss, Paul, and Arthur Burks. 1945. "Peirce's Sixty-Six Signs." *The Journal of Philosophy* 42 (14): 383–388.

Weiss, Peg. 1986. "Kandinsky and the 'Old Russia': An Ethnographic Exploration." *Syracuse Scholar* 7 (1): 43–62.

Weiss, Peg. 1995. *Kandinsky and Old Russia: The Artist as Ethnographer and Shaman.* New Haven, CT: Yale University Press

Welsch, Robert, Virginia-Lee Webb, and Sebastine Haraha. 2006. *Coaxing the Spirits to Dance: Art and Society in the Papuan Gulf of New Guinea.* New Hanover: Hood Museum of Art and Dartmouth College.

Wengrow, David. 1998. "The Changing Face of Clay: Continuity and Change in the Transition from Village to Urban Life in the Near East." *Antiquity* 72 (278): 783–795.

Wengrow, David. 2014. *The Origins of Monsters: Image and Cognition in the First Age of Mechanical Reproduction.* Princeton, NJ: Princeton University Press.

Were, Graeme. 2019. *How Materials Matter: Design, Innovation and Materiality in the Pacific.* Oxford: Berghahn.

Whorf, B.L. 1956. "The Relation of Habitual Thought and Behaviour to Language." In *Language Thought and Reality,* edited by John Carroll, 134–159. Cambridge, MA: MIT Press.

Wiberg, Mikael, and Erica Robles. 2010. "Computational Composition: Aesthetics, Materials and Interaction Design." *International Journal of Design* 4 (2): 65–76.

Wigley, Mark. 1996. *White Walls, Designer Dresses: The Fashioning of Modern Architecture.* Cambridge, MA: MIT Press.

Wolff, Janet. 1975. *Hermeneutic Philosophy and the Sociology of Art: An Approach to Some of the Epistemological Problems of the Sociology of Knowledge and the Sociology of Literature International Library of Society.* London: Routledge & Kegan Paul.

Wolff, Janet. 1983. *Aesthetics and the Sociology of Art.* London: Allen & Unwin.

Young, Diana. 2005. "The Smell of Greenness–Cultural Synaesthesia in the Western Desert." *Etnofoor* XVIII (1): 61–71.

Young, Diana. 2006. "The Colour of Things." In *Handbook of Material Culture*, edited by Chris Tilley, 173–186. London: Sage.

Young, Diana. 2011. "Mutable Things: Colours as Material Practice in the Northwest of South Australia." *Journal of the Royal Anthropological Institute* 17 (2): 356–376.

Zakinthinos, Tilemachos, and Dimitris Skarlatos. 2007. "The Effect of Ceramic Vases on the Acoustics of Old Greek Orthodox Churches." *Applied Acoustics* 68 (11–12): 1307–1322.

Zeidler, Sebastian 2004. "Totality Against a Subject: Carl Einstein's 'Negerplastik'". *October* 107: 14–46.

INDEX

A'a 221–2
ABC (art movement) 109
abduction 8, 11, 14, 21–2, 24–7, 33–6, 50–1, 53, 58, 93, 104, 108, 111–12, 115, 122, 134, 136, 138, 147, 152, 154–5, 168, 169, 187, 203, 206, 225–6
Abelam 86, 94–8, 100, 115, 176, 180, 187
Aboriginal Australians *see* Australian Aboriginal
Achuar (people) 156
acrylic painting 105, 114, 119, 130
aesthetics 14, 25, 43, 51, 54, 62–3, 66, 74, 81–2, 88, 90–1, 101–8, 110–11, 113–16, 118–19, 124, 128, 131, 140, 144–5, 152, 187, 193, 196, 206, 209–11, 213
affordance 14–15, 54, 69, 74, 78, 81–2, 90, 99, 143, 154–5, 161, 164, 167, 176, 186, 188, 194, 217, 224
Africa (region) 2, 197, 214
agency 1, 11, 14, 20–4, 27–8, 33, 40, 50–1, 53, 111, 115, 132–9, 145–7, 151, 154–5, 165, 176, 207, 216–17, 225
agent 11, 20, 22–24, 29, 36, 96, 135, 145–6, 167, 173–4, 216
Alexander, Christopher 130–1
Alice Springs 57, 114
Amazonia (region) 128, 130
America, North 54, 174
America, South 69, 109, 156
Amerindian society/art 117, 128, 156, 239, 245
analogically 176, 210

analogical thinking 2, 38, 46, 97, 122–3, 138, 143, 166, 170, 176–7, 182, 192, 210–12, 216, 221–2
anamnesis 120, 162
anamorphosis 199
Anderson, Christabel Helena 32
Andre, Carl 108, 110, 115, 205
Anthropometries (1960) 211–13
ao and *po* (Polynesian cosmology) 191, 208, 210, 216–17
Archer, John 200–203
Arnaut, Karel 86
Arnhem Land (region) 60, 62, 72–3, 107
artefactual domain 11, 117, 121, 207, 210
artefactual form 2, 54, 203, 224
art nexus, the 12–13, 19–24, 26–7, 32–4, 36, 40, 47–50, 53, 104, 152, 188, 222
Ascher, Marcia 77, 116, 195
Ascher, Robert 77
Athanasius of Alexandria 163
Australasia (region) 42
Australian Aboriginal (people) 2, 55, 60–1, 63, 70, 72, 105, 107, 114–15, 119–20, 146, 169, 171
Azande 107, 115

Bach, Johann Sebastian 218–19
Bakhtin, Mikhail 73
Bali (region) 90
Bangana 70–3
Bardon, Geoffrey 114
Barthes, Roland 173

Bateson, Gregory 2, 4, 8, 9, 12, 14, 21, 25, 53, 54, 62–3, 72, 89, 90, 108, 117, 118, 124, 136, 168, 187–8, 203, 207
Baumgarten, Alexandeer Gottlieb 102
Baxandall, Michael 75–6
BaYaka (people) 206
beauty 7, 26, 54, 87, 102–3, 105, 117, 124, 151, 211
Benjamin, Walter 174–5, 206
Bergson, Henri 11, 30
biographical relations 1, 19, 57, 59, 61, 63, 79, 80, 123, 143, 175, 193, 212, 224–5
bir'yun 61, 72–3, 105
Boas, Franz 2–4, 6–7, 9, 12, 14, 87–9, 100, 153
Boast, Robin 69
Bourdieu, Pierre 8, 48, 111
Boyer, Pascal 29, 215–6
Breton, André 133–4, 136
Buchli, Victor 27
Burma 123

Cage, John 112, 211
Calder, Alexander 223, 226, 230
Campbell, Shirley 24, 39–41
canonical formula 3, 14, 55, 116–7, 122–3, 131, 139, 220–2, 224–5
canon of image 4, 14, 85–6, 94, 97, 131, 141, 218, 221
Carroll, James 201
Carroll, Timothy 31–2, 115, 181
Chaîne Opératoire 93–4
Chinese (people) 51, 146, 158, 181
Clarke, Alastair 189–90, 200
Classen, Constance 173
Clement of Alexandria 162
Clifford, James 68
Coburn, Alvin Langdon 110
code 52–53, 56, 58, 76–7, 89, 117–18, 191
coherence 8, 37, 86, 89–90, 118, 213–4, 221
colour 15, 26, 38, 54, 62, 113, 125, 127–8, 132, 144, 158–9, 169–77, 179–87, 206, 211–2, 221
Congo 27, 206
continuous and discontinuous motivic forms 56–7, 59, 194
Coote, Jeremy 66, 104, 107
Corbin, Alain 172
Coupaye, Ludovic 93–5, 98–100
cubism 30, 32, 131
Cyril of Jerusalem 163, 167

Damon, Frederick 38, 41–4, 48, 51, 204, 225

Danto, Arthur 107
Dany (people) 172
David, Jacques-Louis 141
Davy, Jack 54
Deacon, Arthur Bernard 123
Deger, Jennifer 63, 70–74, 81–2, 111, 122
Deleuze, Gilles 33, 76, 196, 199, 213
de Saussure, Ferdinand 34
Didi-Huberman, Georges 2–3, 89, 213
differentiation 53, 86, 97–9, 116, 128, 173, 180, 187, 193–4
Dioscorides, Pedanius 161
discontinuous forms *see* continuous and discontinuous motivic forms
Djenné 90–1
Dogon (people) 92
double description 8, 11–12, 21, 25, 27, 33–4, 72, 81, 136
Douglas, Mary 5
Douny, Laurence 92–3, 100
Duchamp, Marcel 30–33, 49, 131, 133–4, 136, 141, 178, 217, 223, 245
Duck, Michael John 180
Dulcinea (1911) 30, 33, 131
Dürer, Albrecht 75
Durkheim, Emile 213

Eco, Umberto 21
Eglash, Ron 197
Einstein, Carl 14, 24–6, 28, 30, 66–7, 73–5, 221–2
Empson, Rebecca 196–7
Ephrem the Syrian 162, 164
Equivalent VIII 108, 110, 205
ethnographic collections 1, 61, 69, 74, 104
etua (deity) 74, 221
Europe (region) 7, 19, 35, 56–7, 73, 85, 103–5, 117, 137, 141, 147, 151, 174–6, 183–5, 208–9, 214, 217
evolvent 221–2; *see also* involution

Fang (people) 29, 214–15
Faris, James 107
Farris Thompson, Robert 103–4, 106
fei 45
Feld, Steven 173, 183
fetish *see 'nkisi*
Fiji 144, 159
Finlayson, Christopher 202
Flannery, Tim 13, 42
Forge, Anthony 94, 96, 100, 124
Fortis, Paolo 129, 156
Foucault, Michel 5, 7–8, 89

250 Index

Fountain (1917) 133, 134, 136, 141
4'33" (1952) 112, 211
Frazier, James 35, 72
Freud, Sigmund 174, 223
Freytag-Loringhoven, Baroness Elsa
 Von 133–4
Fuente, Eduardo de la 65–6, 74
Fuller, Chris 12, 32
Furness, William Henry 45
futurity of object 28, 49, 99, 131, 147, 189,
 204, 213, 226

Gage, John 169
Galen of Pergamon 161
Gauguin, Paul 176
Gawan (people) 42, 44, 46, 139, 210,
 214, 241–5
Geertz, Clifford 3–4
Gell, Alfred: influences upon 2, 12–13, 25,
 30–1, 36, 40, 66, 86, 90, 97, 100, 116, 124,
 188, 191–2, 203; theory of 1, 4, 8, 12,
 15, 19–25, 27, 30–3, 36, 39–40, 48–50,
 65–6, 74, 86, 88, 93, 104–8, 111, 124–5,
 131–2, 135, 138, 152–5, 173, 183, 188,
 191–4, 198–9, 204, 207–8, 210, 215–7,
 221, 224–6
generativity 97–9, 116, 119, 130, 132, 225
geometry 3, 15, 30, 40, 43–4, 48, 58, 61–3,
 80, 82, 91, 94, 96, 99, 100, 108, 122–3,
 144, 157, 176, 186–7, 189, 192–8, 200,
 203–5, 207, 210, 219, 224–5, 225
Germany 2, 75–6, 113, 175, 185
gesture, creative 3, 11–12, 14, 25–6, 30, 52,
 54, 74–6, 89–90, 92, 99–100, 111,
 114–16, 121, 131–4, 136–7, 152, 178,
 180, 182, 187–9, 200, 203–4, 206–7,
 210–13, 217, 219, 222–5
Gibson, James 81, 154–5, 188, 217
Ginzburg, Carlo 25, 35, 72
Glowczewski, Barbara 63, 196
Gödel, Kurt 220
Goethe, Johann Wolfgang von 76,
 180, 183–185
Goltzius, Hendrick 85
Gottlieb, Adolph 178
Gould, Andrew 166
Gould, Glen 219
Graburn, Nelson 145
graphic: element 41, 57, 60–1, 63, 65,
 96, 100, 156, 193, 196; gesture 12,
 25–6, 89, 99; system 55–6, 58, 60, 62–3,
 97, 193
Groenewegen-Frankfort, Henriette 213–4
Guattari, Felix 196

Haddon, Alfred Cort 7, 69, 111
haka 200–4, 207, 243
Hallowell, Alfred Irving 100
Hamby, Louise 170–1
Harrison, Simon 2, 68
Hauser-Schäublin, Brigitta 86, 95–6,
 99–100
Hawaii 157–8, 193
Hildebrand, Adolf von 30, 74
Hirschfeld, Lawrence 10
Hodges, Christopher 119
Hofstadter, Douglas 218–21
Hoskins, Janet 185–6
Houston, James 145
Howes, David 170, 173, 177
Hsu, Elisabeth 180–3, 237
humour 15, 108, 189–90, 205
Husserl, Edmund 30–1, 120, 203, 213
hylomorphic design 136, 225

iconography 2, 55, 96, 120–1
icon (religious) 31–2, 120–1, 166–7
icon (semiotic) 35, 47, 100
IKB (International Klein Blue) 180, 212
immanence of prototype 13, 24–5, 33, 35,
 62, 66–7, 73–4, 76, 81–2, 100, 116, 136,
 147, 188, 194, 222, 224
immanent relations 4, 5, 7–10, 13–15, 24,
 53, 58, 62, 65–9, 73, 75, 78, 81, 85, 94,
 100, 111, 125, 132, 136, 143, 155, 168,
 170, 187–8, 191, 193, 198, 203–4, 206,
 212, 222, 224–6
indexical relationality 24, 36, 50, 74, 130,
 153–5, 167, 176, 198
India 142, 152, 184
Indonesia 173, 185
inferential thinking 9, 21, 22, 25, 54, 138,
 147, 154, 168, 169, 187, 203, 206, 208, 224
Ingold, Tim 11, 90, 92, 136
Inka 76, 78
intention 14, 20–4, 30, 36, 50, 53, 93,
 130–1, 134–6, 138, 141, 145, 147, 154–5,
 194, 205, 217, 225
intentionality: of human 11, 23, 29, 135; of
 object 29, 69, 138, 152, 213
intentions (Husserlian) 15, 31, 32, 120, 204;
 protentions 31–2, 203, 213,
 216–7; retentions 31–2, 120, 203,
 213, 217
interartefactual domain 29, 43, 136, 182,
 187, 203, 221, 224
intuition 3, 11, 15, 38–9, 41, 44, 50, 65, 85,
 89, 94, 100, 115, 120–2, 136, 153, 155,
 195–6, 200, 202–3, 205, 221

Index **251**

Inuit (people) 145
invention 14, 74, 75, 115–7, 120–1, 131–2,
136, 188, 190, 200, 224, 226
involute nature of object 13, 26–7, 48, 98,
140, 217, 221, 223, 226
isomorphic structure 2, 10, 82, 115, 132,
183, 219, 221, 224
Italy 21, 75, 85, 173
iterativity 80, 116, 126, 132, 144, 158–9,
189, 191, 195, 197, 213, 222

Jackson, Michael 173
Jacquard, Joseph Marie 52–3, 60
Jakobson, Roman 63, 106, 121
Jamaica 139
James, William 30
Jerusalem 162
Jones, Owen 117–9, 130, 194

Kachin (people) 123
Kaeppler, Adrienne 86
Kandinsky, Wassily 174–5, 179
Kant, Immanuel 25, 103, 209
Kantian aesthetics 7, 103, 140
Kapferer, Bruce 124
Kapoor, Anish 187
Keane, Webb 4, 11
Keynes, John Maynard 138
khipu 76–8, 80, 224
King, Helen 182
Klee, Paul 175
Klein, Yves 112, 178, 180, 187, 211–3
Klimt, Gustav 6, 223
Köhler, Wolfgang 183
Küchler, Susanne 153–4, 197
Kuh, Katharine 178
kula 13, 34, 36–9, 41–2, 44–8, 50, 214,
230–1, 239; canoe 37, 39, 41–2, 47, 88,
176; as system of exchange 13,
36–9, 41–2, 44–5, 48, 50, 214
Kuna (people) 128–30, 156, 240
Kurd (people) 68

Lagrou, Els 128
Lambek, Michael 139–40, 224
La Mort de Marat (1793) 141
language 2–4, 9, 11, 57, 62, 77, 88, 106, 113,
131, 172–4, 182, 194–5, 206, 219
lateral thinking 8, 21, 187
Latour, Bruno 20, 135
Layton, Robert 36
Leach, Edmund 123
Le Corbusier 112
Leibniz, Gottfried 33, 100, 199

Lemonnier, Pierre 93–4
Levinson, Stephen 194–6
Lévi-Strauss, Claude 2–5, 7, 9, 11–12, 54–5,
89, 116, 121–3, 156, 214, 220–2, 224–5
Lewis, Jerome 206
limewood sculpture 75, 76, 78
Loos, Adolf 112, 113
Losche, Diane 86, 97, 98–9, 126
Lutkehaus, Nancy 94

Malafouris, Lambros 9, 10
malanggan 79, 80, 160, 176, 177
Mali 90, 92
Malinowski, Bronisław 37, 39
Maniglier, Patrice 7, 9, 89, 98
Māori (people) 193, 200–4, 207
Maprik (region) 94
Marat (Sebastião) (2008) 141
Marchand, Trevor 90, 91, 100
Marcus, George 145–6
Marquesan (people) 90, 96, 221
Marshallese (people) 195, 198
Mary Magdalene 162–3
Massim (region) 2, 37, 39, 41–3, 48
matang (stick chart) 195, 198
materiality 11, 24, 27, 51, 92, 93, 144, 153,
155, 167, 168, 182, 206
Matisse, Henri 175–6
Māui 200–4
Mauss, Marcel 6, 86–7, 90–1, 100
Mead, Margaret 63, 90, 203
Melanesia (region) 42, 51, 79, 117, 125–6,
128, 130, 157, 159, 160, 170, 173, 176,
213, 216
Melion, Walter 85
Miller, Daniel 139–40
mimetic representation 14, 25, 35–6, 66–7,
72, 76, 212
mind 1, 2, 6, 8–11, 14, 19, 51–4, 58, 62,
65–6, 82, 100, 121, 135–6, 138, 147,
168–9, 187–8, 203–4, 207, 217, 226
miniature 41, 54–5, 126, 130, 156
Mnemosyne Atlas, Warburg's 99, 174
mobiles, Alexander Calder's 223, 226
model as mode of thought 8, 11–3, 34,
40–1, 43–4, 48–50, 66, 75–6, 86,
97–8, 100, 108, 116, 126, 128, 164, 195,
198, 224
mola 128–9, 156
Mondrian, Piet 113–14, 180, 223
Mongolia 196–7
Monotone-Silent Symphony (1960) 211–2
Moorish Screen (1921) 176
Morava, Jack 122–3, 220

252 Index

Morocco 51–2, 87, 176
Morphet, Richard 110
Morphy, Howard 60–2, 65, 72–3, 104–5, 107, 111
Morris, William 113
motifs 13, 24–5, 40, 52, 61–2, 64, 69, 72, 79, 81, 105, 111, 118, 124, 129, 152, 164, 191, 193, 194, 208
motivic elements 3, 25, 40, 56, 86, 90, 92, 100, 111, 115, 118, 120–1, 124, 132, 158, 176, 187, 189–92, 194, 207–8, 220
Muniz, Vik 141–2
Munn, Nancy 2, 4, 9, 11, 12, 44–8, 55–60, 62–3, 139–40, 194, 210–1, 214
Mutt, Richard 133, 134, 136
Muybridge, Eadweard 31
mvet 214–6
Myers, Fred 63–5, 105, 106, 111, 118–9, 120, 130, 145–6, 194

Naji, Myriem 51–2, 87, 92
Network of Stoppages (1914) 32, 131, 217
New Ireland, Melanesia 79, 160, 176–7
Newton, Isaac 180, 183
New Zealand 200, 202
Ngāti Toa (tribe) 202–3
'nkisi 26–9, 33, 86, 215, 217, 245
Norris, Lucy 137–8, 142–3
Norton, Louise 133, 134, 136
Nude descending the staircase No 2 (1912) 30–1, 33, 131

objectification 6, 12–13, 15, 33, 136, 204, 207
Oceania (region) 2, 45, 69
optical naturalism 14, 24–5, 30, 66–7, 70, 73–4
Oro (deity) 208, 209, 215
O'Hanlon, Michael 126
O'Keeffe, Georgia 110

Papua New Guinea 37, 94, 173, 213
Papunya Tula 63, 114, 228
paradigm certainty 74, 78, 82, 122
pattern 2, 7–8, 10–11, 15, 39, 40, 43–4, 48, 51–2, 54–5, 57, 62, 69–74, 80–1, 87–9, 96, 111, 105, 108, 115–6, 121, 123, 128–9, 131, 138, 144, 146, 152, 157, 159–60, 170, 183, 187–92, 194–201, 203–7, 209–10, 213, 221, 224
patternation 88, 187, 189, 191, 200, 203, 207, 209
Peirce, Charles Sanders 21, 26, 34–6, 47, 50, 210

Peircean semiotics 9, 13, 34–6, 49–50, 120
Pintupi (people) 63, 119–20
po (Polynesian cosmology) *see ao* and *po*
Polynesia (region) 69–70, 74, 80, 144, 146, 156, 157, 160, 191–4, 200, 207–8, 210, 216–17, 221
Pratt, Mary Louise 69
Propp, Vladimir 20–1, 121, 135
prototype 13–15, 20, 22, 26–7, 36, 49–55, 58, 60, 62, 65–8, 74–5, 81–3, 86, 94, 97, 99–101, 111, 121, 136, 155, 167–9, 187–8, 204, 215, 224–5
prototypical 13, 27, 51, 53, 59, 65–7, 78, 81, 85, 94, 96–7, 138, 140, 147, 152, 188, 212, 224–6

qualisigns 11, 35, 47, 173, 210–1
Quechua 77, 78
quipu see khipu

recipient 14, 20–22, 27, 36, 38, 45–47, 50, 51, 58, 76, 79, 94, 111, 115, 136, 152, 154, 155, 182, 187, 188, 225, 226
referent (semiotics) 4, 34–6, 58, 65, 97, 155, 192, 219, 221
relational immanence 24, 25, 33, 67, 73, 74, 76, 82, 116
Rembrandt van Rijn 26, 74, 107
Richardson, Mary 26, 27
Rokeby Venus (1647–1651) 26, 27, 33, 217
Rosch Heider, Eleanor 172
Rothko, Mark 177–80, 187
Rubik's Cube 123, 205, 221
Russell, Bertrand 220
Russell's paradox 219
Russia 174, 175

Saint Dominique (island) 184
Saint George vs Dragon (1911) 174
Samoa 192–4
Saussure, Ferdinand de 34–5
Schacter, Rafael 118, 140
Schütz, Alfred 107, 217
Scoditti, Giancarlo 40, 41
semiotic 4, 6, 9, 11, 13, 15, 21, 22, 33–6, 40, 49–50, 71, 85, 186
Semper, Gottfried 111–3
senses 15, 39, 102, 163, 167, 172–4, 180, 182, 186–7
Sepik (region) 94–8, 126, 173
sequence 12, 15, 28, 29, 31, 33–4, 37, 41, 44, 46, 48, 54, 57, 62, 64–5, 76–9, 90, 93, 116, 118, 125, 132, 170, 187–90, 195–8, 200, 204, 205, 207–9, 211, 217, 224, 225

Index

sequencing 15, 57, 65, 136, 191, 206, 208
sequentiality 11, 13–4, 33, 54, 77, 90, 125, 132, 136, 188, 191, 198–210, 213, 220–1
Severi, Carlo 29, 214–17
Siberia (region) 174, 175
signification 4, 21, 34, 117, 210
sign (semiotics) 11, 13, 15, 21–2, 33–6, 41, 45, 47, 50–1, 54, 57, 61, 72, 77–8, 107, 165, 169, 182, 188
Simmel, Georg 26, 30, 65–6, 74–5, 107, 209
Singer, Milton 35
Sperber, Dan 10, 192
Standard Stoppages (1913–14) 32
Stedman, Captain JG 109
Stieglitz, Alfred 110, 134
Stifin, Pwyll ap 212
Stoller, Paul 173
stoppage: of movement 32, 222; of time 213, 214
Strathern, Andrew 157
Strathern, Marilyn 2, 125, 126, 157, 207, 213
style 2, 14, 74, 82, 85, 86, 89, 90, 94, 100–3, 113–18, 130, 131, 152, 168, 221
substitutionary representation 14, 25, 36, 66, 67, 72, 73, 78
substitution of object 6, 12, 15, 28, 35, 65, 74, 76, 81, 207
Sumba (island) 185, 186
surface 6, 7, 14, 26–7, 30–1, 40–1, 51, 55, 57, 61–3, 65, 70–1, 75, 80–2, 87–8, 92, 100, 112, 113, 116, 119, 153–7, 167, 169–70, 175–6, 179, 183, 187, 195–7, 221
symbol 3, 6, 24, 25, 35–6, 40, 41, 68, 73, 74, 81, 87, 94, 124, 125, 155, 163, 165–6, 181, 186, 191–2, 220, 224
synaesthesia 15, 169, 173, 175, 177, 181–3, 187, 211
synesthesia 174

Tahiti 80, 157, 158, 176, 208–9, 217
Tanner, Jeremy 24
tattoo 69, 74, 90, 156, 186, 191–4, 207–9, 215, 221
Taussig, Michael 184, 185
Te Heu Heu II Mananui 202
temporal perches 32, 44, 132, 217
Te Rauparaha 202, 203, 205
thing 1, 8–11, 14, 34, 36, 100, 132, 134, 147, 187, 207, 212, 221
Thom, René 122
Thomas, Nicholas 70
Thompson, Michael 137, 138, 140, 147, 155

time 1–2, 9, 13, 27, 29–33, 38, 41, 43, 49–50, 59, 62, 89, 93, 99, 120–1, 131, 195, 196, 203, 212–15
tivaivai 80, 145–7, 153, 157
Tonga 160, 193, 194
Torres Strait Expedition 7, 68, 69, 111
totality of the object 24–6, 40, 70, 74, 81, 221, 222, 224
Tozzer, Alfred Marston 67
transformation 14, 29, 39, 42, 47–8, 61, 88, 89, 92–4, 97, 98, 115–17, 119, 121–6, 130–2, 134, 136–40, 142, 153, 155, 160, 166–7, 170, 176, 184, 204, 206, 210, 219–20, 222, 224–6, 231, 241
transmission of canonical image 10, 46, 54, 55, 86, 197, 206
traps 93, 94, 108, 113, 115, 135, 152, 188–9
Trobriand Islands 43, 88, 176, 177
Turkey (region) 68
Turner, Terence 191
Turner, Victor 124

Ucko, Peter 12
Umeda (people) 117, 124, 173, 183
Urton, Gary 76–8

Vanuatu 143
Varèse, Louise *see* Norton, Louise
Velázquez, Diego 26, 27
Vella Lavella, New Georgia 69
virtuosity 2, 7, 11, 14, 32, 51, 63–4, 82, 85–88, 94, 97, 99–102, 104, 106, 116–20, 130–1, 136, 141, 152, 153, 155, 168, 188, 203, 225
Viveiros de Castro, Eduardo 128, 156
Vogel, Susan 107, 108
Vologda (region) 175

Wagner, Monika 167
Wagner, Roy 74, 75, 81, 86, 116, 122, 190, 200, 207
Wahgi (people) 117, 126, 128, 242
Waitangi Tribunal 202
Walbiri 55–7, 59, 60, 194, 241
Wallace, Anthony 11, 207
Warburg, Aby 1, 2, 9, 12, 89, 99, 100, 174, 213
Warlpiri *see* Walbiri
Weiner, Annette 39
Wengrow, David 10, 11
Were, Graeme 204
Wigley, Mark 112, 113
Wuta Wuta Tjangala 63–5, 119, 120

254 Index

Yanyatjarri Tjakamarra 63–4, 194, 105, 106, 119
Yap (island) 45, 147, 158
Yolngu (people) 55, 60, 63, 70, 72, 73, 81, 105, 107

Yoruba (people) 103, 104, 106
Young, Diana 169–71, 180, 181
Yuendumu 57, 114

Zeidler, Sebastian 25, 74